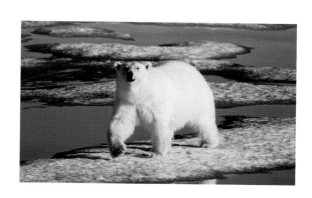

POLAR BEARS

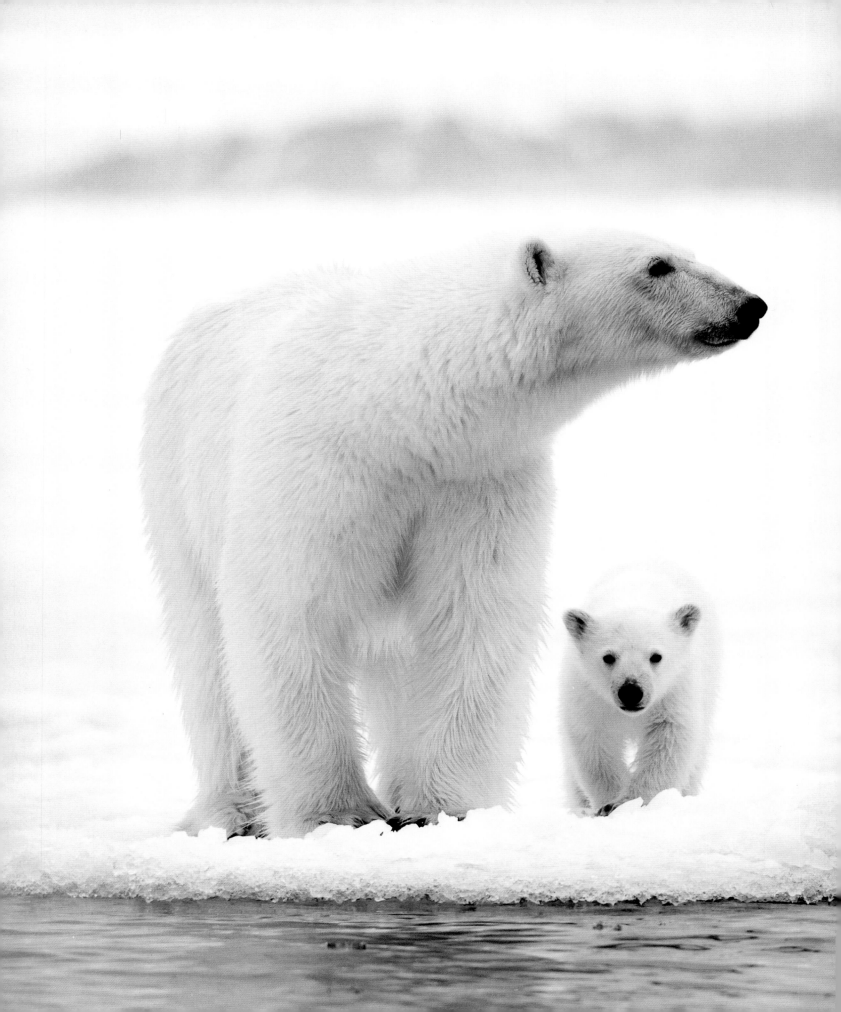

POLAR BEARS

A Complete Guide to Their Biology and Behavior

Text by Andrew E. Derocher

Photographs by Wayne Lynch

IN ASSOCIATION WITH

POLAR BEARS
INTERNATIONAL

The Johns Hopkins University Press Baltimore

© 2012 The Johns Hopkins University Press
All rights reserved. Published 2012
Printed in China on acid-free paper
9 8 7 6 5 4 3 2 1

The Johns Hopkins University Press
2715 North Charles Street
Baltimore, Maryland 21218-4363
www.press.jhu.edu

Library of Congress Cataloging-in-Publication Data

Derocher, Andrew E.
Polar bears : a complete guide to their biology and behavior /
text by Andrew E. Derocher ; photographs by Wayne Lynch.
p. cm.
Includes bibliographical references and index.
ISBN-13: 978-1-4214-0305-2 (hardcover : alk. paper)
ISBN-10: 1-4214-0305-6 (hardcover : alk. paper)
1. Polar bear. 2. Polar bear—Behavior. I. Title.
QL737.C27D47 2012
599.786—dc23 2011021303

A catalog record for this book is available from the British
Library.

Frontispiece: Polar bears are perfectly adapted to their Arctic
world where they make their living as the top predator of
the ice-covered seas. This mother has a little over two years
to teach her cub the skills needed to survive in this extreme
environment.

*Special discounts are available for bulk purchases of this book.
For more information, please contact Special Sales at 410-516-
6936 or specialsales@press.jhu.edu.*

The Johns Hopkins University Press uses environmentally
friendly book materials, including recycled text paper that
is composed of at least 30 percent post-consumer waste,
whenever possible.

Contents

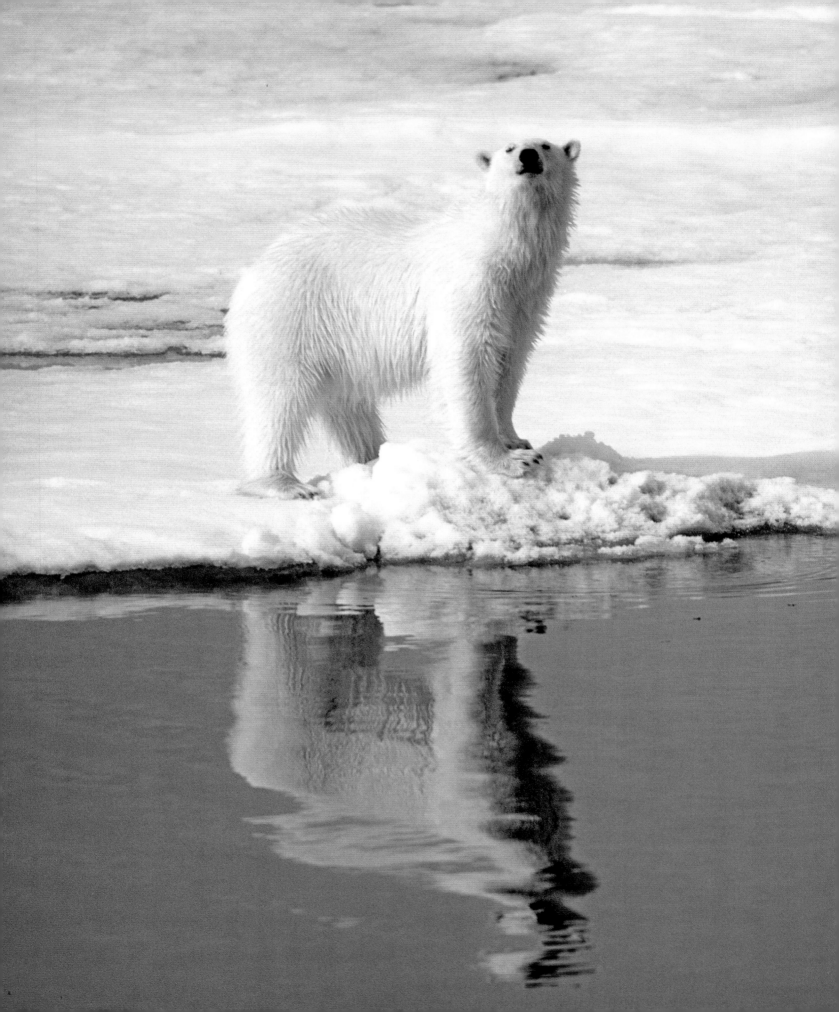

Acknowledgments

Andrew E. Derocher

My interest in natural history began at an early age, fostered by catching snakes, dragonflies, and salmon fry in wild corners of Vancouver, British Columbia. I saw my first bears, black bear cubs with their mother, grazing on spring grass along the edge of a coastal rainforest while on a family outing as a child. That event sparked a lifelong interest in bears. Supporting my interest in wildlife, my parents, Edward and Shirley Derocher, encouraged me to get a university education and for this I am eternally grateful.

I would like to thank Fred Bunnell and Tony Hamilton who gave me an opportunity to study grizzly bears after finishing my undergraduate degree at the University of British Columbia. This experience set my career in motion and further fueled my interest in these wonderful animals. One rainy day in the coastal rainforest, I had the good fortune to be working with Ralph Archibald, who asked if I might be interested in studying polar bears. I thank Ralph for suggesting I contact Ian Stirling of the Canadian Wildlife Service. The following year I began a steep learning curve with Ian while completing two graduate degrees at the University of Alberta. I would like to thank Ian for his advice and direction over the years. My education in polar bear biology was aided by Dennis Andriashek, who taught me the minutiae of good planning and the importance of maintaining field gear. His mantra, "one to use, one to lose, and one as a spare," saved me more than once in remote field camps.

While working at the Norwegian Polar Institute, I was fortunate to have many discussions with scientists who helped shape my understanding of Arctic ecosystems. In particular, I thank Pål Prestrud for wide-ranging discussions on the Arctic, Christian Lydersen for expanding my knowledge of seal ecology, Magnus Andersen for his solid assistance,

(Opposite) **Fresh from a swim, this young adult female surveys her surroundings as they rapidly melt with the advancing summer. Polar bears are a threatened species because global warming in the Arctic has caused major changes in the sea ice that they depend on to hunt, travel, and mate.**

Dag Vongraven for our discussions about polar bear management, and Øystein Wiig of the University of Oslo for many wonderful field seasons in the Norwegian Arctic. I have had the good fortune of working with many talented graduate students in my lab and I would like to thank them for their contributions. Over the years I have flown with many incredible pilots. I would especially like to thank pilots Steve Miller and Mike Woodcock for their contributions to polar bear research.

Much of the information in this book was gleaned from more than 40 field expeditions and hundreds of scientific papers. Modern polar bear research now spans almost 50 years, and over those years, numerous researchers have labored, often under difficult and dangerous conditions, to obtain insights into this intriguing and complex species. This book is a tribute to the people who have worked over the years to understand polar bears.

Working with Wayne Lynch on this book has been a dream come true. Wayne and I first met more than two decades ago, early in his career as a wildlife photographer. A polar bear scientist could not have a better photographer, and the process of melding words with images has been wonderful. Stephen Hamilton kindly assisted with the production of maps. The Johns Hopkins University Press has been a delight to work with, and Vincent J. Burke, the life sciences editor, provided crucial direction. I am thankful to the managing editor, Juliana McCarthy, the copy editor, Anne R. Gibbons, the production editor, Andre Barnett, and the designer, Glen Burris, who all made significant contributions in moving this book to fruition.

Over the years, my research has been supported by a wide array of agencies. I thank ArcticNet, the Canadian Association of Zoos and Aquariums, the Canadian Wildlife Federation, the Canadian Wildlife Service, the Inuvialuit Game Council, Manitoba Conservation, Minerals Management Service of the US Department of the Interior, the Natural Sciences and Engineering Research Council of Canada, the Northwest Territories Department of Environment and Natural Resources, the Norwegian Polar Institute, Nunavut Department of Environment, Nunavut Wildlife Management Board, Parks Canada, Polar Bears International, Polar Continental Shelf Project, Quark Expeditions, and World Wildlife Fund (Canada).

More than anyone else, I thank my partner in life, Kathy Pontus. Through many years of long field seasons, Kathy encouraged and supported my passion for studying polar bears. Without her assistance, this book would not have happened. Kathy patiently reviewed many drafts of the book and made numerous important suggestions to increase its accessibility. My children, Angus and Emma, provided me with ongoing inspiration to keep working to ensure that polar bears are around for future generations.

Wayne Lynch

I saw my first polar bear in 1981. Three decades later, having traveled the globe in search of wildlife, I still find the polar bear one of the most engaging and beautiful creatures on earth. Perhaps the reason *Ursus mar-*

itimus has held my interest for so long is the endlessly fascinating details that scientists continue to discover about the bears' biology, physiology, and ecology. One of these scientists is the author of this book, Dr. Andrew Derocher, who has succeeded in writing the most exciting, informative, and comprehensive text on polar bears ever attempted. I am proud and thankful to be part of this project. I am also grateful to Andy for welcoming me into his research camp so many years ago and providing me with countless unique photographic opportunities.

I owe a huge debt of thanks to Dr. Ian Stirling, who invited me to join him while he tagged bears in Lancaster Sound and observed their hunting behavior. The memories of those weeks with Ian are still some of my most treasured experiences with polar bears and the Arctic.

This is my second book with the Johns Hopkins University Press and I am thrilled to be working with them again. I especially thank life sciences editor Vincent J. Burke for keeping this project alive. As always, he was understanding, supportive, friendly, and professional. I am also thankful to managing editor Juliana McCarthy and designer Glen Burris for their creative contributions.

Last, and most important, I thank my loving wife, Aubrey Lang, for her decades of unflagging enthusiasm and unselfish encouragement. My life with her has taken us in directions I could never have imagined and it has been a great ride.

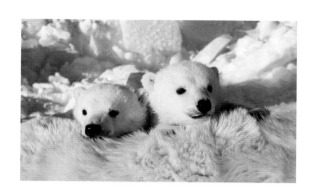

POLAR BEARS

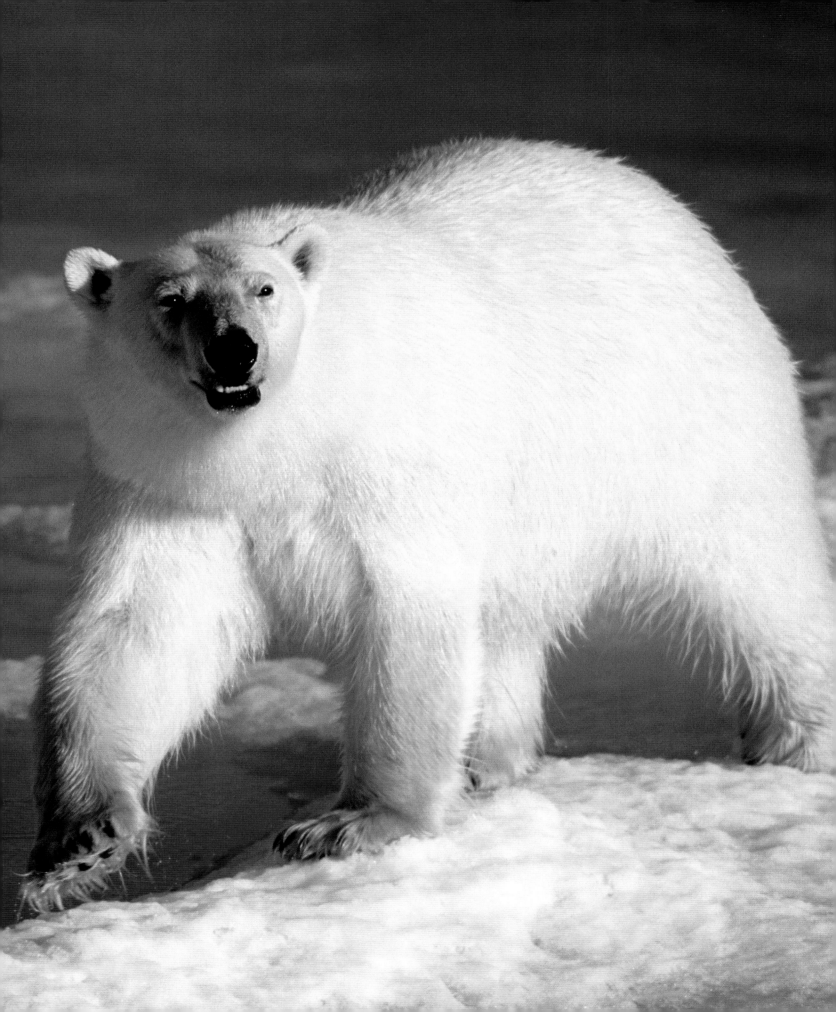

1

INTRODUCTION

Sea ice, snow, caribou, narwhal, walrus, and polar bears are easily sufficient elements to define an area of the globe called the Arctic. For many people, polar bears alone are enough to characterize the top of our planet. Antarctica has penguins; the Arctic has polar bears. That their habitat is restored each year as winter builds is the antithesis of that for most other species. Many people find something mystical about a huge, potentially dangerous, pure white predator that stays awake all winter, walking on a frozen ocean under the northern lights.

The polar bear (*Ursus maritimus* Phipps 1774) derives its Latin name from the words for "bear" and "maritime": the bear of the sea. The polar bear is also known as the "ice bear" or the "white bear" in various languages. Polar bears, the apex predator and a prominent part of the Arctic marine ecosystem, live in most of the ice-covered seas of the Northern Hemisphere. Though polar bears can swim, they are far more often found on sea ice than in the water. Some Arctic marine mammals use sea ice merely as a handy place to snooze or to give birth. Polar bears use the sea ice as a platform for traveling, mating, and feeding. As its scientific name suggests, the polar bear is a marine mammal, and it derives almost all its sustenance from the marine environment. Sea otters are clearly marine mammals and nobody would call them a terrestrial mammal despite their terrestrial origins. But the polar bear is often mistakenly identified as the largest of extant terrestrial carnivores. The stereotype of a bear lumbering across the land is hard to erase.

There are about 100 living marine mammal species in three taxonomic orders: seals, sea lions, walrus, sea otters, and polar bears in the Carnivora; whales, dolphins, and porpoises in the Cetacea; and manatees and dugongs in the Sirenia. Of these marine mammals, all of the Carnivora are amphibious, which means they spend time in the water and on land or, for Arctic species, on ice. Some polar bears are born on

(Opposite) **Truly at home only on the sea ice, the polar bear is one of the most recognizable animals in the world. Of the eight living species of bears, only the polar bear has evolved to have a carnivorous diet.**

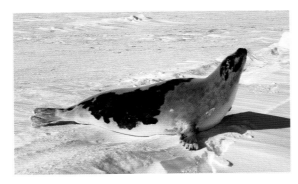

The order Carnivora, which represents a diverse taxonomic group, includes marine mammals such as the harp seal, Antarctic fur seal, Atlantic walrus, and sea otter. Despite absolute dependence on the marine environment for their food, all marine Carnivora species retain a link to sea ice or land for various life history events.

the ice and live out their lives on the ice, never stepping onto land and are just as "marine" as seals and sea lions.

That the Arctic is centered on the North Pole is not in dispute. What constitutes its southern border, however, is debatable. For some purposes, the Arctic Circle, at 66° 33' 44" N, is considered the southern boundary of the Arctic. But many polar bears live far outside the Arctic Circle. In southern James Bay, polar bears live at the same latitude as London, England, although in a decidedly more arctic environment. For the purposes of this book, a polar bear–centric view seems reasonable for defining "the Arctic."

Any polar bear living above the Arctic Circle sees the midnight sun on the summer solstice and experiences the polar night on the winter solstice. The never-setting sun in summer and the never-rising sun in winter last for months, depending on how far north a bear lives. Bears living at 74° will not see the sun from November 10 to February 1 (84 days), whereas those at 80° will experience polar night from October 22 to February 20 (122 days) when only the moon, stars, and the aurora borealis provide light.

Given my long acquaintance with polar bears, I am clearly biased toward these intriguing animals. There is nothing unusual about biologists being fascinated by their study organism. I know scientists who are passionate about orchids, butterflies, albatross, caribou, and grizzly bears. There is also no question that the public is intrigued by many of the plants and animals with which we share the earth. But the public's fascination with the polar bear may outstrip that for all other species.

That the general public is captivated by polar bears is evidenced by the bears' ubiquitous presence in historical and popular culture. Paintings, carvings, T-shirts, jewelry, "bearaphenalia," magazines, advertise-

ments, television shows, Hollywood movies, and soft drink containers are infused with polar bear images. And interest is always piqued by scientific findings. The appetite for polar bear information is apparently insatiable, whether it is a report on cannibalistic polar bears or a picture of cubs riding on their mother's back.

My wife's aunt once asked me what I would do to make a living as a "polar bearologist" and what sort of future did such a career hold (fearing, perhaps, that her niece would suffer an impoverished life). I do not think I had an answer all those years ago but I have, indeed, made a living studying a big white bear. I have been conducting research on polar bears for almost three decades, and my fascination with their natural and unnatural history has not waned. I am every bit as intrigued by what I will learn about polar bears today as I was when I embarked on this odyssey.

The Arctic is not pristine, but until recently it has been largely unaltered by humans. Arctic whaling in the 1800s was a booming industry until most of the whales were killed. A vibrant commerce in polar bears in the 1900s almost drove the bears to extinction in some areas, and it was a long slow climb back to healthy numbers. The Arctic has been

Polar bears are distributed throughout the circumpolar Arctic in close association with the distribution of sea ice. They are, however, a species of the continental shelves and are much more abundant over the shallow productive waters nearshore. The solid orange line indicates the higher density areas and the dashed yellow line outlines the normal range of polar bears. Shallower ocean depths are lighter in color.

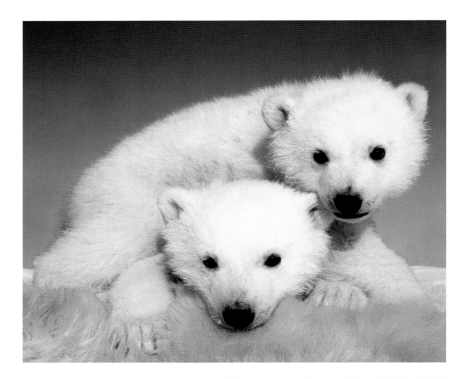

(Right) Polar bear cubs in spring are among the most photogenic animals in the world. Twins are the norm. Average litter size is smaller than that of their grizzly bear ancestors due to the Arctic's harsh environmental conditions.

(Below) An adult female with two spring cubs not long out of their den pause on the sea ice. The spring feeding period is critical for the mother who must replenish her fat stores after fasting for many months while rearing her cubs.

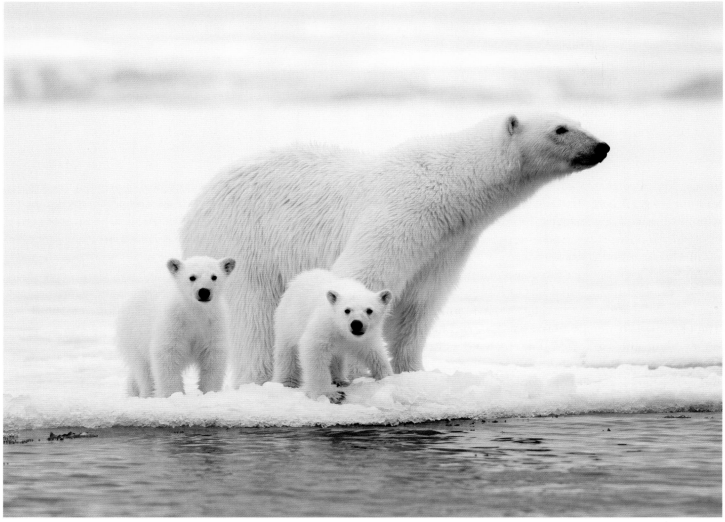

The Intriguing Polar Bear

It is hard to say why people are so intrigued by polar bears. Being snowy white and photogenic probably does not hurt, nor does having adorable cubs and a remote, mysterious lifestyle. I have concluded that the bears' massive size, good looks, and intelligence combined with the frisson of fear inspired by such a canny predator are probably the driving factors behind our fascination with the ice bear. Whatever the reason, humans are drawn to this lovable animal like few others. Arctic foxes, as snowy white in winter as any polar bear, are also photogenic and their kits are adorable. But they do not draw in the crowds. Arctic foxes are just not big enough or scary enough.

Humans have a long history with predators, bears in particular. In some ecosystems, bear species fill almost the same role as humans. We consume many of the same foods as bears and live in many of the same habitats. Sometimes we eat the bear and sometimes the bear eats us. It is probably deep in our DNA to be alert when we see a large predator and prepare for flight or a fight. Such emotions are hard to conjure up while sitting comfortably in a house. But those who have seen polar bears in their natural habitat know just how awe-inspiring they are. Polar bears are the original beauty and the beast all in one.

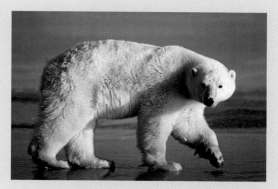

Snowy white fur, claws designed for killing, and a hint of danger are characteristics of the ice bear that may be what people find so intriguing about this denizen of the Arctic.

viewed as a frozen wasteland with little to offer but freezing cold winters and summers filled with biting insects, but new exploitation is coming. Climate change is fomenting increased interest in Arctic resources. Such exploitation poses a daunting threat to polar bear habitat. As the sea ice disappears, so will polar bears. Perhaps the public's fascination with the maritime bear will be strong enough to save it.

I have been privileged to study polar bears and, in a sense, I owe them. The bears have been good to me (so far) and have provided a window on the Arctic unlike any other. I hope that by writing about their natural history, I can provide people with better insight into how they live in one of the harshest environments in the world. The ecology and conservation of polar bears cover myriad complex topics. And almost 50 years of serious polar bear research means there is no dearth of information. Although some of my observations are anecdotal, they illustrate elements of polar bear ecology not usually found in scientific papers. The topics I undertake and the depth of my discussion reflect my biases and experiences. On some topics, we know enough to bore any but the most dedicated "bearologist" to tears. In other areas, the paucity of informa-

tion is profound. I have tried to distil the essence of the polar bear literature to give insights into the depth and diversity of what we know.

There are few polar bear biologists in the world and each lives in one of the five polar nations that have polar bears under their jurisdiction. The incredible tenacity of these scientists is notable; many have careers spanning decades. Their collective dedication to the wise management and conservation of polar bears is outstanding. Perhaps the bears inspired them as they did me. Serendipity set me on the path to studying polar bears. I hope to follow that path for years to come.

Introduction

2

A POLAR BEAR DESCRIBED

Bears are so recognizable that even the less common species can easily be identified by most people as a bear. But the many fascinating aspects of polar bears justify a detailed description. Many of the polar bear's adaptations stem from the ecological position they fill but they have not diverged much from the basic bear morph.

From the Outside: Bear Fur

The characteristic white to pale yellow color of polar bears is caused by a lack of pigment. A snippet of polar bear fur looks like glistening glass fibers. A bear seen at sunrise or sunset can radiate an orange-red halo from reflected light. If you are on the ice searching for something white, you will see only snow. Even sea ice is shades of gray or blue rather than white. If you are looking for a polar bear you should look for a yellowish object, preferably one moving as a stationary yellowish object might just be algae on a chunk of upturned ice. Among mammals and birds, there is a significant association between having white fur or feathers and living in the Arctic. An adaptation to life on the sea ice, polar bear fur provides camouflage for this huge predator. Some color variation is associated with season, age, sex, and light conditions, but it is unpredictable. Oil oxidation on the hair, the summer molt, bleaching by the sun, a recent meal, or dirt when bears are ashore in summer can also affect fur color.

Polar bear fur has two layers. There is a fine dense underfur up to 2 inches (5 cm) long and a longer coarser guard hair layer up to 6 inches (15 cm) long. Guard hairs on the back of an adult male's forelegs, however, can be 17 inches (43 cm) or longer. The underfur is 0.0008 inches (<20 μm) in diameter; the guard hairs range from 0.002 to 0.008 inches (50–200 μm). All hairs have an outer cuticle layer that can be diagnostic of a species. In polar bears, a scalelike pattern covers the hair surface but is not particularly dramatic. Polar bear guard hairs have a hollow but di-

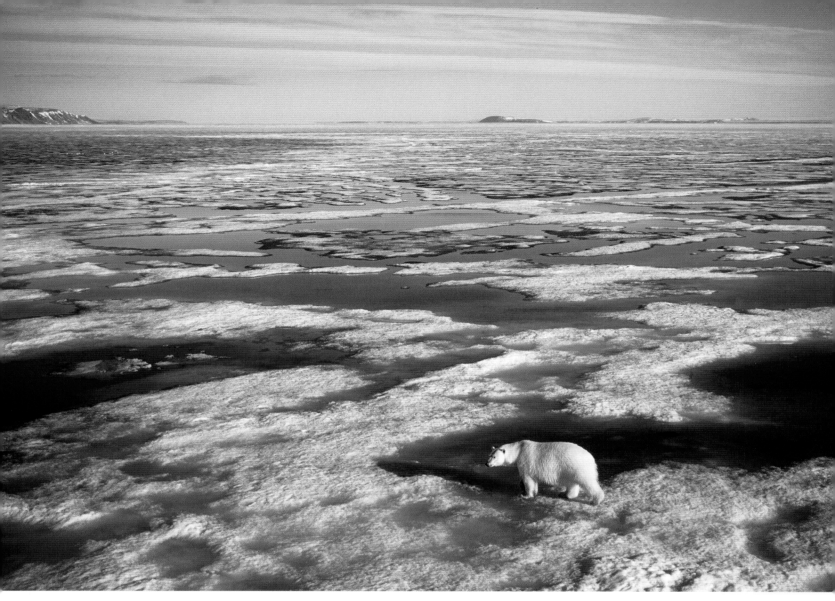

The polar bear, also known as the ice bear and the white bear, is truly at home on the vast expanses of the sea ice. If you are looking for a polar bear in the wild, look for a yellowish object, preferably one that is moving.

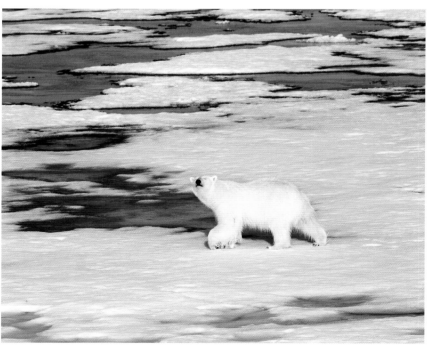

Polar bear cubs have fluffy fur designed to withstand the frigid Arctic air, but they are vulnerable to hypothermia if they get wet. Mothers will walk long distances to find a pathway of solid ice rather than make small cubs swim.

vided center (medulla). Hollow hair is found in many species and is best developed in the deer family. In polar bears, the hollow center aids in insulation and buoyancy. Polar bear hair differs from that of their grizzly bear ancestor in that the hollow core is more honeycombed, or divided, in grizzlies. In captivity, polar bears can develop a greenish cast caused by algae cells inside the hair that invade when the hair tips are worn down, exposing the hollow center. The warm moist environment inside the hair makes a perfect little greenhouse. Such bears look like they have been dipped in green dye.

The fur of polar bears grows to a fixed length before being molted and replaced: mammalogists call this "definitive" growth. Molting occurs from May through September, and at times, handfuls of hair can be pulled from the hide. Grizzlies can look unkempt while molting because they have denser underfur than polar bears. You will never see a scruffy polar bear. In summer, bears have thinner coats and their black skin can create a dark undertone. The black skin is most apparent on the face. Only once have I seen a bear with pigmented fur. I caught an adult male with black-brown hairs scattered over his whole body. The hairs were only noticeable close up and did not change the color of the bear. It is

odd that no totally black (melanistic) or albino polar bears have ever been reported. Such abnormalities are fairly common in mammals from porcupines to moose to jaguars and humans. Presumably the selective pressure on polar bears to be white is intense and being albino may cause problems during the long summer.

Cubs leaving the den have distinctively different fur from adults. They are conspicuously fluffy, with short woolly fur. The guard hairs of cubs are wavy and have a tawny cast to them. The tawny cast varies between cubs and even in twins the intensity can vary. Some cubs are distinctly beige when they emerge from the den, but after a while the sun bleaches the fur. Cub fur provides better insulation than adult fur in dry air but the insulative value drops markedly when the fur is wet, which explains why mothers with small cubs avoid swimming.

The skin of polar bears is pink in cubs up to 5 months old but is black in all older bears. All grizzlies have pink skin no matter their age so the black skin of polar bears is an evolved trait but we do not know why it changed. A 1970s study of aerial photography of polar bears revealed that the bears were black on ultraviolet sensitive film: the bears absorbed ultraviolet light. This eventually led to a novel supposition: polar bear hair behaves like a fiber optic filament, transmitting light to the black skin as a form of thermal warming. A physicist testing the fiber optic properties of polar bear hair found, however, less than a thousandth of a percent of the light traveled 1 inch (2.5 cm). For ultraviolet light, the loss of light happened in a fraction of that distance. An intriguing idea disproved by simple fact: polar bear hair does not transmit light and is not fiber optic. Upon further consideration the fiber optic fur theory did not make sense because in the coldest parts of the year, winter, there is no daylight and in the sunniest time, summer, bears need to dissipate heat, not retain it.

A Big Bear by Any Standards

Polar bears are large in the mammalian context and large by bear standards as well. They are more streamlined than the blockier grizzly bear. If we average the size of all polar bears and compare them to all grizzly bears, the Arctic ice bears are bigger. However, grizzlies in coastal Alaska and Kodiak Island, Alaska, which feed on Pacific salmon, are as large as the biggest polar bears. Standing next to an adult male polar bear is like standing next to a large pony. Adult male polar bears can weigh over 1760 lbs (800 kg) and are up to 8.3 feet (253 cm) long. Adult females can weigh up to 990 lbs (450 kg) and be up to 7 feet (214 cm) long. Scientists measure polar bears from the tip of the nose to the last tail bone. Hunters talk about "10- or 12-foot bears," but these are hide measurements from a skinned bear. The weight of a bear varies widely throughout the year. A lean adult male might weigh only 660 lbs (300 kg) while the fattest bears might carry an additional 50% as fat. Most fat is deposited at the base of the back by the tail, around the rump; there is less fat over the rest of the body and gut cavity. The fat is thinnest on the legs, neck, and head, which gives a plump bear a light-bulb-with-legs profile. A bear in good

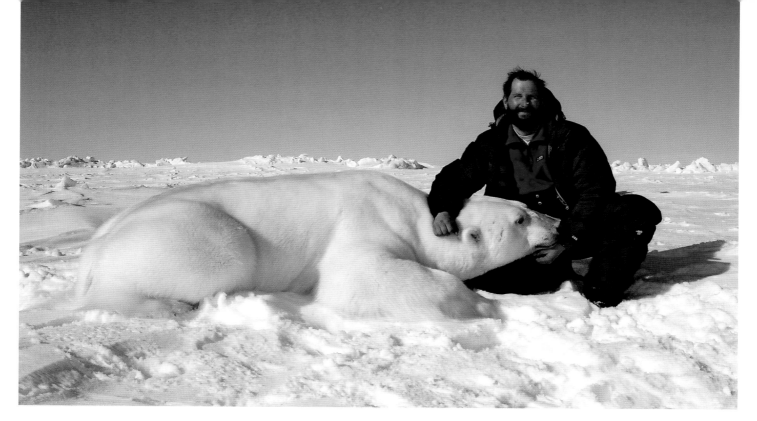

Polar bears are one of the largest carnivores on earth. The author kneels beside a large adult male polar bear for scale. Bears are drugged with a dart shot into the rump or shoulder.

condition characteristically has a chubby rump whereas bears in poor condition have rather bony, skinny hips. A fat bear's rump will be higher than its shoulder, and its belly will sag. If viewing bears in the wild, a bear in good condition has a convex curve from its hips to its tail while a bear in poor condition will have a straight line.

Keeping warm is an important force in the evolution of polar bears. Temperatures with high wind chills can easily dip to –60°F (–51°C) and heat loss is considerable. Polar bears have evolved several modifications for staying warm. For any species, the bigger you are, the less surface area you have relative to your volume because surface area increases as a function of two and volume by three. A bigger volume is akin to a bigger furnace to keep the body warm: volume increases faster than surface area as an animal gets bigger. The surface of an animal is how most heat is lost. This relationship explains why polar bear cubs are vulnerable to cold: they have a large surface area relative to their tiny volume. Being large is important for more than just staying warm. Larger animals can carry more fat and this is an essential component of a polar bear's life history. Being large allows bears to gorge, technically called hyperphagia, when food is plentiful and then store the energy on their bodies for times when food is scarce. Polar bears are also large in part because of their evolutionary history. They arose from grizzly bears that can grow very large on an energy rich diet. The diet of polar bears is extremely rich and almost exclusively animal fat and protein. Diet plays a key role in determining body size for all bear species.

Being large comes at a cost because moving a large body takes more energy than moving a small one. A polar bear's massive limbs are designed for strength not speed. Studies suggest that walking polar bears are energetically inefficient compared to other mammals. That polar

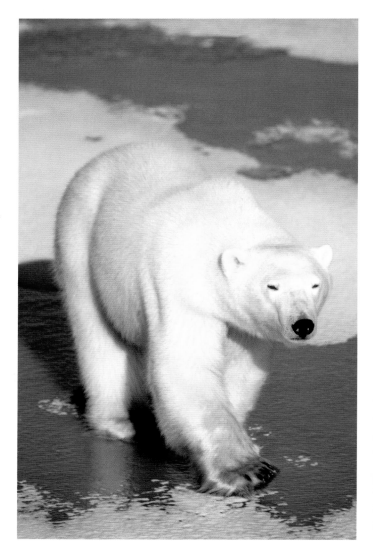

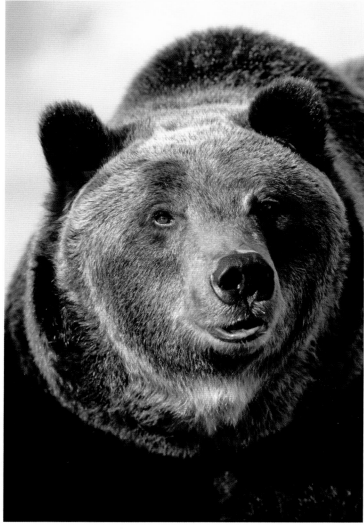

Adult polar bears such as this male have a noticeable hump at their shoulders caused by their shoulder blades. The hump is more pronounced in grizzly bears because their longer, fluffier fur exacerbates it.

bears, with their vast home ranges, move inefficiently seems counterintuitive. But polar bears can afford to use a lot of energy for movement because their diet is so energy rich. Despite their lumbering appearance, polar bears can top 20 miles per hour (32 km/hr) on flat ice. A large fat male, however, can barely achieve half that speed and then only for a short distance before it begins to overheat. Though large, polar bears are incredibly agile. A bear can climb a tumbled mass of ice several stories high like it is a staircase or careen down a mountain slope with amazing maneuverability. While polar bears rarely jump at biologists in helicopters, grizzly bears do so regularly. Polar bears save their jumping for moving from ice floe to ice floe.

Polar bears' substantial fat reserves serve two functions: energy storage and insulation. Seals and whales need blubber to keep warm in water. Because polar bears spend most of the time out of the water, they also rely on fur to keep them warm. Fur insulates polar bears from severe weather, but its insulative value when dry is a bit lower than that of grizzly bears that have a heavier undercoat. And that value is reduced by about 90% when the fur is wet. The fur's ability to shed water and regain

its insulative value when dry is critically important. Polar bears are meticulous in drying themselves when they emerge from the water. They shake and roll in snow to remove water; in doing so, they trap air in their fur that prevents water from penetrating to the skin when they are swimming. I have caught many bears that have just emerged from the water and their skin is usually dry. Oils on the hairs also help with waterproofing. Polar bears fastidiously clean their coats after feeding and this also aids in keeping them warm. Similarly, sea otters also rely on trapped air in their fur to stay warm and they too spend a lot of time grooming.

About the only "small" part of a polar bear is its tail. Normally about 3 to 6 inches (8–15 cm) long, the tail serves no obvious function beyond keeping a bear's rear warm, not an unimportant function. When a bear defecates, the tail rises like a trap door. If the bear has been eating low-fiber seals, a gooey stream follows. I have caught bears with abnormally short tails and others with particularly long tails. As long as the tail covers the sensitive part of the rear end, there seems to be no significance to its length. Periodically, I have encountered bears with damaged tails though I do not know how the damage occurred: frostbite, an accident

The massive limbs, stocky build, and elongated neck of this adult male characterize the ice bear. Despite their size, adult males are incredibly agile, moving with ease over ice rubble. Their huge paws provide great traction and help distribute their weight.

Typical of all bears, the polar bear has a short and inconspicuous tail.

jumping across the ice, or being bitten by another bear are the most probable causes.

The Business End

Compared to other carnivores, all bears have large skulls relative to their body size. The skull of a polar bear is longer and narrower than a grizzly bear. In profile, polar bears have a "Roman nose" that slopes more from the forehead. The ice bear's eyes are also slightly elevated: perhaps an adaptation to spending time in the water. Grizzlies have pie-shaped faces with a distinct stop at the base of the snout. The polar bear's narrower head is advantageous in accessing birth lairs and breathing holes in pursuit of fleeing prey. A wide snout is important for carnivores that deal with large, dangerous prey. Polar bear prey is not dangerous so this selective pressure was relaxed. An elongated skull also helps warm inhaled air. Like many mammals, polar bears have well-developed scroll-like bony plates in their nasal cavity (turbinate bones). These bones increase the surface area of the nasal passages and warm inhaled air to protect the lungs and aid in moisture retention.

Skull length in carnivores is also influenced by a forward part of the

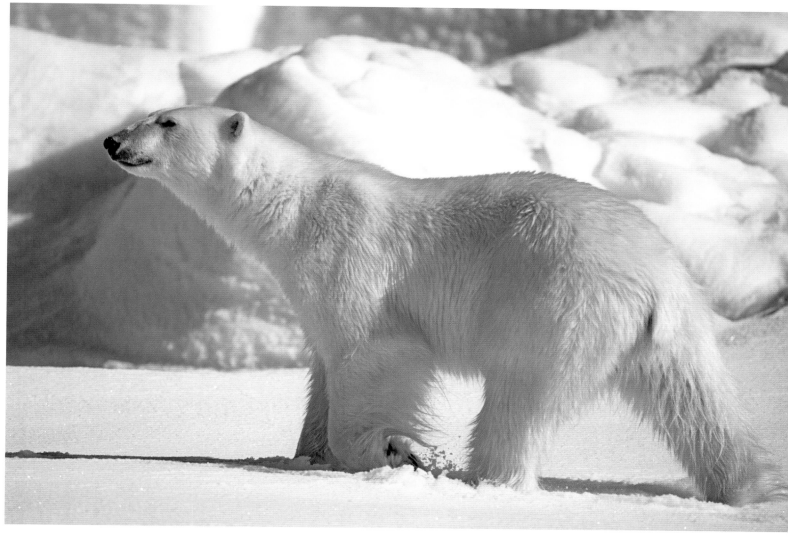

The elongated neck and narrow skull of polar bears are ideal for preying on ringed seals.

brain called the olfactory bulb. A larger bulb increases the sense of smell and requires a longer skull. In mammals, larger olfactory bulb size correlates with larger home range size. Polar bears have expansive home ranges and are highly reliant on their sense of smell for foraging. It is said that when a leaf fell in the forest, the deer heard it, the eagle saw it, the bear smelled it. In the rapid evolution from grizzly to polar bear, the skull was adapted to a semiaquatic lifestyle and a diet of blubber and meat. One consequence of these specializations is that a polar bear, unlike its omnivorous ancestor, cannot effectively chew coarse vegetation.

Many adaptations of polar bears are related to hunting and each one likely increased hunting success. For example, polar bears have a longer neck than grizzlies, possibly another hunting adaptation. Being able to reach a bit further to catch a seal was likely the selective pressure for the elegant form of the polar bear.

Whiskers are not abundant on the face of polar bears nor are they easily visible. But they are present if you look closely. The whiskers, more formally vibrissae, of the polar bear are short, relatively stiff, and a pale mocha color. The bear's whisker spots, small dark round areas at the base of the whisker follicle, are easier to see and can be used to identify

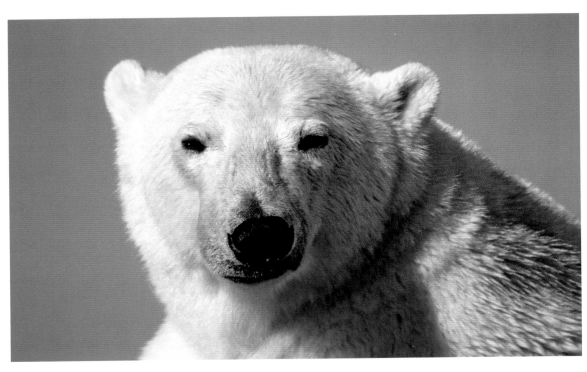

One consequence of remaining active all winter is that the extremities of the body have to be kept warm. The small ears of polar bears have evolved to reduce heat loss and the risk of frostbite.

individuals. Whisker spots are also used in African lion studies. Whiskers on animals other than humans normally function as touch sensors but they are poorly developed in all bear species. The polar bear's whiskers were lost a long time back in the evolution of bears. But whiskers (I know from experience with beard and mustache) ice up in cold weather. An icy muzzle is not beneficial.

Another adaptation to cold climates is small ears. Reduction of body extremities in colder climates is known as Allen's rule, and when it comes to ears, polar bears fit the rule. I have seen only one polar bear with large ears. Unfortunately, I was laughing so hard about the poor bear's ears that I failed to measure how big they were or take a picture. Ears are not something I would normally measure, but in this case it would have been interesting. I am not sure, but my guess is that the large ears were a throw back to grizzlies, which have much larger ears than their polar bear cousins. Uncharacteristically and perhaps unkindly, I wrote "Dumbo" on the bear's capture sheet.

Studies with captive polar bears have allowed scientists to determine that the bears' hearing range is not that different from humans'. One study used electrodes placed just under the skin to measure the bear's response to sound; another trained bears to touch a target for a food reward when they heard a particular sound. Polar bears have good hearing in the 11,200 to 22,500 Hz range, but it is best at 8000 to 14,000 Hz. On the low end, dogs and polar bears have similar hearing to 125 Hz or slightly lower. On the high end, dogs hear up to 60,000 Hz, well beyond the range of polar bears or humans. The frequencies at which a species can hear vary with the environment in which it lives. A polar bear does not to need to hear at extremely high frequencies. In the water, ringed seals make barks, growls, yelps, and chirps below 2000 Hz. When these sounds were played to captive polar bears, the bears became notably

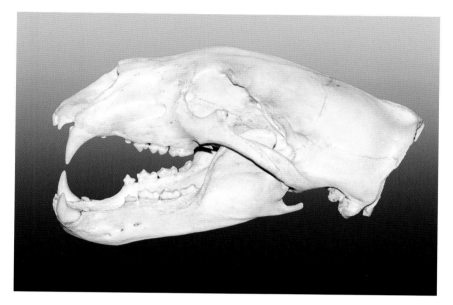

A polar bear's canines are used to seize and control prey. The molars are slightly sharper and better at shearing flesh than those of their grizzly bear ancestor. The roman nose of the polar bear is indicated by the small bump on the gentle slope from brow to nasal opening.

interested, sniffing the air and pacing. What does this mean with regard to the role of hearing when polar bears are hunting? We know that smell is important. Does hearing help refine the location of seals either under the snow or in the water? Probably, but we do not know for sure.

The dental formula (number and type of teeth on one side) of polar bears is 3 incisors up and 3 down; 1 canine up and 1 down; 2 to 4 premolars up and 2 to 4 down; and 2 molars up and 3 down, putting the total number of teeth at 34 to 42. The gap behind the canines (diastema) may aid in grasping prey and results from the tiny nonfunctional first three premolars: the second and third premolars, if present, often look like nothing more than a tiny white dot about as wide around as pencil lead.

The teeth and jaw structure of polar bears are typical of carnivores. The canines are elongated, conical, and slightly hooked. The large canines, which are critical for seizing and subduing prey, also function in threat displays when bears curl back their lips in aggressive encounters. The row of incisors across the front of the mouth is for grasping and ripping blubber and meat from prey. The cheek teeth of polar bears are higher and more pointed than those of grizzlies, an adaptation to a more carnivorous diet and the need to shear flesh into smaller pieces to aid swallowing and digestion. The molars are evolving toward specialized slicing teeth known as carnassials, which are common in other carnivores.

Relative to body size, the bite force that the canines exert in polar bears is not very high but is slightly higher than grizzly bears. High canine bite force is common in carnivorous dogs and cats, where it is necessary for subduing and controlling prey. In the dog and cat families, extended kill times are common, whereas polar bears easily dispatch their prey. Even the largest seals are not dangerous but they do require

a strong bite if only to hold onto them. Thus there is no intense selection on polar bear teeth, jaw, and muscle structure for preying on seals but they have diverged somewhat from their ancestor. Polar bears have changed back towards a more carnivorous form.

Polar bears have a tiny duct (nasopalatine duct) that opens in the roof of the mouth near the front. This duct, which opens into the nasal cavity, may link into a "mouth-smelling organ" (vomeronasal organ) used in determining the estrous state of females. Many mammals have such abilities but they have not been studied in polar bears.

The polar bear's tongue is pink, mottled with black, and is relatively smooth, more doglike than catlike. The inside of the lips are similarly colored. A polar bear's lips are not particularly mobile (unlike the lips of some other bear species) but can be pursed when vocalizing. Somewhere along the line, an unknown taxidermist decided that polar bears have blue mouths. A polar bear rug with baby blue on the inside of the mouth may be artistic but is certainly not biologically accurate. The roof of the mouth has well-developed side-to-side ridges (palatal rugae), much like a dog's, thickened with keratin protein, which aid in the mechanical manipulation of food.

The skull of polar bears is robust and typical of carnivores in general. The strong jaw hinge (mandibular fossa) is deep and well defined but a bit flattened in bears, allowing some lateral motion. The jaw is free to move up and down but has restricted side-to-side movement.

There are two bony crests on a polar bear skull. Running along the midline on top of the skull is a well-developed sagittal crest typical of carnivores. Large jaw muscles (temporalis muscles) are attached to this crest and provide bite force. Across the top rear of the skull lies the nuchal or occipital crest where muscles and ligaments that support the head are attached. The occipital crest is exceptionally large in polar bears and aids a bear in extracting squirming seals from the ocean. In most bears, the skull is 20% of the skeleton's total weight. I once had the inglorious task of transporting the head of an adult male polar bear to a museum to be cleaned and can testify that the weight was impressive. The impressive neck muscles and their robust attachment to the skull are designed for brute force. Watching an adult male kill and drag a massive bearded seal across the ice like a rag doll gives a clear indication of the bear's strength.

The eyes of a polar bear, like all bears, face forward, providing good binocular vision; they are set far enough to the side to provide good vision beside the animal. Visual acuity in polar bears is only partially understood, but myths about poor eyesight abound. For example, Russian scientists reported that polar bear vision is not very keen but have both day and night vision. I am doubtful about claims about poor vision: I have seen polar bears spot me on the sea ice from a long ways off. A polar bear's eye is spherical with a circular pupil; it is adapted for seeing in air, not water. The iris is always brown; I have never seen any variation in eye color. Polar bear eyes have both short- and long-wave sensitive cones giving them dichromatic color vision. The short-wave cones are most sensitive to blue-violet light and the long-wave cones to yellow

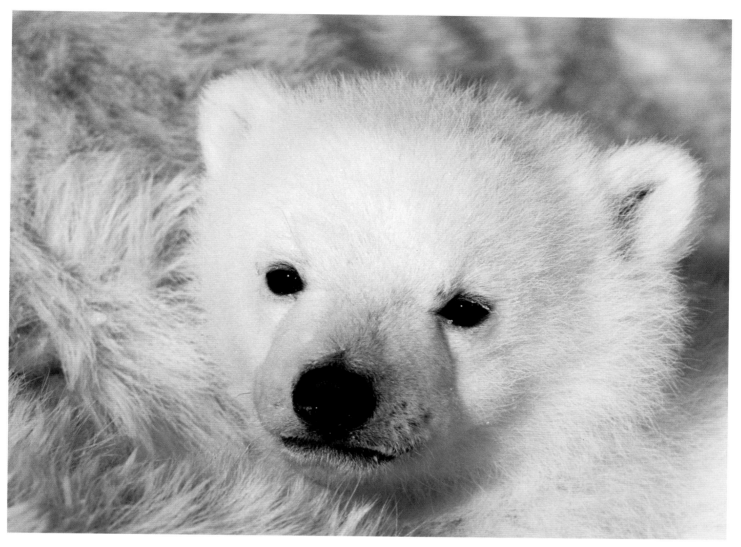

Polar bears can see color but not as well as humans. The small eyes of polar bears may reduce the risk of snow blindness and help the bears see during bouts of blowing snow.

light. Humans have an additional cone in the middle that is most sensitive to green, giving us trichromatic color vision. Not seeing green well is no great loss to a polar bear out on the sea ice. An abundance of rods in the eye provide good vision at night, which is an obvious advantage during the long Arctic night. On a dark night a bear will probably see you before you see it, but it had smelled you long before it saw you.

My first inkling of polar bear color vision came while conducting field studies in western Hudson Bay. I was wearing a bright fluorescent orange rain jacket to help the pilot find me on the tundra (this was before the days of GPS). One rainy day when I approached 8-month-old cubs (their mother was drugged), I noted that they were greatly agitated and bolted when I approached. Sensing that something was amiss, I removed my new jacket. I could now approach the cubs.

The exposed part of a polar bear's eye is small, a distinct advantage in an environment that can have blowing snow or 24 hours of daylight. Snow blindness is the result of ultraviolet light reflecting off the snow and burning the surface of the eyes. The condition is extremely painful and the human eye is highly susceptible to injury after only a few hours of exposure on a bright day. How do polar bears, which are exposed to

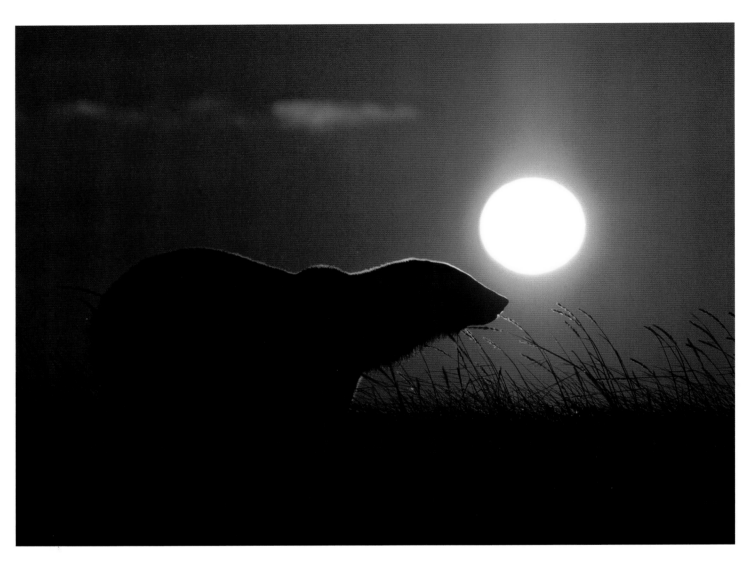

Polar bears have good vision under low light conditions, an essential adaptation for hunting and traveling during the dark polar winter.

24 hours of sunlight during the summer, avoid snow blindness? The answer is unknown. Ground squirrels, which are also resistant to snow blindness, have a yellow pigment in the cornea that acts like sunglasses. Mammals active during the daytime have higher levels of a charged molecule, ascorbic acid or vitamin C (ascorbate), in the liquid between the cornea and the lens (aqueous humor). Ascorbate absorbs high amounts of ultraviolet light and protects the eye. Many mammals also have ascorbate in the outer layer of the eye (corneal epithelium) possibly providing more filtering. Birds have uric acid instead of ascorbate. Some mammals, including humans, have uric acid in their tears that may provide additional protection from ultraviolet light. Polar bears must have substances in their tears and eyes that function like sunglasses, because we are sure they do not suffer from snow blindness. Collecting some polar bear tears for analysis may help solve this mystery.

Polar bears are not alone in avoiding snow blindness; many species have evolved coping mechanisms. The selective pressures would be intense. A snow-blind caribou being hunted by a gray wolf can have only one outcome. Inuit in the Arctic make snow goggles from antler or bone

with a fine horizontal slit that allows in enough light to see but not enough to damage the eye.

A Beautiful Bear Foot

There are three forms of locomotion in mammals described by which part of the foot makes contact with the ground. Polar bears, raccoons, mice, and humans all walk with the soles of their feet making contact with the ground (plantigrade). Some consider the forefeet of polar bears shifted a bit more on the toes (semi-digitigrade). The cat and dog families are fully digitigrade, meaning only their digits make contact with the ground. Digitigrade locomotion is helpful when speed and maneuverability are critical. The third form of locomotion is unguligrade seen in hooved animals where only the tips of the digits contact the ground. For bears, which are heavy and rely on strength and stability not speed, the plantigrade form works best. Foot structure influences structural changes depending on whether an animal is built for speed or strength. Fast animals have thinner leg bones, larger hip and shoulder muscles, and a restricted plane of motion. When you are running fast, you do not want your limbs flailing about and getting sprained or broken. Animals built for strength often have heavy limbs for killing prey or in the case of ancestral polar bears, digging roots and tearing up logs to get at insects hidden inside. The linkages of the limbs to the skeleton of polar bears allows a wide range of movement, particularly in the front legs, useful for snagging slippery seals.

The paws of polar bears are notably massive. When walking, polar bears appear pigeon-toed, with their front paws angled inward. Their most common gait is walking and they can gallop and pace but do not trot. A notable sway in the hips is evident when a walking bear is viewed from behind. In large males, one has the sense that the bear's hind legs are swinging in a tight circle.

The massive limb bones of polar bears are only slightly modified from those of grizzlies. The front and back leg bones of polar bears are denser than grizzlies, which is an adaptation to a more aquatic lifestyle. Polar bears are highly capable swimmers. When polar bears swim, they use their paddlelike front feet and leave their hind feet trailing behind. Their back legs are used to dive and to turn while in the water. The selective pressure to modify leg bones is not intense because polar bears have to balance walking and swimming. The front paws are similar to other bears and surprisingly dexterous. The bears can use their claws almost like fingers. The claws are the primary tool for catching and killing seals. The claws cannot be retracted. (This is true for most carnivores. Cats, except cheetahs, are the exception to this rule.) Polar bear claws are black-brown, fading towards the tips that are almost clear, short, curved, and very pointed. The claws are more catlike than those of grizzlies that have long and blunt claws designed for digging. When working with polar bears, one should remember that the claws are sharp. More than once I have cut my hand while repositioning a paw. Claws can whiten with age, and polar bears over 20 years old often have claws with a pale waxlike

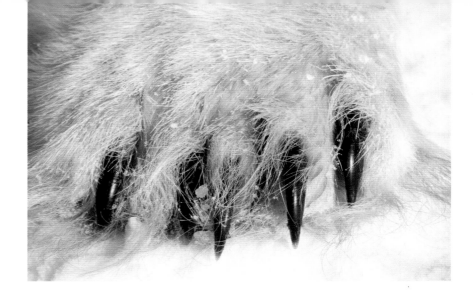

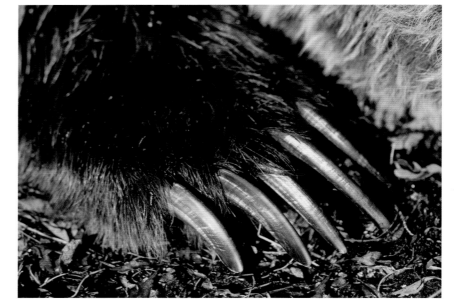

A Polar Bear
Described

The claws of polar bears—short, curved, and sharp—are well adapted to snag fleeing prey. A grizzly's claws are more like excavating tools; they are used to dig up roots or rip open insect-filled logs.

appearance fading to light brown edges. Young cubs have pale brown-bronze colored claws. Polar bear claws resemble those of the American black bear that presumably have remained curved to aid in climbing trees. This raises the question—can polar bears climb trees? Hudson Bay has white spruce trees large enough to support a bear, but I have never seen a polar bear climb a tree nor seen any indication that a bear was considering climbing a tree. Adult grizzlies can climb trees; they just do not often do so. I once watched a polar bear climb a ladder to reach a platform where seals were cached for dog food so climbing a tree should not pose a challenge.

Polar bears are well adapted for walking on snow and sea ice. Sea ice is rough and snow-covered. Unlike freshwater ice it is not particularly slippery, with the exception of snow-free refrozen leads. Polar bear feet, unlike those of other bears, are overgrown with hair. Hair growing around the footpad and between the toes creates friction on the ice and helps keep the bear's feet warm. The black, or black and pink, footpads are made of thick, fibrous connective tissue that protects the foot and overlying bones. Each toe has a small round digital pad, and as in all bears, the pads behind the toe pads have fused into a single large cush-

Determining a Bear's Age

At capture, we extract a tiny premolar found just behind the canine using dental tools. It takes about 20 seconds on a young bear, a bit longer on older bears with brittle teeth. Just as trees grow a ring every year, so do a polar bear's teeth. Back at the laboratory, the tooth is softened in a series of acid baths. It is then sliced thinner than a sheet of paper along its length, mounted on a glass slide, and stained with a purple dye. To age a bear, we count the rings in the outer surface of the root (cementum). Using a microscope, a skilled reader can age a bear exactly or to within a year for more difficult teeth. Perhaps due to the ice-free summer season, teeth from southern populations are easier to read than those from northern populations. Recently, studies of growth layer widths have allowed us to determine the reproductive history of female bears. The rings shrink in width in the year that a female gives birth.

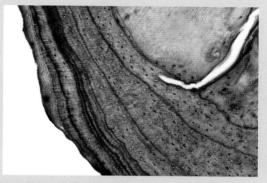

This thin-section of a polar bear tooth shows the layers set down in the outer part of the root that reveal the animal's age. Just like rings on a tree, polar bears lay down one ring every year. This bear is in its eighth year of life.

ion extending from one side of the sole to the other. Farther back on the front foot is a tiny round pad. The hind footpads are similar to those on the front feet, except that the rear pad is much larger and elongated. The footpad surface is sandpaper rough. It is covered with small bumps (papillae) 0.04 inches (1 mm) in diameter that are visible without magnification. The papillae consist of whorls of fibrous protein (keratin) with circular depressions.

The footpads of polar bears, the original "nonslip" material, were once studied in the hope of designing footwear to reduce industrial accidents associated with slipping. Perhaps work boots with claws would help, because claws play a big role in traction. For example, claws supply traction for pushing off because the bear's forward motion comes from the push created by the toes. Claws are also used for climbing or descending steep slopes and most certainly in predation and defense. On steep slopes, polar bears often descend backward, using their claws for gripping. I once caught an adult female with six toes, complete with six claws, on one front foot. Typically, however, each foot has five toes. In addition to gripping, polar bear feet can be used for sliding. I have often seen bears, escaping from other bears or from researchers, hold two

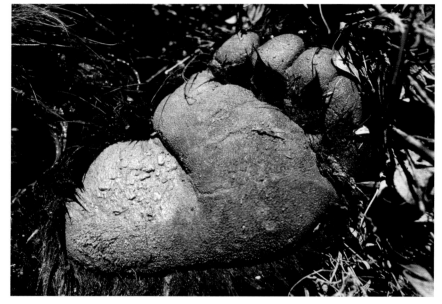

The hind foot of a polar bear has an abundance of fur around the pads; the fur keeps the toes warm and provides traction on ice and snow.

The hind foot of a grizzly has a full pad without the polar bear's insulating fur. Because grizzlies sleep through winter, they rarely have to cope with extreme cold.

legs on one side of the body stiff and use the other two legs to propel themselves quickly forward on smooth ice: the polar bear equivalent of skateboarding.

In many species, including polar bears, the extremities cool far below the core temperature of the body but remain above freezing. Polar bears spend most of their lives walking on a frozen surface and have adapted to ensure their feet do not freeze. Even on extremely cold days, the footpads of a polar bear are warm to the touch. Infrared cameras used to detect polar bears found the clearest signals from the nose and eyes, breath, and tracks the bears left in the snow. The paws must maintain the proper mechanical properties over a wide range of temperatures to function. The paws likely contain a higher proportion of unsaturated fatty acids than other body areas. Whether polar bears have a counter-current blood exchange system in their legs is unknown. Such a system, common in birds and mammals, keeps their body core warm while the extremities cool. This system is similar to a heat-exchanger in a house. Warm arterial blood heading to the feet runs past colder venous blood returning from the feet. Heat moves from the warm arterial blood to the cold venous blood thus keeping the animal's core warm.

Important Bits

Like many male mammals including primates, except humans, polar bears have a penis bone (also called a baculum or os penis). The penis bone, which is not attached to the rest of the skeleton, is used to assist copulation. It grows in length for the first 10 years and continues to add weight for another 4 to 5 years. In polar bears the penis bone is less curved and finer than it is in grizzlies. The penis is retracted into the body wall until the vascular part becomes engorged with blood, which increases the length, diameter, and rigidity of the penis for copulation. Penile hairs can be long, often yellowed, and at times are a diagnostic feature for sexing a bear from the side.

The testes of adult males are well hidden by the hind legs. They undergo a seasonal enlargement in length and weight during the mating season, March–June. Similar in structure to those of other mammals, adult polar bear testes weigh about 3.5 ounces (100 g) each. The size of testes in mammals is related to the mating system. Species with high competition for females and high copulation rates tend to have larger testes. At the same time, larger mammals tend to have proportionally smaller testes than smaller mammals. Overall, polar bears' testes are unremarkable.

The external genitals of female polar bears are similarly unremarkable in the mammalian world. Perhaps the only noteworthy aspect is seasonal variation in the labia. As the breeding season progresses, labial tissue swells. Mating females are typically the most swollen. Females often have longer yellow urine-stained hairs associated with external genitalia under their tail. If visible, these can be used as a cue for sex determination from a distance.

Female polar bears have four mammae following the normal mammalian pattern of roughly twice the number of mammae as the average litter size. They are well furred and only visible in the profile of some nursing females. Mammae are on the chest about 2 to 3 inches (5–8 cm) either side of the midline with two just back of the foreleg pits and two approximately 6 inches (15 cm) farther back. Occasionally, females have one or two additional mammae located behind the normal ones or, rarely, between the back legs (inguinal). These mammae may be functional or nonfunctional. Grizzlies and American black bears have six functional mammae, but the harsh Arctic environment makes raising larger litters difficult. Polar bears have lost two mammae because they are not needed for rearing smaller litters. Females that have not nursed have small nipples and flat undeveloped mammae. It is possible to roughly assess the age of a female by the size of her nipples, which get longer and wider until the early teens.

On the Inside

Carnivores in general do not have particularly remarkable viscera. The stomach of polar bears is a simple sack where the chemical and mechanical processes of digestion take place. When a polar bear has fed on vegetation, berries, birds, reindeer, or other high-fiber material, feces are full of poorly digested material and indistinguishable from those of grizzlies.

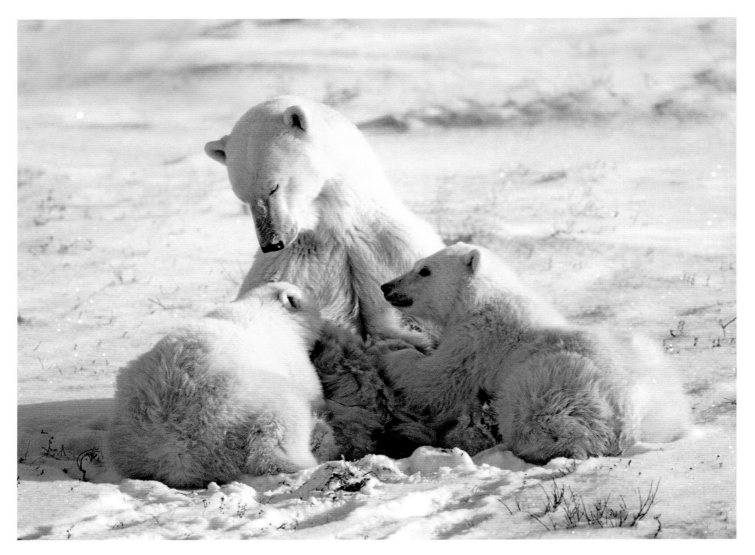

This female ice bear is in a typical reclining nursing position that exposes her four nipples to cubs, which thrive on the fat-rich milk.

The passage time of food in polar bears is dependent on the bear's diet. A bear eating blubber will release loose fecal material, best described as black-brown liquid oil, in about 36 hours. If it is eating material with bones, muscle, or skin, the passage time drops to 14 to 17 hours.

Unlike a polar bear's other organs, the kidney is remarkable. It is highly lobulated, with lots of ripples or bumps. These extra lobes help marine carnivores handle the salt in their diet. A study from the 1930s awarded polar bears with the carnivore record at 65 lobules.

Scent of a Polar Bear

Scent glands in bears are a mystery. Scent clearly plays an important behavioral role. I have often watched two adult males approach each other and in a ritualized manner move their noses over the neck and shoulder of the other bear, as if performing an olfactory inspection. Many carnivores have sweat glands on the skin between their toes that provide scent. Although we do not know for sure what olfactory information polar bears obtain from each other, there are tantalizing studies with captive bears suggesting they have glands in their feet that provide individual identification or possibly reproductive status.

Polar Bear Liver and Vitamin A

Somewhere in the Arctic, a long time ago, a member of some indigenous group ate polar bear liver with very unhappy results. Whether this anonymous person died or simply became extremely ill was not recorded. But the event was preserved in lore because the earliest Arctic explorers reported that Inuit knew about the dangers of eating polar bear liver. A diary from 1597, while the diarist was wintering on Novaya Zemlya in Russia, may be the first written record of the perils of eating polar bear liver. Not everyone took note of this report because the annals of Arctic exploration are filled with tales of woe as a result of eating polar bear liver.

In March 1907 the physician of a Danish expedition reported on the condition of 19 men who had such a sorry feast. The onset of symptoms began within three to four hours after the meal: headaches, sluggishness, and an irresistible desire to sleep. This was followed by vertigo, pain in the eyeballs, vomiting, diarrhea, and constipation. Those who consumed the most liver suffered from muscle spasms and cramps in the arms and legs. A loss of appetite (hardly surprising), a bad taste in the mouth, and a grayish coating on the tongue came next. After a day or more, the skin began peeling around the mouth, hands, and feet. This peeling persisted for up to a month. Early accounts from Inuit suggest that eating polar bear liver can be fatal.

What caused such a reaction remained a mystery until a post–World War II study. Researchers fed polar bear liver to laboratory rats. The rats died. But rats that were fed polar bear liver with the vitamin A removed thrived. For humans and rats, eating polar bear liver causes hypervitaminosis A—too much vitamin A.

About 80% of an organism's vitamin A is stored in the liver, inside fat droplets contained in hepatic stellate cells also known as Ito cells. Polar bears store 20 to 100 times the vitamin A of humans but have about four times as many Ito cells to avoid toxic effects. Vitamin A accumulates as you move upward in a food web. Seals, the primary food for polar bears, have high vitamin A levels themselves.

Bearded seals are a primary food source for the ice bear. The high level of vitamin A in seals is biomagnified up the food web until it reaches extreme levels in polar bears.

Most carnivores use anal sacs to produce scents for communication or defense. It is unclear if polar bears have anal sacs but grizzly bears have them and they contain over 90 different compounds. It would be interesting to know if polar bears have anal sacs and what role they might play in social organization. Given the opportunity to "sniff" a polar bear, our paltry sense of smell does not return much information. Polar bears are remarkably "scent free," possibly because of their fresh snowy environment and regular salty baths. Grizzlies have a much more "doggy" smell, and while it is not unpleasant, I venture to say that if

required to make a choice, most people would prefer a polar bear as a house guest.

It Is in the Genes

Polar bears carry 37 chromosomes from their mother and 37 from their father (2n = 74) and five other bear species share this number. Having so many chromosomes is unusual in carnivores. Bears and dogs are the exceptions to low chromosome numbers in carnivores. Raccoons have a paltry 36 chromosomes; 18 from each parent. Why bears and dogs ended up with a plethora of genetic material is unclear. More chromosomes is a result of a chromosome splitting and it has happened many times in the evolution of bears. Reflecting their earlier split from the bear family tree, the giant panda has only 42 chromosomes and the spectacled bear has 52. Humans have 46 chromosomes (the same number as guppies). A large number of chromosomes provide more possible combinations when eggs and sperm are mixed, but how this helps a species is not clearly understood.

To Den or Not to Den

One unusual aspect of polar bear behavior is that only pregnant females hibernate for extended periods. This is contrary to the behavior of the bear's grizzly ancestor. In the middle of the darkest, coldest nights, grizzly bears are nowhere to be seen; they are curled up and cozy, hibernating in their dens. But polar bears are out on the sea ice trying to find enough food to survive. Hibernation is a common adaptation used by many mammals to avoid inclement weather or food shortages, but most polar bears do not, suggesting enough food is available and that the chilly conditions are not a problem.

Hibernation in mammals is characterized by reduced physical and physiological activity. Reduced body temperatures, slowed respiration and heartbeat, and lower metabolic rate are hallmarks of hibernation. Some researchers consider bear hibernation as the most refined mammalian response to food deprivation. Pregnant polar bears can remain in this dormant state for up to 8 months, during which they do not eat, drink, urinate, or defecate. A hibernating Arctic ground squirrel enters a deep hibernation and has to rouse itself every 4 to 10 days to eliminate waste products. The "hibernation-induction trigger," a chemical compound in the blood that induces hibernation in ground squirrels, has also been found in polar bears but the differences between the species are profound.

For pregnant polar bears, a reduced metabolic rate is essential to conserve energy. Polar bears do not go into deep hibernation and some researchers use the terms "dormancy" or "torpor" to describe the dormant state. Body temperature only drops a bit from the normal 98.6°F (37°C). Heart rate drops from around 40 to 27 beats per minute and respiratory rates drop markedly. Arctic ground squirrels are deep hibernators, and their body temperature drops to within a few degrees of the ambient temperature, which can be below the freezing point of water. Hibernat-

Hibernation is not a particularly common strategy for Arctic mammals. Ground squirrels drop into deep hibernation; the heart rate, breathing, and body temperature drop dramatically. Bears, including polar bears, show much less reduction in these vital signs.



ing ground squirrels can be picked up and handled; it takes them about an hour to wake up at room temperature. Bears cannot drop their body temperature so low because it would take a massive amount of energy to reheat the body to normal temperatures. A hibernating polar bear can reduce energy use by 60% or more compared to normal activity. Hibernation is a means of escaping harsh environmental conditions and conserving energy but is largely reserved for reproduction in polar bears.

American black, grizzly, and polar bears share four physiological states: normal activity, walking hibernation, hibernation, and hyperphagia. All age and sex classes of bears can enter the altered physiological state when they are fasting known as walking hibernation. The state is hallmarked by physiological changes in the serum urea to serum creatinine ratio in the blood. Serum urea indicates protein metabolism; serum creatinine does not vary much and is used as a baseline. The ratio in polar bears approaches ten when they are in walking hibernation. In this state, they can recycle nitrogenous wastes back into essential amino acids, thereby minimizing muscle tissue loss. Grizzlies and American black bears enter this state just before or while hibernating. Polar bears, provided they have sufficient fat reserves, can enter this state at any time and can remain active.

Bears do not defecate while in dens because they are not eating. Because bears can recycle nitrogen, they do not urinate during hibernation and thus conserve water. Recycling nitrogen also means a bear's muscles remain intact. Maintaining your strength is essential if you must walk about on the sea ice hunting seals after spending the winter in a den. Another evolutionary adaptation is that bears do not lose much bone mass while in dens. This is a remarkable feat because limited physical activity usually results in loss of bone. For example, bed-ridden humans and

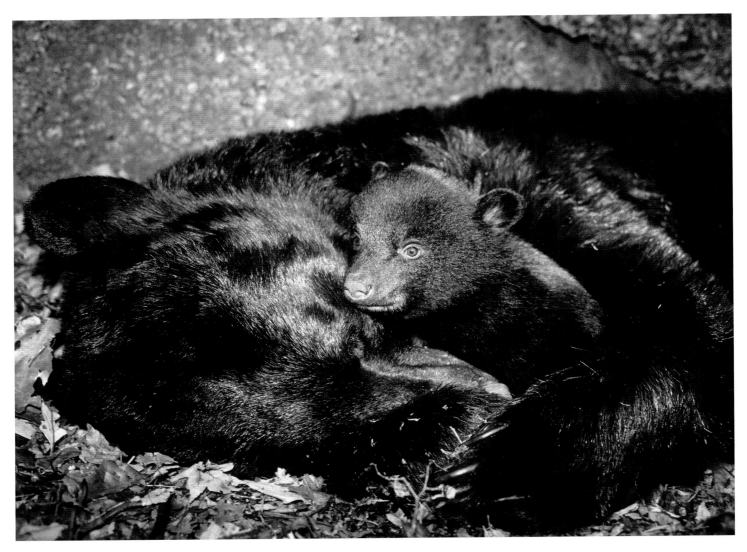

Hibernating bears, such as these American black bears, have a host of specialized physiological adaptations for overwintering in dens. Recycling waste products and conserving muscle and bone are essential for the long winter fast when cubs are reared until they are big enough to leave the safety of the den.

astronauts in space often suffer damaging bone loss. Hibernating bears seem to avoid bone loss by balancing bone building and bone breakdown in a cycle that keeps the bones strong.

The adaptations of hibernating polar bears may have implications for human medicine in such areas as obesity, anorexia nervosa, kidney disease, and osteoporosis. The ability to recycle nitrogen during hibernation into essential amino acids may ultimately provide a means of treating kidney disease. If humans with kidney failure could recycle nitrogenous wastes, then their kidneys would not be as heavily tasked and dialysis could be reduced. Understanding how bears preserve bone mass might improve the condition of astronauts on prolonged voyages or be used to prevent osteoporosis.

Vocalizations

Polar bear vocalizations are poorly studied, partially because, compared to other mammals, they have relatively few calls, possibly fewer than American black bears or grizzlies. Observers rarely hear polar bear vocalizations other than during aggressive interactions or courting so the bear's full vocal repertoire is unknown. The chuffing vocalization of

polar bears, a pulsed blowing sound, is usually offered as a warning. A threatening bear may also vocalize by growling, moaning, roaring, huffing, blowing, chomping its teeth, or popping its jaw. Adult males courting females produce a quiet chuffing for extended periods. Most bears, including polar bears, have epipharyngeal pouches just behind the mouth that may be used to modify and amplify vocalizations.

A cub can be extremely vocal when frightened or stressed, such as when it is separated from its mother. The call is a prolonged "maaaaw." In one instance when a cub had wandered away from its mother, I could hear the call from half a mile (1 km) away. The mother eventually emerged from the den to retrieve her cub. When nursing, cubs make a quiet clicking or chuckling sound called humming.

3

EVOLUTION

I f, on the evolutionary tree, bears are a young branch of mammals, polar bears are like a bud on a twig. Bears share enough characteristics to make it possible for paleontologists to reconstruct the recent ancestry of polar bears, but the record of the earliest bears is sketchy. Part of the confusion comes from the profusion of bear-dog or dog-bear species, which obscure where bears come from.

The study of bear evolution involves systematics using the fossil record and genetics. Using fossils alone to sleuth out the lineages can lead to some confusing relationships. Based on fossils, modern bears were thought to be related to the lineage that gave us raccoons and red pandas. But DNA studies reveal that those two species are more closely related to the weasel and skunk families.

The ancestral root of bears lies with the dogs. Bears were not the only group to arise from that ancestry and polar bears are not the only species that moved to the oceans. About 26 million years ago, a common ancestor gave rise to the seals, the walrus (at one time there were numerous species of walrus), and the sea lions. *Arctocephalus,* meaning "bear head," from the Greek "arktos" (bear) and "kephale" (head), is the genus of fur seals. The fur seal skull still shares many similarities with the bear skull.

Dogs gave rise to a group of bear-dogs Hemicyoninae (half-dog) some 25 million years ago that includes the genus *Cephalogale. Cephalogale* arose in Asia and eventually led to the modern bears. The raccoon-size *Cephalogale* moved from a carnivorous diet to an omnivorous one. About 20 million years ago *Cephalogale* gave rise to the earliest known bear-like ancestor in Europe: the dawn bear. Though *Cephalogale* died out about 5 million years ago, the dawn bear kept the bear lineage alive.

About the size of a fox terrier, the dawn bear gave rise to subfamilies that branched off well before the polar bear lineage. About 15 million years ago, one subfamily (Ailuropodinae) branched; it is now represent-

(Opposite) **In springtime in the Arctic, some polar bears retreat into fjords or onto land while others will race northward to summer on multiyear ice.**

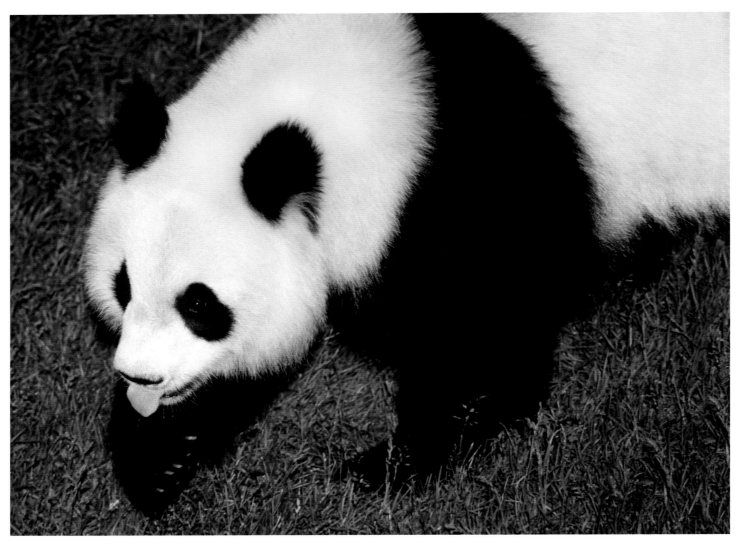

Giant pandas are the only remnant of an early branching of the bear family. Almost totally herbivorous, the giant panda has evolved a "thumb" (really a modified wrist bone) that aids it in manipulating bamboo, which forms the bulk of its diet.

ed solely by giant pandas in China. The giant panda is what is known as a "sister taxa" to the modern bears—a split from the same branch of the evolutionary tree. Giant pandas, which feed almost exclusively on bamboo, live all year in an area the size of which a polar bear covers before noon. Nonetheless, the giant panda and the most recent member of the bear family, the polar bear, have many things in common.

The dawn bear gave us two subfamilies, the Tremarctinae and the Ursinae, which split 12 to 15 million years ago. The Tremarctinae branch has only one surviving species, the spectacled or Andean bear in South America. This branch also included the extinct giant short-face bear, which weighed 1300 to 2200 pounds (about 600–1000 kg) and was more than 6 feet (2 m) tall at the shoulder. Its long legs suggest that it may have been a speedy predator or at least a formidable scavenger. Other analyses suggest it was a colossal omnivore. This is the biggest bear that has ever existed. The largest predator of the Pleistocene (2.6 million to 10,000 years ago), this bear was found from what is now Mexico and Florida to Virginia and California and north to Alaska. For bear biologists like me, the extinction of this formidable predator is a disappointment. North American Paleo-Indians might not have shared that sentiment.

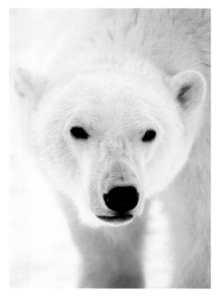

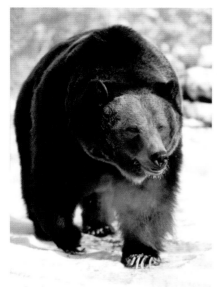

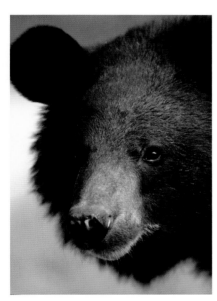

Although easily identifiable as bears, each of the six species of the genus *Ursus* has adapted to its particular ecological niche. The spectacled or Andean bear is the only remaining species of the genus *Tremarctos*. The existing species are really only the tips of the bear evolutionary tree; many species have disappeared in the 20 million years since the dawn bear arose from the bear-dogs. *Top row:* polar bear, grizzly bear, American black bear. *Middle row:* sloth bear, Asiatic black bear. *Bottom row:* sun bear, spectacled bear.

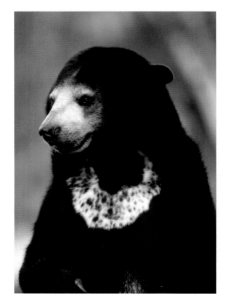

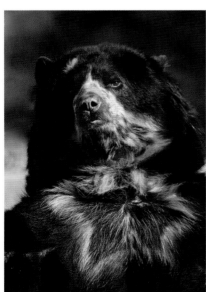

The other branch from the dawn bear, the Ursinae, leads to polar bears via the Auvergne bear. The Auvergne bear weighed about 110 pounds (50 kg) and arose in the Old World about 4 to 5 million years ago. All modern bears of the genus *Ursus* derive from this forest-dwelling species that slowly increased in size over time.

One branch from the Auvergne bear is the extinct European cave bear, which was about the size of our largest grizzlies. Males weighed 900 to 970 pounds (410–440 kg). Cave bears had a broad, domed skull. A very sharp stop at the base of the muzzle created a steep forehead. The last cave bear died about 28,000 years ago. Climate change may have been a factor, but paleo-DNA (DNA extracted from subfossil material) analyses suggest that cave bears had been fading away for 25,000 years. Modern humans and Neanderthals might have been in competition with the bears for the very thing that gave them their name: caves. As with most ecological questions, several factors were probably involved in the cave bear's extinction.

As the earth's climate became drier about 5 million years ago, many mammalian groups in the Northern Hemisphere diversified. The zenith of the bears arose and then faded by the end of the Pleistocene. Six *Ursus* species survive today: the American black bear; the Asiatic (or Asian) black bear, the sun bear, and the sloth bear of Asia; the grizzly or brown bear (grizzlies and brown bears are the same species) of North America, Asia, Europe, and the Atlas Mountains of north Africa, and polar bears.

To get to polar bears we have to follow the evolution of the grizzly. About 2.5 million years ago the Auvergne bear gave rise to the Etruscan bear. Fossil remains from Spain, France, Italy, and China suggest that Etruscan bears were about the size of modern American black bears and were gradually increasing in size. They were well suited to cold temperatures and survived a variety of ice age advances and retreats. The Etruscan bear, about 2 million years ago, gave us the grizzly bear. The earliest fossil grizzlies date from around 500,000 years ago in China. Roughly 250,000 years ago they moved into Europe, where they shared the landscape with cave bears. As the ice sheets melted about 25,000 years ago, they moved into mainland North America, heading southward until they reached Mexico. Their southern progression may have been slowed by the presence of the giant short-faced bear.

Anatomy, morphology, protein comparisons, and DNA analyses all indicate that polar bears evolved from grizzly bears. The big question is when and how. In some aspects, polar bears have diverged little from grizzlies but in others, the changes are profound. The question of which grizzlies were the ancestors and when the divergence occurred is still being studied and every new study rewrites the story. Living and dying on the sea ice is not conducive to creating a good fossil record, so clues can be contradictory. In addition, polar bears are at the top of the food web, which means they are less abundant and leave fewer fossils than species lower in the web.

In any case, most polar bear fossils do not add much to our understanding of their evolution. Specimens from Sweden, Denmark, and Norway show that polar bears were in the North Sea and Baltic Sea as

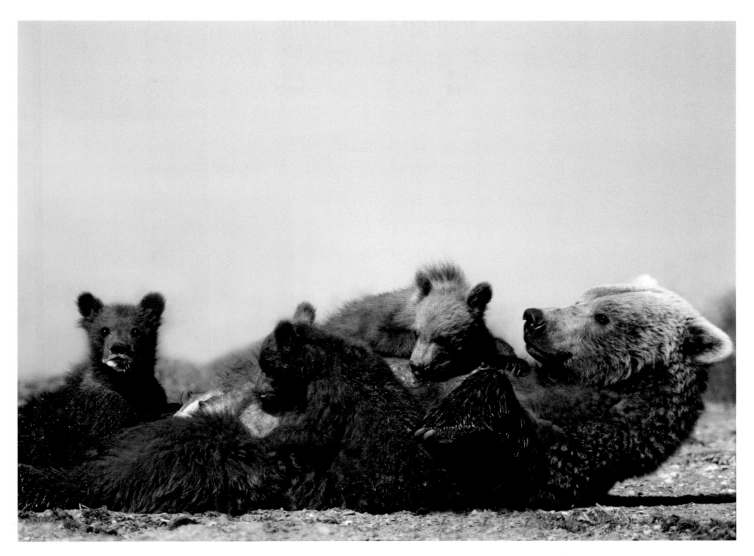

recently as 10,660 year ago and existed alongside grizzlies. The morphological similarities between polar bears and grizzlies make differentiation of fossil material difficult. For example, a bone found near Kew Bridge, London, that was originally ascribed to *Ursus maritimus tyrannus,* a large subspecies of polar bear, has recently been reclassified as a large grizzly. I found the reclassification a bit sad because I rather liked the idea of giant polar bears in London.

The Arctic has been repeatedly glaciated, which further complicates the fossil record. Glaciation and deglaciation pushed polar bears south and north as they responded to changes in sea ice. Exactly where polar bears lived during these various periods is unknown. Possibly the bears were present in ice-covered waters over the Bering Sea and the Atlantic and Pacific oceans and may even have gone as far south as Spain. Refugia may also have existed in eastern Siberia and the Beaufort Sea. Most intriguing though is a new study that suggests that polar bears were in Ireland and that they interbred with grizzlies there. We simply cannot tell from the fossil record.

Early postulations on the evolution of polar bears suggested a Siberian origin, with the separation from grizzlies occurring about 70,000

The grizzlies of southeast Alaska are closely related to polar bears. Polar bears generally have twins, and the reduction in the female's functional mammae to four reflects this smaller litter size. The grizzly cub at the rear of the mother is feasting on milk from a third pair of mammae, which polar bears do not have.

Stable Isotope Diet Analyses

Determining the diet of a live, or even a fossil, polar bear has become easier in the last decade with the advancement of stable isotope analysis. Stable isotopes, different forms of the same atom, vary in their atomic number because some atoms of the same element have more neutrons than others. The isotopes are not radioactive and do not degrade easily, hence the designation "stable." Polar bear scientists analyze carbon and nitrogen isotopes, both of which have a light form and a heavy one. Heavier isotopes increase in each level of the food web. A bowhead whale that eats invertebrates is feeding much lower in the food web than a ringed seal eating fish. Each species has its own isotopic signature.

To determine the diet of a polar bear, you need the isotopic signature of the prey and the bear. Determining that signature can be tricky because different tissues reflect different periods of metabolic activity. Metabolically slow tissues like hair and claws reflect the bear's diet when they were growing, whereas blood reflects their diet over the last month. A bear's breath, on the other hand, will reveal what food the animal is burning when it is sampled. A bone or tooth sample provides an integrated estimate of an animal's lifetime diet. Regardless of the tissue used, it must be cleaned, dried, and processed through a mass spectrometer to determine the ratio of the isotopes present. The isotope ratios of the predator and prey are run through statistical models to produce possible diets.

The Arctic food web starts at the bottom with photosynthetic algae that feed a diverse variety of invertebrates and ends with polar bears at the top. Depending on their position in the food web, species, such as this Arctic sea star (*at left*) and isopod, will have an isotope signature that allows scientists to construct a map of who eats whom.

to 100,000 years ago or possibly as much as 200,000 to 250,000 years. Adding to the confusion, one genetic study using a molecular clock suggested that polar bears separated from grizzlies up to 1.17 million years ago. The Siberian origin was not challenged until genetic studies revealed that the grizzlies of Admiralty, Baranof, and Chichagof islands in Southeast Alaska (the ABC bears) were genetically unique and had been separated from other grizzlies for some time. These ABC bears were genetically very similar to polar bears. It was considered probable that polar bears originated from southeastern Alaska grizzlies or at the very least, from the ancestors of the grizzlies that gave us the ABC bears. In less than a year, this story was revised with the Irish link.

The incomplete fossilization (subfossil) of some polar bear material is important because DNA (paleo-DNA) can be recovered and used to time speciation. The oldest known polar bear subfossil, a lower jaw from an adult male, is 130,000 to 110,000 years old. It was discovered on Svalbard. Everything about this jaw indicates it is from a polar bear very similar to those of today. Stable isotope analyses indicated that it was feeding in the marine environment as polar bears do today.

DNA analyzed from a canine tooth from this jaw suggests that this

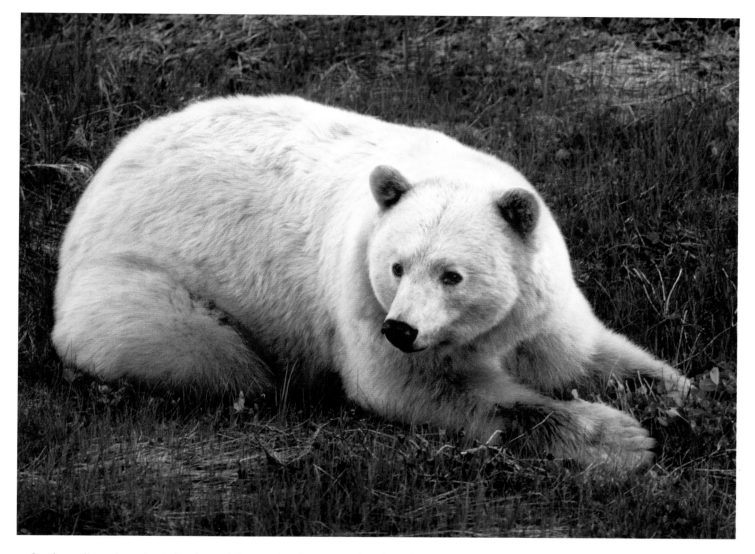

polar bear lies almost at the branching point between the ABC bears and polar bears. This suggests that the sample is close to the first polar bears. The study concluded that the ABC bears split from other grizzlies about 152,000 years ago and polar bears split from the ABC bears about 134,000 years ago. The separation occurred near the Eemian interglacial, which was a particularly warm period that started about 130,000 years ago, and might have resulted in the "new" polar bear moving northward thus fostering separation.

So is this the answer? Maybe. But the latest analyses changed everything. The problem stems from polar bears repeatedly hybridizing with grizzly bears over thousands of years. A few years ago I would have thought this unlikely, but a polar bear–grizzly hybrid shot in Canada in 2006 changed my perspective. The key is that mitochondrial DNA only comes from the mother and this is what was analyzed from the Svalbard jaw and from the Irish samples. If a polar bear female crossed with a grizzly and female offspring stayed in the ABC islands, then this confounds the link to the ABC bears. The latest version of polar bear evolution suggests three options. First, polar bears very recently evolved from the extinct Irish grizzly bears about 35,000 years ago. This seems unlikely. The

A white phase American black bear called the Kermode or spirit bear is found on the coast of British Columbia, Canada. Only a tiny genetic alteration was required to turn this "black" bear "white." Scientists do not yet understand the genetics of how the pigment-free fur of polar bears arose from grizzly bears.

Hybrids: Grolar, Pizzly, or Nanulaq

Polar bears and grizzly bears have been interbred in European and Russian zoos for decades. Hybrids are fertile and can reproduce with either polar bears or grizzlies, indicating a very close genetic relationship.

Hybrids were a novelty in zoos but had little relevance beyond scientific curiosity until April 16, 2006, when a guided polar bear sport hunter near Banks Island Canada shot what he thought was a polar bear but upon inspection found something very different. I was sitting in a small cabin about 75 miles (120 km) south of where the bear was shot. The single side-band radio, or bush radio as it is locally known, was abuzz about the bear. The hunting guide knew this was not a regular polar bear or a regular grizzly. From the get-go, he fig-

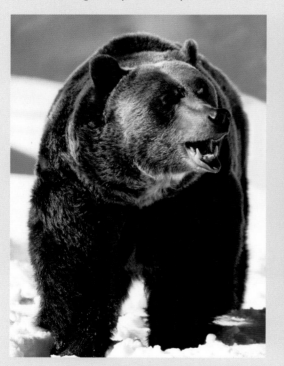
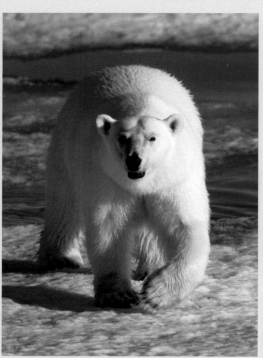

Male grizzlies usually emerge from their dens earlier than the females in spring. If they wander onto the sea ice, as they are apt to do, they may encounter female polar bears in mating condition. Love is blind, and the first wild grizzly bear–polar bear hybrid was found in the Canadian Arctic in 2006.

second option is that polar bears diverged from grizzlies about 90,000 years ago and then several hybridizing events occurred with the ABC bears and Irish grizzlies throughout the Pleistocene. The last option (for now) is that polar bears are a much older species (more than 125,000 years old) and that hybridization with grizzlies happened about 85,000 years ago and then more recently in Ireland 35,000 to 40,000 years ago. I tend to lean toward this latter proposal. Additional analysis on the nuclear paleo-DNA of polar bears and grizzlies may shed more light into the depths of time. Evolution is never a simple process, and branches on

ured it was a hybrid. A hybrid had not been seen before and there was no local Inuktitut word for it. Subsequently, a variety of names arose ranging from pizzly to grolar bear to nanulaq or nanulak (a combination of nanuq for polar bear and aklaq for grizzly in the local Siglit Inuvialuit dialect). Officially, it is called *Ursus arctos* x *U. maritimus*.

From genetic analysis, we know the male hybrid's mother was a polar bear and the father a grizzly. We suspect from isotopes and fatty acid analyses that it was living more like a grizzly than a polar bear. However, it was out atypically early for grizzlies and was on nearshore ice. A curiosity and nothing more? Not when another hybrid was shot in April 2010 on Victoria Island not far from the first one. This one had a polar bear–grizzly bear hybrid mother that mated with a male grizzly: a second generation hybrid. Somewhere in the western Arctic in Canada, there is another hybrid female—the one that produced this latest hybrid.

Grizzlies are moving northward, so it is tempting to invoke climate change as a cause, but the northward expansion has been ongoing for decades. Grizzlies have been seen up to 74°N on Melville Island, Canada. In one instance, a grizzly killed and ate a 2-year-old polar bear. Is it climate change or something else? Hard to say because grizzlies have also been showing up farther east and farther west, as well as in other "unusual" places in recent years.

Hybrids are beige-white to white-gray to brown-white, lighter than grizzlies but darker than polar bears. The shoulder hump is present but not large. The claws are more curved than a grizzly's but not as much as a polar bear and not as long as grizzly claws. The neck length also is between that of the grizzly and the polar bear. The hair in cross section appears intermediate. In every way, the hybrids fall "in the middle"—a bit like mom, a bit like dad.

Other bear hybrids have been bred in zoos: sloth bear x sun bear, Asiatic black bear x grizzly, American black bear x grizzly, suggesting incomplete reproductive isolation. Natural hybrids are common and occur between Canada lynx and bobcat, wolves and coyotes, mule deer and white-tailed deer. In polar bear prey species a harp seal male crossed with a hooded seal female. Hybrid young often do not fare well, being poorly adapted for the conditions of either parent species.

Hybrids do not challenge our species concept and even the most extreme "lumper" would not consider grizzlies and polar bears the same species. Hybrids show that species that have recently separated can cross back. Once species have grown far apart, hybrids do not occur. Nobody can say if we will see more hybrids, but with more people in the Arctic to see them and grizzlies expanding northward, it is possible. They will likely remain rare and will not result in a new species, but predicting evolution is a fool's game.

an evolutionary tree may cross many times before they fully diverge. It appears that the evolution of polar bears from their grizzly bear ancestor might have been more like intertwining vines than the branches on a tree. Understanding the evolutionary history of polar bears using genetics is only just beginning, and new analyses will likely change our perspective again.

To understand how polar bears evolved, we have to consider the selective pressures on the ancestral polar bears. It is easy to imagine grizzly bears on land expanding into an area where the climate was a bit cooler

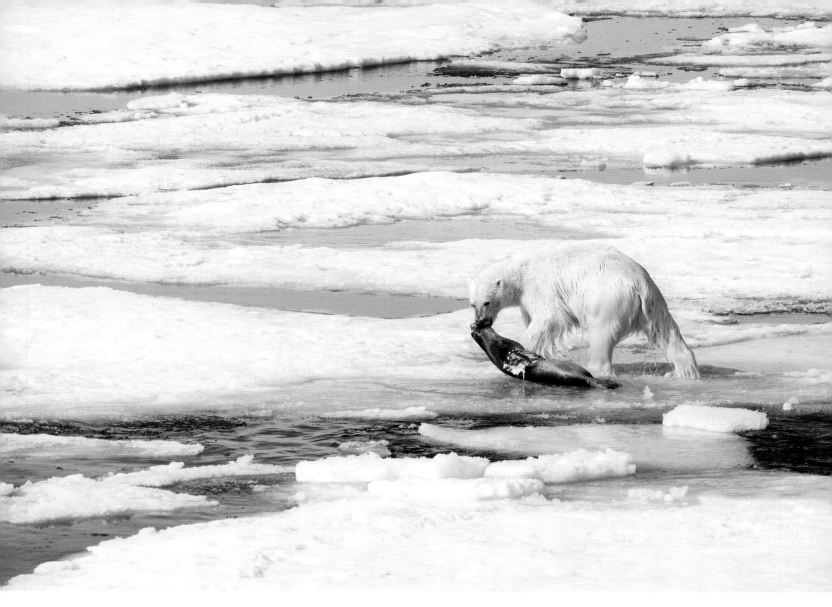

The abundance of seals on the sea ice drew the ancestral polar bears into the marine environment. Once there, the bears evolved to become one of the most specialized predators on earth. This polar bear drags a freshly killed juvenile bearded seal across the sea ice.

or perhaps a cooling period occurred. Sea ice along shore is difficult to distinguish from land. A hungry grizzly coming out of its winter den would find marine mammal carrion a welcome food source. Eventually, some grizzlies started wandering a bit farther onto the sea ice. Ringed seals, which are an older species at about 5 million years old, might have been abundant in the nearshore ice. Given that the seals had not seen any predators in their recent evolutionary history, they were probably incredibly naïve. Antarctic seals have no terrestrial predators. You can walk right up to them without their paying much attention to you. Grizzlies that moved onto the ice likely found an abundant early spring food source in these seals, and bears that did it more often possibly had more success rearing young. Presumably, lighter colored bears fared better at catching seals until whiter bears became the norm.

The difference in color between polar bears and grizzlies is not preserved in fossil material, so we cannot determine when the color change happened. Paleo-DNA research, however, might tell us when the first polar bears were white, but we have to wait for such studies. Very pale or blond grizzlies are common, and I have seen grizzlies that look almost as white as polar bears. White chest patches and shoulder markings are also

common in grizzlies. In the Southern Kuril Islands just north of Japan, a curious color morph of grizzly called the Ininkari bear is white on its head, neck, and forelegs. The bear is named after an Ainu chief, whose portrait from 1791 shows him with one white and one dark grizzly cub led on ropes. The Ininkari bears are still commonly sighted. Even the American black bear has a non-albino white phase. The Kermode, or spirit bear, is found on the central coast of British Columbia and neighboring offshore islands.

Kermode bears have pigmented eyes and skin and can constitute up to 25% of the population. The white phase is fully recessive to the black form, so a Kermode has to have two copies of the white gene to be white. Shifting from a black bear to a Kermode involves a tiny genetic change that shuts off the production of pigment (melanin). The Kermode came into being because one nucleotide (the basic unit of DNA) in a single gene mutated. A significant difference in a species does not necessarily require large genetic change. What controls the lack of pigmented fur in polar bears and how these genes differ from grizzlies is not yet known. New genetic tools should provide such insights before long.

The fishing success of Kermodes provides an insightful link to polar bears. Kermodes fishing for Pacific salmon were less successful at catching fish than black phase bears during the night, but Kermodes were more successful during the day. Salmon are wary of black objects during the day and Kermode bears can exploit daytime fishing better than the black-phase bears. This advantage may allow Kermode genes to persist over time. The selective pressure on ancestral polar bears is easy to imagine. Lighter grizzlies likely did much better catching seals than dark ones. A white grizzly would have outperformed them all. Polar bears have no pigment variation in coat color, indicating strong selection.

A modern-day parallel of polar bear evolution exists in the grizzlies that live on land next to the sea ice of the Beaufort Sea. The Horton River area in the Canadian Northwest Territories has grizzlies that kill a variety of mammals, from musk ox to beaver to Arctic ground squirrels. In addition, these grizzlies regularly wander onto the sea ice in spring to hunt ringed seals and to scavenge marine mammal carrion.

Feeding on marine foods is an obvious evolutionary step toward shifting from grizzlies to polar bears. But ancestral polar bears also had to break away from the rest of the grizzlies because reproductive isolation is necessary for speciation. During the Eemian interglacial period, planetary dynamics were warming the climate and the planet was quite different than it is today. For example, hippopotamus could be found in the River Thames near London and in the Rhine in Germany. Possibly, Eemian warming resulted in a northward retreat of the ancestral polar bears, which would provide the isolation needed to sever gene flow and allow speciation. Alternatively, seal hunting could have become the specialization of a group or population of bears. With the peak of seal hunting coinciding with the breeding season of grizzly bears, the seal-hunting grizzlies on the sea ice could have become reproductively isolated from their terrestrial counterparts. Adaptations to hunting on the sea ice and severing of the gene flow with terrestrial grizzlies would have occurred

if some grizzlies kept moving northward and farther offshore. Exploitation of the seal bonanza, with no other predators in competition, and radically different ecological conditions would have created intense selective pressures conducive to rapid speciation. The differentiation of polar bears from grizzly bears happened so rapidly that it is considered an example of quantum evolution: radical changes in a very short time. Eventually, the terrestrial grizzlies were not terrestrial anymore and the ice bear was born. Perhaps, similar to what is seen today in parts of polar bear range, the ancestral polar bears moved onto land to overwinter in dens or to spend the summer when the ice melted, returning to the ice when they could.

As the early polar bears relied more and more on marine resources, their connection to the land weakened. We cannot say exactly when a polar bear was truly recognizable as a polar bear. Regardless, the ice bear's reliance on land was eventually severed. Today, some polar bears are born, live, and die on the sea ice without ever stepping onto dry land. Somewhere along this evolutionary path, they met humans.

Evolution

4

EARLY POLAR BEAR–HUMAN INTERACTIONS

The first humans in the Arctic probably were not there very long before they found themselves looking at a large white bear. It is impossible to say who was more surprised by the encounter and who was on the menu. But as the first humans to see polar bears were well adapted to dealing with large predators, such as grizzlies, polar bears have probably been on the losing end of human-bear interactions for a long time. Polar bears have long been of cultural and nutritional importance to the Paleo-Eskimo and Inuit (the people). Even today polar bears (nanuk or nanuq in Inuktitut and umky in Chukchian) are an important species for northern people.

Inuit mythology and culture are infused with polar bear lore. Polar bears were dangerous but essential prey. And dead or alive, the bear deserved respect. Precautions were taken to ensure that the bear's soul would not return and harm the hunter or his family. In 1924 the famed Greenlandic anthropologist Knud Rasmussen reported that a harpooned polar bear's soul was believed to remain on the point of the harpoon for four days if it was a male bear and five days if it was a female. To prevent the dead bear from becoming an evil spirit, its skin and skull were hung up by the nostrils in the snow house (igloo). In addition, men's tools, such as knives and harpoon heads, were hung near the skin of a male bear; women's knives (ulus), cooking utensils, and the like were hung near the skin of a female bear. Young girls wore protective amulets to prevent polar bears from coming into their igloo.

Polar bear–related traditions varied widely across the Arctic, but practices concerning how the meat from a polar bear would be shared in a community were common and are still followed in some areas. Polar bear bones were once used in constructing tools and other implements such as forks, projectile points, and skin scrapers. Ribs were used to make bow drills and back scratchers. Hides were used as mattresses and to

Polar Bears in Mythology and Other Tales

Humans likely had stories about bears from the earliest encounters. Polar bear stories would have started with the first encounters with humans: there were important lessons to be taught. Polar bear tales have been passed from generation to generation. Sometimes polar bears in stories are kind and gentle; other times they are fierce predators.

All northern cultures have polar bear stories and none richer than the Inuit. A story collected by anthropologist Franz Boas in *The Central Eskimo* from 1888 retold how the constellation of Udleqdjun came to be. Three men and a boy went bear hunting. While in pursuit of a bear, the boy fell from the sled trying to pick up a mitten. Sitting on the ice, the boy sees the bear lifted up into the sky and the sled with the men following. They all became part of the constellation we know as Orion (a hunter in Greek mythology). The bear became the star Nanuqdjung (Betelgeuse), the men became Orion's belt, and the sled Orion's sword.

The story of the White Bear King Valemon is a Norwegian folktale in which a white bear, in exchange for a golden wreath, takes a king's daughter as his wife. The bear alternates between human and bear forms. Gold, trolls, and trickery all play a part in the story, which ultimately has a happy ending. That this bear lived in the forest might make one think it was a white grizzly. But polar bears were hunting the fjords in what is now Norway 10,000 years ago, and folktales last a long time.

According to the mythology of the Ainu people of northern Japan, they are descended from polar bears. The reasoning behind such a tale is not hard to understand when you see a bear skinned out: the musculature is remarkably humanlike. Such bear-human linkages are common in many cultures. Hokkaido, the northern island of Japan, still receives sea ice from the Sea of Okhotsk in winter. Polar bears may have wandered these waters in past ice ages and interacted with the Ainu.

Other myths are more modern. I am often asked if polar bears cover their noses when they hunt so that seals cannot see them. I myself have never seen such behavior nor do I know of anyone else who has seen it. Bears often rest their chin on a paw when sleeping but my dog does the same thing. I have been asked if polar bears are left-handed. No one has studied this, and I was skeptical of handedness until a study documented that walrus preferentially use their right flipper to clear sediment when feeding on clams. Furthermore, measuring bone structure revealed that the right

make apparel such as mitts and pants. When hunting seals, men might use a piece of bear hide to slide across ice without getting wet. Equally ingenious, but less appealing, was the use of a small piece of polar bear skin attached to a stick to remove lice from a person.

The early history of humans and polar bears may extend back to ancient Rome where one could see bears chasing seals in captivity. This record is questionable because early naturalists are conspicuously silent on the presence of white bears, which would surely have been notable. Pelts and live polar bears were in Japan and Manchuria in 658 AD. In northern Europe, polar bears have been reported as far back as 880 AD when inhabitants from Iceland and Greenland trapped polar bears and trained them as pets. Ingimundr the Old caught two cubs that had come ashore with their mother in Iceland. He presented them to King Harold the Fairhaired of Norway (850–933), who rewarded him with an ocean-going vessel loaded with timber.

Polar bears were presented to royalty to garner favor throughout the Middle Ages. Polar bear pelts were known in Egypt by 1300, and live

flippers were larger. Future research may reveal that polar bears are left- or right-handed.

Philip Pullman's book *The Golden Compass* (also known as *Northern Lights*) features polar bears, called armored bears, from Svalbard. In the film version, the animated armored bears looked and moved remarkably like real polar bears. The movie won an Academy Award for visual effects. I suspect such films foster interest in polar bears and may prompt people to see them in the wild.

The most dangerous myths are the prattling of people who believe polar bears will adapt to global warming. Such fantasy is beyond imagining for anyone who has studied polar bear ecology and has a basic understanding of evolution. The elevation of polar bears to an icon or "poster species" for climate change has made the bears a rallying point for action as much as they have become a species to vilify for those willfully ignoring the science of global warming.

In the Norwegian folktale "White Bear King Valemon," the beautiful daughter of a king dreamed of a wreath of gold. Her father was unable to make such a wreath, but she found one in the possession of a white bear in the forest. In exchange for the wreath, the king's daughter agreed to leave with the White Bear King. The painting is by the Norwegian artist Theodor Kittelsen (1857–1914).

polar bears were kept by the emperors Henry III and Frederick II of Germany and King Henry III of England. Writs from Henry III (1207–1272) directed "the sheriffs of London to furnish six pence a day to support our white bear in our Tower of London; and to provide a muzzle and iron chain to hold him when out of the water; and long strong rope to hold him when he was fishing in the Thames." Such a sight in downtown London must have been remarkable.

One group of sixteenth-century explorers became familiar with several aspects of polar bear ecology. In 1597, an officer with William Barents (after whom the Barents Sea is named), exploring near Novaya Zemlya in Russia wrote:

There came a great beare towards us, against whom we began to make defence, but she perceaving that, made away from us, and we went to the place from whence she came to see her den, where we found a great hole made in the ice, about a man's length in depth, the entry thereof being very narrow, and within wide; there we thrust in our pikes to feele if there was anything

within it, but perceaving it was emptie, one of our men crept into it, but not too farre, for it was fearfull to behold.

Things did not always have such a happy outcome. Two sailors with Barents were lying on shore when a large, skinny bear snuck up and caught one of them by the neck whereupon he cried out "Who is that who pulls me so by the neck?" Twenty men came to the defense of the fallen man, who was now the bear's meal. Before the bear could be driven off, another sailor met an untimely end. The remaining sailors retired to the safety of the ship and carefully planned their revenge on the bear, which they achieved with guns and axes. The two men were buried the next day.

In 1773 Constantine John Phipps, 2nd Baron Mulgrave, with Britain's Royal Navy, took two ships, HMS *Racehorse* and HMS *Carcass*, to the Arctic. The first use of the name *Ursus maritimus* for polar bears is attributed to Phipps in his 1774 book *A Voyage towards the North Pole*. Phipps said precious little about the bear beyond citing a few measurements and noting that they were "found in great numbers" and that the "seamen ate of their flesh, though exceedingly coarse." The year 1774 is assigned with the binomial Latin name as the formal time of classification. Early taxonomists sometimes assigned a new name to a species that had already been described. Confusion also occurred when a larger or smaller specimen was obtained and incorrectly identified as a new species. Thus, polar bears have been variously called *Ursus marinus, Ursus polaris, Thalassarctos labradorensis, Thalassarctos jenaensis, Thalarctos maritimus,* to name a few. Only *Ursus maritimus* and *Thalarctos maritimus* achieved common usage. *Ursus maritimus* has been the designation accepted since 1953, with no recognized subspecies.

Arctic exploration increased in the 1800s and interactions with the ice bear continued. Sometimes the explorer got the bear; sometimes the bear got the explorer. In 1869–1870, a German expedition to East Greenland suffered a polar bear attack. On a cold winter's night, a scientist checking the thermometer on shore heard a noise behind him and turned to find himself face to face with a polar bear. Before the man could cock his gun, the bear grabbed him by the head and began dragging him off. His cries for help brought shots from the ship, which scared off the bear. Though the scientist was gravely injured, he did recover, having been protected somewhat by his thick fur cap.

As usual, when people interact with the natural world, the balance of power soon shifted in favor of humans.

(Opposite) **All northern cultures are linked to bear species found in their area. The Inuit are still closely tied to polar bears. Folktales, stories, and taboos continue to be a part of polar bear hunting. In parts of the Arctic, polar bear mitts and pants are prized by hunters for their water repellent nature. Though hunting polar bears by dog team is now uncommon, it is still practiced in some areas.**

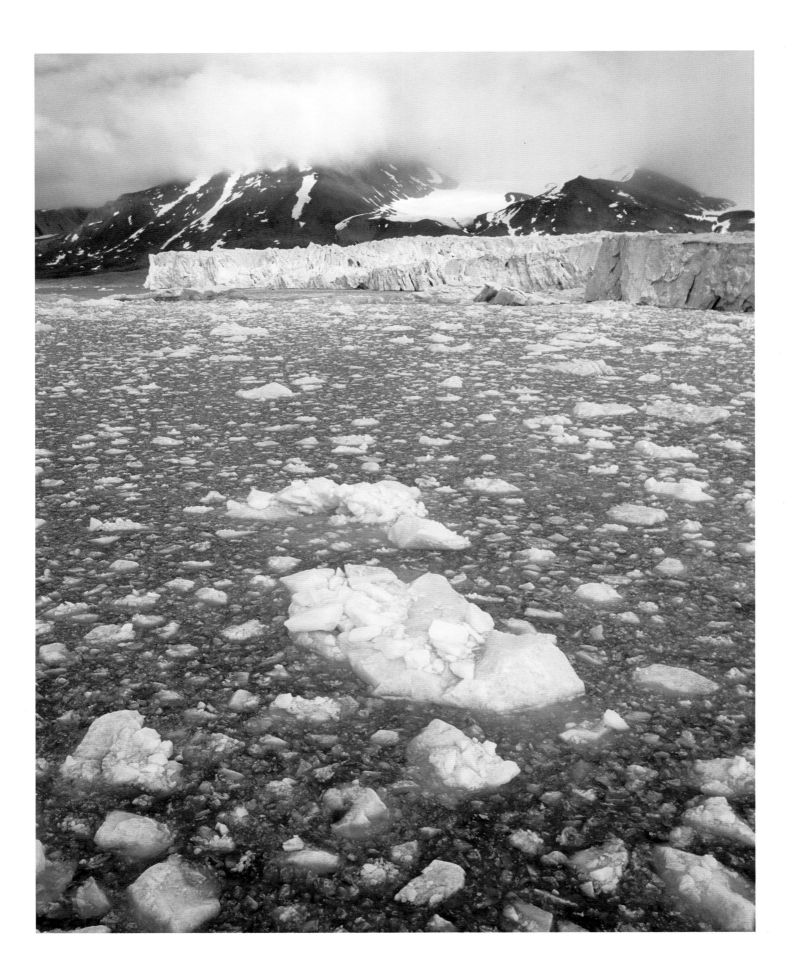

5

ARCTIC MARINE ECOSYSTEMS

Almost all polar bear habitat is in the United States (Alaska), Canada, Greenland, Norway, and Russia. Land ends before 84°N and most land beyond 75°N is covered with thick ice remnants of the last glaciation. It is the marine areas over the shallow continental shelves along the southern edge of the range of polar bears, however, that the bears rely on.

The idea that the frozen Arctic seas are a wasteland is erroneous. Compared to terrestrial ecosystems, the ecosystem of the ice bear is simply upside down. Most of the activity in Arctic marine ecosystems happens where we cannot see it: underwater, attached to ice, or in the sea ice itself. In the Arctic, sea ice has a function parallel to soil in a forest. If you do not have sea ice, the ice-associated species are replaced by those from open ocean ecosystems. Whereas most marine ecosystems have a water-air interface, polar ecosystems have a more complex water-ice-air interface. Ice is the substrate that controls what, how, and when everything grows. It is also the platform the bears walk on.

Except for humans, polar bears are at the top of the ice-covered Arctic marine food web. In general, Arctic marine ecosystems are poorer in species diversity than more southerly areas, but new species continue to be discovered. The Arctic food web, from primary productivity to polar bears, is short and is characterized by extreme seasonal and yearly variations in productivity. In the simplest terms, there are two parts to a marine ecosystem—open water (pelagic) and ocean bottom (benthic). These interacting parts have about five steps (trophic levels) in the food web. Like terrestrial systems, the sun drives the Arctic food web. As day length increases, activity in the Arctic food web explodes. Changes in a terrestrial ecosystem, known as succession, take place over decades or centuries. In a sea ice ecosystem, where ice forms, melts, re-forms annually, succession is condensed in time.

(Opposite) **Although glaciers are not normal habitat for polar bears, the bears will often cross them, despite the risks presented by crevasses. The hunting of seals where glaciers meet the sea ice can be particularly productive. Monaco Glacier in northern Svalbard was named in honor of Prince Albert of Monaco more than 100 years ago.**

Zooplankton, or "animal drifters," like this amphipod are critical links in the Arctic marine food web. The small grazing creatures, which feed on the abundant bloom of algae, are prey for fish, seabirds, seals, and whales.

**Arctic Marine
Ecosystems**

Sea ice drives the ecosystem structure and species composition. (Although Arctic marine ecosystems without sea ice exist, they do not have polar bears and are beyond the scope of this book.) Bacteria, viruses, algae, diatoms (microscopic single-celled plants with shells made of glass), protozoa, and small invertebrates inside and underneath sea ice form the food web base. Salty brine channels, varying from the thickness of a hair to a pencil, form in sea ice during freezing. These salty channels contain their own ecosystem, composed of a variety of organisms, that undergoes its own annual cycle. Not all organisms are adapted to extreme cold and some shut down until the next melt. While some species merely tolerate the cold, others thrive in it, growing and reproducing to create the ice-associated, or sympagic, community. Diatom production often stains the ice a brownish color showing it is packed with life. Many of these ice-adapted species can photosynthesize at very low light conditions resulting in the underside of sea ice covered in long diatom strands that feed the under ice (epontic) community. Approximately 200 species of Arctic diatoms form a diverse base for the food web. These diatoms also give us a window into the history of the oceans. Their glass shells are well preserved in sediment. And because many species grow only within specific temperature ranges, they can provide a perspective on paleoenvironments that can be explored using cores from the ocean floor.

Sea ice is a complex environment. Melting can form drainage channels that are quickly invaded by invertebrates looking for a safe home. Some of the most abundant invertebrates are copepods and amphipods, shrimplike zooplankton that graze on the primary production. Larger zooplankton eat smaller ones and the energy moves upward in the food web. Several zooplankton species have complex life cycles lasting many years. Some of these species migrate upward in spring to feed on the flush of new life, then downward to great depths in autumn to avoid be-

ing eaten. Like polar bears, many zooplankton species rely on stored fat to survive winter. Many of the larger zooplankton are eaten by seabirds, ringed seals, bearded seals, and bowhead whales.

Following the grazers and invertebrate predators are a host of larger predators, the most important of which is the polar cod. This is a slender fish up to 12 inches (30 cm) long that lives mainly in association with sea ice and is quite abundant in some areas. The species is a major link in moving energy up the food web. Young polar cod often live in sea ice cracks and are a major part of the ringed seal's diet.

Even a few inches of snow affects light transmission through sea ice. When the sun returns, the snow melts and primary productivity increases. As ice melts along the marginal ice zone (the interface between open water and sea ice), the ice-associated community, previously locked away from herbivores and carnivores, is released in an explosion of food resulting in a massive productivity pulse. Warmer nutrient-rich waters along the marginal ice zone create an algae bloom 10 to 30 miles (16–48 km) wide. Such blooms can contribute 40% to 60% of the total annual algal production. Once the ice has melted, productivity shifts to the water column, where, depending on water clarity, photosynthesis can continue down to 330 feet (100 m), though usually the depth is less. Diverse carnivorous species live in the water column, including comb jellies, jellyfish, beautiful shell-less snails called sea angels, predatory copepods, and squid. With more than 150 fish species in the Arctic, the food web has many links. In some areas, capelin and herring, which harvest much of the plankton production, are important food sources for seabirds, harp seals, and minke whales. More than 40 species of seabirds migrate to the Arctic to partake of the brief abundance of food and reproduce. The Arctic tern travels more than 50,000 miles (80,000 km) round-trip from the Antarctic to exploit the food that the Arctic offers.

The black-legged kittiwake is found throughout the Arctic, where it feeds on or just under the surface of the sea on invertebrates and small fish. Perhaps the most abundant gull in the world, black-legged kittiwakes nest in massive colonies on rocky outcrops. A colony can contain tens of thousands of individuals.

The Arctic fox, a member of the dog family found throughout the Arctic, is often seen far out on the sea ice preying on newborn ringed seals or scavenging remains of prey left by polar bears. Although the Arctic fox is at home on the sea ice, it depends heavily on terrestrial prey such as small mammals and birds. Arctic fox rely on their thick fur to endure the winter cold; polar bears rely on their size and fat stores for warmth.

Numerous other birds and mammals make impressive migrations to the Arctic to reap the short-lived bounty.

The ocean bottom food web in the Arctic is different from that in warmer waters. For example, sea grasses are rare. Seaweed is common in rocky substrates but not in the shallower areas where ice scouring makes existence challenging. There is also a diverse community on the ocean floor with sponges, corals, clams, mussels, whelks, crabs, sea cucumbers, starfish, octopus, and a variety of fish. Bearded seals feed on the bottom-dwelling invertebrates and walrus, largely on clams. Typical of many Arctic species, walrus are opportunistic and will snack on ringed seals given the chance.

Arctic marine ecosystems do not have strong links to the terrestrial world but some nutrients are moved to shore by seabirds; their waste fertilizes the tundra and can create green oases in the Arctic desert. The Arctic fox is the only species with a strong connection to both worlds. This small member of the dog family skips happily from ice to land and back in an annual cycle. Unlike polar bears, the Arctic fox does not always rely on sea ice. If small mammals like lemming and voles are abundant, the foxes will stay ashore. If small mammals are at the bottom of their cycle, the foxes will opt for the sea ice and venture far offshore. In the Arctic it helps to have a flexible meal plan. But it had better include fatty foods if you want to stay in the north through the winter.

6

SEA ICE AND HABITAT

To understand polar bear ecology it is essential to understand something about sea ice and how it varies in space and time. People in colder climates are familiar with frozen ponds, lakes, or rivers. Freshwater ice, however, has little relevance to the polar bear's world. The home of polar bears consists of a huge frozen ocean with its adjoining seas and a floating ice crust. Ocean currents and tides add dynamics that do not exist in freshwater systems. In addition, sea ice does not behave like freshwater ice: sea ice bends when freshwater ice would shatter. I would rather walk on thin sea ice any day than to walk on thin freshwater ice (although I prefer to stay off thin ice altogether). I recall catching a polar bear on thin gray ice. The ice being too thin to land on, we set the helicopter down nearby. Walking out to the bear, I watched uneasily as the ice flexed and little fountains of water shot up from cracks to either side with every step. Freshwater ice would have collapsed.

Sea ice appears homogenous to the uninitiated. One has to spend considerable time traveling on or over it for the subtleties to emerge. Eventually, the different habitats become almost as distinctive as terrestrial ones. Sea ice is deformed by winds, currents, and tidal action that create surface variation in the form of pressure ridges, hummocks, rafted ice, and cracks. While sea ice may appear to be a two-dimensional habitat, important structural elements affect the height and depth of the ice and the nature of the cracks within it. The most dramatic third dimension of ice in the Arctic is icebergs. These chunks of ancient freshwater ice from glaciers are infrequently of significance to polar bears. Polar bear scientists are most interested in sea ice less than one year old.

In its simplest rendering, sea ice starts as ice crystals formed by falling temperatures. These crystals slowly coalesce through a variety of ice types until a solid platform results. Depending on salinity, seawater freezes at about 28°F (−2°C). Ice crystals form in a variety of shapes and float to

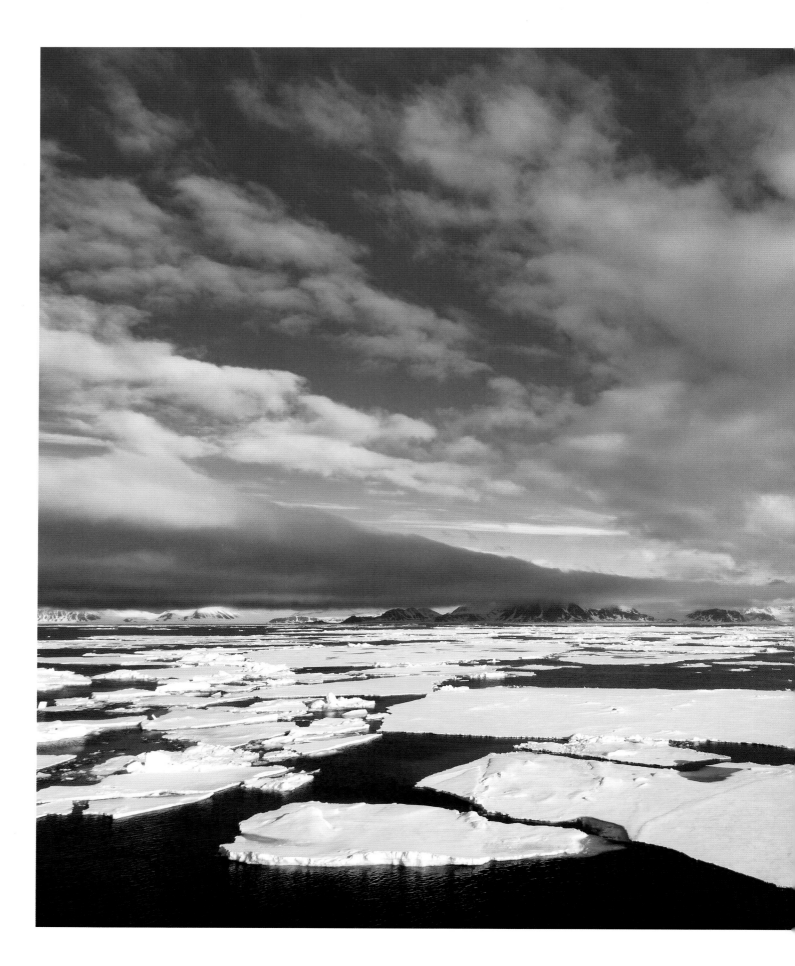

As the Arctic ice melts in spring, hunting conditions for polar bears decline. Seals are no longer restricted to the small cracks and breathing holes that make them vulnerable to polar bear predation. Once the ice cover drops to 50% or less, most bears head north to thicker ice or move onto land to wait for cooler temperatures.

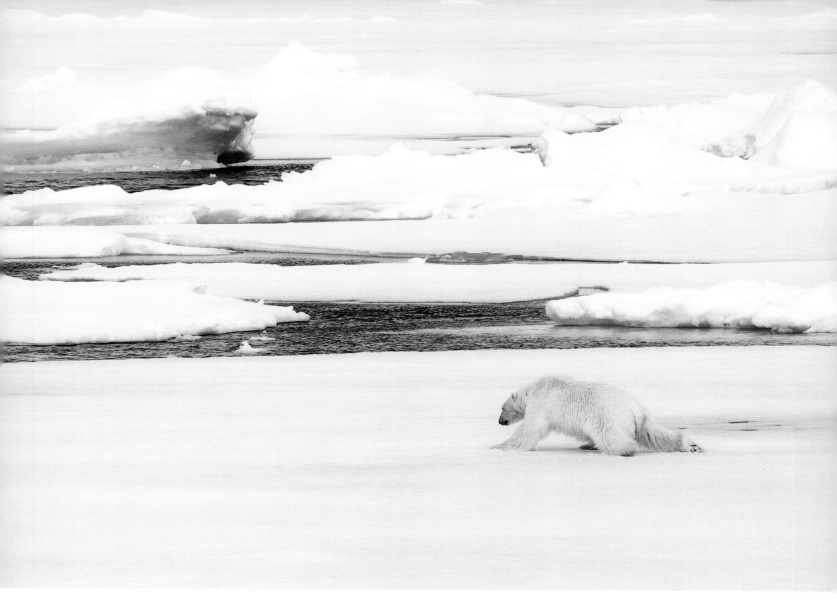

Sensing that the ice is flexing, a bear will splay its paws in a starfish pattern to distribute its weight more evenly; this may help it reach more solid ice without breaking through. Though polar bears can swim, they may have difficulty getting back on top of thin ice.

the surface, forming frazil ice. As the ice crystals thicken, an oily looking slick aptly called grease ice forms. Wind, currents, and tides determine what happens next. On a still day, the crystals form young ice, called nilas, a thin, elastic crust 4 inches (10 cm) thick or less. Watching nilas flex in the waves is an intriguing sight. Nilas is transparent but seems dark because of the underlying water; as it thickens it becomes whiter. If the water is moving, grease ice aggregates into small disks called pancake ice up to 10 feet (3 m) across. If the temperature remains low, these pancakes grow at the margins and bump into each other, turning upward at the edges. Eventually, smaller pancakes fuse together or the flat nilas thickens and larger pieces of ice called floes are formed. Floes vary from the size of a dining room table upwards to over 6 miles (10 km) across.

Regardless of how the ice started to form, in cold temperatures it continues to add long crystals on the underside. These crystals can be many inches long and wide. Air and water temperatures determine the rate at which the ice thickens. Over the course of a year, the ice can thicken to more than 7 feet (2 m). This is what is known as annual ice or first year ice. If it formed above a continental shelf, it is prime polar bear habitat. Annual ice melts during the summer. If it does not, it becomes multiyear

ice that can last many years and reach up to 15 feet (4.6 m) thick. Interestingly, the Arctic has thicker ice than the Antarctic because most of the southern ice melts each summer while not all of the Arctic ice does. Furthermore, Arctic ice extends right over the North Pole whereas the Antarctic ice only reaches the continent.

Multiyear ice is generally considered poor hunting habitat for polar bears. Seals have a hard time maintaining breathing holes and are less abundant in thick multiyear ice. Nonetheless, multiyear ice is a critical polar bear habitat. Many bears from the Beaufort Sea west to East Greenland retreat northward to multiyear ice each summer. Here they wait for autumn when the annual ice will re-form, allowing them to begin their southward migration to better hunting areas.

Exactly how thick the ice needs to be before a polar bear can walk on it depends on the weight of the bear more than anything else. Although polar bears can certainly survive a swim in the waters of the Arctic, watching a bear's behavior on thin ice makes it clear that it does not want to fall through. When a bear senses the ice flexing, it splays its legs as wide as possible to spread out its weight. If a polar bear ever resembles a starfish, it is on thin ice. A bear desperate not to crash through the ice will slide on its belly pulling itself along with its paws. Belly sliding is often seen when a bear is trying to get on top of thin ice that keeps breaking.

Numerous other issues, including the presence of freshwater, affect sea ice. Because freshwater is not as dense as saltwater, it floats on top and is important in several areas. In western Hudson Bay, freshwater from the Churchill River moves along the shore and ice here freezes earlier than other areas, allowing polar bears staging nearby to leave land earlier and start hunting a bit sooner. The freshwater ice of glaciers and icebergs can also create pockets of good polar bear habitat. Some bears in Svalbard and Greenland are expert ringed seal hunters along glacier edges. I satellite-tracked an adult female for several years whose entire home range consisted of a series of bays with large glaciers. She never left this area, moving no more than 60 miles (100 km) north to south in a year. She was just as successful at raising cubs as other bears that covered huge areas in a single year.

Ice either drifts or is stationary. Ice attached to land is called landfast ice. Often landfast ice has gigantic grounded ridges as high as a two-story building where the drifting pack ice smashes into the thicker landfast ice. Landfast ice can be very good polar bear habitat because ringed seals pup in these areas. The stability of the ice also makes these areas suitable habitat for polar bear mothers with small cubs. Adult male polar bears are less often found in such areas because they are hunting for larger seals in more active ice. Fewer males mean a lower risk of harassment and infanticide.

Most of the Arctic ice is drifting pack ice, which is the primary habitat of polar bears. Ringed, bearded, harp, and hooded seals as well as walrus are abundant here. Pack ice rarely forms a solid cover. Wind, tides, and currents can open a strip of water called a lead that can vary in width from inches to miles. Leads are ephemeral but critical hunting areas for

Infanticide and Cannibalism

Infanticide, the intentional killing of an infant, and cannibalism, the consumption of one's own species, commonly occurs in bear species, including polar bears. These events rarely affect a population but the risk of being killed by another bear drives many aspects of polar bear ecology and behavior. Reasons for infanticide abound: to obtain mating opportunities, for nutritional gain if the young are eaten, to reduce competition for resources, for parental manipulation of offspring number, and due to abnormal behavior.

One common reason for infanticide in species like African lions and grizzlies is that females rearing and nursing young will not enter estrous. If a male kills dependent young, the mother may become estrous, possibly allowing the male to mate with her. In grizzlies, infanticide is sometimes linked to disruption of social structure. When dominant male grizzlies are killed, juvenile males invade the vacated home range and kill cubs so they can breed with their mothers. Males are the killers in most cases of polar bear infanticide. But infanticide often occurs outside the breeding season, so a mating opportunity is not always the driving force in polar bears.

Nutritional gain is the motivation in many instances of cannibalism. If the killer is in poor physical condition, killing and eating another of its species may be its only chance for survival. Cannibalism can be a sign of stress in an individual or a population. Polar bear cannibalism is reported throughout the bears' range. Adult males in poor condition have been observed to kill and consume adult females and juveniles many times. Active predation and cannibalism may be important to the survival of these desperate males.

I found three young cubs killed at a den site in Svalbard. The mother of the cubs was in poor condition and had been wandering far from her den searching for food. During the mother's absence, a male excavated the den that was close to the sea ice, killed all the cubs, and ate one. The fat content of these cubs was low so the energy return was minimal and two cubs were left uneaten.

Rarely, or perhaps never, do mothers kill their own cubs. At one den intensive washing behavior by the mother suggested she had eaten a cub that had died. Russian scientists have also reported mother-offspring cannibalism when a cub died. The mother-offspring bond is intense and a mother would not intentionally kill her young.

Cannibalism shows up in a variety of situations. In Svalbard, polar bears ate five polar bear skins and two whole frozen bears taken in harvest. However, I have also seen many polar bear carcasses that have not been scavenged despite bears walking right past them. Apparently eating other polar bears is not high on the menu for most polar bears. If no other food is available, the situation changes.

As sea ice conditions in many parts of the Arctic have declined, increased reports of cannibalism have been observed. Stressed animals resort to desperate means to stay alive.

(Opposite) **Landfast ice forms early in the ice cycle and melts last in summer. The ice thickens over winter to form a stable environment for female polar bears with small cubs. Ringed seals favor these habitats because snow has accumulated over the pressure ridges, providing safe places for their lairs, in which they give birth to their pups.**

polar bears, which walk along the edges, or sometimes actually on top of refreezing leads, looking for a seal breathing hole. Ice can also form belts, tongues, and strips in open water, allowing polar bears to hunt prey like harp seals that do not penetrate deep into heavy ice. As in almost every habitat, edges are important. The marginal ice zone, where pack ice meets the open ocean, is a hugely productive area. The edge between the landfast ice and the drifting pack ice usually forms a large shore lead that recurs annually. Shore leads can be highly labile opening and closing

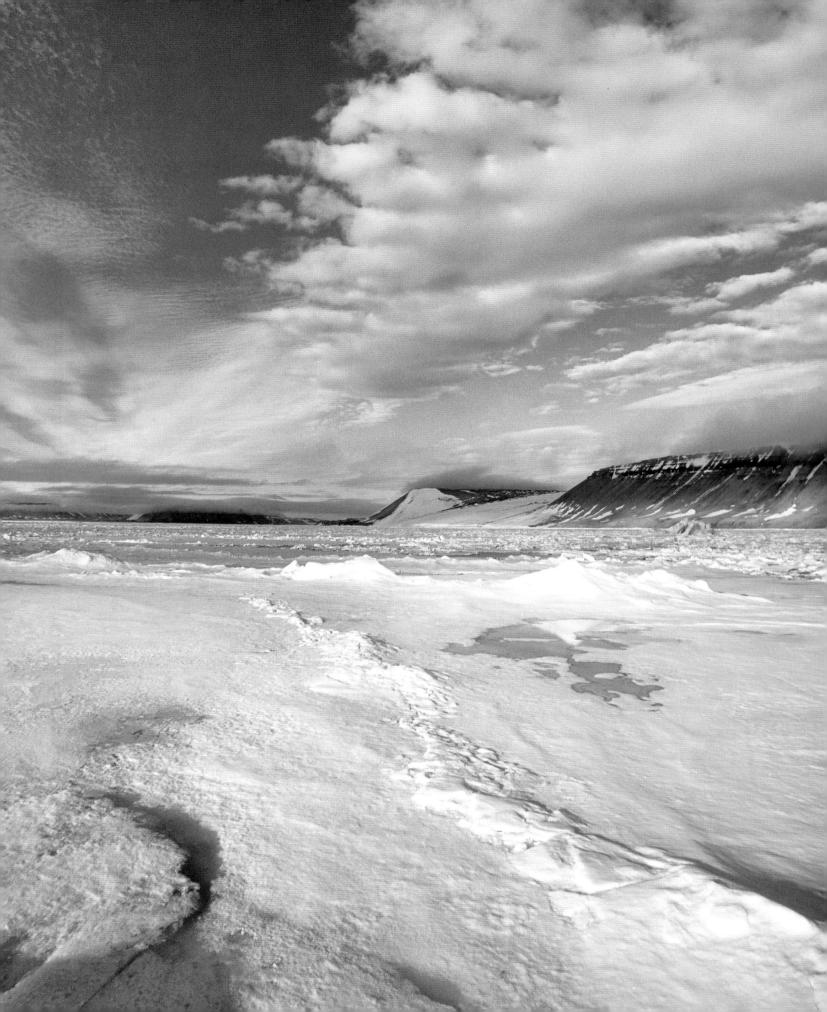

Seals often feed far under the ice, but they come up to breathe and haul out along the floe edge where the ice meets open water. Polar bears are often waiting for them at the edge: an Arctic cat and mouse game.

over hours or days. In many areas, the shore lead acts like a polar bear highway.

Ice cover is normally described in tenths. Compact pack ice with no water visible has 100% cover. Ice with decreasing cover is called very close pack, close pack, open drift, and finally very open drift. Good polar bear habitat is normally above 50%; below this, bears head for land or to areas with more ice. It is energetically expensive for bears to move across areas with low ice cover because they are repeatedly in and out of the water. In addition, hunting success declines because seals are not restricted to breathing holes; instead they surface in open water away from the ice that polar bears hunt from.

Polynyas are irregular shaped recurring bodies of water that persist all winter surrounded by ice. Polynyas are kept open by currents, wind, tides, or upwelling of warm water. They vary from a few square miles to more than 19,000 square miles (50,000 sq km). Polynyas occur between pack ice and the coast or between pack ice and landfast ice. Arctic whales often follow polynyas during migration and walrus use them all winter. In some areas, seals are abundant but only if walrus are absent. Polynyas may provide the only open water for eider ducks and seabirds in spring.

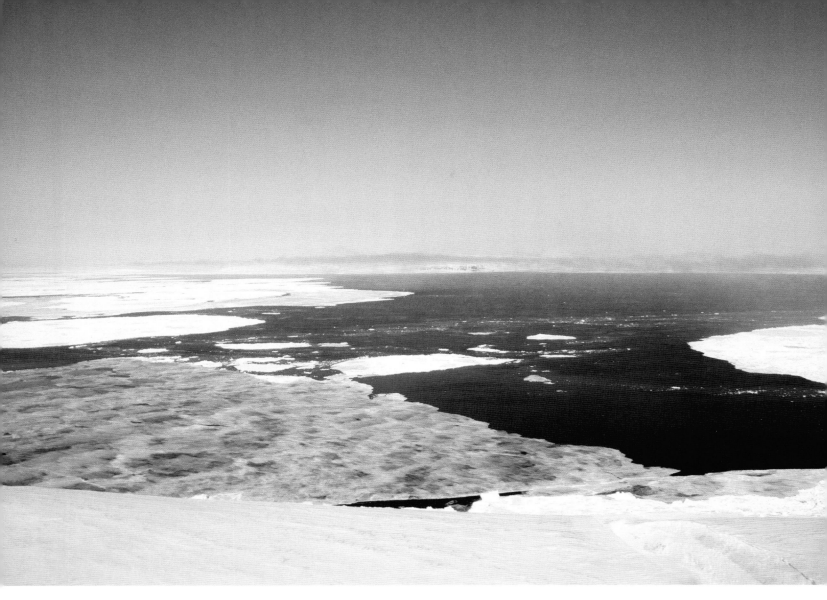

While sea ice in all its various sizes, shapes, and forms is distant from the day-to-day life of most people, it plays a crucial role in the thermal dynamics of the planet. First, the sea ice is a reflective cap that sends much of the incoming sunlight back into space. As we lose sea ice cover, more sunlight reaches the darker ocean and more heat is retained. This warming can result in a feedback loop—less ice means warmer water, warmer water means thinner ice, and thinner ice melts sooner, which then allows more sunlight to warm the water. This loop is one of the reasons that the Arctic is warming so much faster than the rest of the planet. Scientific measurements over the last 30 years show that both the thickness and the extent of sea ice in the Arctic have declined dramatically. Just as the existence of sea ice was crucial for the evolution of polar bears, the future of sea ice will dictate the future of the polar bear.

The second important feature of sea ice formation is that, as saltwater freezes, salt is expelled from the ice in a process called brine formation. Some of the salty water is caught in the brine channels inside the ice but much of the salt is ejected into the water below. Brine formation results in cold dense salty water that sinks rapidly to form deep water. The area from Labrador to Svalbard is a key area for deep water formation. A simi-

Polynyas, areas of open water surrounded by ice, are important features for wildlife throughout the Arctic. Walrus, eider ducks, and whales all make use of these areas. Polar bears regularly wander by polynyas.

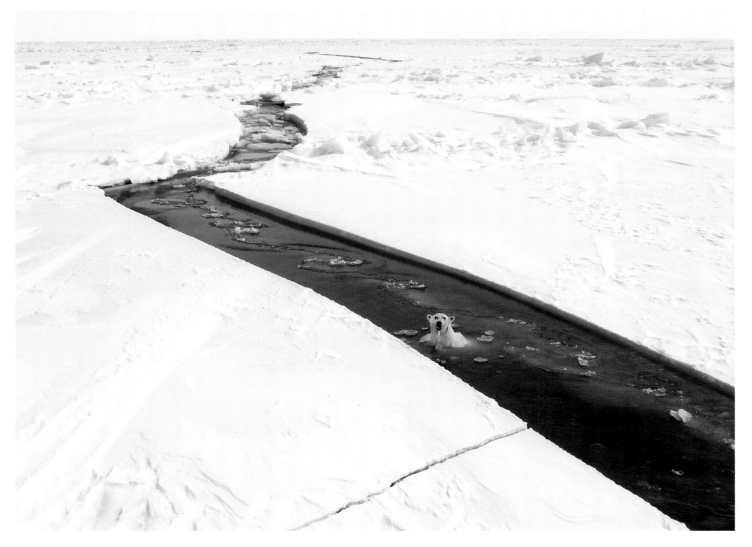

Polar bears do not normally enter very narrow leads, but they will do so when hunting or trying to hide.

lar process occurs under the Antarctic ice. The key here is that this deep water in effect pulls the ocean current along in what is called the global thermohaline conveyor belt. The cold salty water that sinks is replaced by the warmer, less dense surface water transported northward by winds on the Gulf Stream. Changes to sea ice formation may have serious effects on global climate patterns.

Inuit have known about the extrusion of salt from sea ice for generations. Multiyear ice eventually extrudes all the salt, leaving freshwater behind. If the ice is old enough, it is good for drinking. Multiyear ice looks different from annual ice because it melts a bit in summer giving it rounded ridges and more air in it makes it blue.

Pack ice is in almost constant motion. When floes collide they break, creating piles of broken ice called pressure ridges. These ridges can be a stone's throw long or extend for tens or even hundreds of miles following a wiggly path. Above the surface, a pressure ridge can reach 65 feet (20 m) but most are less than 6 feet (2 m). Below the surface, the keel can reach 165 feet (50 m). Pressure ridges are key habitats for ringed seals, which create breathing holes along or underneath the ridges. Blowing snow gathers in the lee of the ridges and ringed seals dig birth lairs from

Pressure ridges form where ice floes collide. Such ridges collect snow and make critical habitat for ringed seals to pup. The ridges also create complexity below the surface where numerous invertebrates and fish live.

underneath in the drifts. Polar bears walk and hunt along pressure ridges but avoid extremely rough, broken ice because it is difficult to walk through. Females with small cubs and subadults often rest atop large pressure ridges because of the good visibility they offer.

Wind is the primary force behind ice ridging and any deformation in the ice acts like a tiny sail. Millions of deformations form a huge "sail" that the wind pushes against. Friction quickly slows the ice when the wind stops. Sea ice pressure ridges also have substantial keels under the surface that are pushed along by ocean currents. In some parts of the Arctic, large circular currents called gyres push the ice around. In Hudson Bay a counter clockwise gyre pushes the last sea ice southward. Bears on that ice can remain a few weeks longer than bears in areas farther north. The clockwise Beaufort Gyre in the Beaufort Sea moves ice from east to west where it is picked up by the Transpolar Drift, which moves it across the North Pole toward the Atlantic Ocean. No matter where a polar bear finds itself, the ice is always changing.

One unique feature of sea ice is how fast it can change. In a period of hours, open water can congeal into a vast plain of ice or a huge field of ice can disappear in a windstorm. I had firsthand experience of this

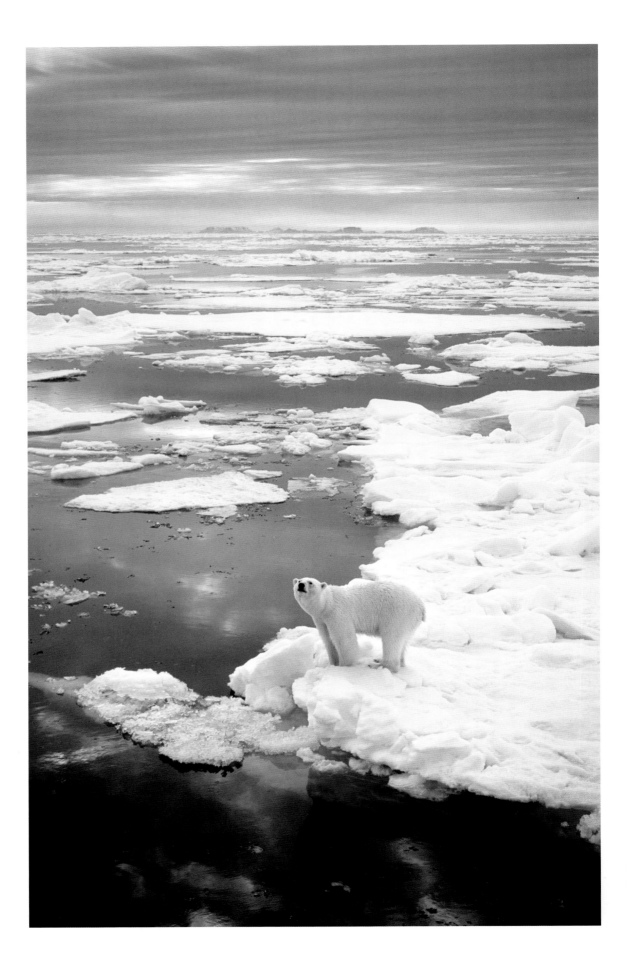

Sea Ice and Habitat

while catching bears with Russian colleagues from an icebreaker in the Barents Sea. We had had a great day and had caught several bears. Overnight a storm blew up, and by morning, the ice we had been working on was nowhere to be seen. It had moved more than 60 miles (100 km) northward. Satellite collars on the bears we had caught the previous day revealed that they had taken a free ride north on the drifting ice.

Another striking aspect of sea ice is the variation in its spatial coverage. At maximum ice extent, usually in late February or March, Arctic sea ice covers 5.8 million square miles (15 million sq km). This is equivalent to about 60% of North America or 1.5 times the area of Europe. After the peak, the sea ice begins to melt and by mid-September less than half or 2.7 million square miles (7 million sq km) remains. Ice that remains in late September is either multiyear ice or is on its way to becoming multiyear ice. The area of ice cover, however, has been declining for decades so polar bear habitat is disappearing. The significant change in habitat from month to month and year to year affects every aspect of polar bear life from feeding to migration.

Not all sea ice is good polar bear habitat. It must be thick enough to support a bear, yet thin enough to allow seals to live there; have high enough concentration to provide a connected path; and most important, be biologically productive. The most biologically productive ocean areas are over the continental shelves where water depths are no more than 460 feet (140 m). Beyond the shelves lie the deep, cold, unproductive waters of the Arctic Ocean more than 2.5 miles (4 km) deep, far deeper than seals dive. The size of the continental shelves also affects ecosystem productivity. Shelves vary from a few miles to more than 350 miles (563 km). Overall, polar bears are a species of the continental shelves and they are far more abundant on the fringes of the Arctic Ocean than elsewhere.

Preferred polar bear habitats are fairly similar throughout the Arctic if the bears are seeking the same prey. Ice that is moving, near shore, has active or refreezing leads, and has pressure ridges is a good place to look for polar bears. If there are seals in an area, it is polar bear habitat and seals respond to the distribution of their prey, ice conditions, and the presence of other seals. There are, however, some geographic differences in habitat use. In the Bering Sea and the Chukchi Sea, female polar bears rarely use landfast ice. In Lancaster Sound in the Canadian archipelago, 69% of satellite tracked bear locations were on landfast ice. The reason for this difference is habitat availability: the former have little landfast ice in comparison to drifting pack ice, while the reverse is true in Lancaster Sound. The Bering and Chukchi seas are open systems; Lancaster Sound is constrained by land.

Terrestrial Habitat

Many polar bears never step on land, but in some areas, the whole population makes landfall annually when the sea ice melts. Nobody thinks of polar bears as a woodland species, but at certain times of the year, bears in Hudson Bay can be found in forested areas. One of my favorite memories is of a huge adult male polar bear walking through a forest of bright yellow larch trees on a frosty autumn morning.

(Opposite) **Broken ice forces hungry polar bears to shift their hunting strategies to aquatic stalks.**

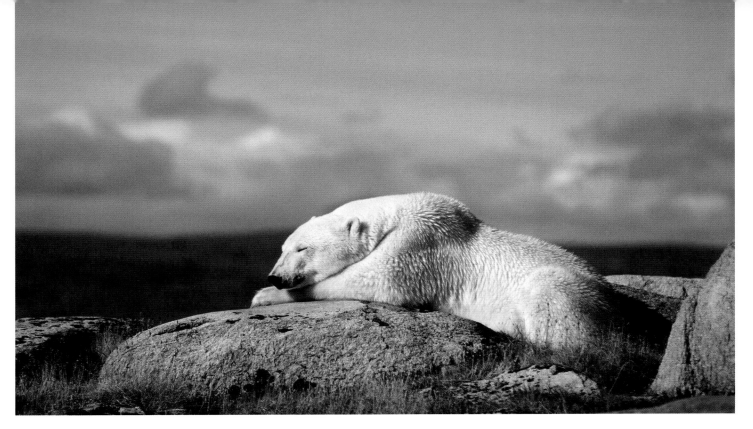

When there is nothing better to do, polar bears will often snooze on a rocky outcrop with a view. Adult males are unconcerned about other bears. Subadults, as well as females with young, often seek areas where they are less likely to be disturbed.

When on land, females with young tend to seek areas away from other bears. Adult males hang out wherever they want, usually along the shore. Pregnant females seek remote areas near their eventual den sites. Because the mating season is over and most terrestrial areas offer little food, there is almost no competition for resources and habitat selection pressures are relaxed. Most bears seek a dry comfortable spot with good visibility. Some bears select the edges of lakes or creeks in the open tundra. Adult males along the coast often dig shallow pits in beach ridges.

Farther north, terrestrial habitat use is more variable. Some bears select small rocky islands. In Alaska, narrow barrier islands provide a place to wait for the ice to return. In mountainous areas, bears may be seen tucked high above their surroundings on a rock platform. Such locations provide a bear with a good view of the area, and it is unlikely to be disturbed. While on land, some bears wander in search of food. Their summer habitats include beach edges where they find carrion or the occasional meal of seaweed. Other bears head for islands with goose or duck populations and partake of a few eggs. If a carcass of any size is found, male and female bears of various ages may gather around it.

Polar bears regularly wander far above sea level, walking over mountain passes and glaciers while moving from one area to another. Some routes are learned and used repeatedly. Overland treks can be impressive, and bears crossing the whole of Chukotka in eastern Russia from the Bering Sea to the Chukchi Sea or from the North Greenland Sea to the Barents Sea in Svalbard are common. Many glaciologists have been unnerved in the morning to find polar bear tracks near their tent at 2500 feet (762 m) above sea level.

7

PREY

More than anything else, polar bears are specialized predators of ice-loving (pagophilic) seals. While carnivore is apropos for meat-eating animals, it may be appropriate to invent a new term for polar bears that make their living eating blubber (lipids). While science frowns on inventing words, the term "lipivore" aptly describes what makes polar bears tick. To put blubber consumption into perspective, the energy in seal blubber is about 82% of that in heating oil; polar bears have an incredibly energy-rich diet. To understand polar bear ecology, it is essential to understand the polar bear's prey.

Ringed Seals: The Small Meal Deal

Ringed seals get their name from the gray-white rings on the darker fur on their backs. The smallest and most abundant of the Arctic seals, there may be as many 2.5 million individuals worldwide. Adults are about 4 feet (1.3 m) long and weigh up to 150 pounds (70 kg). Females are sexually mature at 4 or 5 years old and give birth to a single pup each year. Ringed seals are found everywhere polar bears are; they are also found farther south in some areas. Densities of ringed seals vary widely, and their abundance is a major factor influencing the distribution and abundance of polar bears.

Ringed seals feed on well over 72 different species, including marine worms, copepods, amphipods, squid, crabs, and most important, polar cod. Ringed seals are in their best condition in spring; they lose weight through the breeding and molting season until early September when polar cod are readily available. A seal killed in spring has more fat than one killed in autumn.

A ringed seal uses open water in cracks and leads to breathe. As ice cover increases, it pokes holes in thin ice with its head, creating a Swiss cheese appearance in young ice. As the ice thickens, the seal maintains

Smallest and most abundant of the Arctic seals, the ringed seal is the most common prey species for polar bears. The reliance of ringed seals on breathing holes and birth lairs make them vulnerable to polar bears. It is a veritable arms race: polar bears adapting as a specialized seal predator and seals evolving behaviors that reduce the likelihood of being eaten. The contest is relatively new as ringed seals are a much older species than polar bears.

its breathing hole by abrading the ice with the large claws on its fore flippers. Holes can be maintained in ice more than 6 feet (2 m) thick, but the seals prefer thinner ice and will exploit cracks when available.

Ringed seals use lairs for protection from predation by polar bears and Arctic fox. The female digs a lair into a snowdrift next to a pressure ridge; there she will give birth to and nurse her pup. The seal accesses the lair from below. Females often maintain two or more lairs in case pups have to be moved. If predators approach, pups will enter the water. No other seal has evolved such shelters, which provide protection from the environment. Pups are born with a white coat, called lanugo, that keeps them warm until they store enough blubber to provide insulation. Pups weigh 9 to 11 pounds (4–5 kg) at birth in April and are only about 5% fat. In 5 to 6 weeks, the now-chubby pups weigh 44 pounds (20 kg) and are almost half fat.

Predation by Arctic fox is limited to young pups but they are important predators in some areas. All age classes are vulnerable to polar bear predation. To a lesser extent, walrus, Greenland sharks, killer whales, and humans also prey on ringed seals.

Polar bear habitat selection in spring is driven by the distribution of ringed seals. Ringed seals use stable ice with pressure ridges and accumulated snow for pupping and many polar bears make a living in these areas. Landfast ice, which does not shift, provides the best sites for ringed seal birth lairs. Large moving ice floes are also used, but they are riskier because shifting ice can trap pups in the lair, crush them, or eject them onto the surface. I have seen pups ejected onto the ice many times; they scramble about the ice seeking a way into the water. It is a sad sight and I have been tempted to "save" the seal pup. Ultimately, I have always let nature take its course and left it to polar bears to find their snack.

In some areas, ringed seals pup onto the ice surface. I have seen

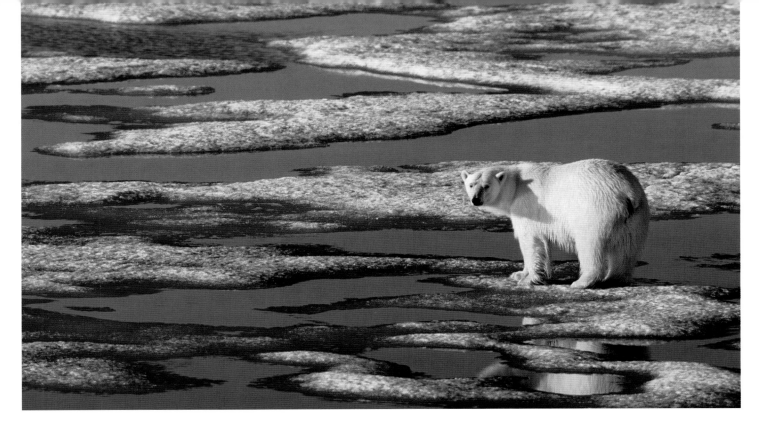

this in the fjords of Svalbard where the ice freezes flat and there is not enough snow for lairs. I remember seeing the ice dotted with newborn ringed seal pups one day. Flying over the same area the next day, I saw the ice dotted by Arctic fox tracks and bloody spots that were the remnants of the pups. The foxes had cleaned out the area, caching the pups on land for their dining pleasure later on. In other areas I have seen just a thin layer of snow in which seals managed to make lairs just under the surface. Polar bears had easy pickings and they cratered the area searching for pups. Polar bears have much lower hunting success at birth lairs when the snow is thick and hard because the mothers and pups have more time to escape.

Ringed seal populations can be reduced by predation but the relationship is poorly understood. In the Canadian Arctic, researchers used dogs trained to find seal lairs and found that polar bears excavated up to 42% of the under snow (subnivean) lairs and killed a seal in 17% to 33% of the digs. Hunting ringed seal pups is chancy. A skinny pup is meager fare and is often left uneaten. Hunting success is a function of the age and experience of the bear, the density of seals, the age of the seal, and ice and snow conditions. Subadult polar bears often investigate dozens of seal lairs and breathing holes without making a kill. In contrast, I have seen an adult female make only 8 digs, while walking 19 miles (30 km), and kill 3 fat pups.

On warm days in spring and summer, ringed seals bask on the sea ice. It is common to see 3 or 4 seals at a single breathing hole or a 100 or more dotting a crack. Ringed seals are nervous creatures and vigilantly scan their surroundings every 20 to 30 seconds. They are never more than half a body length from water. Ringed seals rarely have wounds from polar bears, suggesting few survivors if a bear makes contact.

Male ringed seals during the breeding season have a pungent and

In late spring, a labyrinth of ice and water provides a challenging habitat for hunting. But fat, recently weaned ringed and bearded seal pups make the hunt worthwhile as this well-rounded bear attests.

The bear that dug out this ringed seal birth lair in landfast ice was unsuccessful, but this can be a highly efficient form of hunting.

lingering odor reminiscent of gasoline and musty socks. Inuit call these seals *tiggak* (stinker). Some say the scent penetrates the seal's whole body, rendering the meat inedible to dogs, people, and polar bears. But I have seen many tiggak seals eaten by bears. If polar bears actually avoided tiggak males, the selective benefits of stinking all year would be intense and females might be expected to evolve a similar antipredator defense. Given the stink of other food sources such as rotting whale carcasses, it is likely that tiggak seals indicate a lower probability of success to a polar bear. Tiggak seals defend territories in the April–May breeding season and a male defending its underwater territory spends little time out of the water.

Bearded Seals: The Big Seal Meal

Aptly named, the bearded seal is the second major polar bear prey species. The characteristic beard (technically a "moustache" because the long and abundant whiskers grow on the upper lip) is the hallmark of this species sometimes called the "square-flipper" because of the blunt fore flippers. Bearded seal are the largest northern seal and can exceed 935 pounds (425 kg) and 6.6 to 8.2 feet (2–2.5 m) in length. Females mature at 5 or 6 years old and males a year later. They have unpatterned gray to brown fur with some lighter patches on their face and back. Most have a rust-colored face caused by mineral oxides from foraging in sediments. A prominent field characteristic is that the head appears rather too small for the body. Oddly, for an animal this size, the skull can only be described as delicate.

Bearded seals are less common than ringed seals and world population estimates range to 750,000. Bearded seals are found in all northern ice-covered seas with the exception of thick multiyear ice. They prefer less stable drifting pack ice over continental shelves and are common

around the marginal ice zone and polynyas. They haul out and rest right at the edge of the ice facing the water. When alarmed, bearded seals galumph into the water. Solitary seals for most of the year, they aggregate in late spring and early summer, with dozens of individuals neatly spaced along a crack. Bearded seals are bottom feeders and normally dive less than 300 feet (91 m) although they can reach 1000 feet (305 m). They feed on more than 40 prey species, mostly bottom and swimming invertebrates, shrimp, crabs, bivalves, snails, worms, and fish.

Pups are born onto the surface of ice floes within 3 feet (1 m) of water from March to May. They weigh about 75 pounds (34 kg) at birth and can swim almost immediately. During the nursing period, which is only 18 days, pups consume more than 1.7 gallons (6.4 L) of milk per day. Almost half the milk is stored and pups balloon to between 187 and 220 pounds (85–100 kg) in that period. Older pups are much more energetically attractive to polar bears. Bearded seal pups are rather naïve and often fall victim to polar bears.

Adult bearded seals escape polar bears more often than ringed seals because they are more difficult to control. When caught, a bearded seal will spin in an attempt to free itself. A massive rotating seal is a mouthful for all but the biggest bears. In one study, over 80% of bearded seals had claw or bite marks consistent with an escape from a polar bear. Bearded seals have no teeth of any prominence so such wounds were not caused by others of their species. Predators besides polar bears are killer whales, possibly walrus, and, of course, humans.

Because the hide of bearded seals is extremely thick, it is difficult for bears to tear. Polar bears open these seals like a banana and peel back the skin to feed on the blubber. Bearded seal remnants eventually consist of the spine and the shredded hide. Historically, bearded seal hide was used by Inuit for making rope.

Though less abundant than ringed seals, the much larger bearded seal is an important prey item for polar bears. Because of their large size and their preference for more broken ice, they are hunted primarily by adult male polar bears.

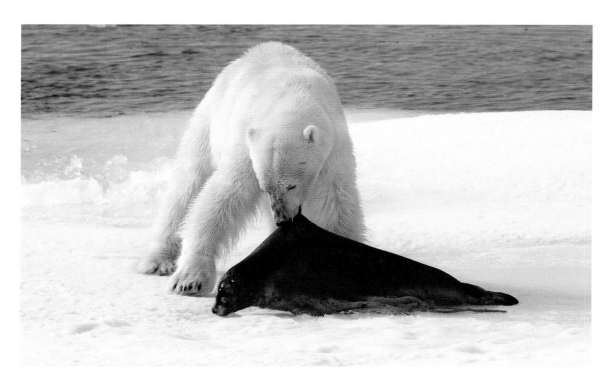

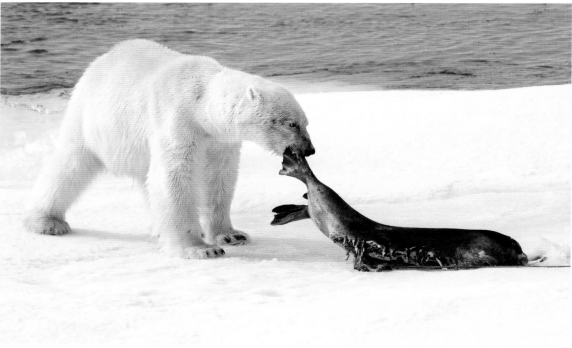

Bearded seal pups are extremely vulnerable to polar bears, relying on a quick escape into the water when danger approaches. This incautious pup, which was caught in a typical habitat of ice floes interspersed with open water, will provide a good meal, though it lacks the fat layer that older pups have.

Bearded seal males have an eerie and haunting song: the bizarre modulating calls sound like the whistle of falling bombs (without the explosion). These vocalizations are part of a male defending a maritory, which is the marine equivalent of a territory.

Harp Seals: A Regional Specialty

Harp seals, whose scientific name, *Pagophilus groenlandicus,* means "ice-lover of Greenland," are one of the most abundant seals in the world with a population of more than 7 million spread from western Russia

west to the northwest Atlantic in the sub-Arctic. The name "harp" derives from the V- or O-shaped pattern of dark black fur on the seal's back. Also known as the saddleback seal and the Greenland seal, they can weigh up to 286 pounds (130 kg) and reach about 5.6 feet (1.7 m) in length. Harp seals are common prey for polar bears in Davis Strait, Baffin Bay, Foxe Basin, Greenland Sea, Barents Sea, and to a lesser extent in adjoining waters.

The harp seal lives on the edge of the pack ice on the fringe of polar bear habitat. Choosing such habitat may be a strategy to avoid, or a consequence of, predation by polar bears. Harp seals pup and mate in large "patches" near the southern edge of their distribution in February and March. There are four patches, with the largest off Newfoundland and Labrador and a smaller one in the Gulf of Saint Lawrence. The two others are north of Iceland toward Greenland and in the White Sea in western Russia. The single "whitecoat" pup weighs about 24 pounds (11 kg) at birth. Within 12 days the pups are weaned. Weighing about 79 pounds (36 kg), they are left on their own while the mother mates with an attending male. Pups fast for 6 weeks and lose up to half their blubber before they enter the water and start feeding.

When preying on harp seal patches, polar bears sometimes kill more pups than they can possibly eat. The Norwegian scientist Fridtjof Nansen described such an event in the early 1900s: "The bears have a rare time with the seal pups, which are an easy prey, as they do not, of course, enter the water until they have cast their woolly covering. The bear will then often play with the pups, as a cat plays with a mouse; it will pick one of them up in its mouth and throw it high up into the air, roll it like a ball over the ice, give it a knock so it tumbles over, and then perhaps take a bite, but leave the little creature half-dead, to begin the same game with another one." Polar bears are often attracted to new things in their

A harp seal mother with a classic "harp" on her back lies near her newborn whitecoat pup. Harp seals, which live on the edge of polar bear habitat in the North Atlantic, are an important food source for polar bears with access to them. When a polar bear gets onto a harp seal patch, it can wreak havoc on the pups, which have no antipredator defense. There are almost 7 million harp seals worldwide.

An adult hooded seal is a big but aggressive meal package for polar bears. There has been one account of an adult hooded seal killing a polar bear. In their natural habitat, on the edge of polar bear country in the North Atlantic, they are an uncommon prey item. But when they migrate northward to the ice edge in summer, hooded seal pups are often taken.

environment and it is possible that the act of killing so easily is novel. Historically, sealers killed any polar bear on the patches.

Harp seals normally dive from 65 to 980 feet (20 to 300 m) and have a diet that includes more than 67 fish and 70 invertebrate species. Harp seals move far north in summer to molt along the edges of the pack ice, where they are vulnerable to polar bears.

When attacked, harp seals can enter a self-induced paralysis: body rigid, fore flippers drawn in, hind flippers pressed together, while they defecate and urinate. Possibly, harp seals evolved in the presence of polar bears and paralysis is a defense to reduce injury when handled. Polar bears that have caught harp seals sometimes lose them if their attention is diverted from the apparently dead seal. Given that harp seals cannot fight back against such a predator, playing dead offers at least the possibility of escape. People do it with grizzlies. Of course, better still is not to get caught in the first place.

Hooded Seals: A Meal with Attitude

Hooded seals are uncommon polar bear prey. Larger than harp seals, hooded seals can reach 660 pounds (300 kg) and about 7.2 feet (2.2 m) long. Their name derives from a nasal appendage or "hood" that hangs over the male's nose and is inflated as part of mating behavior. The males also have an elastic septum that they blow out through a nostril like a big liver-colored balloon.

Pups, which are born in March–April, weigh about 53 pounds (24 kg) and are 3 feet (105 cm) long. Hooded seals have an incredibly short 4-day nursing period. Every day they drink 2.6 gallons (9.8 L) of rich milk and gain about 13 pounds (6 kg) until they are weaned at 92 pounds (42 kg). The pups lounge on the ice for days or weeks until they take to the water and begin feeding.

Confined to the northwestern Atlantic, hooded seals pup at the southern edge of their range but summer along the southern edge of the pack ice. Juvenile hooded seals, called blue-backs, are often in the pack ice in summer where they make a welcome meal for polar bears cruising the ice-edge. Adult males are a more challenging meal for polar bears and are rarely killed.

These are deep-diving seals that forage for Greenland halibut, squid, herring, capelin, Atlantic cod, polar cod, and a variety of other fish. While nowhere near as abundant as harp seals, there are half a million or so worldwide.

Harbor, Spotted, and Ribbon Seals: Southern Fare

Normally a temperate species, the harbor seal would not be considered polar bear prey, but in Svalbard, Greenland, and North America this species is increasingly on the menu. The spotted seal, only recently recognized as a separate species from harbor seals, is restricted to the seasonally ice-covered seas in the Bering and Chukchi seas and occasionally fall prey to polar bears. In Hudson Bay and Svalbard, harbor seals are restricted to nearshore habitats and fjords. These seals can weigh 110 to 374 pounds (50–170 kg) and reach lengths of 3.9 to 6.6 feet (1.2–2.0 m). Harbor and spotted seals may become more common in polar bear diets as the climate warms. But both are ice-edge species at best and have evolved to avoid polar bear predation by using habitats the bears do not use.

The wonderfully decorated ribbon seal has beautiful creamy-white ribbonlike bands that encircle the neck, fore flippers, and waist on a black-brown background. While uncommon prey for polar bears, the bears are more than willing to take them when they can. Ribbon seals are in the North Pacific Ocean and the Bering and Chukchi seas.

Normally considered a temperate species, the harbor seal is increasingly becoming a part of the polar bear diet. Harbor seals, which use beaches or rocks to haul out, are not as accessible to polar bears that are farther offshore. When harbor seals are available, the bears will eat them, but they are much less abundant than ringed seals.

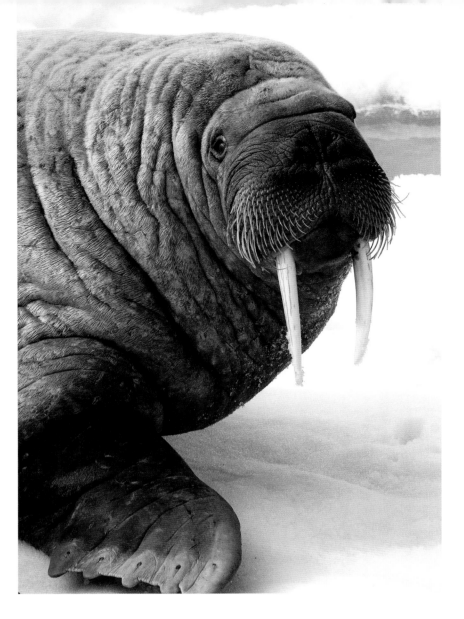

The walrus is a formidable prey item for polar bears and even short tusks can be fatal to the would-be predator. Polar bears are not effective predators of walrus, but adult males can dispatch calves and juveniles.

Walrus: A Dangerous Dinner

The scientific name of the walrus, *Odobenus rosmarus*, means "tooth walking sea horse." Adult walrus, by virtue of their size, are almost immune to polar bear predation. Males can top 3740 pounds (1700 kg) and be 10.5 feet (3.2 m) long; females weigh about 1870 pounds (850 kg) and reach a length of about 8.8 feet (2.7 m). The hallmark of walrus is their modified canines, called tusks, which can grow up to 3.3 feet (1 m) long. Though the tusks, larger in males than females, are formidable weapons against polar bears, they are usually used as a sledge for feeding on the ocean bottom where walrus forage mainly on clams. Walrus use their sensitive whiskers to locate prey and then suck the soft parts out of a clam about every 6 seconds, eating more than 50 clams in a single dive. It takes a lot of clams to keep a walrus fed.

Walrus, which have an Atlantic and a Pacific subspecies, overlap extensively with polar bears in the area around Foxe Basin, Lancaster Sound, Baffin Bay, Greenland, Barents, Kara, Laptev, Chukchi, Bering, and western Beaufort seas. The global population numbers around a

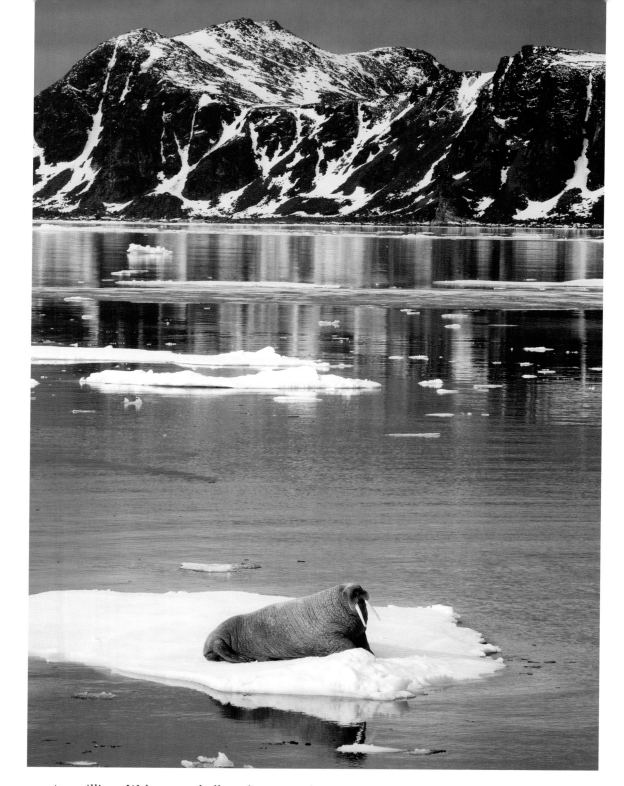

quarter million. Walrus are shallow divers, so their distribution is usually restricted to the continental shelves.

Walrus have skin 0.8 to 1.6 inches (2–4 cm) thick around the neck and head; this helps protect them from polar bears. Killing an adult walrus is no easy task and only the largest adult male polar bears have much success. Early last century, Fridtjof Nansen wrote, "Although I have seen a lot of both walruses and polar bears in the same areas in Franz Josef Land, I have never seen a bear chase a walrus. The walruses were com-

Walrus often haul out on small ice floes that allow easy access into the water. Walrus on land are more vulnerable than walrus in the water or on ice. Polar bears will sometimes stampede a large herd hoping to grab a calf in the ensuing chaos.

pletely indifferent to the bear; it could go close by them without their noticing it. They obviously feel quite safe and superior." Observations on Wrangel Island suggest that the preferred method of attack is to stampede hauled out walrus and hope to capture a calf in the ensuing confusion. Walrus are not particularly agile on land, and juveniles crushed in the mayhem can provide a welcome polar bear meal. Attacks also occur on pack ice when walrus haul out at leads and ice-holes, but usually only adult males are strong enough to control walrus.

Many polar bear populations do not have access to walrus. Of those that do, males attempt about 60% of attacks on walrus; adult females, 17%. The remaining 23% of attacks are made by subadults, who rarely do well with large prey. On Wrangel Island, only about 6% of walrus predation attempts were successful, with calves and juveniles the most common target. Hungry bears are often desperate and when death by starvation is a possibility, they are apt to take more chances. A walrus meal does not come without a cost and injuries to polar bears are common. If polar bears had evolved to be major predators of walrus, they would be even larger than they are.

There is a curious link between polar bears and walrus: both prey on ringed seals. While searching for polar bears on the north end of Svalbard, I was attracted to the ice edge by a flock of glaucous gulls flying about. Expecting to find a polar bear and its kill, I was a tad perplexed to find nothing on the ice. Circling with the helicopter revealed a walrus in the water. At first, I thought the walrus was tangled in rope but a closer look revealed the walrus had a ringed seal in a "walrus hug" and the "rope" was the seal's intestines coiling below. Such observations are periodically noted in other areas. Where walrus are abundant, ringed seals are scarce; polar bears often avoid areas used by walrus.

Whales in the Belly of a Bear

Polar bears only prey on two small Arctic whale species, but they will scavenge whales of any size. The beluga or white whale, also known as the "canary of the sea" for its curious songs, are 11 to 18 feet (3.5–5.5 m) long and weigh up to 3300 pounds (1500 kg). At birth, the light gray calves are 4.9 feet (150 cm) long and weigh 176 pounds (80 kg). They whiten with age. They have a circumpolar distribution that extends beyond the range of polar bears to the south but does not reach as far to the north. There are more than 150,000 worldwide. A true Arctic whale, belugas lack a dorsal fin, which would make life in the pack ice difficult. Their diet consists of a variety of fish and invertebrates.

Parallel scars on some belugas suggest unsuccessful predation attempts. There are, however, three situations in which polar bears can kill belugas: on beaches, from ice floes over deeper water, and in small openings in the ice. In shallow waters when belugas move into river estuaries to molt their outer skin layer, individuals can become stranded and preyed upon by polar bears. In Cunningham Inlet on Somerset Island, Canada, belugas make regular migrations in July and August into shallow water to rub on rocks to loosen their shedding outer skin. On

the highest tides, some whales are stranded in the shallows and have to wait for a higher tide to lift them back to safety. Some bears have figured out that these high tides can mean an easy meal and seek out these sites. The bears feed on skin and blubber of a stranded whale, which ultimately results in death. The size of belugas and their strong skull make them tough to kill. Under some conditions, a bear can stun a whale with a blow to the head and one bear in Russia reportedly killed at least 13 belugas this way. Over deeper waters, adult polar bears leap from ice floes onto surfacing calves that are then pulled onto ice floes to be eaten.

Polar bears also catch whales trapped in restricted patches of open water within a large expanse of sea ice that sometimes develop with sudden changes in ice conditions. "Sassat" is the Greenlandic and "savsatt" the Inuktitut word to describe these rare entrapments of several whales in small openings. The animals come to the opening to breath but if polar bears find a sassat, they will harass the whales and force them to dive without getting enough air. Eventually, the exhausted whales are mauled by the bears and die. Sassats are uncommon but spectacular. In one sassat 50 by 13 feet (15 by 4 m), 40 belugas and 1 bowhead were present; 8 belugas were killed, pulled onto the ice, and fed on by more than 20 polar bears. In another instance up to 55 belugas, mostly juveniles, were pulled onto the ice by polar bears. Initially, 15 bears were present and many of the whales had not been scavenged. Two weeks later, 30 bears were feeding on the carcasses. When food is plentiful, sharing is not a problem among polar bears. Surplus killing makes sense in situations where killing many animals is relatively easy and a bear can create a food supply that lasts for an extended period. Monopolizing a whale carcass for an extended period would be difficult and risky.

This stranded beluga whale near Somerset Island, Nunavut, was killed by a polar bear. Under normal conditions, adult belugas are almost immune to polar bear predation but in shallow waters, the bears gain an advantage.

This spyhopping beluga whale is keeping a close watch on its surroundings. If a polar bear is swimming nearby, a pod of whales will often move in and herd it away.

By killing many whales, a bear creates a food supply it can use without having to defend it.

When belugas find a polar bear in the water, the whales may form a semicircle around the bear and apparently try to move it away. Such an organized response to a potential predator notifies the predator that it has been spotted. Similar group threat displays toward polar bears have been seen in walrus.

The narwhal is another whale species polar bears sometimes prey on. The narwhal, whose scientific name, *Monodon monoceros,* means "one tooth, one horn," is affectionately known as the "sea unicorn." The common name derives from Old Norse meaning "corpse whale" because they resemble a drowned person. At birth, calves weigh about 180 pounds (80 kg) and are blue-gray. They develop the characteristic mottled pattern as they mature. They keep whitening with age. The most notable feature of the narwhal is the spiral tusk reaching to 10 feet (3 m) long in males. Only about 3% of females develop a tusk, and it is much smaller. Despite the deadly appearance of the tusk, an overgrown incisor, it has no defensive role. Narwhal, which prefer deeper waters than

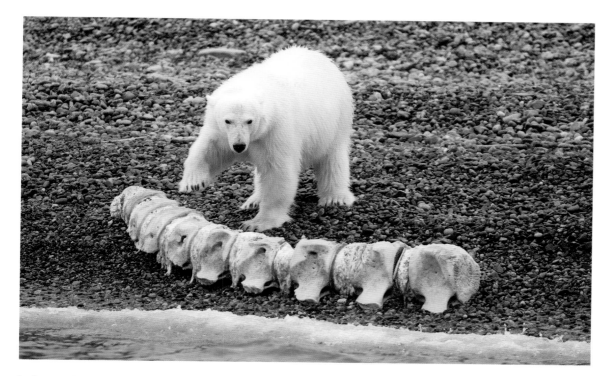

Carrion from whales like this minke whale, a small baleen whale, can be an important food source for an individual bear until seals become accessible with the return of the ice in winter. Polar bears have been observed killing two whale species and scavenging five others.

belugas, feed on Greenland halibut, other fish, squid, and crustaceans. Narwhal are largely confined to part of the High Arctic and only overlap with certain polar bear populations. The role of narwhal as prey for polar bears is poorly documented but stranded narwhal are eaten by the bears. Narwhal trapped in sassats also fall prey to polar bears.

Polar bears are opportunistic feeders and will take advantage of any available food source. In Svalbard, 56 polar bears were seen in the vicinity of a bowhead whale carcass floating in the drift ice. The bears were gorging on the whale and many of them had pendulous bellies. Such bonanzas draw bears in from huge distances. One bear sighted at the carcass had been captured 12 days earlier, 112 miles (180 km) away. How far away a bear can smell a rotting carcass is not known, but even humans, with their feeble sense of smell, would be aware of the stench a long way off.

One of the most unusual whale eating episodes involved a 350-year-old bowhead whale that melted out of a glacier in Svalbard in 1996. When the carcass was first spotted, polar bears were scavenging the muscle and blubber remnants. Nobody has ever accused polar bears of being fussy eaters and a bit of freezer burn did not deter them. What was a bowhead whale doing in a glacier? Apparently the carcass had been incorporated into the glacier during an advance sometime around the end of the Little Ice Age.

Scavenging is common among polar bears. The town of Kaktovik along the north coast of Alaska has become the center for an increasing number of polar bears that aggregate nearby to feed on the leftovers from bowhead whales harvested by Inupiat hunters. Interestingly, grizzly bears are often drawn to the carcasses and despite their smaller size are able to run the polar bears off. Bears scavenging on these whale car-

casses grow obese on the available energy. I have caught some of these bears five months after they have left the carcasses; they are often still chubby with the fat they stored the previous autumn.

Lots of Other Things to Eat

Polar bears are opportunistic carnivores; they are more than willing to eat marine and terrestrial plants. Many other species are also dietary opportunists. Caribou will gobble up bird eggs and I have seen Arctic hare happily chew on a seal carcass left onshore by polar bear hunters.

Polar bears eat well over 80 different species including 32 mammals, 21 plants, 18 birds, 6 fish, and numerous invertebrates (Appendix B). Does this contradict the assertion that they are a highly evolved specialized predator? No. Ringed and bearded seals are the mainstay of a polar bear's diet. Most individual bears never eat more than a handful of species in a lifetime. It is unfortunate that some have distorted the importance of terrestrial prey for polar bears. Failing to properly assess the energy return of incidental foods or their reliability and abundance create a misleading viewpoint. From an energetics perspective, it is one thing to lie at a seal breathing hole and catch a chubby blubber-filled seal and another to wander around bug-infested tundra to graze on a few berries. Polar bears supplement their diet and some species may be high in nutrients and vitamins but not energy. For example, mountain sorrel, crowberry, and alpine blueberries are common Arctic plants high in vitamin C that polar bears eat. Inuit also eat these species. In such a challenging environment, vitamin supplements may be important but seals are also a good source of vitamin A, C, D, and E so it is hard to know for sure.

Another dietary oddity is Svalbard reindeer. Clearly, polar bears, at least in Svalbard, consider these wild reindeer prey. Polar bears sneak up on reindeer just as they do on seals. Because Svalbard reindeer evolved with no terrestrial predators, they are less wary than caribou (the same genus, *Rangifer*, and species, *tarandus*, as reindeer), which spend their lives running from gray wolves and grizzlies. The dietary importance of reindeer is minimal from a population perspective, but for an individual, a reindeer meal could be significant. Polar bears can kill musk ox but rarely do. Barren-ground grizzly bears are fairly effective musk ox predators but these two species overlap extensively. There is little overlap between polar bears and reindeer or musk ox so there are few predation opportunities.

Polar bears will eat almost anything. When on land, polar bear scat (feces) commonly contain wood, stones, and other items with little or no nutritional value. I have never been inspired to collect scats of polar bears feeding on seals. The liquid, tarlike mess that comes from digesting fat and meat is foul. There is not much fiber in such a diet. It is an occupational hazard that the person working on the back end of a bear has to be aware of intestinal rumblings to avoid a flood of processed seal. Such an event can render a previously amiable field assistant an unwelcome companion in the helicopter.

There are many reports of polar bears hunting seabirds by swimming

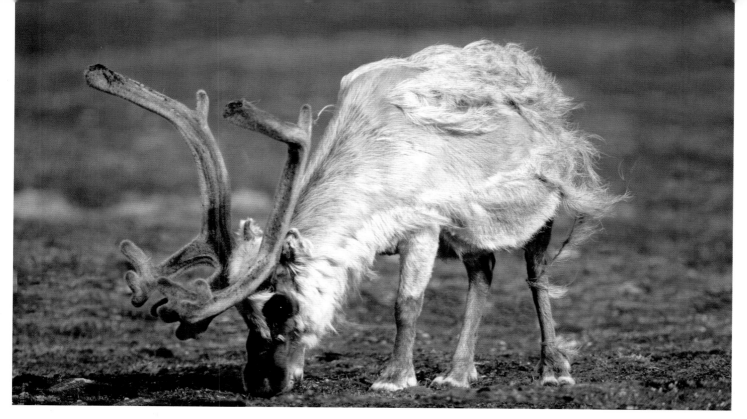

(Top) Svalbard reindeer are opportunistic prey for polar bears. The lack of wolves in Svalbard makes the reindeer less wary than caribou in North America.

(Left) The king eider may be the most colorful species eaten by polar bears. Eiders aggregate in large flocks in open leads and polynyas while migrating to breeding grounds. Some polar bears sneak through the leads, poking up through thin ice to grab a breath before slipping under the water to snatch an unsuspecting duck. Such prey do not return much energy, but every little bit helps.

under water and grabbing them from beneath. In the Beaufort Sea, the famed Inuk hunter David Nasogaluak once observed a young male polar bear causing a commotion among king eiders near Banks Island. When Nasogaluak shot the bear, he found the remains of three king eider ducks in its stomach. Eiders often gather in large flocks in open leads and on a cold day, thin ice can concentrate the ducks. Thin ice often reveals where a bear slipped into the lead, swam out to the flock, and caught a duck from below.

Speculation that polar bears may rely more on snow goose eggs in

Snow goose eggs, goslings, and molting birds make a welcome snack for polar bears. Opportunistic predators, polar bears will eat pretty much anything they can get their teeth into. Several species of geese provide variety in the diet.

Prey

the future was developed from the increasing overlap between the two species as the sea ice in Hudson Bay continues to melt earlier in the year. Unfortunately, extrapolating such events misses the point. The occasional bear will grab a few goose eggs and be happy for the prize. This, however, ignores the disturbing fact that if the sea ice continues to decline, there will not be any polar bears in Hudson Bay. In any case, consideration of energy gain relative to use is vital for such issues. One analysis calculated that a running 700-pound (320 kg) polar bear would have to catch a snow goose in 12 seconds to gain any energy from the event. That is not very long for chasing a goose. Geese are only available for the brief period that they are molting their flight feathers. Chasing geese does not add to the energy balance of a bear.

Under the right conditions, however, polar bears can be significant egg predators. In Svalbard, polar bears were the major predator of light-bellied brent geese. Approximately 60% of all eggs lost in the goose colony were due to the presence of polar bears because geese abandoned nests and left eggs vulnerable to the predatory seabird skuas (also known as jaegers). The bears are interesting catalysts in the ecosystem. That polar bears are active predators of geese and search for nests is not new. In 1898, early explorers reported that polar bears competed with egg collectors and that a "colossal scrambled egg" was found in the stomach of one bear they killed.

Bears do exploit such food sources but seals are the mainstay in their diets. If the sea ice breaks up a month earlier than normal, an adult female polar bear would need up to 2350 pounds (1065 kg) of alpine blueberries or about 1670 snow goose eggs to compensate for lost feeding on seals. Collectively, the 900 polar bears in the western Hudson Bay would have to consume up to 1.5 million eggs to compensate for the loss of

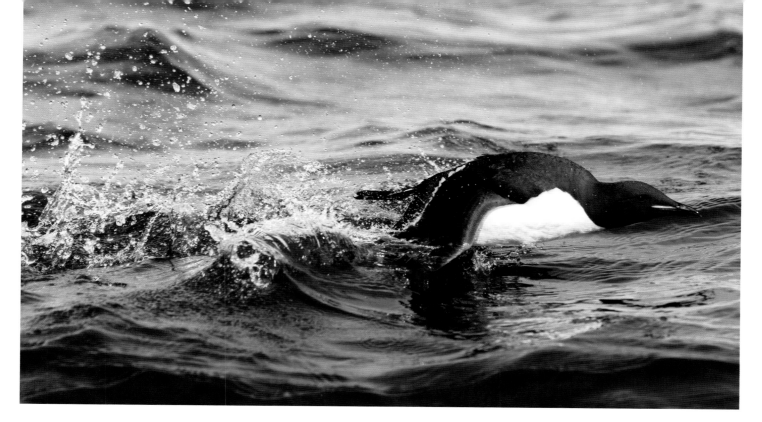

seals. Given that there are only 200,000 eggs in the western Hudson Bay snow goose colony, this is no solution for the bears.

Energy-efficient foraging is not always the rule for polar bears. In Franz Josef Land, Russia, polar bears overturn massive boulders to prey upon eggs, chicks, and adult little auks. A polar bear would have to eat 32 little auk chicks and adults and move several tons of rock to obtain the energetic equivalent of 18 pounds (8 kg) of seal. This kind of foraging usually occurs when seals are inaccessible but the energy return for the energy expended is minimal.

Polar bears commonly prey on thick-billed murres. Sometimes a bear will dive under a raft of murres, surface below a single bird, and capture it in its jaws with assistance from its forepaw. Recently, cliff-climbing polar bears were reported to be devastating local thick-billed murre colonies in northern Hudson Bay. Like all bears, polar bears are opportunistic feeders that are happy to snag an unsuspecting snack. Hopen Island off the coast of Svalbard has a massive colony of thick-billed murres and bears often walk along the landfast ice under the nesting cliffs munching on birds that have fallen to the ice. Murres, which cannot get airborne from the ice, make easy pickings for polar bears and Arctic fox alike. While an Arctic fox might make a decent living off such prey, the black and white murres are little more to a polar bear than a cookie is to a human.

I once saw (and then caught) a 992-pound (450-kg) adult male polar bear lying on a small ice floe below a seabird cliff eating a thick-billed murre. It seemed odd that a bear so big would bother with a meal so small but perhaps murres are novel additions to a diet of seal. Dietary diversity may add trace minerals and vitamins. I often wonder if the predatory instinct is so strong that given what appears to be prey, even a human, polar bears will try to catch it. Nonetheless, seeking such prey

Thick-billed murres are commonly eaten by polar bears, which catch them from below in open water and at cliff nesting sites. These chunky seabirds often fall to the ice below nesting cliffs when they squabble over nest sites and mates. Because the murres cannot take off from the sea ice they become easy prey for a passing polar bear.

varies with the individual and the circumstances. I have also seen adult male polar bears pay no attention to murres lying on the sea ice. Such behavior may signify a full stomach or perhaps a male intent on tracking down a female to mate with. In feeding trials of grizzlies, a mixed diet improved mass gain over a simpler diet. Therefore, the various dietary items polar bears eat may be important in ways we do not understand. As the climate warms, we will see new relationships between polar bears and prey. The timing of biological events (phenology) will rearrange the ecological relationships that have existed for thousands of years. But the polar bear is a seal and sea ice specialist, so the big question is how long can it survive.

Ecological relationships have already changed significantly for some polar bears. For example, in July 1534, the French explorer Jacques Cartier reported seeing polar bears swimming to the tiny and barren Funk Island offshore from Newfoundland. Funk Island at that time was a rookery for the flightless great auks; the closest we came to having a Northern Hemisphere penguin. At 33 inches (85 cm) tall and 11 pounds (5 kg), a few auks would have provided a reasonable meal for a hungry polar bear. Sadly, human hunting drove the great auk to extinction in the mid–1800s.

In July 1497, the Italian-born explorer John Cabot encountered polar bears catching fish in Newfoundland. This is not terribly surprising; grizzlies do extremely well feeding on Pacific salmon. Captain George Cartwright recorded the last observations of polar bears feeding on Atlantic salmon around 1770. The trader-explorer-hunter Captain Cartwright reported large numbers of white bears scooping salmon out of Eagle River and the aptly named White Bear River in Labrador. People were on the coast of Labrador to exploit the riches of the New World and these salmon-fishing bears were soon hunted out.

Polar bears also eat Arctic char and fourhorn sculpins, but such species are not important energy sources for the ice bear. A study on the Union River in Nunavut reported 1 of 8 bears in the area fishing. This bear was seen "snorkeling" and diving for fish. Making too much of such observations, as some have, ignores the energy expended relative to the energy gained. Energetic returns from the summer diet of polar bears do not come close to the return from seals. Such foods will not offset the energy deficit caused by loss of sea ice from global warming.

Vegetation in the Diet

In the grand scheme of Arctic bears, grizzlies are the vegetarians that eat meat and polar bears are the carnivores that eat plants. Some polar bears have been known to graze like a white tundra cow with claws. In Hudson Bay, polar bears overlap with several berry-producing plants during summer. True to its evolutionary roots, a polar bear may tank up on berries. I first noticed the berry feeding in the 1980s working in western Hudson Bay: it was hard to miss. Teeth were berry stained, the fur about their butts was bright purple, and the propensity to defecate massive quantities of "polar bear berry jam" was noticeable. Berry feeding was found in 34% of the females and 26% of the males inland from the coast. Seeds

Crowberries and alpine blueberries are abundant in parts of polar bear range and some bears eagerly devour large quantities, but the energy return is minimal and the berries exit looking much like they went in.

in the scat revealed alpine blueberries and crowberries. One of the problems for berry feeding in the Arctic is the huge variation in production. Reflecting this, berry feeding was seen in only 2% of the bears in some years. Polar bears cannot rely on berries to survive the ice-free period. For those bears that forage on berries, however, the intake may slow weight loss, but only in years when berries are abundant. It is neither practical nor comfortable given the masses of biting insects, to watch polar bears on the tundra to determine whether they are feeding on berries, so scientists have looked for alternate indicators. Stable isotopes offer one option, and such studies indicate that berries add little, if anything, to a polar bear's energy balance. Studies on grizzlies in captivity show that there are severe limitations on what they can do on vegetation alone.

Seaweed is often consumed, either fresh or fermented. Polar bears commonly dig through seaweed piled along shore and chow down. In Svalbard, one bear shot by a hunter had 19 pounds (8.5 kg) of seaweed in its stomach. In another instance, a female and her 2-year-old cub were observed for more than half an hour. They dove 10 to 13 feet (3–4 m) to get seaweed and then ate it while sitting on the ice. Moss and grass are also regularly eaten by polar bears. And my dog eats grass but neither dogs nor polar bears would do well on a strictly vegetarian diet.

Unfortunately, available terrestrial foods are not very nutritious. If such foods were a meaningful source of energy then all polar bears should make use of them. Most polar bears stranded on land opt to conserve energy rather than wasting it seeking trivial returns. The fact that the bears lose weight while stranded on land is evidence that they do not gain much energy. Furthermore, much of the Arctic tundra is barren even at the height of summer. A stroll across the High Arctic in July makes one wonder how the herbivores make a living, let alone a hungry polar bear.

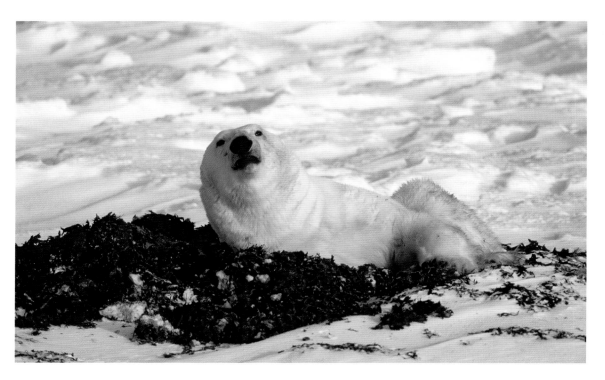

Seaweed, whether fresh or decaying, is a common dietary item for polar bears. Vitamins and minerals are the major benefit because the energy in seaweed is minimal.

When all the information is put into the energy balance, polar bears make their living off the blubber of seals. Polar bears adapted to exploit the huge energy resource of millions of seals. Proposing that the bears will turn back the evolutionary clock in the face of global warming is at best wishful thinking and at worst a willful disregard for how polar bears make a living. Predicting the future for polar bears under a warming climate is difficult enough and wild prognostications do not help conservation biologists plot reasonable courses of action. Polar bears may eat berries, seaweed, and goose eggs when they have no access to seals. Such food items can never replace seals on the menu.

Analyzing Dietary Intake

Diet is a critical component of a species' ecology, but for polar bears, it is notoriously difficult to quantify. Knowing what they eat is one thing; determining how much they eat of any given species is another. From a numbers perspective, your average polar bear makes a living on ringed seals. However, if you convert the number of seals a polar bear eats into seal blubber, bearded seals creep up in the diet because they are so large.

So, how do we know what a bear eats? Several methods provide different insights. Analyzing scat is one option. But scat is hard to find at the best of times and is inaccessible for much of the year. When bears were hunted in large numbers, stomach contents were examined. During summer in Franz Josef Land stomach contents were 44% empty, 38% ringed seal, 12% walrus, 3% bearded seal, 2% seaweed, and 1% bird material. Stomach contents, however, only reveal the most recent meal and nobody today would shoot a bear to determine its diet. And since we cannot determine a bear's diet in the middle of the polar night, such information is unrepresentative of the overall diet.

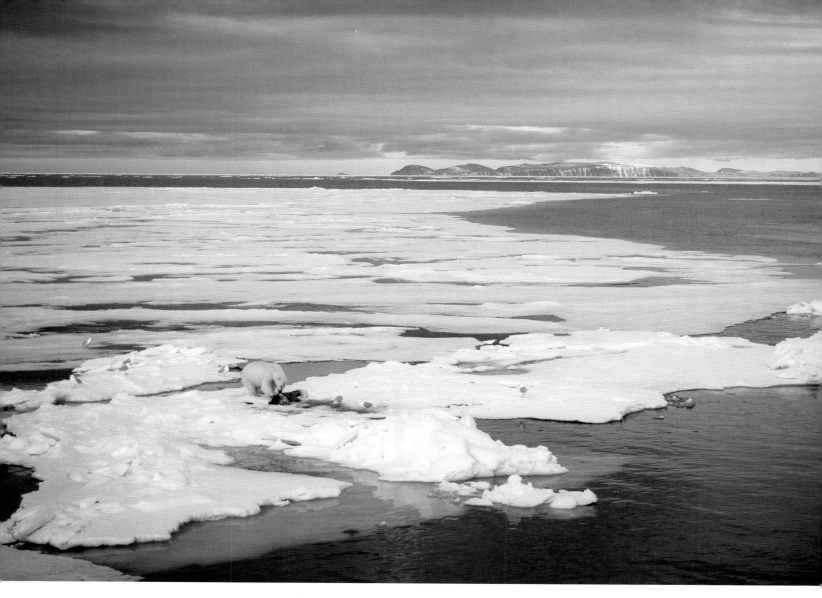

We can use indirect methods such as chemical markers in the bears and their prey. The most insightful method is called quantitative fatty acid signature analysis. Animal fats are usually triglycerides composed of a glycerol backbone and three attached fatty acids. These fatty acids vary greatly in their chemical bonds and how long their carbon chain is. The claim that "you are what you eat" works particularly well when it comes to consuming fat. When an animal digests fats, the fatty acids are released and incorporated into fat stores largely unaltered.

More than 70 different fatty acids in varying quantities occur in polar bear fat. The fatty acids in marine ecosystems are extremely diverse. Every item a seal, walrus, or whale eats has its own signature; thus every species a polar bear eats has its own characteristic fatty acid fingerprint. We use a statistical model to derive the best solution for the fatty acid composition of the bear based on the possible prey. It gets complicated because polar bears can synthesize their own fatty acids and some ingested fatty acids are preferentially used for energy and thus, not stored. Nonetheless, we get an estimate of the diet from each potential prey species.

Such analyses, of course, require a polar bear fat sample, which is

Polar bears are specialized predators of seals and their blubber is essential for the bears' survival. Species such as glaucous gulls are happy to feast on leftovers.

easily obtained. Once we have sedated a bear, we shave a small patch of fur over the bear's largest fat store, its rump, and using a small circular biopsy punch we core into the fat and take a thin sample from the bear. Although the procedure is slightly invasive, the cut heals quickly.

The best information on diet comes from a fatty acid study that used samples from 1738 polar bears. Ringed seals were the dominant prey at up to 75%, but there was regional variation in diet. Logically, areas with more potential prey species had higher diversity. Bearded seals contributed up to 20% of the diet; harp seals, up to 50%; hooded seals, up to 8%. Large adult males have a more varied diet; they ate more bearded seal and walrus. The luxury of being big is that you can eat either small prey or big prey. A large bearded seal is a challenge for subadults or even adult females to handle. Ringed seals and harbor seals were eaten more often by younger bears. Belugas, narwhal, harbor seals, and walrus varied between areas but generally contributed less that 10% of the diet. It is important to note that these are population averages. An individual bear in any given year could rely on a single species for all of its energy.

Knowing the species a polar bear eats is only part of the equation. The next issue is understanding the age and sex of the prey. The only way to get at this question is from kill samples. We know that ringed seal and bearded seal pups and juveniles (up to 5 years old) are the most frequently killed age groups. For ringed seals, over half the kills are pups. Presumably, older animals learn to avoid polar bears. The vulnerability of adult female ringed seals increases when they have pups; nursing is risky because they have to enter the lair. Both sexes of ringed seals, however, appear equally in the diet of polar bears over the spring. Social interactions within seal populations are also important. Weaned pups and juveniles may be forced by adults into less desirable habitats where they are more vulnerable to predation. The notion that predators kill the old and the sick may apply to other animals, but so far, we have no evidence that it applies to polar bears. Polar bears most often kill the young and tender.

How many seals a polar bear eats in a year is still a question. Information on kill rates is limited in both time and space. The only area where predatory behavior has been studied is at Devon Island in the Canadian High Arctic. The observations were made when the sea ice was most consolidated, from early April to late July, meaning we have no information on the predatory behavior of polar bears for 70% of the year. Because of 24-hour darkness and the remoteness of polar bear habitats, we may never get the information for the rest of the year or from other sites. Overall, we have little concrete information, but energetic models can assist us in making scientific estimates.

During the peak hunting season, polar bears kill a ringed seal every 2 to 16 days and one seal every 5 days on average. This March–June hunting period is often referred to as the hyperphagic period. Bears take in most of their energy during the spring pupping season. The average polar bear kills at least 43 ringed seals each year, with most kills made in the hyperphagic period. Energetic calculations suggest that a polar bear population of 1800 (several are near this size) would require from 77,400

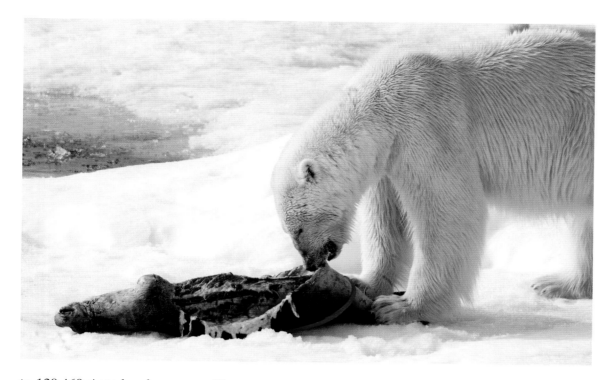

to 128,469 ringed seals per year. There are many caveats for these numbers but clearly, polar bears eat a lot of ringed seals. If there are 25,000 polar bears worldwide, they might eat more than a million ringed seals a year. Such estimates have to be tempered by the availability of other prey, and even a few adult bearded seals or whales dramatically alter the numbers. Further, an adult ringed seal weighs 12 times that of a newborn pup but contains 24 times as much energy. An adult ringed seal that contains over 150,000 kcal (628 MJ) would provide enough energy for a 500-pound (229-kg) polar bear for slightly more than 6 days. A ringed seal pup is no more than a snack for a big bear. An average beluga whale, weighing about 1300 pounds (600 kg), could provide enough energy for a bear to go half a year.

Eating the fat of seals makes energetic sense for a polar bear. A polar bear's stomach can hold up to 20% of its mass. Thus, a 1000-pound (450-kg) polar bear can eat 200 pounds (90 kg) of seal blubber. One study of polar bear feeding found they could eat up to 10% of their body weight within 30 minutes. Russians harvested bears with 22 to 150 pounds (10–71 kg) of food in their stomachs. In another observation, a female with her two yearlings consumed over 176 pounds (80 kg) of seal blubber in less than 12 hours.

Competition for kills is one reason to favor the fat of a seal. Unless you are a large dominant male, another bear may steal your seal. Therefore, it makes evolutionary sense to gobble down the most energetically advantageous parts. Fat contains over twice the energy of protein. Polar bears often leave the skin, viscera, and muscle behind. Utilization of ringed seals killed by polar bears was estimated at between 61% and 91%, whereas 32% to 89% of bearded seals were eaten. Polar bears are similar to other carnivores in assimilating dietary energy, with digestibility of 98% for fat, meaning that virtually all of the blubber going

A polar bear can eat up to 20% of its body weight in a single meal. Bearded seals, like this pup, have thick skin that is peeled back so the blubber layer can be eaten first. Young bears need more protein in their diet and will often eat most of a kill.

This young ringed seal pup did not live long enough to acquire a thick layer of blubber. Skilled hunters often abandon small prey to look for a fat seal that has more energy.

into a bear will end up being stored on the bear. Assimilation of protein at 83% is somewhat lower than other carnivores but still indicates that much of what goes into a bear stays with the bear. But just as humans crave fluids after a protein rich meal, a polar bear needs water to excrete nitrogen after eating meat. Polar bears regularly eat snow but it is energetically expensive; especially on cold days. Eating cold snow that has to be warmed to body temperature consumes a lot of energy. Fat, however, releases metabolic water when burned so blubber-eating bears do not get as thirsty.

When feeding on newborn seal pups, polar bears often do little more than a taste-test to check the fat content, abandoning skinny pups uneaten. Such selective behavior is correlated to the size of the bear. Skinny bears are more likely to eat skinny pups; a fat bear can afford to be more selective. Because hunting skill increases with age, older bears are usually the ones that abandon meager prey.

Polar bears are programmed to eat and even a fat bear will continue to hunt and gorge on more blubber; it seems that a polar bear can never be too fat. In essence, polar bears are consummate processors and hoarders of seal blubber. This is what makes a polar bear tick: if there is lots of blubber to eat, eat lots; if there is little blubber, eat protein; if there is nothing to eat, use the fat you have stored.

8

DISTRIBUTION AND POPULATIONS

Polar bears are a circumpolar species of the Northern Hemisphere with their distribution constrained by the southern extent of the maximum ice cover of the polar seas. They range over a span of latitudes from 90°N at the North Pole to 53°N in James Bay, Canada: 2555 miles (4112 km). Polar bears were once in the Gulf of Saint Lawrence (50°N) but no longer. Polar bears are common on the coast of Labrador and regularly drift onto Newfoundland where they soon cause trouble.

Some out-of-range locations of polar bears are of interest. In September 1999 a subadult male polar bear was spotted in Saskatchewan, Canada, about 280 miles (450 km) inland from Hudson Bay. In March 2008 a skinny bear was shot 200 miles (320 km) south of the Beaufort Sea; a month later, a starving mother and her two yearlings were shot a similar distance inland farther to the east. Being so far from the sea ice is not adaptive. The bears simply start wandering in an attempt to find food. The Icelandic Annals recorded that polar bears have a long history of coming ashore in Iceland; 22 bears were slain in 1274 and 27 the following year. Landings on Iceland are linked to the southern extent of sea ice, which has been reduced during recent years. Polar bears still land on Iceland where they are quickly dispatched. Polar bears have been seen on the Norwegian mainland but these may have been escapees from the zoo trade. Nonetheless, a big storm can blow polar bears close to the European mainland. There is some concern that out-of-range sightings are increasing as the climate warms because more bears are losing contact with the sea ice.

Home Ranges

A home range is the area that an animal normally lives in, usually over a year, which provides all the necessary resources for life. For a polar bear, these resources include food, den habitat, mates, and refuge habitats.

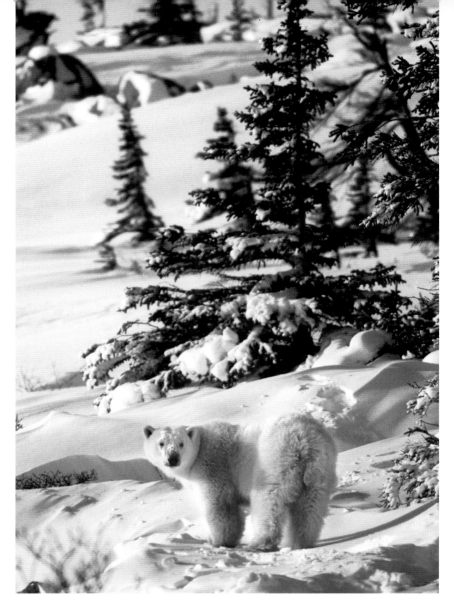

**Distribution and
Populations**

Hudson Bay polar bears regularly move far inland,
to the boreal forest, in the summer and autumn.
Pregnant females overwinter there to rear cubs.
Females that lose their cubs often wander back to
the coast in late winter.

Unlike a territory, home ranges are not defended, so individual polar bear home ranges overlap completely with other bears.

Early thoughts had polar bears part of one big circumpolar population wandering freely across frozen seas as Arctic nomads: a romantic construction but absolutely wrong. Satellite telemetry has provided significant information about the movements of polar bears and the realization that each bear has a defined home range. If ice conditions permit, a bear will use the same area year after year. Female polar bear home ranges vary from tiny areas of about 77 square miles (200 sq km) packed into a single fjord to massive expanses of 371,000 square miles (960,000 sq km), which is about half the size of Alaska. A variety of factors affect how large an area a bear uses in a year. Mothers with older young have larger home ranges than less-mobile mothers with small cubs. Differences in home range sizes between populations are also affected by sea ice dynamics. Home range sizes are larger in active drift ice and smaller in areas dominated by landfast ice. Baffin Bay, the Barents Sea, Bering Sea, Chukchi Sea, and Beaufort Sea all undergo wide variation in the annual distribution of sea ice. Thus most bears living in these areas have large home ranges with long migrations. For example, between Alaska and

Polar Bears in Antarctica?

Polar bears and penguins live on opposite ends of the planet but a plethora of cartoons, doctored photos, and advertisements showing them together make people ask: why are there no polar bears in Antarctica? The answer: they never got there.

Polar bears evolved in the north and species usually need habitats linked together to move from one place to another. Even during the coldest periods since polar bears evolved it has not been cold enough to have sea ice connecting the northern and southern hemispheres. Sometimes, species move through "sweepstakes dispersal routes," which can be illustrated by two mice (male and female) or a pregnant mouse being swept out to sea on a raft of vegetation. If they land on an island with appropriate habitat, a new population might be established. For polar bears the "raft" would have to be made of ice and the mid-latitudes have always been too warm for

such a raft to persist. Could polar bears thrive in Antarctica? Yes, without a doubt. The diversity and large populations of Antarctic seals would easily accommodate polar bears. Polar bears would happily snack on penguins (rather than take a free soda as in some advertisements). Back in the mid-1900s there were stories that polar bears should be moved to Antarctica to provide sport hunting for overwintering crews in stations. It is a good thing it did not happen because polar bears would have wrought havoc on the ecosystem. Thankfully, the Convention on the Conservation of Antarctic Marine Living Resources now prevents such disruptive introductions.

Russia, polar bears range south to Saint Matthew Island (60° 25' N) in the Bering Sea and migrate northward over 1000 miles (1600 km) to summer on multiyear ice in the Chukchi Sea. Some central Canadian Arctic and Svalbard polar bears do not follow the receding ice, instead they retreat into ice-covered bays and fjords during summer and thus have much smaller home ranges.

Unfortunately, little is known about the home range sizes of males because their necks are wider than their heads so they cannot wear satellite collars. Short-term tracking of males suggests that home ranges sizes are similar to adult females. Recent tracking of juvenile bears suggests they too are similar to adult females. Typically, carnivores have larger home range sizes than herbivores. Consistent with this, grizzlies eat far more vegetation than their ice-loving cousins and the largest polar bear home ranges are up to 450 times larger than the home ranges for grizzlies. Polar bears have access to much higher energy food and can fuel large migrations.

Home range size often relates to resource availability. The more abundant the resources, the smaller the home range. However, a small home range may result from low food availability but predictable re-

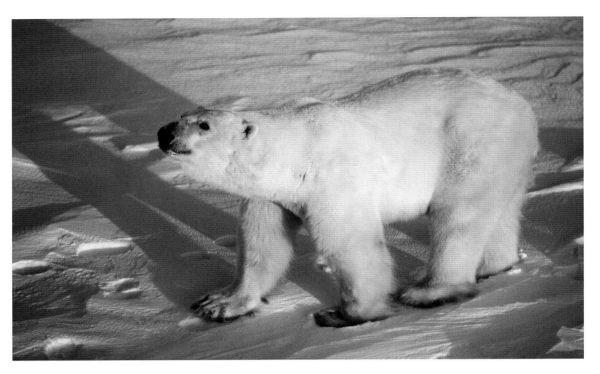

Because an adult male's neck is larger than its head, it cannot be fitted with a satellite collar. Information on home range sizes comes mainly from adult females and can vary over 2000-fold in the same population. Some bears live in a single fjord while others wander areas larger than Texas.

sources, whereas a large home range can result from greater food availability but lower predictability. There is a balance between energy used and energy gained and the strategy of having a large or small home range seem equivalent measured by females' ability to produce cubs. Though both big and small ranges can work, moving over huge areas means you have to take in more calories. In essence, small home range bears are "energy conservers" while huge home range bears are "energy intake maximizers."

Movement Patterns

Time of year has a profound influence on movement rates and direction but age, sex, reproductive status, population density, prey availability and distribution, weather, sea ice conditions, and land barriers are also important factors. Polar bears show marked variation in movement rates. They can move 2.5 miles per hour (4 km/hour) but they average half this or less. Polar bears regularly move 9 to 11 miles per day (14–18 km/day). Mothers with young cubs move less; lone females and mate-seeking males move much more. Keep in mind though we are only sampling the movements every 4 hours. Because bears walk in tortuously convoluted paths, we are underestimating the distances they travel.

An interesting aspect of polar bear ecology is that their habitat itself is moving, which makes it difficult to separate ice-drift from active movement. Sea ice can easily drift more than 37 miles per day (60 km/day). In some populations, such as the Barents and Chukchi seas, the bears are counteracting the drift of sea ice; thus they are effectively living on a treadmill. This is a concern because climate warming is reducing ice cover and thickness making it more prone to drift on winds and currents. Such changes increase how much energy the bears use to stay in preferred areas.

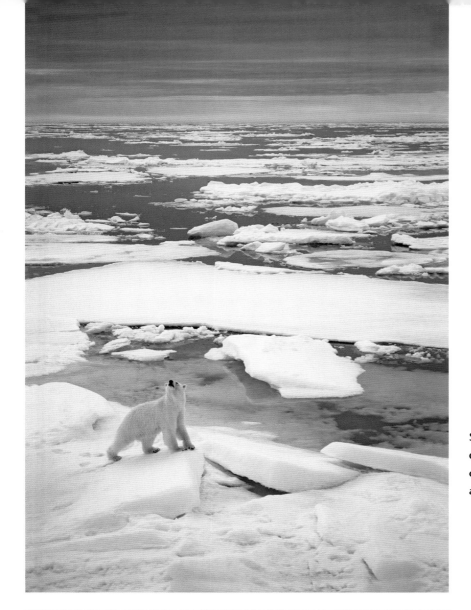

Sea ice is a dynamic habitat and can drift great distances in a single day, pushed by wind and ocean currents. Polar bears on active drift ice are living on a treadmill.

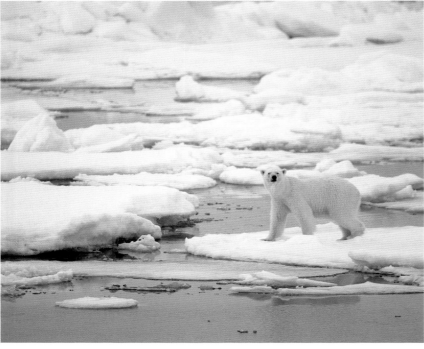

Activity levels peak in late spring and early summer when seals are most available. Polar bears can travel long distances in a single year. The average distance for a female polar bear in a single year is 3400 miles (5472 km). But actual distances vary for individual bears. One female radio-tagged off the coast of Alaska moved north to within 2° of the North Pole and continued onto northern Greenland and Kane Basin in a 4450 mile (7162 km) trip over 576 days. This female moved 3 to 56 miles per day (5 to 90 km/day). Such a trip shows the potential for gene flow, but such long movements occur in less than 1% of tracked bears. The collar failed while she was in Greenland so we do not know which end was "home" or if both were!

Navigation Techniques

Different species use different methods to navigate. Animals with a home range have the ability to orient themselves and assess their location in time and space, otherwise they would wander aimlessly. Any species with a home range must be able to determine its location relative to where it wants to go. In species with stable environments, navigation is simpler. In dynamic or seasonal environments, as well as in migratory species, highly developed navigational abilities are essential. Orientation involves several mechanisms, and polar bears, similar to other species, make use of many different cues.

Consideration of polar bear evolution yields clues into how they navigate. The ancestral grizzlies roamed over areas a fraction of what a polar bear covers now. Terrestrial environments are stable and resources are predictable: the berry patch a grizzly used last year will still be there the next and landmarks are stationary. In contrast, the sea ice is extremely dynamic. If the ancestral polar bears were largely land based and added marine mammals into their diet, their early movements were likely near-shore. Gradually, individuals that moved farther offshore for more food might have had greater reproductive success. Even from the start, only individuals that maintained contact with land or the sea ice survived, so the selective pressure on navigation ability was intense. Drifting too far south and losing contact with the pack ice in the open ocean could be fatal. Heading too far north would leave a bear in the barren Arctic Ocean. Individuals with such poor navigational skills do not pass genes onto the next generation.

Intense selection may explain why polar bears show highly repeated movements. For a bear to wander huge distances is the norm. But most bears returns to the same area year after year. A bear can wander from Canada to Russia and be right back where they were the year before. Their ability to find home is impressive. It is this tenacity to a specific area that creates population structure.

Catching a tiny cub ambling about with its mother and finding it years later as an adult with cubs of its own at almost the same location is inspiring. The navigational processes used to live in a vast changing environment are a critical component of polar bear life history. When I started studying bears, we did not have GPS units linked to satellites to tell us where we were. Instead, we used dead reckoning, a combination

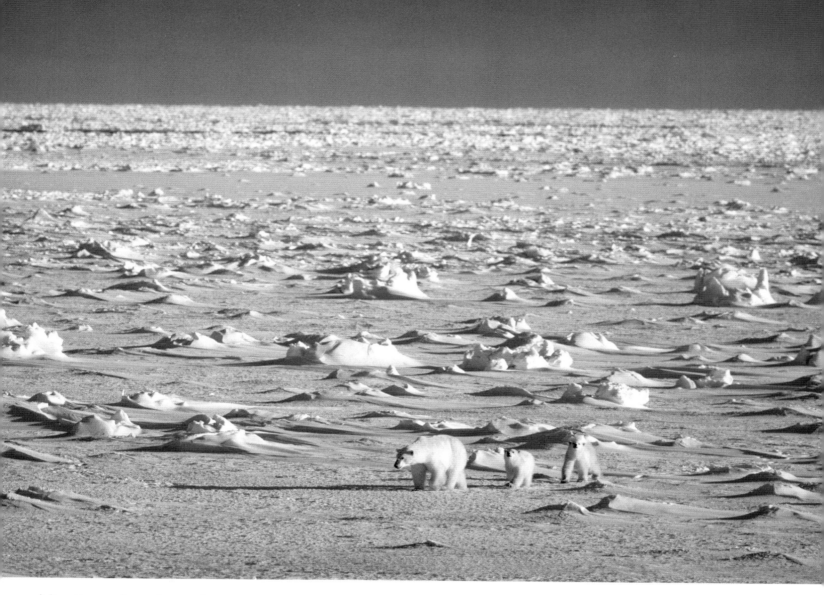

of direction and speed, to estimate our current position. The gyroscopic compass in the helicopter would drift while tracking a bear but we could reset it using our longitude and the sun. Possibly the bears do something similar. Being in the right place at the right time is crucial for survival.

Sometimes, the right place turns out to be the wrong one. I once caught a mother and her two yearlings in Svalbard and transported them 90 miles (146 km) by helicopter because they had broken into several cabins, including what was supposedly a bear-proof shed. The trapper had stored his snow machine oil in the shed with eider down he had collected. The down, which was to be sold for making duvets, was worth the equivalent of about 5 pounds (2.3 kg) of gold at the time. Polar bears have a fondness for biting squishy things like oil jugs, snow machine seats, and seals. When the bears punctured the containers of oil it soaked into the down. Within weeks, the family had returned despite a long walk and a long swim. The mother knew where she wanted to be. Fortunately for the bears, the ice came back and seals became more interesting than eider down.

Navigational methods fall into three categories: *piloting,* the use of fixed points to navigate; *compass orientation,* movement in a given direc-

This female is being followed by her yearlings. Polar bears retrace the same route year after year, adjusting for ice conditions that affect hunting opportunities. Once thought to be Arctic nomads, polar bears are in fact stay-at-home bears—it is just that their home is incredibly large and it moves.

To Catch a Polar Bear

While not all polar bear research requires capturing the animal, numerous aspects of an animal's life—growth, reproduction, survival, pollution levels—cannot be understood without examining and marking the bear. And, obviously, scientists must capture a bear before they can attach a tracking device.

Once a bear is located, a safe place to handle the bear must be found. The primary concern is the safety of the bear and field crew. Open water, cliffs, thin ice, other bears, and suitable landing spots all need assessing. Every bear is different and a bear's personality factors into the capture. A quick approach with the helicopter indicates if the bear can be safely controlled. The size and condition of the animal has to be assessed. The objective when drugging the bear is to have it lying quietly, but not so heavily drugged that it will sleep for too long.

Once the correct dose has been determined, the drug is loaded into a dart, which is put into the projectile gun. Safe capture requires careful dart placement; the rump and shoulder are the preferred spots. It is very rare to lose a bear during capture. A polar bear is safer being drugged in the wild than a human drugged in a hospital.

The helicopter brings the biologist in low over the bear. Though most shots are from a distance of less than 15 feet (5 m), the bears are a moving target being shot at from a moving platform. Once the bear has been darted, the helicopter backs off to let the bear relax but circles high above to keep the bear within a certain area. The back legs begin wobbling first; within 7 minutes the animal is usually asleep on the ice or snow. If there are small cubs (a few months old) we approach slowly and slip a rope over their heads to make sure they do not run off. We inject them by hand syringe. Cubs usually stay close to their mother but if they run, it is polar bear round-up time. Older cubs are injected using a syringe on a pole or darted from the air because they can be dangerous. If we find a mating pair, we capture the female first because males will stay nearby and we can herd them close to their mate once she is asleep.

With the old drugs, even a sneeze could wake up a bear: sneezing sounds like a polar bear warning call. With the drugs we use now, when a bear is asleep, it is safe to begin our routine. Each bear receives a unique number and an associated letter that identifies the country of capture. White plastic tags with the identification are placed in each ear and tattoo pliers place it on the inside upper lip. Measurements are collected on body length, chest girth, head length and width, and for some bears, weight. Weighing requires a heavy tripod to suspend the bear so weight is often estimated from length and chest girth measurements. Samples of skin, fat, blood, milk, claw, and hair are collected. A tiny premolar tooth is also taken to age the bear. GPS satellite-linked collars that provide locations are deployed on some bears.

All the while, breathing, heart rate, and temperature are monitored. Just before we leave, we apply a black dot on the bear with an animal marking crayon so we do not catch it again. The mark also warns hunters that the bear has been drugged and should not be eaten for 45 days.

When we are working with a bear, we do not want others to come too close. Should it happen, we are well armed. I have never had to shoot a bear. But when I jump from a helicopter to grab a wayward cub, I have some firepower should I need it.

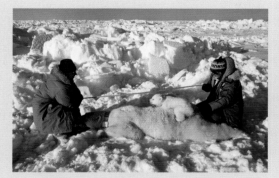

An immobilized mother is measured while her 4-month-old cub looks on. Body measurements are a foundation of understanding the status of polar bear populations. Lower body weights are indicative of tough times.

tion without reference points; and *true navigation,* moving to a specific goal without direct sensory contact with it. We do not know how polar bears navigate but they may use all three methods varying in importance geographically and seasonally.

Bears living near land in the Canadian Arctic Archipelago have many reference points, such as mountains and cliffs, to assist them in piloting. Bears in the middle of the Chukchi Sea may use compass orientation. Though the bears have no fixed references, land-based smells may be of assistance even when a bear cannot see land. I have seen many polar bears on land scavenging reindeer in Svalbard during the spring. These bears were on the ice when they smelled a free meal and followed the scents to shore. How other land-based smells like soil and vegetation play a role is difficult to determine.

Wind and current move polar bears, but if they allowed themselves to be planktonic (drifting) they would travel long distances, have no home range, sometimes drift into the Atlantic Ocean or the Pacific Ocean, and be nomadic. Instead, bears have a well-developed sense of place. The sun, stars, planets, and moon are navigation aids, but their use would vary throughout the year given the 24-hour polar days and nights. Some animals use the earth's geomagnetic field for orientation and this cannot be ruled out for polar bears. But magnetic compasses are almost useless at high latitudes. Some polar bears living in the Canadian Arctic have home ranges that include the north magnetic pole so movement toward it could be any direction. Nonetheless, some birds use magnetic inclination or magnetic dip to assist navigation and the bears could be using such means to navigate.

Navigational ability is essential in all areas but the navigational rules change between populations. In the Barents Sea, for example, bears retreat northward to stay with the ice as it melts; in western Hudson Bay, bears move south and west to land. Learning must play a role in navigation.

The bears also must sense changes in ice conditions, likely cued by wind, and they orient to stay with the ice. For example, if extremely strong winds cause a bear to drift far from the ice, the bear could travel into wind, move toward land, or move north. Repeating movements on a seasonal basis imply a map of annual events and the associated movements that must follow. A yearly cycle of behavior (circannual rhythms) would control timing. The prolonged mother-offspring bond would allow learning of appropriate directional cues.

Another example of navigation is females with cubs moving out of the Churchill den area; they maintain a northeast heading that takes them out to the coast. How and why these females follow this route is unknown. It is often shorter to head straight north or east. Geographic features such as creeks may assist orientation or perhaps they are retracing the route they took eight months earlier heading inland to den. It is possible that the northeast heading takes the bears to good hunting habitat on the ice. There is no question that mothers are driven to find food.

The simplest navigation rule for polar bears is to rely on what your

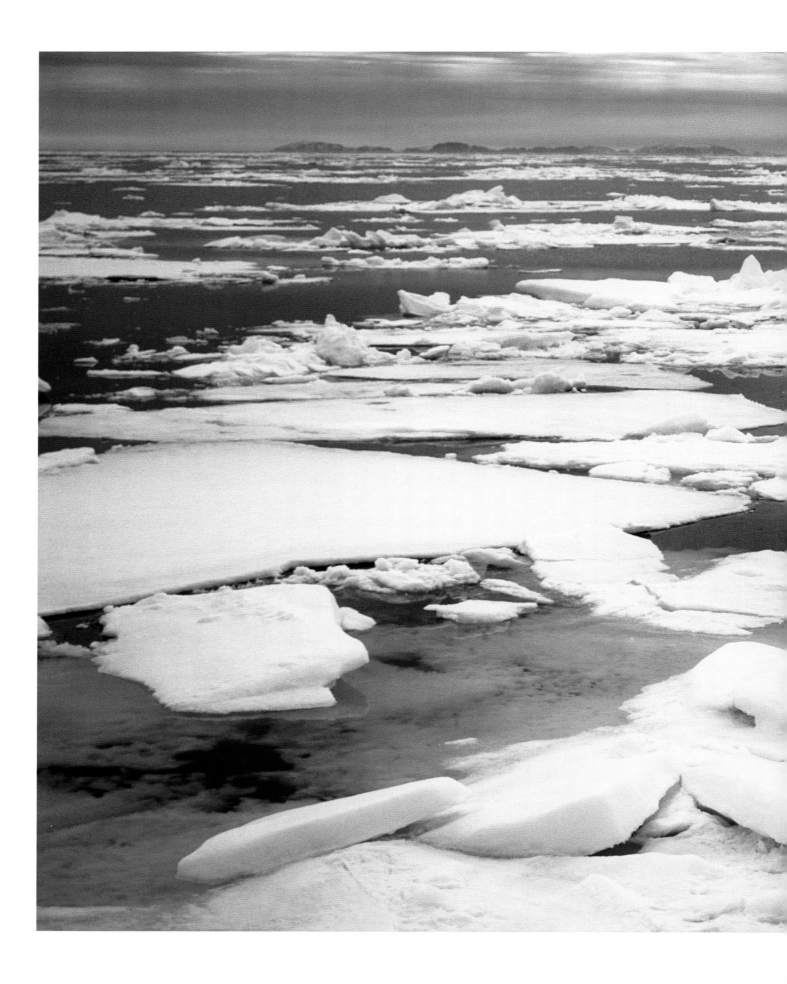

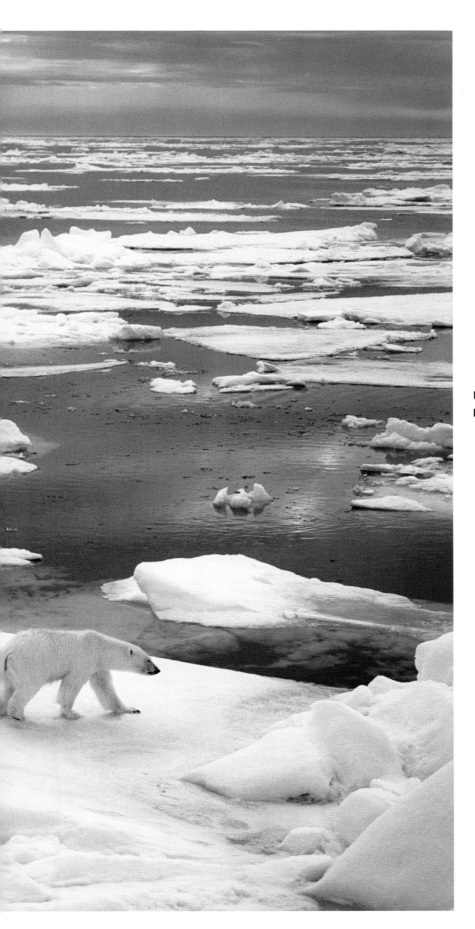

Polar bears show amazing fidelity to specific areas, but how they navigate is still a mystery to scientists.

mother taught you: use landmarks when they exist, and at all costs, stay in contact with the ice unless there is no ice, then head for land. Scientists have much to learn about the navigation abilities of polar bears, and the research will not be easy.

Dispersal

Polar bears are stay-at-home animals, but their home is quite large. Dispersal is the movement of an individual from its place or group of origin to a new place or group. From a population perspective dispersal can be viewed as emigration. All species disperse given enough time. If they did not we would only have species exactly where they evolved. The circumpolar distribution of polar bears shows that they dispersed and colonized a large area on an evolutionary timescale. The huge southern shift in the distribution of polar bears during prehistoric cooling periods suggests that they are sensitive and responsive to shifting ice conditions.

Dispersal is common among juvenile mammals, with males leaving most often. Dispersal away from the birth area (natal dispersal) has received little attention in polar bears because it so rarely occurs. In American black and grizzly bears, dispersal is a topic of considerable interest because it is an important population regulation mechanism. With both species, the mother often donates a portion of her home range to her daughters but runs off her sons.

Dispersal is harder to document than fidelity. It is easy to show that an individual returns to the same site year after year. It is much more difficult to show that an individual has left, settled elsewhere, and is not coming back. Information from mark and recapture studies indicates that less than 1% of a cohort permanently leaves to settle in another population. Those that leave usually move to the population next door. However, a bear moving from one population to another may simply be exploring. Furthermore, you cannot adequately document dispersal from a hunter turning in a tag from a bear: dead bears cannot make a return trip home. Nonetheless, we know that bears periodically move outside their normal range. In the Beaufort Sea during the 1970s, heavy multiyear sea ice resulted in a mass movement of bears out of the area. As ice conditions improved, the bears returned. Satellite telemetry did not exist back then but the bears probably moved westward into the Chukchi Sea.

Dispersal theory is tied to the balance between the costs and benefits of staying home (philopatry) versus dispersing. If individuals that disperse produce more offspring than those that do not, then dispersal becomes more common. Of course, if almost everybody disperses, the benefits of philopatry increase. As in most things, there is a balance and this balance varies over time.

Risks involved with philopatry include the perils of mating with relatives (inbreeding depression), reduced access to resources due to crowding or subordination, and competition with close kin. All of these costs pertain to the genes an individual can pass on. On the plus side, philopatric individuals may benefit through co-adapted gene complexes

Polar Bear Research in Action

Patience is the main virtue of a dedicated polar bear researcher. Nothing in polar bear research comes easily and being able to wait out snowstorms, high winds, thin ice, lost equipment, and helicopter repairs is all part of the job. If patience tops the list of desirable qualities for a polar bear researcher, then good planning skills are next. All the pieces must be in place; a good research question is only the beginning. Without the permits, consultations, logistics, and funding in place, nothing happens. For example, the lifeblood of most polar bear research is jet fuel needed by helicopters stored in strategically placed caches. I cringe at the thought of my research-related carbon footprint, but the information we collect is vital to the conservation and wise management of the species and their ecosystem.

A polar bear researcher's day starts with a weather check. We turn on our computers, search out the aviation weather, scan the latest satellite images, and make our plans. Or pour another cup of coffee and wait. In remote camps, we check the wind gauge, barometer, and the clouds: it works most of the time. We can only work on sunny days without too much wind. Flying low to the ground on cloudy days with no contrast between the sea ice and clouds is a good way to crash. Snow that is not drifting and sunshine are needed to follow the tracks that lead to the track-maker.

The field crew of two or three people plus a pilot assemble the capture gear. An experienced pilot is a key part of the team—knowledge of Arctic weather and sea ice, and a heaping dose of steady nerves are essential. As we head out, all eyes are scanning the vast sea of ice for a yellowish spot—a "freebie" in polar bear capture vernacular. Usually we just see tracks. Once tracks are spotted, we check if they are fresh enough to follow. Once we start tracking, the twists and turns of the helicopter can render even the most experienced researcher airsick. Tracking can take anywhere from minutes to well over an hour. Fresh snow, good light, and no wind constitute good tracking conditions and allow us to track at full speed. We can cover in a few minutes what took a polar bear

all day to accomplish. Along the way, we note attempted and successful seal kills and stop to take samples.

On a warm day hundreds of ringed seals and dozens of bearded seals emerge onto the sea ice. In some areas, walrus can be seen. A flock of eider ducks is a welcome reminder that spring is coming. Seabirds can collect on open water as they wait for their breeding cliffs to thaw. I am always on the lookout for glaucous gulls, ivory gulls, and Arctic fox. All are eager scavengers of polar bear kills and their presence is a good indicator that a bear may be nearby. When Arctic fox populations are high, they are surprisingly abundant and these bouncy little canids show up far offshore. More often though, fox numbers are low and we are only offered a few tiny tracks here and there as evidence they still exist. Spotting beluga, narwhal, or a bowhead will boost our spirits.

Some days, things do not go according to plan. Fog, high winds, or snow can force us back to camp. Also, just because we find fresh tracks does not mean we will find the bear. We might lose the tracks in an open lead, broken ice, or concrete hard snow. Sometimes, "our" bear crosses the tracks of other bears and is hopelessly lost.

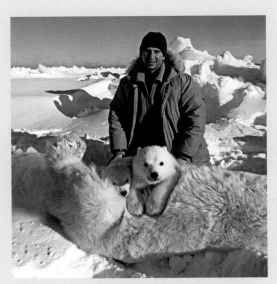

The author in the early days on the sea ice with a mother and her young cub.

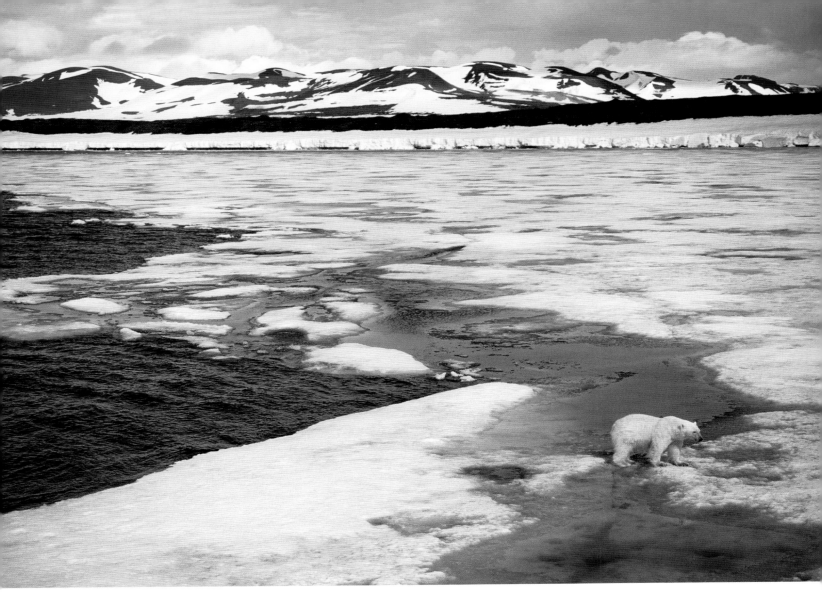

Polar bears like this one in Svalbard rarely leave home: this bear was probably born nearby.

that remain intact, familiarity with resources, reduced energetic costs of movement, and inherited dominance. Dispersers face increased risks of dying, lower reproductive rates, increased energy expenditure, and difficulty finding resources. On the other hand, dispersers avoid inbreeding, overcrowding, and competing with kin. The importance of these factors varies between species. At high population densities, a young bear might easily lose its freshly killed seal to a dominant animal. However, all polar bear populations in North America and Greenland are harvested and thus below what the environment can support. In such conditions, dispersal may be minimal because competition is low.

Polar bears differ from their terrestrial relatives when it comes to dispersal. Perhaps the dynamic nature of the sea ice makes dispersal risky. Terrestrial bears cannot lose contact with solid ground. A polar bear can lose contact with the ice and the consequences can be dire. If polar bears were similar to their nearest relative, the grizzlies, juvenile males should disperse often and at higher population densities. But the majority of polar bear harvest is centered on juvenile males, so scientists do not see dispersal very often. Some aspects of natural behavior cannot be studied in populations heavily altered by humans.

**Young males like this, which have not learned to be
wary of humans, are potential troublemakers and
are the most commonly killed in harvested popula-
tions.**

It is genetically detrimental to breed with a sister or mother, and
this possibility exists in polar bears with prolonged generation overlap.
How the cost of inbreeding is balanced against the cost of dispersing is
unknown. Incest is likely decreased by delayed maturation of males that
reduces the overlap in reproductive lifespan of related individuals. The
situation gets more complex with half sisters and half brothers. We know
from genetic studies that inbreeding is rare in polar bears. Perhaps polar
bears can recognize family.

Populations

A population is a collection of individuals of a species occupying a de-
fined area somewhat isolated from other groups. Caveats are often added
about population abundance being driven by births and deaths rather
than immigration.

A clearer understanding of polar bear populations emerged in the
1970s when tagging studies revealed that the bears were faithful to a
given area. Population boundaries were refined with satellite telemetry
data. Boundaries continue to be adjusted, and as the sea ice responds to
a warmer climate more changes will come. Boundaries are porous (it is

Close Encounters of the Furry Kind

I have never had to shoot a bear but I have had a few close calls. In Hudson Bay, on my first day darting bears, I had an adult female amble out into a shallow lake shortly after I shot a dart into her. Fearing that the partially drugged bear would drown, I jumped in after her to keep her head above water until help arrived. Fortunately, she was cooperative or I would have had a short career as a polar bear researcher.

Another memorable capture happened in Svalbard. I was searching for mothers with young cubs high in a valley when we spotted a female with one cub. The mom tore off down the valley and I put a dart into her rump. Thinking she would soon go to sleep, I directed the helicopter toward the cub that was making a run for the top of the mountain. I had the pilot angle into the slope so I could walk along the landing gear and get out. My plan was to catch the cub. I stepped onto the mountain. As the helicopter took off, I realized that the slope was glazed in ice. One step would send me sliding to the bottom. Just then I noticed that the mother was definitely not asleep. She was headed toward her cub and I was in her way. I recalled the advice: "Never get between

a mother and her cub." Frantic hand signals brought the helicopter back. I jumped onto the skid and crawled back in, my heart in my throat. The mother, deprived of her target, was soon asleep and we managed to coax the cub to its mother from the air.

By and large, polar bear biologists are a cautious lot. There are old biologists and bold biologists but precious few old, bold biologists. Safety of the study animal and safety of the field crew are of utmost importance. Nonetheless, drugs, guns, helicopters, and bears are a dynamic mixture.

Distribution and Populations

Polar bears are not afraid of swimming, but it is more efficient for them to walk on the ice and hunt. Every step a bear takes involves a decision that is affected by a variety of factors including the bear's sex, age, reproductive status, and hunger, as well as external considerations such as the condition of the ice and weather.

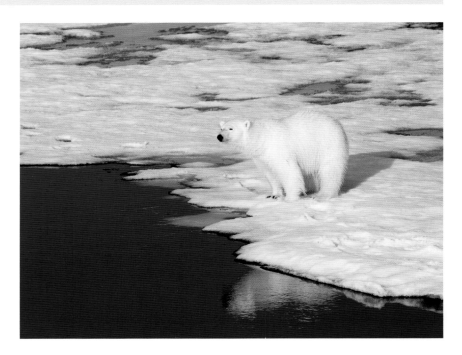

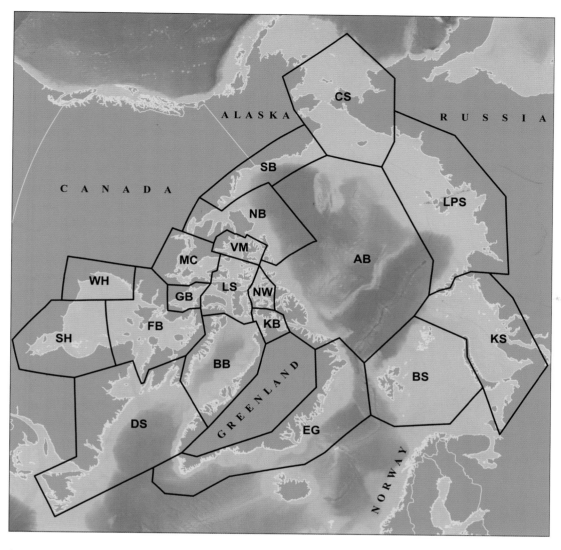

better to think of blurred edges rather than hard lines) and some boundaries are leakier than others. An East Greenland bear is unlikely to make its way westward because the habitat at the north end of Greenland is not very good and the south end is often free of ice. In contrast, bears in Davis Strait and Baffin Bay overlap a lot.

The IUCN/SSC Polar Bear Specialist Group recognizes 19 populations of polar bears with a global estimate of 20,000 to 25,000. Each population varies with regard to ice dynamics, den areas, prey species, ecosystem productivity, communities that hunt them, and the threats posed by human development and climate change.

Estimating the density of polar bears on the sea ice is a tricky proposition because it is so incredibly variable in both space and time. In prime habitat, the density could be as high as 16 bears per 100 square miles (6 bears/100 sq km). In poor habitat, there might not be any bears. On average, 3 bears per 100 square miles (1 bear/100 sq km) on the sea ice is reasonable. When on land, the density can exceed 18 bears per 100 square miles (7 bears/100 sq km). At aggregation sites, the density can be 100 times higher or more.

There are 19 populations of polar bears worldwide identified by the IUCN/SSC Polar Bear Specialist Group. The boundaries of some are leakier than others, but the areas work for research and management.

(Counterclockwise from the top)

CS, Chukchi Sea	SB, Southern Hudson Bay
SB, Southern Beaufort Sea	DS, Davis Strait
NB, Northern Beaufort Sea	BB, Baffin Bay
VM, Viscount Melville Sound	KB, Kane Basin
MC, M'Clintock Channel	EG, East Greenland
NW, Norwegian Bay	BS, Barents Sea
LS, Lancaster Sound	KS, Kara Sea
GB, Gulf of Boothia	LPS, Laptev Sea
FB, Foxe Basin	AB, Arctic Basin
WH, Western Hudson Bay	

Size estimates for 19 polar bear populations reported by the IUCN/SSC Polar Bear Specialist Group		
Population*	**Size estimate**	**Year of last estimate**
Chukchi Sea	Unknown	Never
Southern Beaufort Sea	1526	2006
Northern Beaufort Sea	980	2006
Viscount Melville Sound	161	1992
M'Clintock Channel	284	2000
Lancaster Sound	2541	1998
Norwegian Bay	190	1998
Gulf of Boothia	1592	2000
Foxe Basin	2580	2010
Western Hudson Bay	935	2004
Southern Hudson Bay	900–1000	2005
Davis Strait	2142	2007
Baffin Bay	2074	1997
Kane Basin	164	1998
East Greenland	Unknown	Never
Barents Sea	2650	2004
Kara Sea	Unknown	Never
Laptev Sea	800–1200	1993
Arctic Basin	Unknown	Never

*These are the 19 populations of polar bears recognized by the IUCN/SSC Polar Bear Specialist Group.

Chukchi Sea

Straddling the Chukchi Sea the population overlaps part of the Siberian, Bering, and Beaufort seas. Wrangel Island in eastern Russia has a large number of dens and produces the majority of bears in the population. Lower density denning occurs along the Russian mainland and islands. Because so much of the habitat is a long way from shore and the ice is notoriously broken and dynamic, research has lagged. The population is shared between the United States and Russia and in 2007 the bilateral Alaska-Chukotka Polar Bear Population Agreement was adopted that should foster new research.

Harvest in Alaska was greatly reduced in 1972 and the polar bear population increased. The population is still harvested by native people in both the United States and Russia. Recently, fears about excessive harvesting in the Chukotka area have raised concern. Some of the harvested bear parts end up in the Southeast Asian illegal bear trade where they are used for food and in folk medicine.

The ecosystem in this area is incredibly productive and appears to have abundant seal populations. There are some very fat polar bears ob-

Estimating Polar Bear Abundance

Mark and recapture estimation of population size is central to polar bear research and management. Perhaps better described as capture-mark-recapture the method is simple in principle. The trick is in doing it right.

To determine how many bears are in a population, we capture a random sample of perhaps 100 bears. We mark each bear then let it go. We wait a year, allowing the marked bears to mix with unmarked bears, before we take another sample of say 200 bears, of which we find 20 bears marked from the year before. The proportion of bears that we marked relative to the unknown population size is equal to the ratio of recaptured bears to the number of bears in our second sample. The 100 marked bears as a proportion of the unknown population size equal the 20 recaptures as a proportion of the 200 bears in the second sample. Because we recaptured 1 bear in 10, we assume our first sample of 100 was 1/10th of the population so there would be 1000 bears in the population. This method has been used since the late 1800s. It has obvious limitations because not every bear has an equal chance of being sampled; sometimes ear tags are lost; and not all marked bears are noticed. In addition, population size may change through births, immigration, emigration, and death. For simple analyses, two samples are enough, but if the population size is changing, three or more are needed. Complex models for determining polar bear populations may use age, sex, or even environmental variables like sea ice conditions to improve estimates.

Some early population estimates suffered from small sample sizes or poor distribution of captures.

Getting good estimates is difficult because bears are spread over large areas and live far offshore. For this method to work well, you should catch about 20% of the population in each sample. Do not forget to budget for the expensive helicopter hours: on the sea ice, catching one bear per flying hour is considered pretty good.

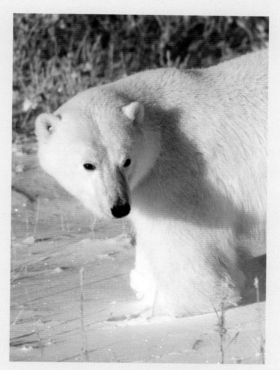

This young polar bear has an ear tag in his right ear. The tags are a critical part of research. Individual identification over time provides information on population size, survival, growth, and site fidelity. Captured bears also have a lip tattoo but hunters often overlook these so the tags are required.

served in this area. This population is the only one with access to ribbon seals, but ringed seals and bearded seals make up most of the diet. Walrus and carrion are also important food sources.

Increasing conflicts between bears and people in Russia, caused by changing sea ice, has led to the creation of patrols to deter polar bears from entering human communities. The patrols use nonlethal deterrence methods. Recent sale of oil leases for exploration are cause for increased management planning and monitoring.

IUCN / SSC Polar Bear Specialist Group

The International Union for Conservation of Nature (IUCN) is the world's oldest and largest environmental network with nearly 11,000 government and nongovernment volunteer scientists from over 160 countries. Under the IUCN, the Species Survival Commission has more than 100 specialist groups that deal with biodiversity conservation. The Polar Bear Specialist Group, formed in 1968, is one of the oldest.

The group was established to ensure scientific exchange of information and sound manage-ment of polar bears. Its guiding principles are in the Agreement on Conservation of Polar Bears. For over 40 years, the group has nurtured the agreement's principles. The 25 members, who are all active in polar bear conservation efforts, meet every few years to discuss and coordinate research and management of the ice bear.

Southern Beaufort Sea

This is one of the best-studied populations, with research dating back to the 1970s. The Southern Beaufort Sea population is shared between Canada and Alaska. Boundaries were determined from satellite collared bears, although boundaries may be shifting. A successful co-management agreement was developed between the Alaskan Inupiat and Canadian Inuvialuit who harvest this population. Historically, the population was notable for the abundance of denning on offshore multiyear sea ice but this has declined over the last decade as the sea ice became less stable. The Alaska Arctic National Wildlife Refuge is centrally placed in the population. The presence of extensive onshore and offshore oil production and exploration are conservation concerns.

Bears in this area prey largely on ringed seals and bearded seals but bowhead and beluga whales, either scavenged from harvested animals or as carrion, are also important. There is concern that the population is currently declining due to deteriorating sea ice conditions. Evidence of poorer body condition, smaller body size, low cub survival, increased cannibalism, and higher fasting rates all suggest a population in decline.

Northern Beaufort Sea

This Canadian population is somewhat distinct from the Southern Beaufort Sea but cross-boundary movements are common. Research has been steady since the early 1970s but less intense than the Southern Beaufort Sea. Polar bear density is lower in the north due to the presence of multiyear ice but recent melting is changing the population. Most denning is land based along western Banks Island. Hunters from Banks Island,

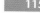

Victoria Island, and the mainland harvest the population. Offshore oil exploration is increasing and may become a management concern. If the climate continues to warm, this population is predicted to decline.

Viscount Melville Sound

This small population is centered on Hadley and Wynniatt bays on the north side of Victoria Island, northern Banks Island, and southern Melville Island. Extensive areas of multiyear ice and low seal densities support a tiny population. The population suffered severe over-harvest, but a hunting moratorium, which ended in 2000, was intended to allow population recovery. Communities on Victoria Island share the small harvest quota. Changing ice conditions are affecting the population and the population may be one of the few that will grow with a warming climate because a shift to annual ice would increase prey abundance. Increased shipping is a concern because the population is the western end of the Northwest Passage. Diamond mining interests in the area are also increasing.

Landfast ice can take on some amazing shapes. The Southern Beaufort Sea polar bear population is shared between the United States and Canada and has a wide band of landfast ice that provides good ringed seal breeding habitat. The rich onshore and offshore petroleum resources overlap with polar bears and raise environmental concerns that call for careful management.

Polar bears in the central Canadian Arctic have access to extensive areas of landfast ice and population densities are higher here than in most other areas.

Distribution and
Populations

M'Clintock Channel

This population was one of the first to undergo a mark and recapture study to estimate abundance. Severe over-harvesting in this population, however, resulted in a decline well over 50%. A hunting moratorium was introduced and the population may be increasing, but lack of monitoring means the current status is unknown. The population boundaries result from surrounding islands, the mainland, and multiyear ice to the north. Only ringed and bearded seals are available to these bears. Gateshead Island off the eastern coast of Victoria Island is a known denning area. Extensive mining claims for diamonds and shipping are environmental concerns.

Lancaster Sound

This is the heart of the Northwest Passage. The western portion of this population was historically dominated by multiyear ice with low biological productivity. The central and eastern areas are hugely productive, with high densities of seals and polar bears. Bears migrate westward or into fjords as break-up occurs. Ringed seals, bearded seals, and beluga whales contribute equally to the diet. The population is thought to be declining due to over-harvesting and environmental change. Parts of this population were recently proposed as a marine protected area that could reduce industrial activity.

Norwegian Bay

The Norwegian Bay population is bounded by multiyear ice, islands, and polynyas. Satellite tracking suggests that most of this population lives along coastal tide cracks. Abundant multiyear ice results in low ringed seal densities and thus low polar bear density. This population is small

in area and size but may increase with climate warming. The bears in this area show high genetic differentiation from all others in the world. The genetic uniqueness may relate to colonization by few individuals a long time ago and little immigration. Population status is uncertain but this area is likely to be a refugia for polar bears if the climate continues to warm.

Gulf of Boothia

This population inhabits a small area but supports an extremely high density of polar bears. The population feeds mainly on ringed seals, with about 20% of sustenance coming from belugas and 10% from bearded seals. The population, thought to be stable, can sustain an annual harvest of 74 bears, which is impressive from such a small area. Abundant prey and connections on the northern end to Lancaster Sound may provide part of the key to the population's productivity. Denning occurs on Simpson Peninsula and the islands near Pelly Bay. In this area, a study that recorded the bears in winter dens found that about 18% were occupied by adult males. How long the males used these dens is unknown.

Foxe Basin

This large population covers all of Foxe Basin, northern Hudson Bay, and western Hudson Strait. There are strong genetic linkages with bears in Davis Strait and Hudson Bay. The ice melts from most of the area in summer and bears retreat to Southampton Island, Wager Bay, and the islands and coast throughout Foxe Basin. The bears have a diverse diet, with about 50% ringed seal and the rest from harp seal, harbor seal, bearded seal, and walrus. Bears in this population are harvested by communities in both Nunavut and Québec. Concentrated maternity denning occurs on Southampton Island and in Wager Bay with other denning widely dispersed. Increased mining activity has raised concerns about ice-breaking ships altering the bears' habitat. The population status seems secure despite a large harvest. Recent use of aerial surveys provided a new estimate of abundance.

Western Hudson Bay

Hudson Bay is an annual ice ecosystem, meaning all the ice melts each summer. The bay, which forms an inland sea 750 miles (1200 km) across, is shallow; average depth is 330 feet (100 m). The shallow depth and southern position make this a productive area.

This population is well known by scientists and the public alike. Research started in the 1960s has provided detailed knowledge of the population. At times upward of 80% of the bears were marked. Research is aided by high fidelity to the summering area in Manitoba during the ice-free period.

Cape Churchill and adjacent areas are aggregation areas where Tundra Buggies bring tourists to view polar bears. Extensive filming and photographing has increased the fame of this population and the town of Churchill has aptly proclaimed itself the Polar Bear Capital of the World. No harvest occurs in Manitoba, but Inuit from Nunavut harvest this

This yawning bear must wait until the ice in western Hudson Bay starts to freeze before it can return to hunting. The ice is melting about one week earlier every decade and is slower to re-form in the autumn. The changing ice conditions have caused a decline in this population.

population when the bears migrate northward. The population is segregated from adjacent populations during the ice-free period but mixes with the Southern Hudson Bay and Foxe Basin populations on the ice. The population has a high density den area that at its peak produced up to 361 cubs each spring from 191 females; cub production is much lower now. In 1996 part of the coast and most of the inland denning area were designated as Wapusk ("white bear" in the local Cree dialect) National Park. A second smaller den area occurs in the Cape Tatnum area next to Ontario.

The population has declined almost 22% over the last decade from around 1194 bears in 1987 to 935 in 2004. Altered sea ice patterns have resulted in lower reproductive and survival rates that made harvest unsustainable. The population is thought to be declining despite reductions in harvest. Earlier break-up and later freeze-up caused by global warming are the main threat to this population.

Southern Hudson Bay

This is the most southern population of polar bears in the world. The bears in this area, which extends into James Bay, spend the ice-free period in Ontario and nearshore islands with a few in Québec. On the sea ice, the population breeds with the Western Hudson Bay and Foxe Basin populations. The population is shared between Ontario, Québec, and Nunavut. Part of the summering range is protected by Polar Bear Provincial Park in Ontario. Harvest is mainly by Inuit in the Belcher Islands in southeast Hudson Bay and communities in northern Québec. Cree in Ontario also take a few bears, which are called "wabusk" in the local dialect. The population is thought to be stable but the effects of climate change are evident in lower body weight that is usually a precursor

to population decline. Changing sea ice conditions suggest longer-term concerns for the persistence of polar bears this far south.

Davis Strait

This population lives in the Labrador Sea, eastern Hudson Strait, and Davis Strait with some contact with southwest Greenland. The diet of the bears is almost evenly split between harp seals and ringed seals. People from Labrador, Québec, Nunavut, and Greenland harvest the population. The population is thought to have grown over the past decades due to increasing abundance of harp seals. Rapid change in ice conditions is raising concerns that this population may now be declining.

Baffin Bay

The long distance between Baffin Island and Greenland has made the population size difficult to estimate because some bears live far offshore on the pack ice. The diet consists primarily of ringed seals that breed in the fjords and drifting pack. Belugas and some harp seals round out the diet. Bears usually move toward Baffin Island during the summer. Shared between Canada and Greenland, the population is believed to be heavily over-harvested and in serious decline. Sea ice changes have also been severe in this area.

Kane Basin

This small population is bounded by the North Water polynya to the south, Greenland to the east, and Ellesmere Island to the west. Shared between Canada and Greenland, the small population is largely hunted by Greenlanders and over-harvest in an ongoing concern.

East Greenland

Little is known about the bears that live in this population and their status is unknown. Bears range widely along the entire coast and there is limited exchange westward toward Baffin Bay and eastward toward Svalbard. Part of the area is protected in the National Park of North and East Greenland, although polar bears can be hunted there. The diet of these bears is a mix of ringed, bearded, harp, and hooded seals along with walrus. Pollution levels are very high here and a variety of detrimental effects have been documented.

Barents Sea

This population includes the bears at Svalbard in Norway eastward to the archipelago in Russia called Franz Josef Land. Movement and population studies have been conducted in the Svalbard area since the 1970s. It holds the distinction of being the first population estimated by aerial survey. Some bears are very local and remain in the fjords of Svalbard; others roam from Greenland to Russia. Russia protected its side of the population in 1956, but heavy hunting occurred in Norway until 1973 when a harvest ban was introduced. It took almost three decades for recovery. Protection in Russia was the only thing that saved the popu-

Icebergs and mountains dominate the seascape and landscape of East Greenland. Polar bears commonly use both the fjords and nearshore pack ice of the world's largest island. The deep waters offshore in the Greenland Sea are poor polar bear habitat.

lation. The Barents Sea is very productive, partly owing to the shallow water, which averages about 750 feet (230 m). Ringed, bearded, and harp seals make up the bulk of the diet of these bears.

The population has a high density denning area in Kong Karls Land and another at Franz Josef Land. Dispersed denning occurs in other areas. Over 60% of the land in Svalbard is protected and Franz Josef Land is a nature reserve. High levels of pollutants have been detected and are adversely affecting the population. The Barents contains large hydrocarbon reserves, so the future is uncertain. The area also has important fisheries. The population trend is unknown but the bears are abundant. Some loss of denning habitat has resulted due to changing sea ice patterns.

Kara Sea

Virtually nothing is known about this population that overlaps with the eastern parts of the Barents Sea population. Denning areas are on eastern Franz Josef Land and Novaya Zemlya. Some pollutants reach higher levels here than anywhere else. Nuclear and industrial wastes raise ongoing concerns about the population.

Surveying Bears from the Air

Aerial surveys, the bread and butter of many wildlife management programs, have only recently become part of polar bear management. Aerial surveys involve counting all the bears you see from a helicopter or plane as you fly along a line. You cannot, of course, see all the bears, but you have to see enough to calculate how many you did not see.

Finding white bears on a white background is difficult. The first aerial survey of polar bears in the 1950s failed to yield acceptable results and the method was shelved. Aerial surveys were attempted again in the 1970s and 1980s, but analytical methods were still rudimentary. Counting white bears on land is a lot easier than counting them on snow or sea ice. I conducted such a survey on land in 1985 in western Hudson Bay but there were methodological bumps. Nonetheless, I held onto the idea that aerial surveys would work. In 1998 on the summer sea ice in the Barents Sea, I ran a pilot study that laid the foundation for a population estimate in 2004 that worked well. New analytical methods have made a huge difference.

Modern surveying methods require measuring the distance between the observer and the bear. A laser range finder works well. The assumption is that bears closer to the observer are more likely to be seen than those farther away. Armed with such data, computer programs crunch the numbers and provide an estimate of polar bear density. The density is then multiplied by the study area size to yield a population estimate. It is a lot more complicated because you have to make certain assumptions. For example, you have to see all the bears along the line you are traveling. Sound simple? What about a bear in a den or a bear sleeping behind a pressure ridge? Video and infrared cameras can help meet assumptions.

Aerial surveys are gaining popularity because they provide an estimate in a single season, can be cheaper than other survey methods, and are less invasive. On the negative side, aerial surveys provide no information on age and sex composition, survival and reproductive rates, body condition, and growth of a population. Nor can aerial surveying provide samples for monitoring pollution, disease, or diet. We will be seeing more aerial survey estimates in the coming years as the sea ice continues to deteriorate making capture-based studies more challenging.

Laptev Sea

The population includes the western part of the East Siberian Sea and the Laptev Sea, including the Novosibirsk and Severnaya Zemlya Islands. Almost no research has been conducted in this area, which remains a mystery. The continental shelf extends far offshore suggesting a large population might exist but the little data that has been collected suggests the opposite. Harvest is limited to incidental kills and illegal harvest. The status of the population is unknown.

Arctic Basin

Describing this area as a distinct population is dubious because so little information is available. Every indication suggests that bear density is very low. Most of the area is multiyear ice over the deep Arctic Ocean although this is rapidly changing. The ice is younger and thinner than it used to be just 20 years ago. Sea ice predictions suggest this area could be ice free in summer within decades. Such a change would mean any bears in this area would have to find land to summer on. The bears in the area may be northern extensions of adjoining populations rather than a

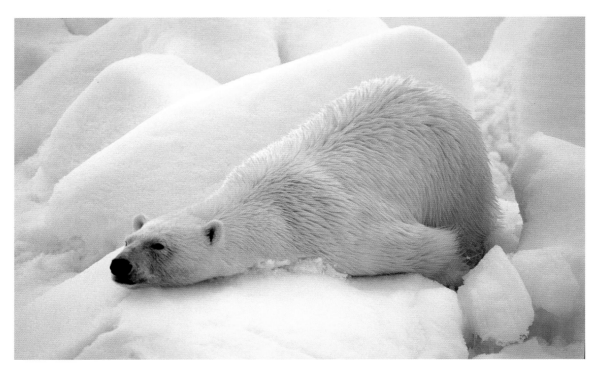

This polar bear is grooming itself on a snowy ice block. Polar bears are meticulous about keeping clean; they remove all blood and fat from their fur by swimming, grooming, and sliding over fresh snow.

distinct population. A recurring lead from the northeastern Beaufort Sea to northern Greenland creates some good habitat, and a few bears have been tracked through this area. There is no harvest except bears shot by Arctic trekkers. Given the ice forecasts toward the end of the century, the area along northern Greenland and the Canadian Archipelago may be the long-term refugia for polar bears in a warming climate.

Genetic Structure

Genetically, polar bears are remarkably similar no matter where they are found. With a bit of DNA, however, you can determine roughly where a bear came from. There is no evidence of strong separation that would be consistent with long periods of isolation but this is not surprising for such a young mobile species that has been moved about by various glaciation events. Because populations overlap, gene flow is fairly high. There are four broad genetic groups of polar bears in the world. The largest group is found from the Northern Beaufort Sea population westward to the East Greenland population. The next area is in Davis Strait, Foxe Basin, and the Hudson Bay area. A third group is in the central Canadian Archipelago, with the exception of Norwegian Bay, which constitutes the fourth group. The genetic groupings vary from 190 bears in the Norwegian Bay area to several thousand in the larger groups. The genetic structure is largely explained by sea ice patterns, large landmasses, and site fidelity.

It is interesting to ponder the genetic patterns in light of past events like glaciations. We know polar bears were hanging around in southern Scandinavia and the Baltic Sea during the last glaciation 10,000 years ago. Were they also pushed south in the western Atlantic off of the Eastern Seaboard? Where were they in the Pacific Ocean? Did some remain in the Arctic or did the ice get too thick? Unfortunately, we will have to

The moon rises on a calm Arctic night. Polar bears tend to be more active at dawn and dusk. During the hyperphagic period, when seals are readily available, some bears switch into a full-time predatory state.

wait for more fossil evidence to tell us because the genetic material does not say if the variation we see happened before the last glaciation or since. Some genetic differentiation must have resulted from postglacial recolonization, because 10,000 years ago, there were no polar bears in Hudson Bay. That area was covered by glaciers. The precursor of Hudson Bay is the Tyrrell Sea, which was much larger 7000 years ago, covering land up to 700 feet (213 m) above modern sea level. Hudson Bay is still shrinking as the land rebounds half of an inch per year (1 cm/yr) from the glaciers that weighed it down. It is interesting to ponder how much of it might be left in 10,000 years—let us hope the bears are around to find out. The latest findings that polar bears hybridized with grizzlies numerous times over the last 100,000 years and most recently in Ireland and Britain raise even more questions. Until we have a more complete picture of the paleo-DNA of grizzly bears in other areas, the mysteries of polar bear prehistoric distribution remain unsolved. For now, however, it appears that our modern polar bears might growl with an Irish brogue.

HUNTING METHODS

Polar bears use several methods to hunt seals. All involve getting teeth, claws, or both into a seal. The different methods are prey and habitat specific. Hunting methods also differ by age, sex, and reproductive status, and some individuals specialize in one method over another. Some strategies are learned from hunting with their mothers; others, by trial and error.

Seal hunting methods fall into a few broad categories that involve either waiting or active stalking. A bear can wait for prolonged periods at a breathing hole or floe edge using what is called a "still hunt." Aquatic stalks, lair crashing, and charging are other hunting methods. Polar bears can demonstrate incredible patience, sitting in one place for a long time. If the bear has chosen its seal breathing hole well, it is just a matter of time until the seal shows up for the polar bear's dinner. On the other hand, the fleetness of foot and the agility of a polar bear as it races in to grab a basking seal never ceases to impress.

Stalking on Ice

Polar bears are masters of getting from one point to another without being seen. Of course, this implies the bear can see the seal so this method is used on hauled out seals. The bears have evolved finely honed predatory skills so they can get close enough to kill seals. Like a golfer estimating a shot, the bear has to judge distance and approach—the bears seem to visualize a route from where they are to where their intended prey is and then develop a means of getting there. Using pressure ridges as cover with periodic "peeks" at the seal, a polar bear can sometimes get close enough, usually within 100 feet (30 m), to make a dash and catch the seal before it escapes into the water. The ability of polar bears to move across the sea ice is truly impressive. To avoid detection, they exploit irregularities in the ice, crawl low to the ground like a cat, and stop and

(Opposite) **A molting adult bearded seal loafs on an ice chunk on a sunny day. All seals undergo an annual molt; the skin must be sufficiently warm for the molt to occur. The need to haul out onto the ice surface gives seals a smidgen of predictability which polar bears are able to exploit.**

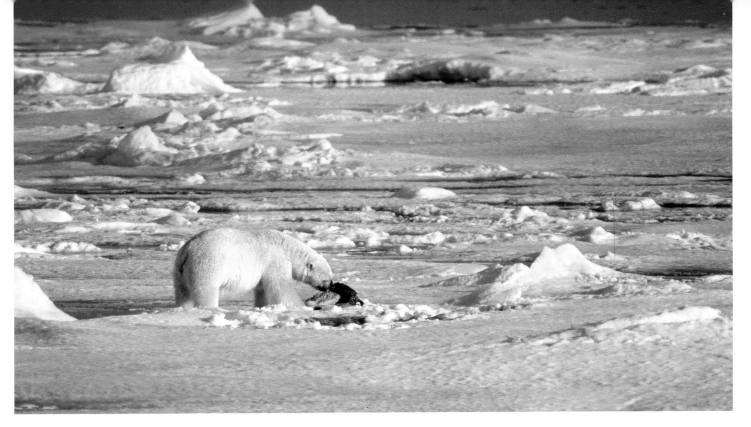

The round rump and pendulous belly of this bear declare that it is an expert hunter. A bear this big is not particularly fast, but it is clever. It will use every available bump and pressure ridge when sneaking up on its intended victim.

start. For such a large animal, the ice bear can move with surprising stealth and agility.

Stalking seals involves both olfactory and visual cues. A bear has to approach from downwind—seals have coevolved with polar bears to avoid predation. The seals usually haul out in areas with good visibility and position themselves to see downwind. They rely on detecting bears by scent from the upwind side. Never being far from the water is the key to avoiding predation. Conversely, polar bears exploit the seals' need to haul out, which brings up the question of why seals haul out if doing so makes them vulnerable. The two primary reasons are to molt and for females, to nurse young. Seals need enough heat on their skin to facilitate the molt that results in the skin (epidermis) and fur being shed. Arctic seals have not evolved a means to molt or nurse without hauling out.

The eyes of ringed seals, bearded seals, and harbor seals are well adapted to seeing in air. Most other seal species have vision more adapted to seeing in water. When there are large predators about on land or ice, good vision is critical.

It is common to see 4 or 5 ringed seals at the same haul out hole. Like the advantage of a herd, flock, or school for other species, having several seals at a hole means more eyes watching for bears. The disadvantage is the line that forms if a bear comes charging. A stalking bear has to catch a seal before it slips into the water. In one observation, a large bear stalked up to 260 feet (80 m) from two adult ringed seals hauled out at the same breathing hole. The bear managed to catch the second seal by the hind flippers. Obviously, "after you" does not apply to seals being pursued by a polar bear. The issue becomes even more severe on particularly cold days when breathing holes start to freeze and it is harder for ringed seals to squeeze into their holes. Periodically, seals are unable to

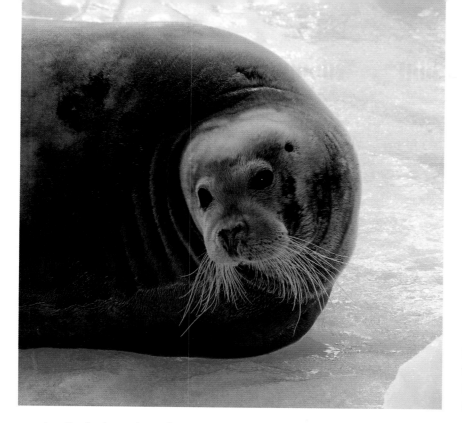

Bearded seals use their sensitive whiskers to search for invertebrate prey on the ocean floor. Once their meal is located, the seals can jet water to clear sediments, and then they vacuum up their prey.

reenter the hole and are frozen out. This is one reason why seals rarely haul out on cold days. The other is that the water is warmer.

Aquatic Stalking

Aquatic stalks are similar to a stalk on ice except that swimming is the primary means of locomotion. No other form of hunting by polar bears comes as close to sneaky as an aquatic stalk. More common during warmer weather in late spring, aquatic stalks are effective as the ice becomes more interspersed with leads. It is also at this time of year that ringed and bearded seals haul out more often. The bears cruise along a maze of cracks. If necessary, the bear will swim under ice and if it is thin enough, rise to the surface and break the ice to breathe. Periodic checks on the intended victim are part of the process, and these checks can remap or modify the intended route. Stalks of over 1300 feet (396 m) are common. In one stalk of a bearded seal, it took the bear 32 minutes to reach the seal, which escaped, albeit with some injury. There is only one anthropomorphic way to describe a polar bear that has missed its kill: ticked off.

Some bears specialize on bearded seal pups using aquatic stalks. This is particularly effective as the ice cover declines and other types of hunting diminish in effectiveness. I have seen polar bears kill bearded seal pups when they were lying on the only ice floe anywhere to be seen. The bear simply swims up and catches the incautious pup.

Birth Lair Hunting

Spring hunting of ringed seals in birth lairs is perhaps the most dramatic kind of hunting. It is only possible for 4 to 5 weeks a year in spring. Most common in stable landfast ice and large thick floes, lair hunting

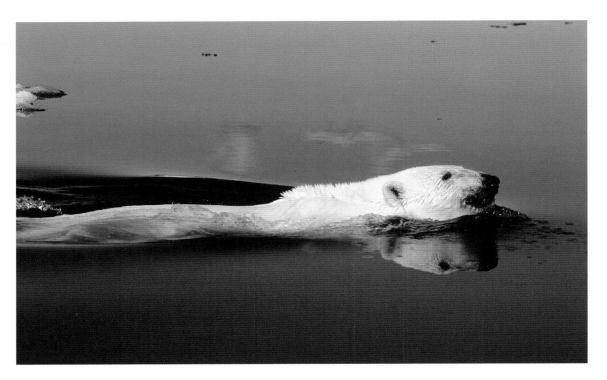

Polar bears spend most of their time dry and on top of sea ice except in spring. As the temperature rises and the ice opens up, they readily slip into the water, using their aquatic stalking skills to sneak up on prey. A bear can come up right under a hauled out seal and block its escape into the water.

can be very effective. Polar bears are olfactory predators and this method involves a bear moving through pressure-ridged sea ice with snowdrifts into or crosswind so they can smell seals. A bear can smell a seal from some distance away, though how far is unknown. Polar bears can likely detect an occupied lair 300 feet (100 m) or more downwind. A Siberian husky was able to detect seal lairs more than half a mile (805 m) away. But smelling a seal from great distances is only useful to locate general areas to hunt. The key is being able to pinpoint a seal's location. A keen sense of smell allows a bear to be sure that the lair is fresh or perhaps occupied by a nursing pup as compared to a tiggak male. All prey emit a cone of scent that widens farther from the source. Once inside the cone, a bear carefully moves from side to side, using its olfactory skills to home in on the source. A bear hunting lairs will weave through an area until it locates a lair it thinks is occupied. Ringed seal pups will escape into the water if they hear suspicious sounds so a hunting bear walks very stealthily, like a cat stalking a bird, positioning each paw with great care. Walking on snow-covered ice is comparable to walking across a drum. Any misstep will nullify the element of surprise. The bear uses smell because it cannot see the lair, but it has probably also identified a likely location for a lair based on snow and ice conditions. I have tracked bears that have excavated dozens of lairs in a small area. These are usually subadults that do not seem to discriminate between high and low probability hunting spots.

Once a bear has pinpointed where the seal is probably hiding, it runs the last few steps and then rises up on its hind legs and plunges down with both front paws together, like a polar bear battering ram. This occurs with amazing speed and is impressive to watch. If necessary, the bear resorts to repeated pounding on the snow. Many factors affect the

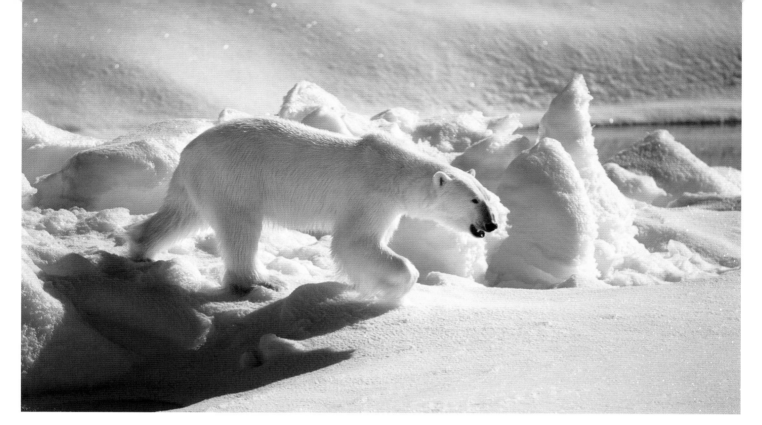

hunting success at birth lairs. Most important is the thickness and hardness of the snow. Thick and or hard snow gives a pup more time to get away. Snow over a lair can exceed 3 feet (1 m) and such lairs are much better protected than ones with a thin cover. Small or lean bears cannot generate as much force as big bears, consequently their hunting success is lower. (The plunging behavior used by polar bears to capture prey is similar to what grizzlies do to open rotten logs.) If successful in breaking through the snow, the bear follows with its head, in an attempt to grasp any fleeing prey. If the first entry does not bring forth prey, the bear will often stop, sniff the area, and possibly listen for cues before additional plunges or digging commences. Every year the last thing thousands of ringed seal pups see is an avalanche of falling snow, some black claws, and white teeth.

Bears sometimes run and jump into a seal lair indicating that they are sometimes able to locate lairs accurately at distance. Crashing into a lair does not necessarily mean the bear makes contact with the seal. Seal lairs can be complex, with many side chambers. But to trap its prey, the bear need only close off the ice hole that permits escape. Other predators that plunge into snow, such as red fox and coyotes, use sound cues to locate prey so why not polar bears. During calm weather, polar bears may hear sounds associated with breathing, climbing out of the water, digging, or mothers nursing pups.

Sometimes when a polar bear crashes into a lair and catches the pup, it will quickly dispatch it and then dig in deeper, hoping that the mother will return to feed her pup. It is an amazing tactic. Once while tracking a lone adult female, I wound along the tracks until they miraculously disappeared. Spinning back around and slowing the helicopter, I discovered the rump of a bear sticking out a pressure ridge. The bear's head was deep

Polar bears normally hunt for ringed seal pups in birth lairs by walking crosswind beside pressure ridges. The pups make a good snack, but their mothers offer a much greater energetic return.

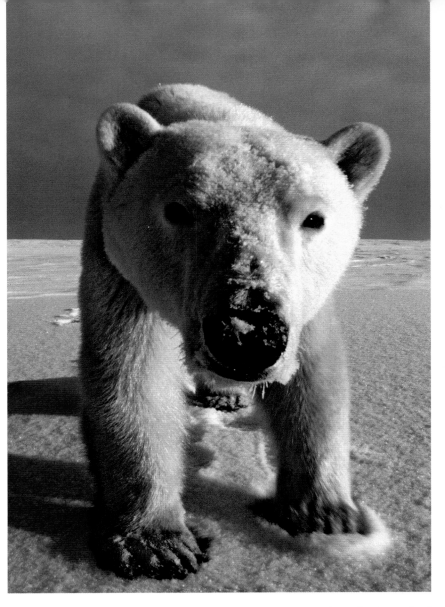

Hunting Methods

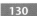

A large black nose, some teeth, and a blur of white will be the last thing that thousands of seals see.

under the snow. Subsequent investigation revealed that the bear had been waiting for some time based on the freezing around the spot where its front legs had melted into the ice. The birth lair hunt had turned into a still hunt.

In the Canadian Arctic, polar bears explored up to 30% of the ringed seal subnivean structures found by dogs trained to find seal lairs. The bears killed seals in 10% to 24% of their attempts, with pups making up 75% to 100% of their prey. Polar bears killed up to 1.3 seals per square mile (0.51 seals/sq km), which translates into some serious seal carnage.

Seals sometimes build lairs under sea ice rather than in snow. Think of two playing cards pushed together and in the upside down V, the seal maintains a breathing hole and a lair. Polar bears do not normally bother hunting such lairs but if the hunting conditions are exceptionally poor or the bear is sufficiently desperate, it will dig through the ice. Such hunting has a fairly low rate of return since digging through 3 feet (1 m) of ice gives a seal plenty of time to get away. Though the technique sometimes works, I have seen the claws of bears that undertake such measures. It is clear that their claws cannot take too much of such work.

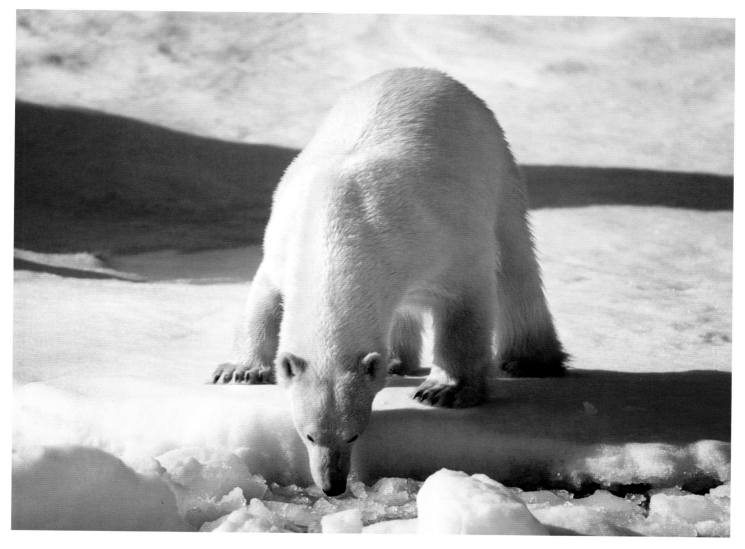

Still Hunts

Perhaps the laziest of all hunting methods is the still hunt. This is the true ambush predator approach. A polar bear moves across a frozen lead or the floe edge and finds a breathing hole or a spot where seals have been hauling out. Then they wait. Still hunting is just that: being still and waiting. Bears can wait standing, sitting, or lying down. For adult males a lying still hunt averages 100 minutes but may last for hours; a female with cubs averages only 58 minutes because cubs usually interrupt. Standing or sitting still hunts usually last 7 to 12 minutes but can last much longer. Bears appear to be sleeping during lying still hunts but the bear reacts instantly to movement, grabbing the seal with teeth or paws. A bear will often jam its head well down the hole and into the water to grab the seal. Ringed seals are cautious approaching breathing holes: any noise, movement, or shadow will cause them to take off for another hole. As the seal approaches the breathing hole, they push a bit of water ahead of them and this is the cue a waiting bear needs. But seals are not particularly maneuverable when swimming up the ice tube that

Polar bears define their world through the sense of smell. This bear is searching for telltale signs that a seal has been breathing at this spot. The bear's nose will reveal whether this is a good choice for a still hunt.

leads to the surface and cannot reverse immediately. If the bear is skilled, or lucky, the seal is ripped out of the hole and dinner is served.

Watching bears hunt at a seal hole enforces the idea that the narrow head of a polar bear is the result of strong evolutionary pressure related to still hunting. Bears with narrower heads could reach just a little bit farther and a little bit faster than their pie-pan faced terrestrial cousin. Hence, the sleeker polar bear.

One study found that bears spent three times more time still hunting than stalking. Still hunting is energy efficient but requires a big-time investment. Sometimes when I have approached a still hunting bear, getting it to move has proved difficult. I have always felt guilty about interfering with these patient bears, although I am sure the seals do not mind.

Open Water Hunting

Polar bears can catch seals in open water though the practice is uncommon. When a swimming bear sees a seal, it drops its body beneath the surface, with only its nose and eyes above the water. When the seal comes to the surface, the bear swims under the seal and catches it from below. Some suggest that seals will actually swim toward a polar bear, thinking it is a piece of ice to haul out on. This is about the closest thing one can imagine to home delivery for a polar bear. Nonetheless, seals are much more maneuverable than bears and have a huge advantage in the water.

Scavenging

Scavenging is a poorly understood aspect of polar bear ecology. Polar bears will eat animals that have died from natural (or unnatural) causes and kills made by other bears. One only has to find a seal kill a few days old to get an idea of the importance of scavenging. Even without Arctic fox being present, seal kills are usually picked clean. I have seen seal kills with more than 8 bears gathered there and dozens of tracks converging on the site like a polar bear convention. A seal carcass is usually fully consumed within days by bears taking advantage of a free meal. Polar bears rarely stay with a seal carcass once they have had a feed. It may be that capable hunters do not want to stay and feed on frozen seal remains. A warm, freshly killed seal is easier to eat than a frozen carcass. Furthermore, a frozen carcass has to be warmed to body temperature, which uses energy.

The polar bear habit of abandoning kills is in stark contrast to grizzlies that remain with their prey and then bury them to reduce odors that might attract scavengers or other bears. Polar bears almost never cover their kills, and even large bearded seals are often abandoned after a polar bear has fed on it. It may be that adult bearded seals are usually killed by adult males for whom mating is a higher priority in spring. I have only once found an adult male polar bear that remained with, and fed on, an adult bearded seal carcass for days. This bear, perhaps by coincidence, was one of the largest I have caught. I am still awed when I ponder his massive proportions. It was many years ago that I last saw him.

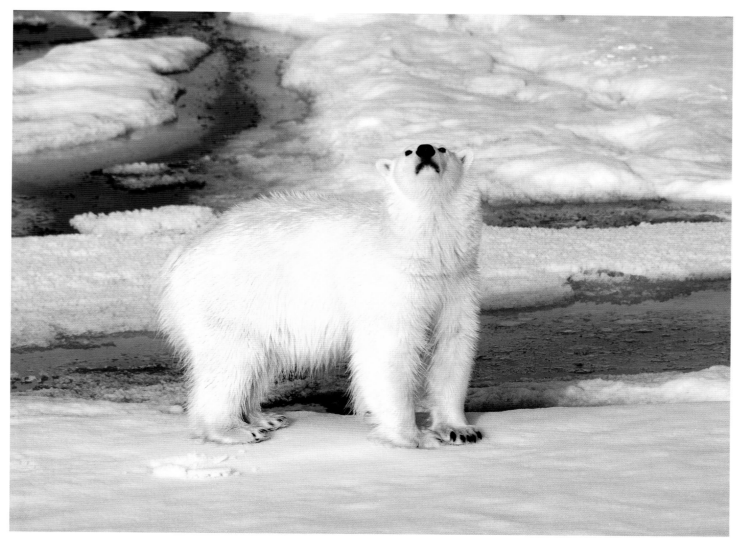

Carrion, which is common in marine ecosystems, represents a sizable if somewhat odiferous food source. In northern Alaska, polar bears regularly scavenge harvested bowhead whale remains. It was estimated that 6% of the marine mammal population dies each year resulting in approximately 0.03 to 0.06 carcasses per mile (0.05 to 0.10 carcasses/km) of beach per year in northern Alaska. A survey along the northern coast of Alaska recorded carcasses of 228 walrus, 13 gray whales, and 15 seals. Areas near walrus haul outs and subsistence hunting areas had carcass densities 10 times the normal density. Seeking carrion is a reasonable strategy if a bear is ashore. Polar bears are opportunists and are not shy about accepting a free meal.

The polar bear's keen sense of smell creates a veritable smorgasbord of information. This bear is holding its nose high to explore scents in the air.

Predator-Prey Dynamics

The predator-prey relationship of polar bears and seals is relatively simple: one predator to two prey. But sea ice and availability of other prey, which vary within and between years, increases the complexity of the relationship. Some years the ice provides good hunting conditions for the bears; some years the conditions favor the seals.

To understand predator-prey dynamics, you need to follow both

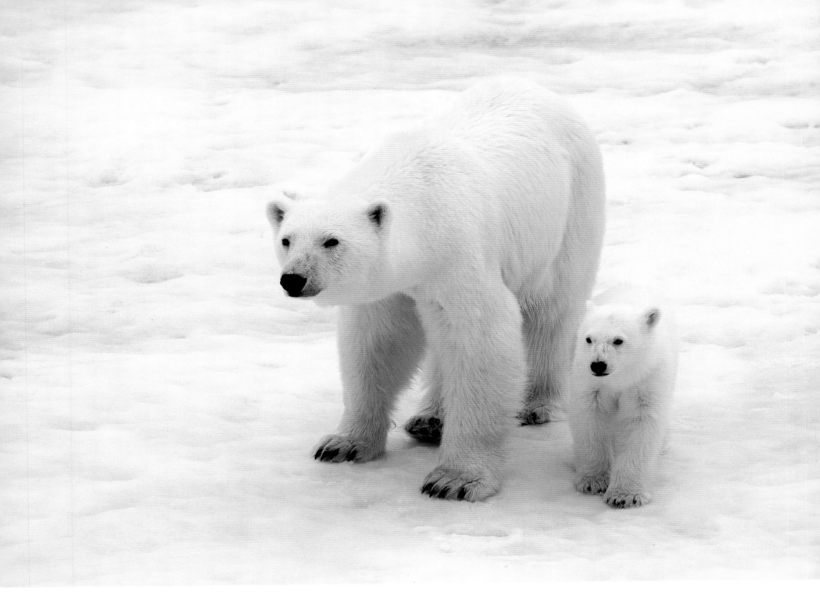

Polar bear populations are punctuated by years of good and bad cub production. When conditions are good, the survival rate of young bears is high. In bad years, a whole cohort can be lost. If cubs die before the mating season ends, many adult females will breed, which creates a synchronous reproductive state resulting in high production the following year.

predator and prey over long periods. It is necessary to have data on the numerical changes in both, and rarely is such concurrent information available. It is difficult to obtain a population estimate of polar bears but it is even tougher to estimate the population size of their prey. Thus, our understanding of polar bear–prey dynamics is limited. In the mid–1970s and mid–1980s, in the eastern Beaufort Sea, information on polar bear and on ringed seal populations was available. Years of very heavy ice decreased seal pup production and polar bears responded with lower reproductive rates. It took about 3 years for the system to recover to normal, albeit normal is hard to define in the Arctic. There may be major reductions in ringed seals at a decadal scale, a form of cycling, but the evidence is limited.

Polar bear abundance is directly related to ringed seal abundance. While other prey may be important, ringed seals drive polar bear populations. There is little understanding about the limits to how many polar bears can live in a population. Hunted populations are below the maximum number of bears the ecosystem can support (carrying capacity); thus prey availability does not limit such populations. The carrying ca-

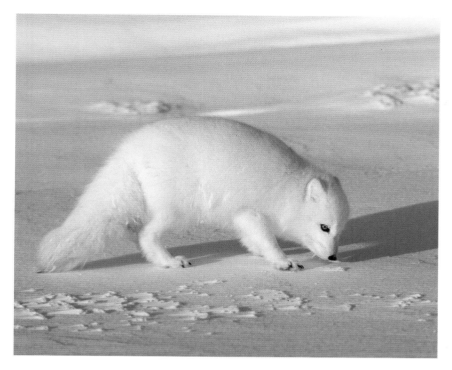

Arctic foxes, bouncy little members of the dog family, weigh less than 9 pounds (3.8 kg). Formidable predators on ringed seal pups at birth lairs, they also clean up polar bear kills. When food is abundant, a pair of Arctic foxes can produce up to 12 kits a year.

pacity for polar bears is likely a combination of social interactions and seal availability.

An unusual aspect in the predator-prey system for polar bears and seals is that polar bears are long-lived predators (up to 30 years) and their prey live to about the same age. This is somewhat unusual in the predator-prey world. The dynamics of long-lived predators and prey result in a slow response in both sides of the relationship unless environmental perturbations occur. This means that both predator and prey populations normally burble along at relatively stable numbers. Given that polar bears prey heavily on pups, they may limit the overall seal population size and growth rate. This raises the question of what would happen to seals if polar bears disappeared. The best guess is that there would be a lot more seals and eventually, the seals would be limited by the availability of their food. This assumes that another predator, such as killer whales, did not take over as the top predator.

Uninvited Guests

Polar bears are linked to a variety of other species because the remains of their kills are food for scavengers. The best-known scavenger is the Arctic fox and it is common to see Arctic fox tracks following polar bears or at seals killed by the bears. Polar bear kills are important for Arctic fox but the foxes also kill young ringed seal pups themselves. Arctic fox are adaptive in their use of sea ice. Some regularly head offshore as part of an annual cycle but in other areas, they remain onshore if food is available. The foxes are limited in their ability to move through broken ice because their fur is poorly suited to swimming, so they must move back on land in spring. It is common to see Arctic fox 100 miles (160 km) or more offshore. The availability of carrion from ringed seals killed by polar bears

may influence the reproduction and population dynamics of Arctic fox, so the linkage is important. Generally, polar bears pay little attention to the foxes though at times they seem annoyed by their presence.

Other scavengers of polar bear leftovers include red foxes, gray wolves, grizzly bears, ivory gulls, glaucous gulls, common ravens, rough-legged hawks, and snowy owls. The importance of polar bear leftovers is hard to quantify. Scavenging by grizzlies, wolves, and red foxes seems opportunistic, but for glaucous gulls and ivory gulls, scavenged food is a major part of their diet.

Hunting Methods

10

POLAR BEAR BEHAVIOR

Behavior influences the survival and reproduction of an animal. How a polar bear behaves in a variety of situations affects its success at passing on its genes to the next generation. Not surprisingly, polar bear behavior varies between individuals and is influenced by sex, age, reproductive status, learning, and environmental conditions. In a broad sense, some bears are more aggressive than others; some mothers will fight to protect their young while others flee when trouble comes; some prefer one seal species to another; some bears move farther than others; and some bears are curious about humans while others are wary. A starving bear will behave differently than a chubby well-fed one. There are well-known photos of a polar bear playing with a sled dog near Churchill, Manitoba. Other bears will kill and eat dogs. Bears are intelligent and individualistic animals. Polar bears quickly learn the costs and benefits of their behaviors; they can even learn from a single event. Rapid learning may yield significant returns. Years back, someone decided to farm pigs in Churchill in the middle of a polar bear migration route. It did not take long for some bears to find the pigs and have a great pork dinner. Those bears kept coming back to the same area even after the pigs were long gone. Similarly, I was doing physiology studies in the Polar Bear Jail in Churchill. Part of the protocol called for the bears to be fed seal and whale blubber to study how their blood chemistry would respond. A couple of the bears that took part in the study broke into the jail the following year. Polar bears never forget!

All mammals interact with others of their species to varying degrees, but polar bears are often considered a solitary carnivore because it is common to see them alone. Solitary behavior is at one end of a spectrum; cooperative behavior, such as group-living gray wolves that hunt together, is at the other. A solitary species does not cooperate to rear young, forage, mate, or defend against others. By this definition, polar

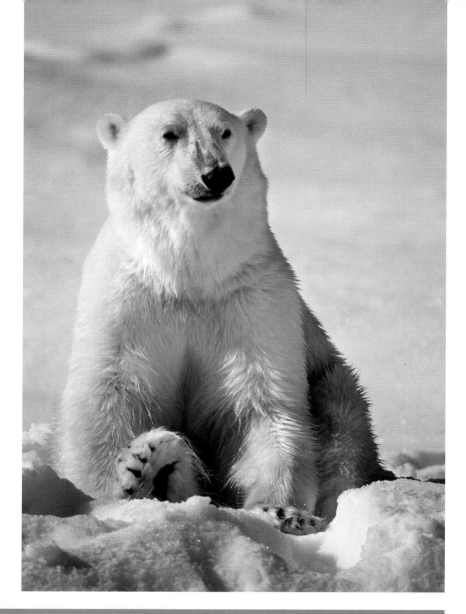

Polar Bear Behavior

Many people consider polar bears a solitary species. But our perception of their world is not theirs. If we do not see or hear another human, we assume we are alone. A polar bear is never really alone if it can smell another bear.

Bears in Captivity

Polar bears in captivity live in conditions far different from their natural environment. A common problem for polar bears housed in older facilities was the development of a repeated sequence of movements with no purpose (stereotypies). The widespread nature of this condition in captive polar bears gave rise to the verb *ijsberen* (to polar bear) in Dutch, meaning "to walk up and down restlessly."

Stereotypies vary between individuals but typically involve walking or swimming in a recurring pattern. The patterns, which can be highly ritualized, may involve recurrent movements of the head or feet, yawning, sucking on paws, or licking. The number of steps in a lap may not vary and the paws may be placed in the same spot during each pass. Bears may engage in stereotypic behavior for up to 77% of their active time; each bout lasts from a few seconds to more than 25 minutes.

Stereotypies are caused by boredom. In the wild, polar bears spend much of their lives stalking their next meal or deciding in which direction to head. The key to avoiding, reducing, or even eliminating stereotypies is to keep the bears interested in sights, sounds, and smells in their captive environment. Many zoos with polar bears have made huge improvements in their facilities and husbandry in recent years. The good zoos can avoid stereotypies.

bears are solitary, but almost everything in ecology resists rigid classification.

Let us consider the life of a polar bear. A cub spends the first 2.5 years of life with its mother. A female cub will have her own cubs within 3 years of weaning and spend most of the rest of her life with successive litters, or for periods in between, with a mate. Hardly a solitary life. Males are more solitary but at certain times of the year, adult males are highly social and seek each other out for company. Being solitary does not mean there is no social life. We view polar bears as solitary because we live in a vision-centric world. Polar bears live in a world dominated by smell. Thus they have a much different perception of other bears and their environment. With such an excellent sense of smell, polar bears may be able to determine more about the other bears passing through an area than we can imagine. Polar bears interact without actually meeting; when they do meet, social interactions are dynamic, complex, and flexible.

Mating System

It is impossible to conduct detailed studies of the mating system of polar bears because all the action occurs far offshore, away from prying eyes, and over a period of months. We have, however, pieced together clues about their private lives.

The first clue about the polar bear mating system comes from the notable sexual dimorphism, with males twice the size of females. Such dimorphism results from sexual selection either through competition between males or by females selecting larger males. The second clue is that males contribute nothing to the rearing of young. With no paternal care, males will not show any fidelity to a female. The next clue is that males do not know and cannot predict where females available to mate are going to be. If males knew where females would be, they could protect the area and defend it from other males. Such territory defense is seen in northern elephant seals on beaches because females come to pup and mate there. Mating behavior in polar bears is different from other bears. Terrestrial bears maintain relatively fixed home ranges that overlap with potential mates, and males know where females live. Sea ice variability is a wild card in polar bear mating, and female polar bears available to breed are unpredictably distributed.

The first step is for males to find females. There is no evidence that females look for males; they are busy looking for seals. Males, however, are single-minded and rove over huge areas to find females. In searching for mates, males seem to pick a direction and follow it for days in an almost straight line, altering course only to check tracks that might have been left by a female. For a randy polar bear, it is all about how things smell, and males can detect the tracks of estrous females. If the tracks are promising, then the male veers off to find the female. It is not clear what cues the bear receives from the tracks but it is likely from hormones in the female's urine or possibly scent pads on the feet. If the tracks are unpromising, the male goes back on his course. We do not know how far a male can track a female but I have tracked males well over 90 miles (145

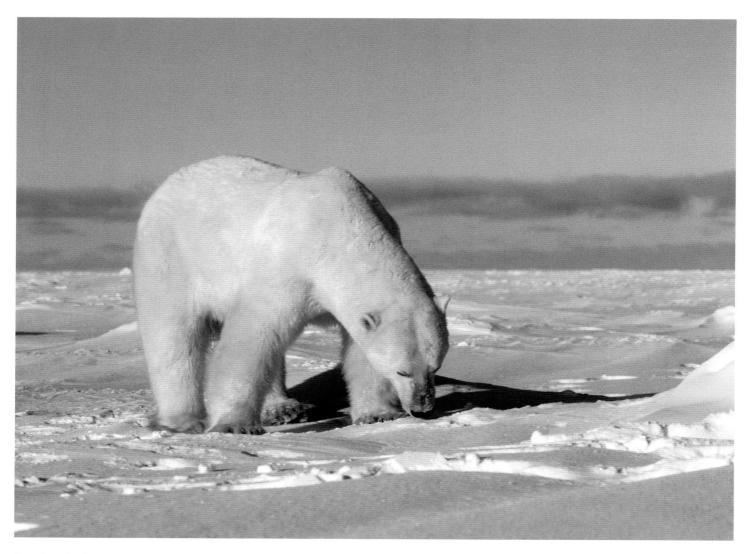

A male polar bear inspects the tracks of another bear. If the tracks were made by a female in breeding condition, he will be hot on her trail. If not, he will continue his cross-country transect until he finds the next set of tracks.

km) before they caught up with the female. It is a lot harder to track a female in broken ice because the tracks get disconnected: this is a negative impact of climate change because warmer temperatures mean fractured ice and reduction in a male's mate-finding ability.

Once the male finds the female, the interactions are curious. Older females that have bred before will tolerate the males, but even they run off forcing the male to tag along. Females are much more agile than males so it may be a test of the male's fitness. Since the female will invest much more than the male in raising the young, it behooves her to have a fit father for her cubs. When an adult male catches up to a female that has not bred before, the females seem frantic and often flee. Evolution is a strong force and eventually, she acquiesces but it takes some convincing and perseverance on the part of the male. If a female has 2-year-old cubs that are close to weaning, the male must run them off before the female will show much interest. Often a breeding pair has an audience because the female's offspring hang about in the wings.

Because of a polar bear cub's prolonged association with its mother, females only breed every 3 years on average, which affects the bears' mating system. The number of males available to breed compared to

the number of receptive females (operational sex ratio) is highly skewed. Many more males than females are available to breed, which often results in two or more males hanging about a female. I have seen as many as six adult males with a female. And judging from the bears hobbling about, the gaping wounds, and the blood spread about on the ice, the gathering was not a friendly one. In sexually dimorphic species, male-to-male competition for mates is often intense. Wounding may be more common in polar bears than other bears because the lack of defined territories results in more males competing for a female. In addition, polar bears do not have a defined hierarchical social system that would allow them to know most of their competitors.

Sex is a strong motivator and two hormonally charged males may end up fighting for their only mating opportunity in a year. Fighting over females is evident from wounds, scarring, broken jaws and limbs, and broken teeth. A severely wounded bear will find a secluded resting place and remain stationary for many weeks. Some bears limp off and die of their injuries. One adult male I caught with a punctured eye was recaptured the following year in fine shape except for being blind in the damaged eye. Canine breakage is common in adult males but rarely seen

Females do not always seem particularly interested when a male comes courting. It can take several days for a pair to form, which may be a way for the female to ensure that the male is a fit partner. Once mating starts, the pair is affectionate and tightly bonded for a period of days or weeks.

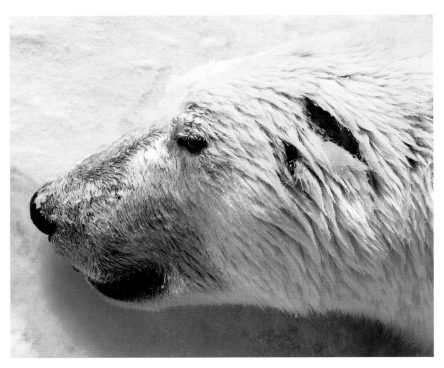

(Right) This adult male failed to avoid a well-placed swipe from another male. Over his lifetime, an adult male will acquire dozens of such injuries or worse.

(Below) This young male is full grown but still early in his mating life, which will peak in his mid-teens. The small scar on his nose is the first of many that he will acquire. Adult males can often be identified by the long penile hairs between the back legs such as those clearly visible in this bear.

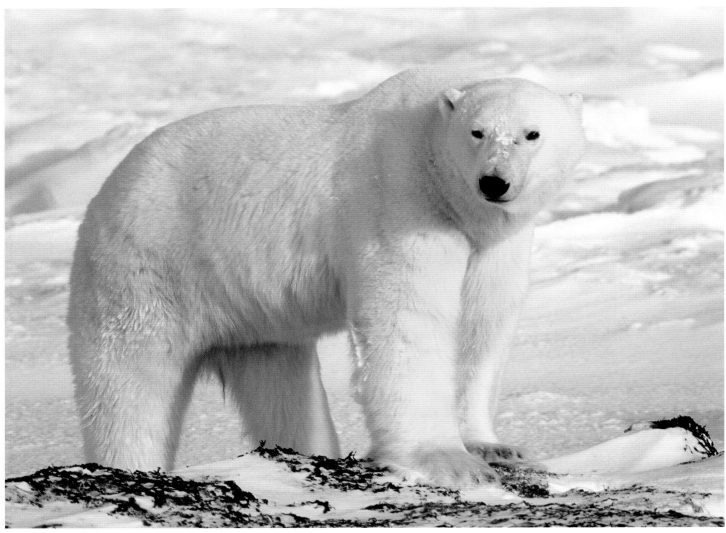

in adult females. Mouth-to-mouth contact between males smashes the canines: the force must be massive because canines are about the width of 2 fingers near the gums. Broken canines, which only result from the most severe battles, start to show up when bears are about 14 years old. Canines are commonly broken down to the gum line and the pulp cavity is often exposed. Serious abscesses into the jaw and even through the gums and into the muzzle are common. Molars rarely break, but incisors are commonly missing or broken.

Wounds do not start to show up until males are about 7 years old. They increase to about 16 years old when they start to decrease. This is about the age when males reach their peak body mass. Bears over 17 years old are starting to decline. The wear and tear of fighting takes its toll, and broken teeth may reduce feeding efficiency, adding to the list of woes. Over a lifetime, a male can accumulate an impressive collection of scars; this is an easy way to identify an adult male. Wounds and scars predominate around the head, neck, and shoulders. The largest wound I have ever seen was about 6 inches (15 cm) wide and more than 20 inches (51 cm) long, extending from the back down to the belly. The wound, deep enough to show the ribs below a thin layer of muscle, was the result of bad timing during a fight. The horribly weeping gash was a couple of months old but you could see the width of another male's paw that had ripped the hide off the bear. Despite this wound, the bear was in good condition and had started to heal. I caught the bear again the following year but the wound had only closed a bit on all sides. I ponder what it was like for that bear in the middle of winter on frigid night with a howling wind: did he walk to keep the wind off his wound or not? That was one tough bear.

Sexual Dimorphism

A difference between males and females in body size, shape, color, or other physical characteristics is called sexual dimorphism. It is a conspicuous feature of many mammals. Bull caribou sport sizable antlers, narwhal males have a tusk, and male African lions have impressive manes. The role of sexual size dimorphism in a species is relevant to discussions of ecology, mating systems, and energetics. Male polar bears are larger than females because of their mating system. Many of these traits result from sexual selection theory rooted in Charles Darwin's 1871 book *The Descent of Man, and Selection in Relation to Sex*. Sexual selection refers to the advantage some individuals have over others of the same sex with respect to reproduction. Normally, we think about males competing for females and their ability to get mates. A characteristic, despite possible costs to the individual, that enhances an individual's mating success is passed on to offspring. Such characteristics might be useful in attracting females, or in fighting with rival males.

All bear species show some sexual dimorphism but the differences are less evident in tropical bears. Polar bears show dramatic size dimorphism. Sex-based differences are a product of different growth rates and growth duration. Sexual dimorphism in mass and other traits increase with age. Twin cubs shortly after emerging from the den show no differ-

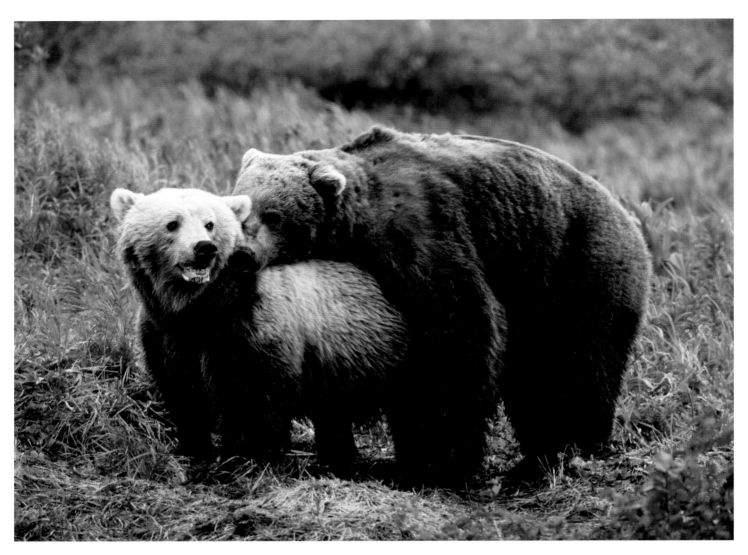

Sexual dimorphism is evident in varying degrees in all bears. This mating pair of grizzlies show the same sexual dimorphism as polar bears with males weighing about twice that of females.

ence in mass or length, but males already have longer and wider heads. By 1 year old, the faster growth of males results in their being 30% heavier and 7% longer than females. Sexual dimorphism peaks in the late teens because males delay maturation and direct energy into growth while females shift energy to reproduction. Adult male polar bears on average weigh 1.9 to 2.3 times that of females. In breeding pairs, the male can weigh more than three times that of the female. Male body length is 16% to 20% greater and their head is 14% to 17% longer and about 30% wider that the female. The wider head is a hallmark of mature males, making them appear massively larger than females.

In part, male polar bears are larger than females because of their mating system. In mating systems where males mate with many females (polygynous), larger males have greater access to breeding females. Larger male polar bears dominate smaller males and thus pass along their genes.

Sexual dimorphism in polar bears is not restricted to body size and weight. The molars of males are notably longer than females, so much so that they can be used to differentiate the sex of skulls. In addition, the sagittal crest along the top of the skull is longer and higher in males, re-

flecting their much larger jaw muscles. Another curious difference is the length of the guard hairs on the back legs of males. These hairs increase in length until the bear is about 14 years old, after which they decrease. Mature male guard hairs average around 14 inches (35 cm) in length. In females there is no variation in length with age and at maturity; they are about 8 inches (20 cm) long in an adult female. The longer guard hairs in males may be a form of ornamentation that females use to judge male quality. Ornamentation depends on an animal's genes and its physical condition. In African lions, the mane reflects the animal's condition, is an indicator of fighting success, and affects a female's choice in mates. In polar bears, long guard hairs may make a male look larger and send off "do not mess with me" warnings to other males. We do not know if the flowing locks of polar bears really result in more mating opportunities, but it is an interesting idea.

There is one niggling point in the sexual selection issue: we cannot conclude cause and effect. Because male polar bears eat larger prey than females, there could be selection for larger males because they are more successful at catching larger prey. This would mean any benefits pertaining to mating success are secondary. It becomes a chicken and egg question. Did male bears get larger because it improved their mating success or were bigger males more successful hunters and thus more successful with females? Furthermore, there is an argument that females of many species are the "ecological sex." In this case, females face selective pressures during reproduction that males do not. Males invest nothing in their offspring but sperm. Females make a multiyear commitment to their cubs. This may place constraints on females. If a female grew as large as a male, would she be able to acquire enough resources to sustain herself and her young during the den period? The energetic demands would be huge. Although the absolute amount of food required increases with body size, a larger animal needs less energy per unit of body weight. A male weighing twice as much as a female does not need twice as much food. It does, however, need substantially more. Strong selective pressures may keep females smaller while males, without the constraints of raising young, are free to grow larger. Being large and growing fast comes at a cost. Young males diverting more energy to growth are more vulnerable to food shortages than young females, which by virtue of being smaller, need less energy for body maintenance and can put more into fat reserves.

The causes of sexual dimorphism and sexual selection are complicated because so many factors are involved. Clearly, the polar bear mating system, diet, and possibly differential parental investment are all tied to why males of the species are larger than females. If we learn how sexual dimorphism arose in the fossil record of bears, we may gain new insights into the matter.

Polar Bear Pairs

While observations are limited, the mating pair, if not disrupted by other males, can remain together up to 22 days but 2 weeks is likely the norm. Mate guarding in polar bears is common. Males often herd females into

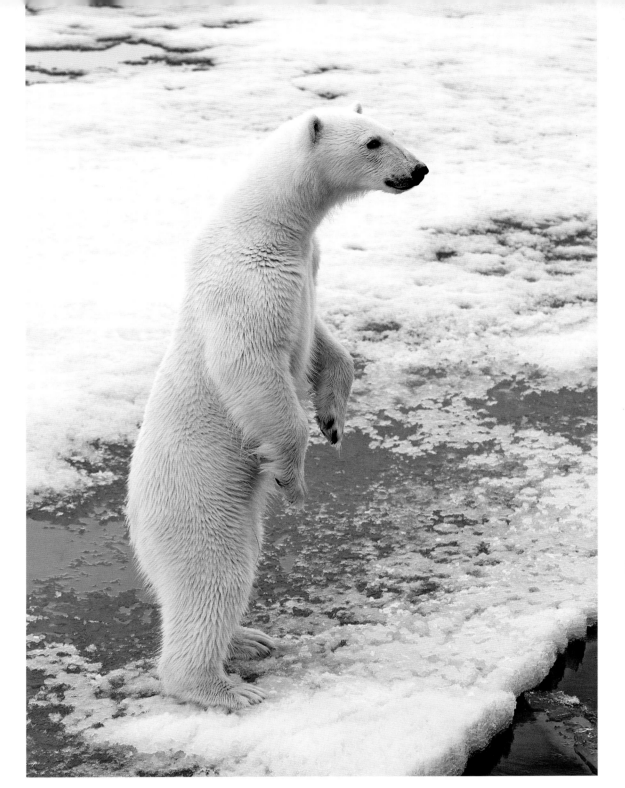

This young bear is old enough to mate, but given its lack of body fat, is likely more interested in food. Polar bears often stand to get a better look at whatever has caught their attention. In profile, many polar bears, such as this one, have a "beard" formed by longer throat hairs.

isolated areas such as remote bays, atop islands, or isolated patches of ice. Similar herding behavior is seen in grizzly bears. The key is to keep the female secluded so other males do not cross her tracks. During courtship, male polar bears make a quiet coughing sound while herding a female. Males snarl, charge, and chase females if they try to flee. There are times when mating looks more like submission than female mate choice. If the pair is disrupted by another male, they may flee together if they are well bonded. If not, the female stands aside, almost disinterested,

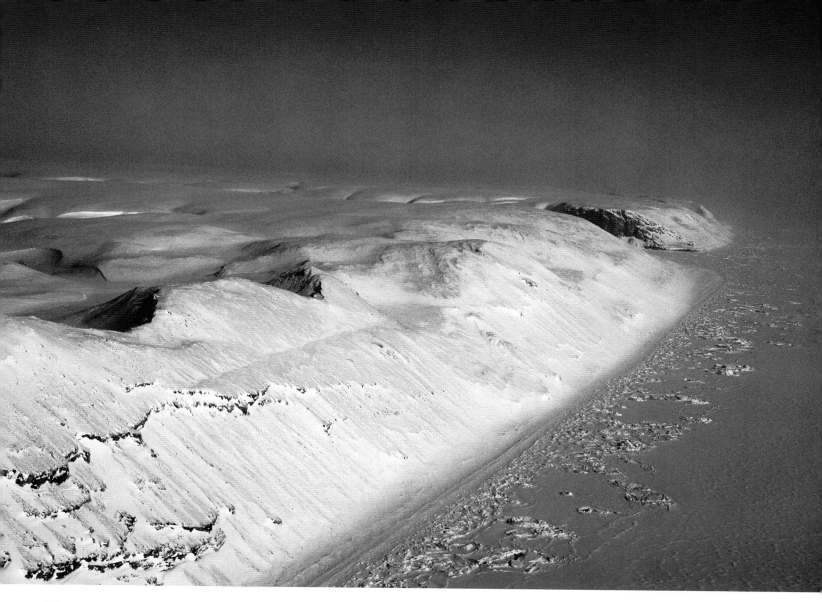

while the males sort things out. If there is an obvious size difference, the smaller male usually flees without much of a confrontation. If the males are evenly matched, displaying and parallel walking follow but eventually, fur will fly and one bear will win. Females may benefit from mating with different males through increased genetic diversity of offspring. We know that some polar bear twins have different fathers.

It is easy to tell where a mating pair has been: the area is covered with tracks. Despite the female's reluctance to begin mating, polar bears are frisky once they have paired off. Males and females become very bonded; some might say they are even affectionate. They make joining pits in the snow and sleep side by side. A common sign of a breeding pair in mountainous areas is slide marks down snowy hills. It is unclear what role sliding has but it is likely just fun. Paired polar bears seem to enjoy each other's company. Prolonged pairing may be required for the female to become receptive to the male, and because females are induced ovulators, frequent mating is needed for ovulation. Repeated copulation, which is common in carnivores, helps a male ensure paternity. When copulating, a male may hold the female's neck in his mouth. Mating

Cornwallis Island in Canada's High Arctic is prime mating habitat for polar bears. Adult males will often herd their mates onto islands to isolate them from potential competitors. These hills are also prime denning habitat for pregnant females.

can last from a couple of minutes to more than 45. I once saw a mating female collapse under the weight of the male—apparently, she had had enough and freed herself of the male through passive resistance.

Males remain with a female until she is no longer receptive. At that point, a male begins to search for another female. The female continues her manic feeding to fatten up. Male mating success is determined by the number of partners in a given year, the number of offspring sired, and the number of years he can successfully compete for access to females. A male may only successfully mate a handful of times in his prime years. Female reproductive success is measured by rearing many young that survive. This dichotomy stems from different parental investment patterns between the sexes. In human terms, males are deadbeat dads. The technical definition of the mating system of polar bears is best described as female defense polygyny (males defend a female and access to her) or serial monogamy (a male pairs with a female and stays with her until he moves on to find another mate in the same year). Repeated mating of the same bears in different years occurs but only rarely and more so in small populations. In situations where females are associated with many males, the term polyandry has been used but seems inappropriate because the female will probably only mate with one male.

At Dens

The period that families spend at maternity dens is important for cubs to develop the motor skills, strength, and endurance required for life on the ice. Families usually emerge on sunny days, but a female does not normally wander far from her den without her cubs. Over roughly a two-week period after the den has been opened, the mobility of cubs and the intensity of their play increase. Families tolerate the close presence of other families but are extremely wary of lone bears. Mothers are patient with their cubs and endure relentless swatting and nipping. Eventually mothers gently communicate that enough is enough.

Cubs partake of play that has the appearance of such human games as king of the castle, stalk your sibling, and tag. As cubs grow older, play devolves into an establishment of a dominance structure. Cubs at dens nurse for about 10 minutes at a time but how often is unknown because they also nurse inside the den. Mothers keep their cubs tidy with regular bouts of grooming.

The Social Solitary Bear

A group of geese is known as a gaggle, a gathering of crows as a murder, and a group of bears as a sloth. A particularly intriguing behavior occurs each year along the coast of Hudson Bay where aggregations of over 14 adult male polar bears occur during the ice-free period. The largest sloth is found during late autumn near Cape Churchill, Manitoba. Aggregating adult males lie in shallow pits resting on points and islands within a few meters of each other. Because the bears show strong site fidelity, spend up to four months on land, and are long-lived, the aggregations may permit a loose dominance hierarchy to develop. Size plays a role in social structure and only larger males tend to aggregate. Males of many

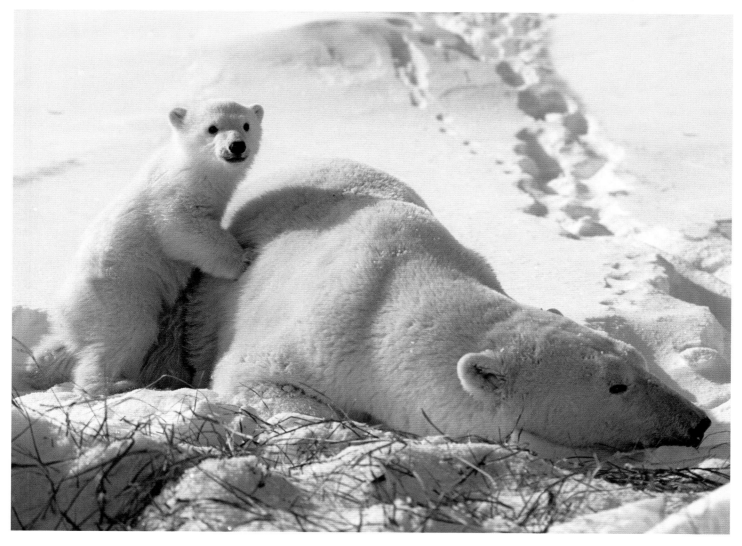

Mom might be longing for a fresh meal of ringed seal but that is no reason for her cub to relinquish its game of hop on mom.

other large mammals such as walrus, sea otter, cheetah, African lions, bighorn sheep, and elk also aggregate during nonbreeding periods. However, males of only 10% to 15% of Carnivora species gather together outside of the breeding season, so the behavior of male polar bears is somewhat unusual.

Various factors may be involved in the formation of a sloth. For example, wind is an important component of the thermal budget of polar bears in summer and cool breezes are accentuated along the coast at islands and points where bears aggregate. While they are on land, there is no food and the mating season is past. Aggregating may familiarize an individual with potential rivals and reduce serious conflicts when mating season returns and there is something to fight about. Aggregations of all age and sex classes occur at feeding sites such as whale carcasses, but again, because food is abundant, risking injury by fighting for sole access is maladaptive.

A dramatic social behavior is play fighting between adult males: usually males up to their early teens. Many immature males are energetically stressed and partake of fighting less often until they are older. The invitation to play is predicated on size and an appropriate partner is usually a

Play fighting is normally seen outside the breeding season. Only adult males engage in wrestling and the pairs are normally evenly matched. Protocol based on size and strength seems to dictate who should back down. Tempers can flare but nobody gets seriously hurt.

Polar Bear Behavior

pretty close match. Play fighting is fairly ritualized with lots of pushing, swatting, mouthing, and wrestling. Rarely more than a nick or a lost tuft of hair results. Occasionally, breaches of protocol occur and tempers flair. If a smaller bear will not concede defeat, play becomes more serious but eventually one bear flees. Play may allow a loose dominance hierarchy to form and provide information that might come in handy during the breeding season. If a bear can remember who is who, play fighting could facilitate opponent assessment and refinement of social interactions. Knowing that an opponent of a certain size can be beaten in a playful match is useful for those times when there is something serious to fight over.

Like any fighter, males benefit from training and conditioning during a period of inactivity. Play fighting uses a lot of energy and females do not partake in the pastime, suggesting there is a benefit only for males. Females have enough demands on their energy stores with nursing young and do not have enough energy to play beyond what they do with their cubs.

Females with offspring normally lead a private life, but at times, they will interact with other families. The best documented case was a 10-year-old female with twin 10-month-old female cubs and an 18-year-old female with twin female 22-month-old yearlings that tolerated close association between their offspring over 6 weeks while waiting for the ice to re-form. Lack of competition for resources seems to be a prerequisite for social behavior in polar bears.

Other forms of play and object manipulation are common among polar bears. They are adept at manipulating prey and use their claws with great dexterity. They are also attracted to novel items and will investigate them extensively. One report from the early 1860s came from Captain Charles Francis Hall, who was searching for survivors of the ill-

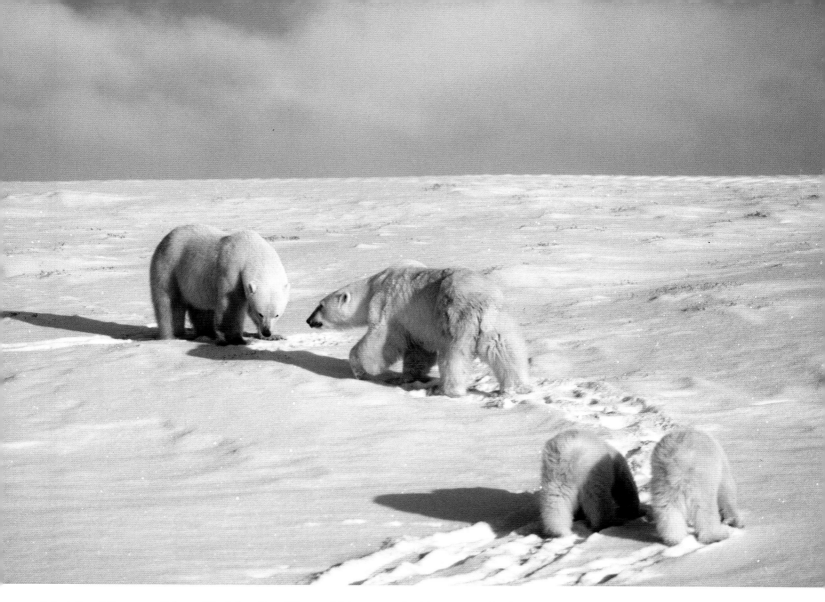

fated Franklin expedition. (Sir John Franklin and his crew of 128 were lost when their ships HMS *Erebus* and HMS *Terror* were beset by ice in the Canadian Arctic.) Captain Hall recorded a story from the Inuit:

> In August, every fine day, the walrus makes its way to the shore, draws his huge body up on the rocks, and basks in the sun. If this happens near the base of a cliff, the ever-watchful bear takes advantage of the circumstance to attack this formidable game in this way: The bear mounts the cliff, and throws down upon the animal's head a large rock, calculating the distance and the curve with astonishing accuracy, and thus crushing the thick bullet-proof skull. If the walrus is not instantly killed—simply stunned—the bear rushes down to it, seizes the rock, and hammers away at the head till the skull is broken. A fat feast follows. Unless the bear is very hungry, it eats only the blubber of the walrus, seal, and whale.

Maybe, but maybe the locals were pulling the captain's leg. A biologist, however, reported that a female polar bear used a piece of ice to smash through the roof of a ringed seal lair. Tool use, if one can call this, is uncommon among polar bears. Nonetheless, zookeepers are full of stories of bears manipulating objects with intent. Throwing objects is com-

This female with cubs is warning the male to back off. The head down position is part of a threat display. The cubs are susceptible to infanticide, but their mother will try valiantly to protect them.

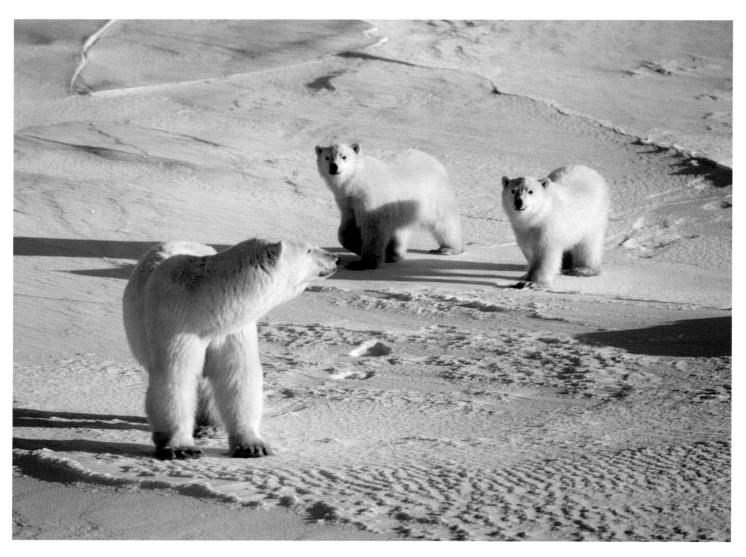

Females with young cubs, like these two just past their first birthday, avoid other bears, and the mother is constantly vigilant for impending danger. Fleeing is always preferable to fighting.

mon in captive polar bears. Males manipulate objects more than females and some seem directed in their use. Who knows, maybe they can throw rocks to kill walrus but it seems highly unlikely.

Some item manipulation may stem from boredom: the sea ice is a familiar place so anything novel is worth investigating. I once watched a large male play with a plastic tarp that had blown away from a camp. As the wind caught the tarp, the bear would pounce upon it and trap it between its paws; he appeared to be having fun. Similarly, any snow machine or all-terrain vehicle left unattended with polar bears about is an invitation to destruction. There is something about spongy seats that appeals to the bears. Over the years, I have had two helicopters damaged by curious bears. Both incidents happened at night. Sensing some give in the windows, they pounded a few out. They also destroyed seat cushions and headsets. I pondered whether these bears were not keen on our research.

Competition

Competition is a one-sided form of social behavior. Larger bears often force smaller bears off seal kills. Whenever a young bear kills a seal, there

is almost a frenzied look to them as they try to bolt down a meal of blubber before some other bear steals its dinner. There are also subtler forms of competition. One of the most obvious is seen in the distribution of bears on land and on the sea ice.

Habitat segregation is the norm for polar bears. On the sea ice, females with young cubs occupy the more stable landfast ice while adult males and females with older cubs use active ice areas farther offshore. The risk of infanticide is a driving force, but the more stable ice may be easier for cubs until they are able to move into less stable ice with more open water. And less competition for a killed seal would be a big help for mothers trying to rebuild fat stores.

Similar habitat segregation occurs on land, with adult males lounging along the shore while females with young and pregnant females move farther inland. We are not sure why females move so far inland in some areas. In Hudson Bay, family groups can easily be 50 miles (80 km) or more inland. Perhaps females are imprinting the den area on the cubs. Some bears inland are snacking on berries but the energy return does not justify the costs. Although cannibalism is rare among polar bears, avoiding other bears is a good idea.

A Ticket to Ride

Female polar bears rarely pick up cubs in their mouth after they are big enough to move on their own. I have seen a few females pick up cubs unable to climb heavy ice and carry them through the obstacle or carry them back to a den. When carried, the cubs go limp. In 1935, the Danish explorer Peter Freuchen reported that a female polar bear could carry two cubs in her mouth if frightened.

On several occasions, I have seen a mother polar bear stop while moving through deep snow to allow cubs to clamber onto her back. The

This downy cub has opted for a ride on its mother's back. The short sharp claws of the cub are like Velcro on its mother's fur. A cub can hang on through deep snow or while its mother is swimming.

sharp claws of the cubs appear to be well adapted to holding tightly to the mother's fur. Cubs often ride on their mother's back while swimming through open water. This may keep small cubs from being exposed to cold water, but with two cubs, it gets crowded at the top. Curiously, sloth bear mothers regularly transport their cubs on their backs. Some polar bear behaviors have deep roots in the bear family.

Polar Bear Behavior

11

DEN ECOLOGY

All American black bears and grizzlies den for extended periods over winter but only pregnant female polar bears den for long periods. Other polar bears sometimes retreat to temporary dens for days or weeks during particularly inclement weather or when food is scarce.

Dens offer pregnant females protection from the cold and predators while they give birth and rear their cubs. The temperature inside a den is often just below freezing and fluctuates much less than the outside temperature. The temperature inside a den can be 38°F (21°C) warmer than outside, and the warmth reduces energy use, which is important for small cubs and for females without access to food.

The distribution of den areas has long been a source of interest. In 1795 the explorer Samuel Hearne outlined the basic denning ecology of polar bears in western Hudson Bay and noted that "the females that are pregnant seek shelter at the skirts of the woods, and dig themselves dens in the deepest drifts of snow they can find, where they remain in a state of inactivity, and without food, from the latter end of December or January, till the latter end of March; at which time they leave their dens, and bend their course toward the sea with their cubs; which in general, are two in number." More than 200 years later, things have not changed very much except that females are entering dens much earlier and, in recent years, mothers and their cubs have been leaving a month earlier in response to changing sea ice conditions in western Hudson Bay.

Polar bear maternity dens are found throughout the Arctic. In some populations, denning areas are small, discrete, and clustered together while in others, denning is spread over a large area. Maternity denning habitat is abundant in most areas and pregnant females are adept at finding a place to den. Most denning areas are used year after year. There are three jewels in the polar bear denning crown with large numbers of dens: Kong Karls Land, Svalbard; Wrangel Island, Russia; and Churchill,

Wrangel Island, Kong Karls Land, and Churchill are three jewels in the polar bear denning crown. These high-density den areas produce a large proportion of the cubs in their respective populations. Elsewhere, den areas are more dispersed.

Canada. Smaller den areas are found in a variety of places but at such low densities that only broad areas can be identified.

The reasons behind concentrated denning in some areas and not in others relate to learned behavior, human harvest, ice patterns, access to feeding areas, topography, access, and wind patterns. The greatest known concentration of dens is in Bogen, a U-shaped valley in Kong Karls Land in Svalbard where the den density can reach 31.3 dens per square mile (12.1 dens/sq km). In April 1999, after flying more than 2 hours by helicopter, I approached Bogen for the first time. This is a mythic place for polar bear scientists and a nature preserve normally off limits. I had permission to catch females and cubs here to determine if this area might harbor older females that were missing elsewhere in Svalbard. Flying into Bogen valley, I was immediately aware that there were females with small cubs present. The families looked more than a little perplexed by the helicopter as they scooted up the slopes and into their dens. Soon the number of dens became apparent. In places, dens were stacked one on top of another only a stone's throw apart: a polar bear condominium complex. I never did find the older females I was looking

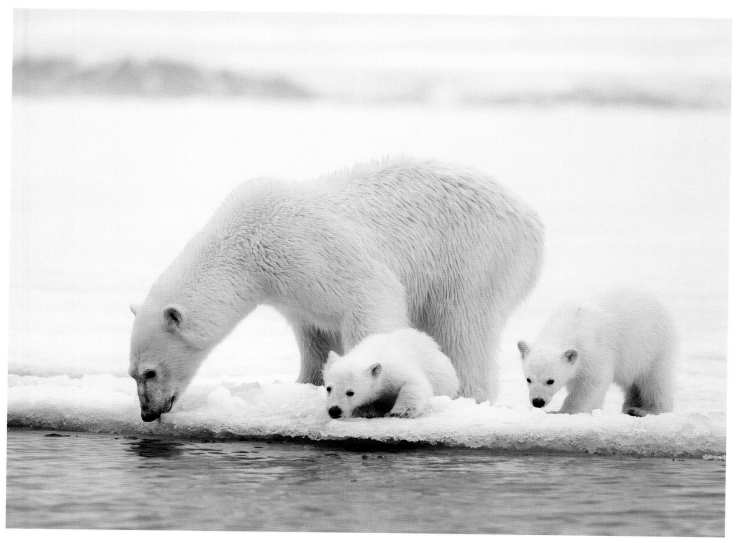

for. It remains a mystery why this population has so few old bears but a clue might lie in the high pollution levels in the bears.

High-density den areas may occur if snow suitable for denning is concentrated in only a few areas when the bears arrive in the autumn. Frozen rock offers no place to dig a den. Lack of harvesting on Kong Karls Land (it has been protected since 1939) likely meant this area was the refuge for reproducing females in the western part of the Barents Sea population. Other parts of Svalbard had been heavily harvested. Ice patterns also contribute to the area's usefulness because ice is packed into shore early in winter making access more reliable than other areas.

Reliability of access is a crucial feature of a denning area: pregnant females have to be able to get to denning habitat. In Hudson Bay, females move ashore when the sea ice melts away in July so they are forced to the den area long before necessary. On Hopen Island in southeastern Svalbard, if the ice does not show up until mid-December, few, if any, dens are present. If the ice shows up in October or November at Hopen Island, there can be well over 30 dens. Females are adaptive and if an area cannot be accessed, they will settle elsewhere. Sea ice in spring also

Monkey see, monkey do. Polar bear cubs learn by following their mother's cues. A mother would be reluctant to take such small cubs into the water.

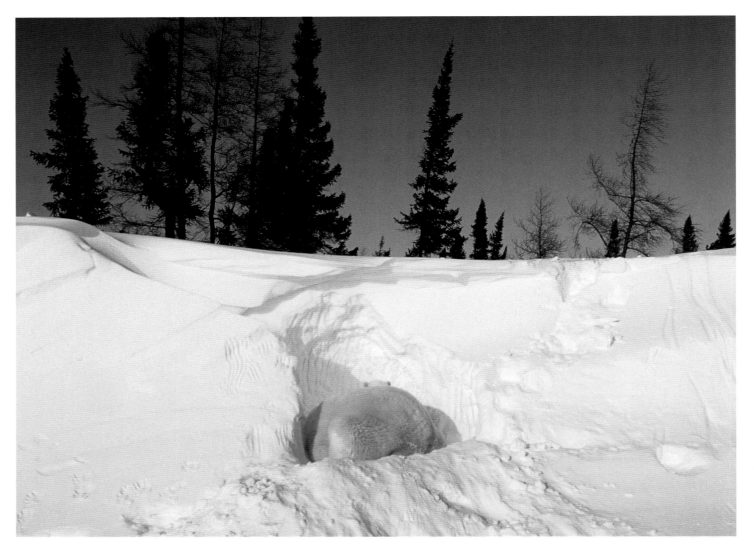

Mother and cubs retreat into a den in western Hudson Bay; the mother has enlarged the den opening. Slide marks to the far right of the den hint at the playful side of polar bears.

affects denning areas because it has to be reliably solid, with little or no open water, to allow a mother to move out from shore without forcing her cubs to swim.

There are no social interactions that might benefit denning in a concentrated area and families tend to avoid each other. Dens may be reused within a single year, however. I have seen a family leave its den to begin life on the sea ice and shortly thereafter another family move into the vacated den. Moving may reflect curiosity. Being in the same den all winter may be boring, and a mother with growing cubs might want to expand the family's environment. As they say, a change is as good as a holiday and females start to wander once the cubs are big enough to follow. From an energetics perspective, it takes less energy to use an existing den than to make a new one.

Dens are normally close to the coast. The closest I know of was about 11 yards (10 m) from the shoreline. I have also found dens the same distance from shore but perched 1150 feet (350 m) high on a cliff. Females will den on cliffs and mountains far from other bears but only if the site is easily accessed. One den in Svalbard was on the edge of a nearly vertical cliff face with a 70° slope. I do not know where the female took her

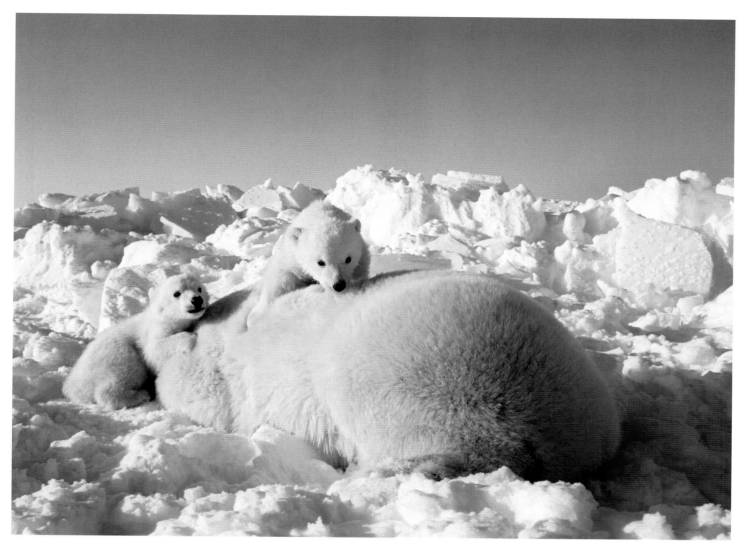

cubs to exercise, but my guess is that she eventually constructed another den somewhere less precarious. The highest reported den was 1800 feet (550 m) above sea level.

In Hudson Bay, females head 12 to 50 miles (20–80 km) inland to den to avoid the high concentration of bears along the coast during the ice-free period. Pregnant females do not like to be disturbed. One wonders about the benefits of denning so far inland when watching a female with small cubs plough through the deep spring snow along river bottoms and through forest as she heads back to the ice in spring with tiny cubs in tow. It often takes a family several days to reach the sea ice from inland dens, so the benefits must be worth the energy expended. The tradition of denning so far inland could be a relict of postglacial times when the Tyrell Sea reached much farther inland. Perhaps as the land rebounded the bears remained tied to the same areas.

Females show fidelity to den areas, if they can, but not to the exact same place or den. Pregnant females in western Hudson Bay used dens 17 miles (27 km) apart during separate denning events. In the Beaufort Sea, the average distance between dens used by the same female was 191 miles (307 km). Den areas are culturally inherited and most cubs show

Females that opt to den on the sea ice seem to do fine rearing cubs, but they risk drifting far from home over the winter.

fidelity to their birth den area. It is hard to see how gamboling balls of fur can remember where they were born and return there four or five years later, but they do. Mothers sometimes return to den areas with their cubs, which may help imprint or refresh the location.

Pregnant females were incredibly vulnerable to harvest before regulations protecting denning females were adopted. Breeding populations were depleted globally. Many den areas took decades to rebuild after harvesting stopped. Beginning as early as the 1800s, years of hunting along the mainland coast of the Beaufort Sea depleted the number of denning females. In Alaska, the only surviving females denned on the sea ice. From 1985 to 1994, 62% of the dens in the Alaskan Beaufort Sea were on drifting pack ice and the rest on land. Females tended to use the same substrate in subsequent denning attempts. Denning on the sea ice is a risky strategy. Females can drift up to 620 miles (997 km) while in dens. Drifting means a female cannot predict where the den will be when she emerges in spring, so she cannot know the distance to good feeding areas. Sea ice denning also poses a greater risk of disturbance by other bears, and there is the possibility that a sea ice den will be crushed. Despite these potential problems, females denning on sea ice are as productive as those denning on land. As the climate has warmed, however, the sea ice in the Beaufort has become less stable and sea ice denning has dropped to 37% as more females den on land. Shifts in land den areas also have been noted in western Hudson Bay. They now occur northward of where they were noted between the 1970s and 1980s.

Some den areas have had a long history; nonetheless, the sites change over time. For example, Churchill would have been deep under ice during the last glaciation. Saint Matthew and Saint Lawrence islands in the Bering Sea were once used for denning during cooler periods when pregnant females could reliably reach them, but this tradition has been lost. According to fossils dating from 3500 to 4500 years ago, polar bears in the Bering Sea were even farther south at the Pribilof Islands. Polar bears might have arrived there just as the climate cooled and woolly mammoths disappeared.

Den Structure

Snow is a surprisingly good insulator and most polar bear maternity dens are built in snowdrifts, which provide a suitable environment for small cubs. Dens are found anywhere sufficient snow accumulates including valleys, ridge tops, river or creek banks, and lake banks. On the flat north slope of Alaska, any relief over 4.3 feet (1.3 m) is potential den habitat. Snow accumulations of 6 to 9 feet (2–3 m) seem to be preferred and snow density is important. Like Goldilocks' bed, snow has to be just right: not too soft and not too hard. Fresh snow lacks structure and strength. Snow more than a year old is often compacted and may not allow a sufficient flow of oxygen into the den. Sometimes, however, the den size and configuration are limited by the substrate. I have seen several dens that were restricted by the underlying dirt so the females just had to make do.

Dens often face south or southwest throughout the Arctic because snow banks form in the lee of prevailing winds. It is also more pleas-

A classic polar bear den in the lee of a ridge has accumulated deep snow that provides crucial insulation. Shallow nursing pits to the left are a common feature once the cubs start spending more time in the open.

ant to lie in the sun in the autumn and spring than sit in the shadows. Maternity dens have entrance tunnels 13 to 49 feet (4–15 m) long, most toward the low end, and 1.3 to 3.8 feet (0.4–1 m) in diameter. Entrance tunnel length is a function of snow deposition and as snow covers the den, females dig a longer tunnel. The almost horizontal tunnels often have a slight dip in the middle or have the entrance a bit lower than the den chamber to keep cold air from draining into the den. Tunneling straight up would allow cold air and snow to fill the den. The opening of a tunnel is so small that the mother bear often has to struggle to get in and out. The small opening serves two purposes: thermoregulation and protection. By keeping the den mouth small, the internal chambers of the den can be kept warmer than the outside air. In addition, if the female and her cubs are harassed by other bears, gray wolves, or humans, it is easier to defend. For me to crawl down the tunnel into a den to look about or to retrieve cubs, I must shed my parka. Squirming headfirst into a polar bear den is an odd feeling, even when you know the mother is not there. The cubs are not a threat but it is dark once the entranceway is blocked. If the entrance is open, dens are bright enough to look about. There have been reports of mothers with both 2-year-old and newborn

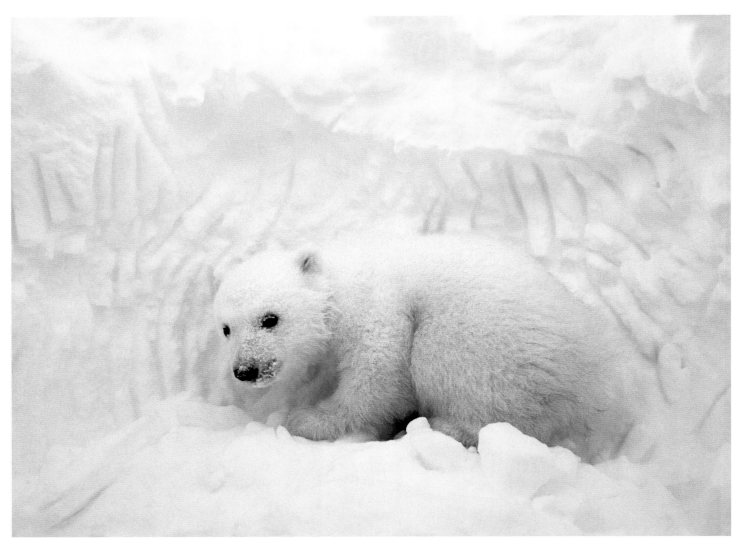

Deep claw marks in the den walls reveal the mother's remodeling efforts during the winter. Dens must strike a balance between being large enough for the mother to move a bit but small enough to keep the cubs warm.

cubs in the same den. Denning with cubs of different ages is extremely rare and likely results from a cub being forced away from its mother by an adult male intent on breeding. Once the male leaves the cub returns but their mother is now pregnant.

A den can consist of a single chamber or up to 4 interconnecting chambers. Chamber width varies from 3.6 to 7.2 feet (1.0–2.2 m); height, from 2.2 to 4.3 feet (0.7–1.3 m). The chambers do not feel roomy and the thought of spending 4 to 6 months inside a den is daunting to me. Mind you, polar bears probably would not like the cafes I frequent, so it depends on what you are used to.

Shallow pits about 1.5 feet (0.5 m) deep and 3 feet (1 m) across are often dug within 160 feet (49 m) of the den. Pits are comfy places for a mother to recline while nursing cubs cuddle up for a meal. The area around a den looks like a herd of horses has been through it if the family has been out of the den for a while. Not surprisingly, the females are hungry after months of fasting and often dig to find vegetation. The energy content of dried grass and roots is meager but may help restore gut bacteria and ready the stomach and intestinal tract for feeding again.

Females often dig secondary dens nearby, which can create a den

Females emerging from dens in spring will eat any vegetation they can find. The nutritional quality is very low, but the fiber may be important for restarting their digestive system.

complex that carves up a snow bank. One March day near Churchill, Manitoba, I landed to take photographs of a massive den complex that I thought had been vacated. It was only after donning snowshoes and walking to within a stone's throw of the dens that it dawned on me that this might be one of those fabled multifemale denning situations. Females have been known to den so close to each other that their dens join. A hasty retreat to the helicopter followed. A cautious approach is essential when studying polar bears.

Snow thickness over a den varies from mere inches to 6 feet (2 m) or more. Some dens have what scientists call ventilation holes. But whether the holes are actually used for ventilation or are just remnants of earlier den exits that have filled in is unclear. I have seen several instances where den entrances have been blown over in a storm and another opening appears in a new direction. Regardless, oxygen transmission to the den must be maintained. Normally, den entrances are closed all winter so oxygen flow through the entrance is minimal. Most dens have little ice buildup on the ceiling because females scratch ice off the den ceiling to ensure sufficient oxygen exchange with the outside. Otherwise, the den would eventually turn into a toxic carbon dioxide–filled ice chamber. During a major storm, thick snow can accumulate over a den, requiring the female to dig closer to the surface. As a new chamber is made, snow is packed into the old one. In addition to this maintenance, the dens I have been in have been very clean, with little more than a few hairs here and there. Presumably, in the manner of other mammals, the mother consumes her cubs' solid wastes.

A unique feature of polar bear ecology in Hudson Bay is the use of peat and earth dens. Most commonly used by pregnant females, dens in western Hudson Bay are dug into the deep peat banks along the edges of rivers, creeks, and lakes. Farther south in Ontario, dens are constructed

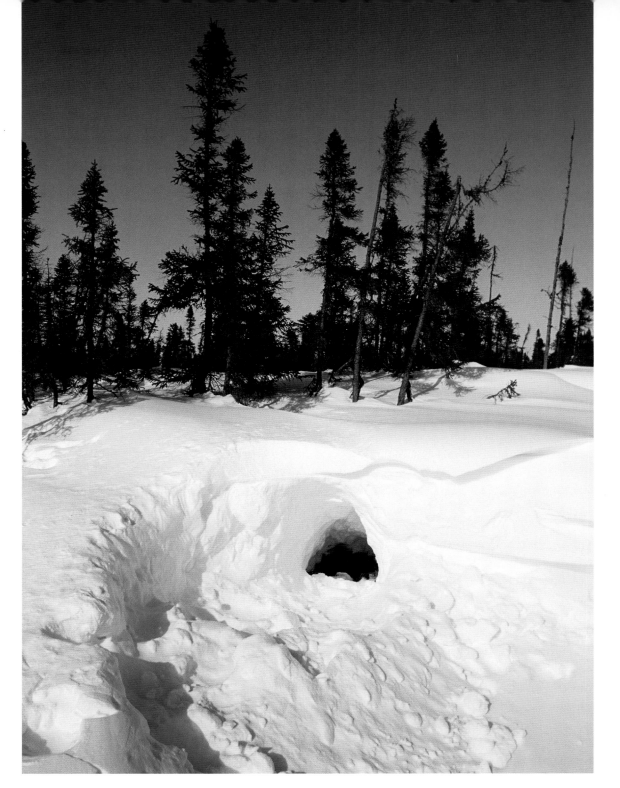

This den in western Hudson Bay has a classic opening, but part of the den is still in a peat bank which is uncommon. Lack of snow may have kept the female from completing a snow den.

in small hummocks created by permafrost or in gravel deposits left behind by glaciers called eskers.

Peat dens are usually under small black spruce trees 3 to 9 feet (1–3 m) tall clumped along the edges of waterways. In early winter these clumps create snowdrifts on the leeward side and when the snow comes, the females moves from her peat den to a snow den nearby. I have only once seen a den in spring still in the peat but the den mouth exited through a normal snow tunnel. I clearly remember my uneasiness crawling into this den to recover two small cubs hidden in the pitch black.

Peat dens are usually dug down to the permafrost layer about 3 to 6 feet (1–2 m) below the surface. The den opening ranges from 1.5 to 3 feet (0.5–1 m) wide. Most are constructed like snow dens but with a short tunnel leading to a deep chamber large enough for a bear to disappear in. Polar bears do not normally use bedding material in snow dens because vegetation is usually unavailable. A few bears, however, bring grasses, moss, and other plants as bedding material into peat dens, just as grizzlies do. Peat and gravel dens provide a refuge for the bears and they retreat into them when harassed. When biting insects attack like a bloodthirsty cloud, their numbers are markedly lower inside a cool peat den. A few adult males, usually the same ones year after year, use peat dens during the ice-free period to escape wind, sun, rain, and insects. Males usually do not move as far inland as pregnant females.

Some peat dens are used repeatedly over many years. Growth anomalies caused by excavation on the roots of black spruce growing over the dens indicate that some dens are at least 200 years old. About half the dens showed reuse within 2 years of being dug. It is easier to clean up an existing den than to build a new one, and there are hundreds of dens to choose from.

While it may seem odd that forest fires have any influence on polar bears, in western Hudson Bay fire can destroy the vegetation stabilizing peat banks, causing the dens to collapse. Forest fire frequency from lightning strikes may be increasing and denning habitat may decline although there is no shortage for now.

When to Den

The timing of den entry and exit varies between populations with southern populations entering and leaving earlier than northern ones. "Den entry" is a somewhat arbitrary term because pregnant females go in and out of dens for a period of weeks. It is common to see roly-poly pregnant females lounging outside their dens on sunny days. They will stay inside when the weather is uninviting or when bugs are swarming.

Some studies use temperature and activity sensors on satellite telemetry collars to determine when a bear enters and exits the den; others rely on direct observations. Den entry is controlled by weather, ice conditions, food abundance, fat reserves, and time of year. A fat bear can "decide" to den whereas a skinny bear may try to acquire more resources before denning. Natural selection for adequate fat stores is intense because pregnant female polar bears are consummate fasters.

Den entry is constrained by snow accumulation. In western Hudson Bay, females can use peat dens until the snow arrives, but in other areas females must wait for snowdrifts of sufficient size to develop. Peat dens can be used as early as July. In some areas, snow deposits from the previous winter can be used for dens. Females seem to slow down their movements in anticipation of denning once the snow comes. Pregnant females may be in a low metabolic state long before they actually stay in the den for an extended period.

Pregnant females in Alaska entered dens on land between 8 October and 24 November, while those denning on the sea ice entered about 2

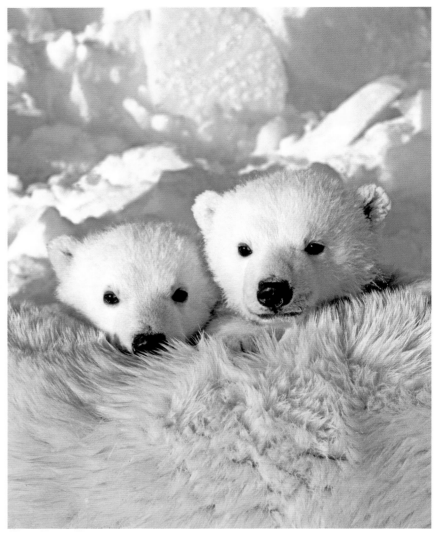

Even at den departure the male cub (*right*) is larger than his female sibling. Body weights will not differ much at this time of year, but the males have bigger heads. It takes weeks after leaving the den for cubs to develop the strength and coordination needed to travel long distances. Mothers are quite patient and will stop frequently to feed their cubs and allow them to rest.

weeks later. Denning duration was the same. In the Canadian Arctic Archipelago, some females were at their dens around 17 September; some bears were still wandering nearby until December. In Svalbard, females enter dens from October to December.

Emerging females start by digging a small opening to the surface. Some females may only stick their head out for the first week. Opening the den in this manner lowers the inside temperature and acclimatizes the cubs to colder temperatures. It is a tricky thing to measure den emergence because snow and high winds can fill in a den and the new opening can be located far from the original. In western and southern Hudson Bay, most females emerge from late February to late March. But some depart with cubs in January while stragglers can leave in late April. In the Beaufort Sea, den emergence occurs in March and April, while in the Canadian Archipelago and Svalbard, emergence is mid-March, with some a couple of weeks either side.

How long a female spends in a den is a product of sea ice dynamics, weather, fat stores, maternal age, and cub growth. Mothers need their cubs to grow large enough to travel on the sea ice; there is no point in leaving before they are strong enough to deal with rough traveling and

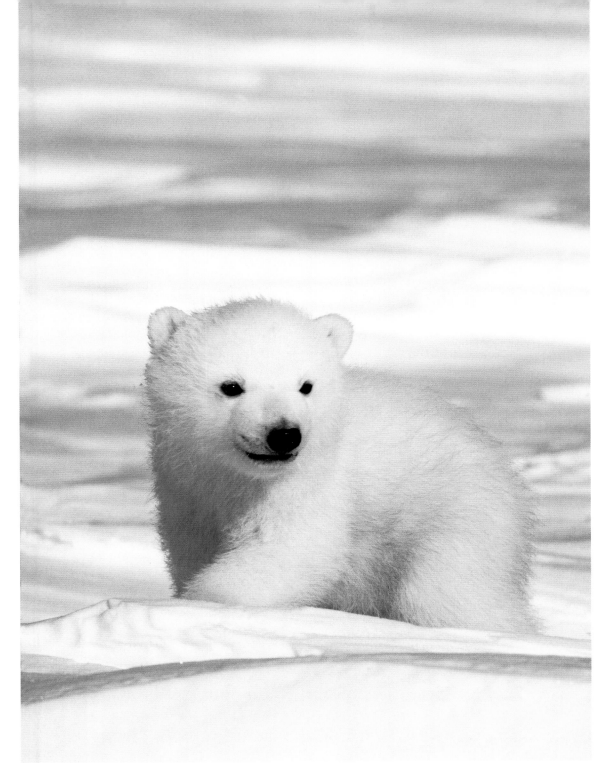

hunting conditions. Nonetheless, departure for the sea ice has to be balanced with diminishing maternal fat stores demanding that she make the move to the ice and start hunting again. Usually, the cubs are big enough to go when a female heads for the ice, but I have seen females in poor condition with tiny cubs, as small as 7.7 lbs (3.5 kg), about a third of the normal size, out on the ice. There is evidence that middle-aged females spend less time in dens than either old or young females perhaps because their cubs grow faster. Once cubs reach a viable body size, the family can head to the sea ice. The main factor is the body condition of

A polar bear cub on its first outings does not wander far from mom. But the cub's curiosity is intense, and every day brings about a bit more independence until family ties are severed at about 2.5 years old.

the mother, which dictates most aspects of reproduction. The time spent fasting in dens averages between 180 to 186 days. But in western Hudson Bay, females can be at their dens for more than 240 days, one of the longest known fasts of any mammal. The shortest known denning that produced cubs was 81 days.

Females emerge from dens with wind chill values ranging from 23 to −67°F (−5 to −55°C). They seem to prefer sunny days or those with partial cloud and little wind. Cubs tend to stay inside the den on cold days. My impression is that females are sensitive to temperature mainly because their cubs seek more attention and shelter from their mothers when they are cold. As cubs get older and larger, cold temperatures are less of a concern. After emerging from the den, the family spends 5 to 27 days, with an average of 14 days, around the den before leaving for the sea ice.

A female's progress to the sea ice depends on how her cubs are doing. Frequent nursing stops are common; the mother will often curl up for a snooze allowing her cubs a chance to recharge. Temporary dens are used if the family runs into nasty conditions or a cub has trouble keeping up. Temporary dens are simpler than maternity dens, with short tunnels and a single chamber. In some places, the trip to the sea ice is little more than a slide down a hill. In others, it is a long journey. The long distance champions of these migrations are the families of Hudson Bay in Manitoba and Ontario.

Shelter Dens and Pits

In highly seasonal environments, animals have physiological and behavioral adaptations to deal with unfavorable conditions. Denning in other bear species is such a mechanism. With the exception of pregnant females, however, polar bears have embraced winter and remain active throughout the harshest season. The only exception is use of shelter or temporary dens during periods of low food availability, extremely inclement weather, or poor sea ice conditions.

Shelter dens, which can be on land or sea ice, are smaller and less developed than maternity dens and used at irregular intervals. The timing of use varies between populations, and the presence of sea ice is a determining factor. Some polar bears use shelter dens in summer and autumn while waiting for the sea ice to return. During winter, bears farther north tend to use shelter dens for longer periods, but use varies from a single day to up to four months. One difficulty in studying shelter den use is that failed pregnancies can appear like shelter den use. Adult females without cubs often leave den areas in December or January, about 1 to 3 months earlier than the emergence of mothers with new cubs. These bears would appear to have used a shelter den, when in reality, their cubs died and they abandoned their maternity dens.

During storms, bears simply curl into a ball and allow the blowing snow to accumulate over them. After a few hours, one has little idea that a bear rests under the snowdrift. It is amazing to see a large bear pop out of these shelters and shake the snow off. Sitting under the snow in the lee of a pressure ridge, is a lot more comfortable than being exposed to the wind. At Cape Churchill, I have seen more than 20 such bear drifts,

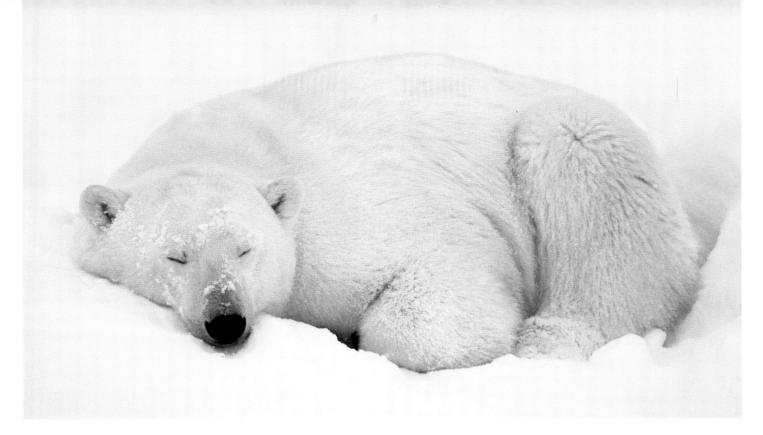

all nicely hidden around the tower I was living in. Going to the lake to chop out the ice and get some water was an interesting event.

Pits are used by all bear species as resting places anytime of year. Dug in snow, sand, gravel, or peat, pits used by polar bears are up to 5 feet (1.5 m) in diameter and up to 1.5 feet (0.5 m) deep and can be thought of as polar bear armchairs—they function as a comfortable place to sit or lie. Apparently, it is more comfortable for a polar bear to lie in a pit than to lie on a flat surface. In peat areas, pits often reach to permafrost and aid in cooling. In some areas, males select beach ridges and lake edges to dig pits and use them for sleeping and loafing. Sometimes pits are little more than a surface scraping; other times they are well dug out. In high use areas, the ground is so pitted it looks like the surface of a golf ball from the air.

When it is time to sleep, there is no reason not to be comfortable. Polar bears dig shallow pits in snow, sand, or gravel to relax in.

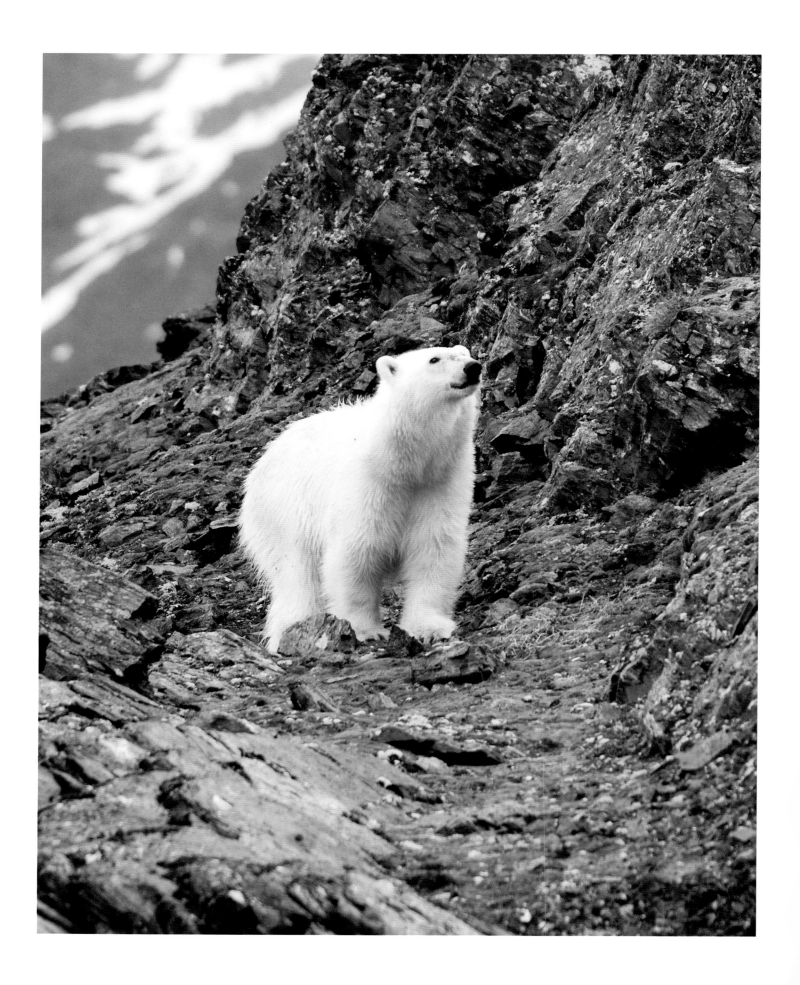

12

FROM BIRTH TO DEATH

Polar bear reproduction begins when a mature female enters estrous, the period of sexual receptivity. Male polar bears determine estrous by scent; polar bear scientists identify it by a female's swollen labia. We do not know how long female polar bears are receptive, but given the protracted breeding season it is likely several weeks. Estrous is controlled by day length (photoperiod). We suspect nursing females cannot enter estrous unless an adult male chases away or kills dependent young.

Ovulation in mammals is either spontaneous or induced. Spontaneous ovulators, such as humans, release eggs at regular intervals, whereas induced ovulators release eggs following copulation. Induced ovulation is common in many mammals, including shrews, weasels, cats, seals, whales, and some rodents. It is believed that American black, grizzly, and polar bears are all induced ovulators. From an evolutionary perspective induced ovulation is advantageous because females can coordinate ovulation with mating opportunities. Induced ovulating females may remain in a premating state for an extended period until a male is encountered. Because encountering a male is unpredictable, waiting to ovulate makes evolutionary sense. How much mating is required to induce ovulation is unknown, but once polar bears start copulating, they do so often.

Determining gestation length in polar bears is tricky. Technically, with mating in spring and birth in early winter, 7 to 9 months might make sense. But following copulation and fertilization, embryos only develop until they reach a multi-celled state called a blastocyst, which then enters an arrested development state (embryonic diapause or delayed implantation). The blastocyst will not implant into the uterine wall until the autumn when development starts again. Thus active gestation is only about 60 days. This explains the weakly developed state of newborn polar bears. The factors that control implantation of the blastocyst are poorly understood but photoperiod likely plays a role. Given that preg-

(Opposite) **A subadult female stranded onshore during summer explores the base of a seabird colony for a possible snack.**

The fading light of an Arctic summer cues hormonal changes in a pregnant female that prompts her to head for a den. This iceberg near Greenland is not an important polar bear habitat, but bears sometimes climb aboard to use it as a resting spot.

nant polar bears enter dens in the autumn or early winter, they may not permanently enter dens without first implanting, thus the timing of autumn den entry may be cued by day length.

Delayed implantation is a specialization from the primitive condition of a fixed gestation length. Delayed implantation is common in carnivores and occurs in 7 of the 12 Carnivora families including the weasel and seal families. Given that it exists in all bears, it is not a specialization by polar bears but an ancestral state. Delayed implantation allows breeding to occur in the spring and ensures that the departure from dens coincides with optimal food availability. Birthing in winter and emerging from dens in spring coincides with ringed and bearded seal pupping when an abundance of food is available for females to meet the high-energy demands of lactation. If polar bears did not delay implantation, the breeding period could be in the autumn, 60 days before birth. But autumn is a time of great environmental change. The sea ice is either advancing or retreating and, in some populations, bears are dispersed on land or over broken ice. This seems an unlikely time to be seeking mates and expending substantial amounts of stored energy. Polar bears could reproduce following other patterns but the one they follow is very simi-

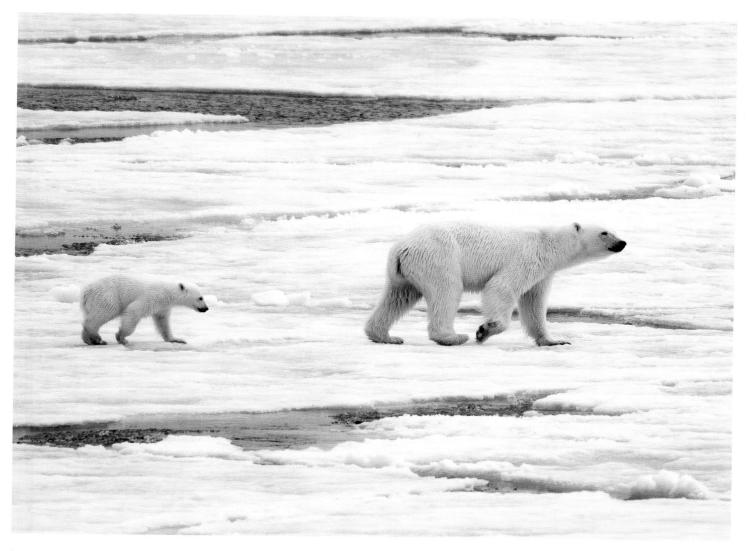

lar to grizzly bears. Ultimately, the pattern they have inherited works, so there is little selective pressure to change.

One advantage of delayed implantation is that it provides a mechanism to adjust reproductive output before any major investment of maternal resources has been made. Polar bears, as well as some other bears, must acquire and store resources to sustain themselves through a long fast, during which mother bears give birth and nurse young. The energy allocated to rearing young must be added to the energy required by the mother for survival. Given that breeding, and thus the number of fertilized eggs, is determined before the fat stores are acquired, a female might adjust her litter size before implanting with little energy investment. If maternal resources for the pregnancy are low, perhaps only one cub will be implanted; if the female has lots of fat, she could implant three.

The timing of autumn implantation coincides with a spike in blood progesterone levels. Given that den emergence varies by up to 2 months between populations and cubs are roughly the same size at emergence everywhere, implantation dates must vary by population. The lower latitude populations emerge earlier than higher latitude areas, suggesting earlier implantation in southern areas.

After months without feeding, adult females with young cubs are eager to replenish their fat stores. Cubs cannot hunt effectively until almost 2 years or older, but they quickly learn to obey signs that mom is hunting and will remain stationary until they are given the all-clear to rejoin her.

Pregnant polar bears perform an amazing feat by producing and nursing cubs while simultaneously undergoing one of the lengthiest fasts of any mammal. Western Hudson Bay females hold the record for fasting. They begin fasting in late June or July, when they arrive on shore with the sea ice break-up and end eight months later, in February or March, when they return to the sea ice. Most of what we know about pregnant females comes from studies in western Hudson Bay. Females in other populations fast for shorter but still impressive lengths of time. That pregnant females can reproduce without eating is a physiological marvel.

Pregnant females are easy to recognize by their chubby appearance. Doubling or tripling body weight during pregnancy is normal. Most of the weight gain is fat, but there is also an associated increase in the muscle mass required to move so much additional weight. A pregnant polar bear in the best condition is the fattest bear in a population. One lone female caught in November in western Hudson Bay was 218 pounds (99 kg). By the following July, the now pregnant female weighed 902 pounds (409 kg): more than a fourfold increase. She went on to produce triplets.

Once pregnant females leave the sea ice, they eat little or nothing. This is in part because there is little nutritious food, but also because their physiology changes to conserve energy and shutting down the digestive system is part of the process. Pregnant females in western Hudson Bay must exceed a weight threshold of 420 pounds (190 kg) to reproduce successfully. Other populations may have lower thresholds if their fasting period is shorter. Females under the threshold are unable to fast long enough to produce viable cubs. If enough weight is gained, a physiological signal triggers embryo implantation in the autumn. Skinny pregnant females forgo the reproductive attempt. Females on the edge may try to den but they often fail and head back to the ice midwinter without cubs.

Pregnant females in western Hudson Bay undergo massive weight changes from autumn to spring. An average pregnant female weighs 635 pounds (288 kg) in the autumn and loses an average of 280 pounds (127 kg) or 1.6 pounds per day (0.7 kg/day) over the winter. Normally, 23% to 55% of the autumn weight is lost. The record loss was 495 pounds (225 kg). Pregnancy dynamics in other populations are poorly understood but are likely similar. Most of the weight loss is fat but some protein, calcium, and minerals are transferred to cubs. Females that are heavier in autumn leave heavier in spring even though they lose more weight. Fat stores, beyond those required to rear cubs in the den, provide a buffer against variation in the availability of seals, enabling a mother more time to find food.

The Number of Cubs in a Litter

Cubs are born from November to January, with southern populations a month or more earlier than northern ones. A litter usually consists of two cubs, although sometimes only one and sometimes three are born. Only one litter of four cubs has ever been recorded. Average litter size across populations is 1.7 cubs but this varies between populations and

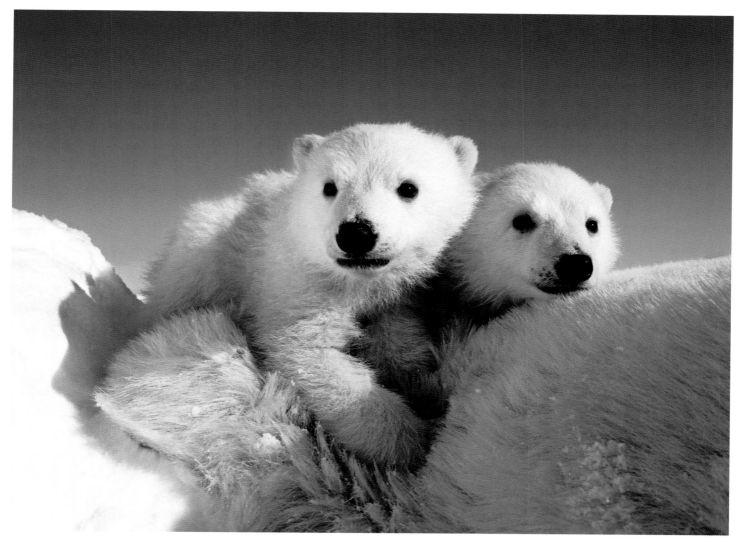

over time from 1.5 to 2.1 cubs per litter. Historically, 12% of the western Hudson Bay spring litters were triplets; other populations have less than 4% triplet litters. Litter size in western Hudson Bay has declined with the increasing length of the ice-free period and triplets are now uncommon. Comparing litter size between areas is not easy because cub mortality increases when cubs leave the security of the den. Some studies determine litter size near the den while others do so once the bears are on the sea ice.

The number of cubs a female has with her when she leaves the den is a function of maternal age and condition, genetics, and cub survival. Younger and older females have fewer cubs than 14- to 15-year-olds in prime condition. The fattest females are more likely to produce triplets while the skinniest tend to produce singletons. Genetics may play a role in litter size but information about this is scant. In the Beaufort Sea, only two triplet litters have been caught on the Canadian side; both were produced by the same female caught many years apart despite dozens of other females being sampled. It is possible that this female was a good hunter, which allowed her to attain the condition required to rear triplets. Or possibly she has a genetic predisposition to produce three cubs.

Twins are the norm for polar bear families though identical twins are rare. Twin females and twin males occur about equally; about half the families are one female and one male.

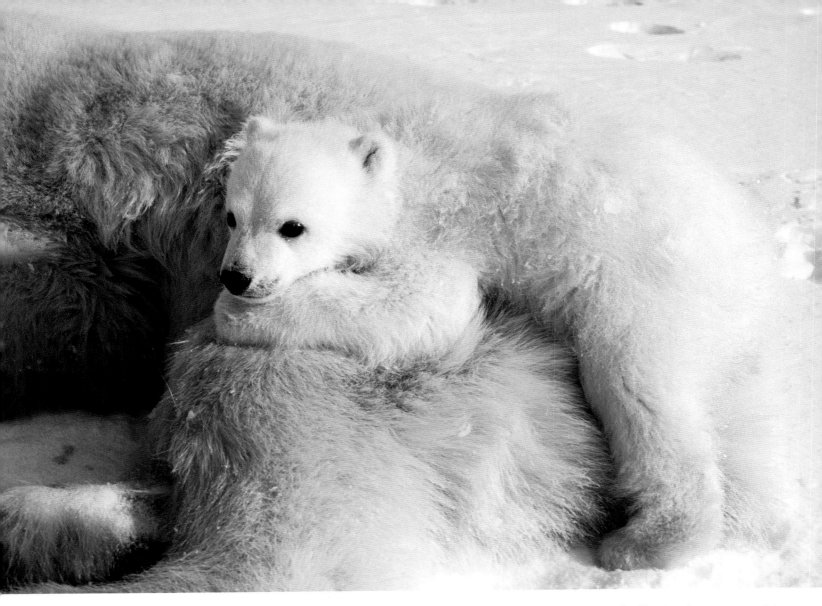

Singleton cubs are usually born to the youngest and oldest females. In general, singleton cubs are larger than the average twin or triplet cub. Singletons do not have to share their mother's resources.

In theory, females might produce "extra" offspring in an attempt to tilt the odds of passing on genes in her favor. If conditions are good, all cubs survive. If conditions are poor, one or more cubs will die. A mother has little control over cub mortality if sibling competition increases and the weaker cub dies. Mortality can adjust litter size to accommodate available resources. A female's investment in her cubs is small until they have nursed for a long period, so losing a young cub is not a major loss of energy. Females are not, of course, scheming to have a cub die. It is a natural consequence mediated by physiological controls. Extra young also serve as "replacements" if any offspring die or develop abnormally.

The oldest females in a population usually rear only a single cub. Reproductive senescence is of trivial importance from a population perspective because there are few very old females and their contribution to the population is small. However, from an evolutionary perspective and for individual reproductive success, reproducing late in life is adaptive. Females can produce cubs up to 27 years of age, so the reproductive lifespan can reach 22 years if the first litter is produced at 5 years. Females over 20 years old are usually in poor condition but by producing a single larger cub, they may succeed in rearing a few additional young.

What older females lack in fat stores may be compensated for by hunting and mothering skills. From a reproductive success perspective, the last seven years of life could contribute 22% to 33% of a female's lifetime reproductive output.

Polar Bear Cubs Are Small at Birth

Bears are rule breakers. Normally, mammals with a well-developed placenta (not marsupials or egg-laying monotremes) give birth to young whose total weight at birth is related to the weight of the mother. Species that weigh more give birth to litters that weigh more. There is variation in the relationship but the general pattern holds from the smallest of mammals, the 0.05 ounce (1.4 g) Etruscan shrew, right up to the 200-ton (180-metric-ton) blue whale. Some species have heavier litters than expected but polar bear cubs and other bear cubs weigh much less than expected. If polar bear cubs held to the mammalian birth weight rule, then a typical female of 660 pounds (300 kg) should produce cubs weighing about 60 pounds (27 kg) at birth, which is 40 times what cubs actually weigh at birth. Variations exist in all aspects of the mammalian world, including birth weight: blue whales at birth are about 2% of their mother's weight, humans about 6%, bats around 30%, and some rodents over 50%. Each polar bear cub is only 0.2% to 0.3% of its mother's mass.

Polar bear cubs at birth are extremely small relative to the size of their mother. A cub weighs about 1.5 pounds (0.7 kg) while its mother can easily top 440 to 660 pounds (200–300 kg). Cubs are born with their eyes closed and have short, densely spaced hair about 0.2 inches (5 mm) long, with 4200 hairs per square inch (650 hairs/sq cm). Being so small, the cubs' surface area to volume ratio is high making it difficult for them to keep warm: in essence, their small bodies cannot generate much heat but they lose a lot through their skin. Cubs are born with little fat under their skin. Internal fat deposits are small and clustered mainly around the kidneys as brown fat, which is specialized for heat generation. The cubs' skeletal muscles contain numerous mitochondria (a cell's power plant). The energy rich molecule glycogen typical of newborn mammals provides energy to help keep the infant warm. Newborn cubs have a very high metabolic rate relative to other terrestrial mammals and need a lot of energy and maternal attention to keep warm.

The reproductive ecology of polar bears yields insight into why cubs are so small at birth. Females conceive during early spring, often after separating from 2-year-old cubs that may still have been nursing. Females coming into the mating season are, therefore, unlikely to be in good condition, and they breed before the resources available for pregnancy have been accumulated. In autumn, a pregnant female, if she has acquired enough stored body fat, enters her den, and starts an extended fast. The only water available is snow. The female implants, gestates, gives birth, and nurses young relying solely on fat stores. Few mammals, except large baleen whales, fast as long during active gestation. While bears are consummate fasters, huge physiological changes make fasting and pregnancy challenging. Cubs may be born so tiny because their mother's use of fatty acids from the breakdown of stored fats can-

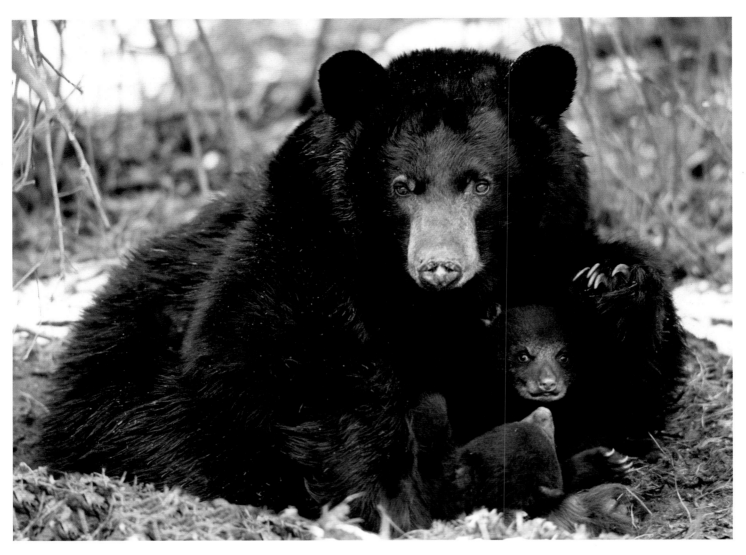

Small cubs at birth are a hallmark of the bear family. These American black bear cubs would have been even smaller at birth than their polar bear cousins.

not be used easily by developing cubs as an energy source. Part of the difficulty in using fatty acids for energy stems from the large amount of oxygen the cubs would need to burn them. A mother could use her protein stores and convert them to glucose, which the cubs could use, but breaking down too much protein puts the mother at risk of weakening her own muscles, rendering her unable to return to the sea ice. Protein conservation is a hallmark of denning polar bears, so this is not an option. The solution to the problems associated with fasting and gestation is to give birth to small cubs in a sheltered den and then to nurse the cubs on fat-rich milk. The cubs are able to get enough oxygen to use the fatty acids in the milk to meet their energy needs and fuel their growth. The 15-fold growth in cub weight from birth to den departure attests to milk doing a fine job of plumping up cubs.

The big question surrounding this explanation is a chicken and egg riddle. Which came first: winter dormancy in dens or small cubs. There is some evidence to suggest that small cubs came first and denning later. Supporting this assertion is the lack of prolonged denning in the giant pandas and tropical bears. But there is contrary evidence to suggest that the ancestors of bears were denning over 10 million years ago. In any

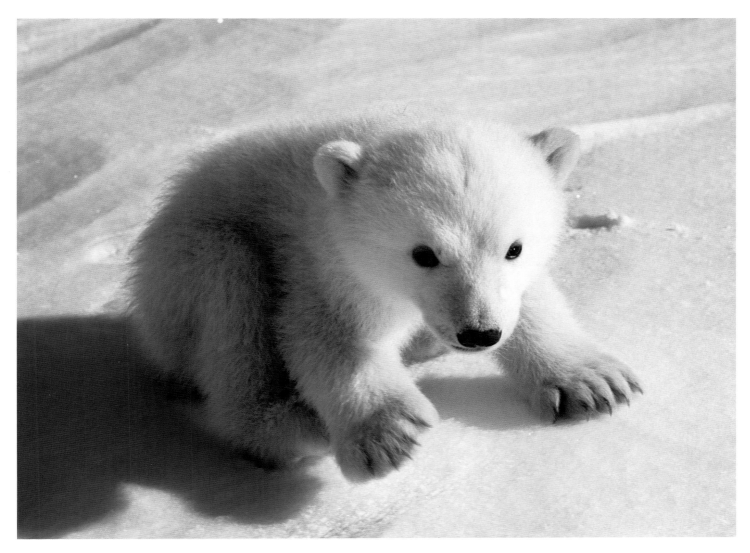

case, today's bears have small cubs and physiology plays a role. Gaps in the fossil record and little record of early reproductive ecology make teasing apart the evolution of bears difficult.

What other implantation and gestation strategies are available to pregnant females? With delayed implantation, a female could implant earlier in the summer and give birth to larger offspring. Energy and timing would be the difficulties encountered in this strategy. If a female gave birth to two 22-pound (10-kg) cubs, then she would have to support the energetic demands of two large growing cubs. Such large cubs would weigh 88 to 110 pounds (40–50 kg) when they departed for the sea ice in spring. Winter is not a great feeding season, so leaving the den earlier would not necessarily yield more food. But a female could not store enough fat, protein, and minerals to produce such large cubs and nurse them through the winter. Therefore, implanting sooner seems an unlikely option.

There are other benefits to giving birth to small cubs. Being in a den does not constitute a major investment in reproduction. A female could return to the sea ice at any time and forgo reproduction for that year. Small cubs means the energy investment is small. The major energetic

The odds of survival for small cubs like this one are not high; their chances improve markedly if the mother is a good hunter. Females in their mid-teens seem to be the most capable hunters, but even then, some are more skilled than others.

Polar Bear Milk

Milk is a diagnostic characteristic of mammals. But it varies between species with regard to the proportions of its basic constituents—water, fat, protein, sugars, vitamins, and minerals. Milk composition also varies over time. The first milk a polar bear cub drinks is quite different from its last maternal meal.

We cannot sample wild females with newborn cubs, but we know from captive polar bears that colostrum (milk produced in the first hours or days after birth) is high in solids and contains antibodies that are important for protecting the cub. Colostrum in polar bears is higher in protein than fat; those proportions switch before long.

Polar bear milk is viscous and white with a yellowish tinge. Bears have much richer milk than other carnivores and polar bears have the richest milk of the bears. The fat content in the mother's milk fuels the rapid growth of cubs, which are tiny at birth (and have very small stomachs). Polar bear milk, which is more in line with the milk of seals and whales than that of American black bears or grizzlies, can be 46% fat. Fat content declines as cubs get older. It can be as low as 5% just before the mother stops producing milk. Protein content varies from 5% to 19%; sugars can constitute 6%. Minerals make up less than 2% of the milk, which has a variety of vitamins including A, B, D, and E.

Polar bear milk, like that of other bears, is low in lactose (a sugar) but high in specialized sugars called oligosaccharides, which are much more abundant in bears than in other carnivores. Oligosaccharides have an antibacterial role. The only other groups of mammals with oligosaccharides levels as high as bears are the egg-laying monotremes and the marsupials. Both these groups also give birth to underdeveloped young.

How do you milk a polar bear? Very carefully. Cubs are a lot more effective than biologists at getting milk from a mother bear. We inject the female bear with oxytocin, a hormone that stimulates milk letdown. After a few minutes, a gentle downward massaging of the mammae will provide our sample. Polar bears are not generous with the quantity of milk released but we only need a few thimblefuls for our analyses. Scientists are, by definition, curious people, polar bear researchers no less so than others. I have tried the occasional drop of polar bear milk. It has a rich, marine, earthy, chalky taste with a finish vaguely reminiscent of fish.

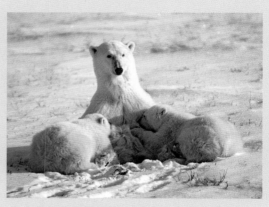

Polar bear mothers produce fat-rich milk that fuels the high energy demands of their young. The energy transferred to cubs drops as they grow and rely on seals killed by their mother. Nursing maintains the family bonds and cubs will suckle until 2.5 years old.

costs come with lactation. Aborting cubs, or abandoning cubs soon after birth, makes evolutionary sense if a female is unable to meet lactation demands. Therefore, giving birth to small young may be advantageous and not simply a physiological constraint.

Finally, would larger cubs really be an advantage over the existing pattern? Perhaps not. By the time cubs leave the den, they weigh about 22 to 26 pounds (10–12 kg). With an average of 2 cubs, the litter weight at birth is close to the weight expected for mammals the size of a polar

bear. In essence, the den for bears is like an extension of the internal development of young. Overall, polar bears, and other bears, have evolutionary baggage. "What if" scenarios are unlikely to explain processes that have evolved over long periods; nevertheless, such speculations are interesting. Simply put, small cubs work for polar bears. The complete explanation for such small cubs is likely to remain a mystery until we have a full understanding of pregnant females' denning physiology.

Interbirth Interval

The interbirth interval, the period between litters, is determined by a variety of factors. Most important is offspring survival. If cubs die shortly after leaving the den and before the end of the mating season, a female could be pregnant two years in a row. If the cubs die after the mating season or as yearlings, there may be two years between pregnancies. Polar bears that successfully rear young to weaning at 2.5 years have a 3-year interbirth interval.

Jumbos and Runts

Natural selection has produced various strategies to maximize reproductive success. Sex-biased parental investment or shifts in offspring sex ratios may be adaptive under some conditions. In theory, a mother should alter the numbers of sons and daughters produced and the resources allocated to them in a manner that passes along the most genes. In polygynous and sexually dimorphic species, greater maternal investment in males may be beneficial because bigger males should sire more young than small ones and female offspring of any size should do fine rearing young.

Theoretically then, differential maternal investment should result in larger male polar bear cubs. This theory fizzles, however, because growth during maternal care has little effect on the adult size of male polar bears. Males do much of their growing after they are weaned; therefore, differential maternal investment does not alter their full-grown adult size very much. Despite this, some sexual dimorphism is evident in 3- to 4-month-old cubs, where males have larger heads than females but they weigh the same. A 1-year-old male, however, is much larger than a female sibling. A 2-year-old male is almost as large as his mother; a female sibling will be noticeably smaller. We do not know what accounts for this difference; males may eat more from kills or mothers may nurse them more. Overall, a mother should not invest more in male offspring than female offspring because the male's size is determined by environmental conditions after he is weaned. Mothers may not have full control over the growth of their cubs.

Sex ratio is another element females might be able to adjust. If raising males is more energetically expensive, then altering maternal investment depending on the mother's condition may make evolutionary sense. In spring, mothers have slightly more male cubs at about 53%. However, mothers with a single cub have a preponderance of males, at about 67%. Mothers with triplets tend to have 57% female cubs. Perhaps raising one

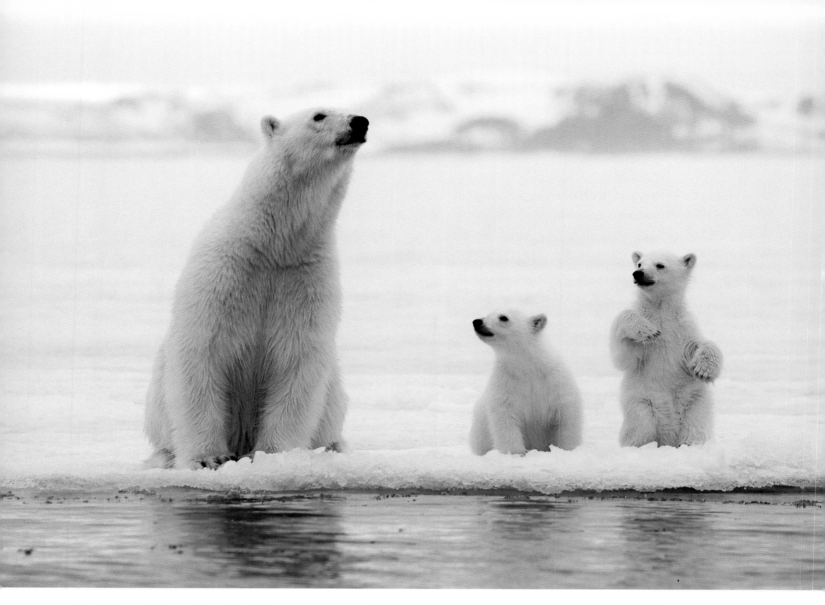

(Top) Theoretically, mothers should invest more energy in rearing male cubs because a large male will pass along more genes than a small one. Sibling rivalry certainly drives resource allocation, but little scientific evidence supports the assertion that mothers intentionally provide more nourishment to sons than to daughters.

(Right) Such well-matched twins are often of the same gender. Competition is intense between cubs.

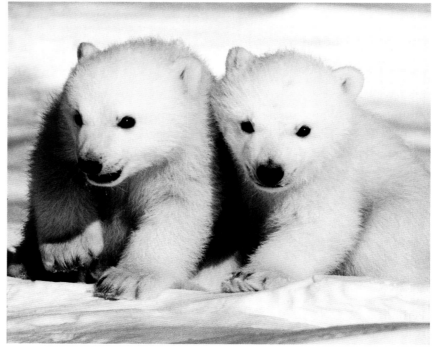

Polar Bear Adoptions

Very rarely, a female will adopt the cub of another female. Only young cubs are adopted and usually those less than 6 months old. We know adoptions occur from tagged cubs showing up with a different mother and from DNA analyses. Theoretically, females could benefit from rearing cubs of related females, but most adoptions occur from a mix-up and are not adaptive. We are not sure how adoption happens but there are some likely scenarios. A female with cubs might show up at a kill site where a mother and cubs are already present. The cubs at the site may take off while mom deals with the approaching threat. Grizzly and American black bear mothers can send their cubs up a tree if danger approaches; polar bear cubs seem to make their own decision to take off and hide. Young polar bear cubs will wait for mom to find them after the danger passes. Older offspring will track mom down. A cub separated from its mother will eventually start bawling, eliciting an intense maternal response to find the crying cub. If more than one female is in the area, the dominant female could claim the crying cub even if it is not hers. Alternatively, a cub might follow a fleeing mother and her cubs. The mother may not recognize that a new cub has joined the group, and once away from the threatening situation, a female will attend to all "her" cubs. I am not convinced female polar bears can count, and a female that had one cub might be content to care for two. Because mother and cubs remain close to each other and normally do not mix with other bears, natural selection for mother-offspring recognition may be weak.

big son if a female only has one cub or more daughters in a triplet litter may be evolutionarily beneficial, but more investigation is needed. Overall, nothing dramatic jumps out in polar bear sex ratios.

Cubs leaving the dens vary widely in weight. The smallest cub I have caught weighed a meager 6.6 pounds (3.0 kg) and the largest was a whopping 54 pounds (24.5 kg). Both were singletons and the big cub survived but the small one did not. On average, single cubs are much larger than twins and triplets are the smallest. Triplet litters are often "two and a half cubs"—there is normally a jumbo cub, a middle cub, and a runt. The jumbo cub can weigh three times what the runt weighs. All three cubs might survive, but the runt often disappears soon after, or even before, leaving the den. With ragged fur and cuts on their ears where siblings have wrestled with them, runts usually look like they are having a tough time. Their smaller size is tied to the fact that larger siblings monopolize nursing.

Time to Leave

Perhaps the largest investment decision that a female must make relates to the length of time that her offspring remain with her. Young are nor-

Two-year-old cubs often lead the way, with mom bringing up the rear. By this age, cubs are able to kill seals independent of their mother although the family will share the meal.

mally weaned at 2.5 years old but may leave a year earlier or, rarely, a year later. If a female did not find a mate, her young might stay close by. Weaning yearlings is challenging to explain. Mothers should wean young when a balance is reached between the survival of the current litter relative to the evolutionary benefits of having another litter.

What drives a mother to wean her cubs? The answer is complex, likely having to do with food availability, size of offspring, maternal condition, and adult males wanting to mate. Males will chase off a female's young if the mother is in estrous. Offspring learn that they are not wanted and leave to begin life on their own.

Family break-up is a process. Young cubs are almost always at their mother's heel; yearlings wander farther away and gain some independence. Two-year-old young are regularly out of sight of mom, hunt independently, and then join back up with mom. Following 2-year-olds while they are hunting is a recipe for airsickness. They check every pressure ridge and dig at a huge number of lairs looking for a meal. Their hunting success results from sheer effort but they are able to kill independently and this is an important part of the weaning process.

The mother-offspring bond weakens with 2-year-olds. When a moth-

er severs the family ties, she sometimes just walks away from her young. No fond farewells, just a disappearing act. Young might try to track their mother, but hunger finally takes over and they turn to hunting. Young that do not get the message can be vigorously chased off by their mothers. They eventually get the idea that they are unwelcome. Siblings often end up traveling together for some weeks or months afterward, but eventually even these bonds melt away and the bears are on their own.

Weaning at 1.5 years was common in western Hudson Bay up to the 1980s when 55% of the yearlings were independent of their mother. Such early weaning is rarely seen in other populations. The reason for early weaning remains a mystery but some theories are worth pondering. The age and condition of mothers as well as the sex of young may play a role. But weaning of yearlings varied from year to year, suggesting that environmental conditions were important. Maybe seals were more abundant in some years resulting in more food and faster-growing yearlings. Or the mixing of three populations in Hudson Bay may have brought a lot of males together, forcing families apart. Then again, females may have run out of food in the autumn, stopped nursing, and then come into estrous the following spring. Another possibility is that early weaning would allow a female to raise up to 50% more litters in a lifetime.

In Scandinavia, grizzly bear mothers tended to keep their young for an extra year if they were smaller, suggesting that the extra year improved survival of young. Independent yearling polar bears seemed to survive just fine. Although they are not proficient hunters, they can make a living scavenging. Weaned yearlings are much less common now. As the ice conditions have declined in Hudson Bay, mothers have kept their cubs for the more typical 2.5 years. The reasons for historic early weaning in polar bears remains a mystery but was likely tied to food.

Growth Patterns

Polar bears, like many mammals, follow a characteristic growth curve. Early growth is slow, increases rapidly during the subadult years, then levels off and stops. Females stop growing in frame size at 4 to 5 years old; males keep growing for another 4 to 5 years. Weight increases until bears hit their mid-teens in both sexes. Growth in head length stops before growth in head width. Comparing the length of a bear's head to its width is a useful indicator of age: older bears look much blockier; younger bears have a narrower streamlined look. Very young bears have a stubby-looking head because their head length is still short.

Growth early in life affects adult body size in females more than males. A female's body size depends heavily on the maternal care period because much of her growth occurs while still dependent on the mother. The longer growth period of males results in more growth beyond maternal care. Males exhibit greater variation in body size than females. Some variation is genetic and some is environmental. If environmental conditions cause food availability to decline, lower energy intake and greater energy use can impede growth. One of the first signs of stress in a population is a decrease in body condition. After a few bad years,

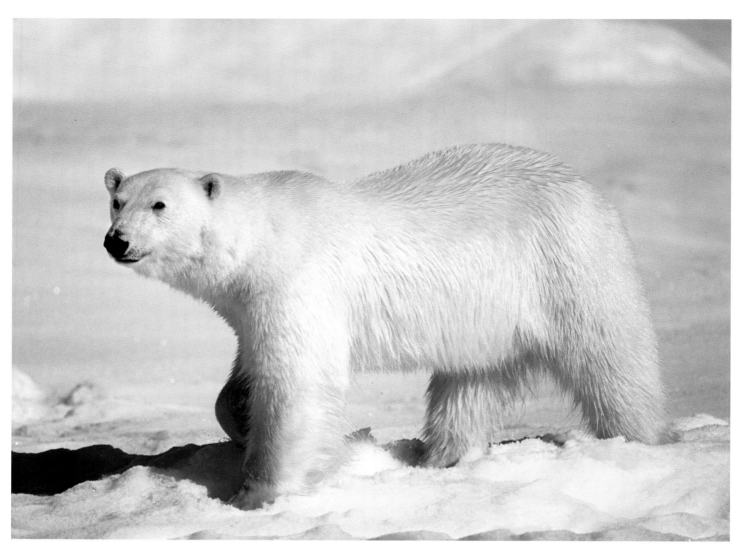

This subadult shows the classic signs of a growing polar bear. The lack of scars indicates that it is young; the head-too-small-for-its-body appearance is a hallmark of young bears.

reduced growth rates are evident. A bear that grew up in favorable conditions is noticeably longer than a bear that experienced poor conditions. Over time, body length can decline by 10% or more in a food-stressed population. Changes in growth are more evident in females than males reflecting the difference in the growth period. Because females start directing energy to reproduction at a much younger age, even a few bad years will stunt their growth.

Geographic variation in polar bear size is fairly small suggesting that net energy availability is similar across populations. In stark contrast, grizzlies vary from small barren-ground bears eking out a living in the Arctic to massive coastal bears that gorge on migrating Pacific salmon.

Life and Death of a Young Polar Bear

Cub mortality, which can occur from conception to weaning, is influenced by maternal weight and age, cub sex, birth weight, and date of birth. Female polar bears can alter their investment in a reproductive attempt at several different points: fertilization, implantation, birth, or after birth. Females do not compromise their own survival. If things get bad, the strategy for long-lived mammals, like polar bears, is for the

Variations in Size and Shape

Polar bears come in different shapes and sizes. Variation is generally more apparent in males. At one extreme are long, thin bears; at the other, short, stocky ones. Sometimes referred to as "weasel bears" and "badger bears," respectively. No formal analysis of bear shapes and sizes has been done. Lacking statistical evidence, it is hard to know if these are two true body shapes or just bears passing through different life stages. From thousands of personal observations, I have noted that some males are massive with huge necks, thick legs, and enormous paws while others are long and lean with gracile legs.

I caught one particularly memorable bear in Svalbard when the Norwegian minister of environment was with me. The minister was a strong advocate for the Arctic, and I was happy to showcase my research. I found what I hoped would be an easy bear to catch on Halvmanoya, Half Moon Island, a fabled bear hunting ground of old. The capture was textbook perfect and soon the bear was asleep. The stocky adult male was in his mid-teens, but oddly, his entire body was unblemished; not a scar or cut was evident anywhere. He was, we learned, just slightly over 6.5 feet (2 m) in length; the size of an adult female. This bear was the shortest adult male I have ever seen. The lack of cuts and scars likely reflected a reluctance to fight with larger males for access to breeding females. I think this bear would qualify as a midget badger bear.

mother to survive to reproduce again. Nevertheless, polar bear mothers have a fierce maternal bond and strive to rear their cubs, even against the odds. Mothers with cubs act to ensure they procure the resources their cubs need. When cubs die, females are seemingly lost without them and wander erratically. Mothers are incredibly attentive to their young, but accidents happen. Cubs can be suffocated or crushed by their mothers in the confines of the den. Some mothers will remain with dead offspring for days, seemingly mourning their loss. Or a mother may leave her den if cubs have died only to return days later, apparently unable to accept their loss. The maternal instinct is intense.

In polar bear reproduction, fat is where it is at. Fat mothers have larger cubs and larger cubs have higher survival rates. Researchers rarely find dead cubs, but those we do find usually show signs of starvation. Some cubs lack vigor and die. Often cubs die because their mother could not provide enough food. Cubs have little stored fat because their energy is used for keeping warm and growing. Cubs quickly starve if their mother stops nursing them. Most cub mortality happens in spring when the mother's body fat is depleted from the long winter fast. If the mother does not eat soon after leaving the den, she will stop producing milk.

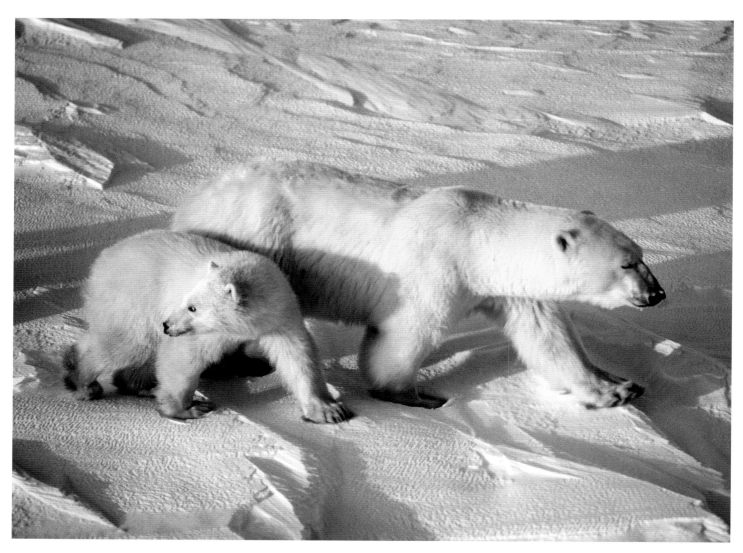

Mom is retreating from trouble, and this yearling's pursed lips indicate it does not like what is behind them.

Under good conditions, a female will nurse young for a full 2.5 years. Cubs take in the greatest amount of milk in their first year; their dependence on milk declines thereafter. Nursing, however, maintains the family bond and keeps the mother out of estrous. A nursing 2-year-old male appears a bit odd because he is often bigger than his mother.

Sea ice conditions affect cub survival. Young cubs forced to swim in cold water are unable to compensate for the heat loss and can die of hypothermia. Cubs can only withstand about 10 minutes of exposure to ice water before they have to rely on shivering to restore body temperature. Cubs can ride on their mother's back as she swims, but mothers with young cubs are extremely reluctant to enter water and do so only as a last resort. Only once has a cub been known to drown, which happened after it dove under a large ice floe. Almost certainly drowning happens more often but it is rarely observed.

Some cubs are killed by gray wolves. Wolves are abundant in many areas of the Arctic and cub predation occurs where they overlap with polar bears. It is easy for a wolf pack to harass a mother while a pack member grabs a cub. Adult polar bears are too formidable to target, but subadults are also vulnerable to wolves. After body parts of a cub were

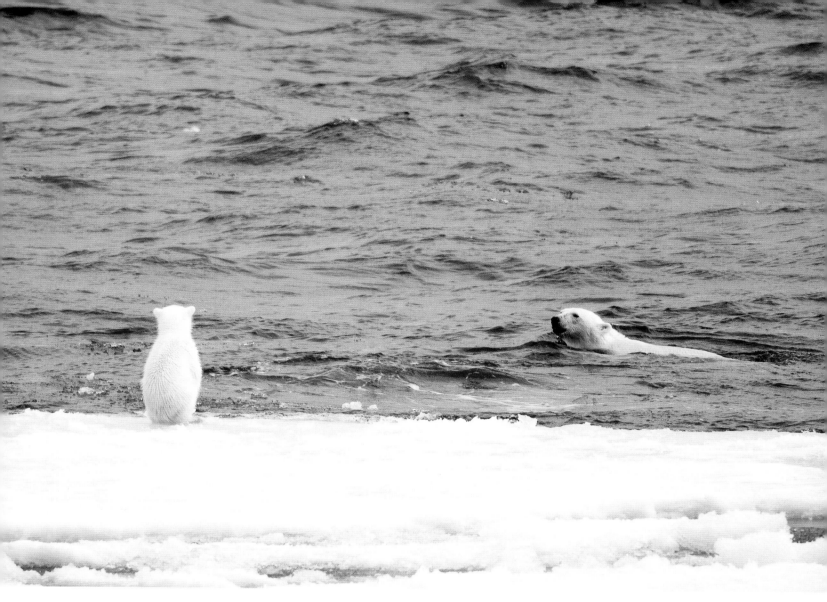

found in a Greenland shark's stomach, it was suggested that they may prey on polar bears. These sharks, which certainly eat seals, can reach 21 feet (6.4 m) in length and weigh 2200 pounds (1000 kg). They are in the same areas as polar bears so predation of cubs is possible but scavenging is an alternative explanation. There is some speculation that the occasional young polar bear is snapped up by killer whales, but given the spatial separation of the two species this would be rare.

A cub has the best chance for survival if it is big, has no siblings, is female, has a mother in her mid-teens that is fat and a good hunter, and if the ice conditions are good. Cub survival in the first year varies from almost 100% in some years to well below 40% in others; it averages about 70%. More singleton cubs make it through their first year than those with siblings. More than 30% of twin litters lose one cub and another 30% lose both cubs in the first year. Triplets suffer the greatest mortality in the first year; less than 20% of triplet litters have all three cubs survive between spring and autumn. Female cubs have higher survival rates than males, and this disparity continues throughout life. When conditions are bad, most families suffer, and a whole cohort can be wiped out.

Despite its mother's assurances, this cub is reluctant to enter the water. Once a cub is in the water the mother must quickly reach an ice floe and warm up her cub. When the ice conditions are poor, a female may have little choice but to swim to reach the next floe with her cub.

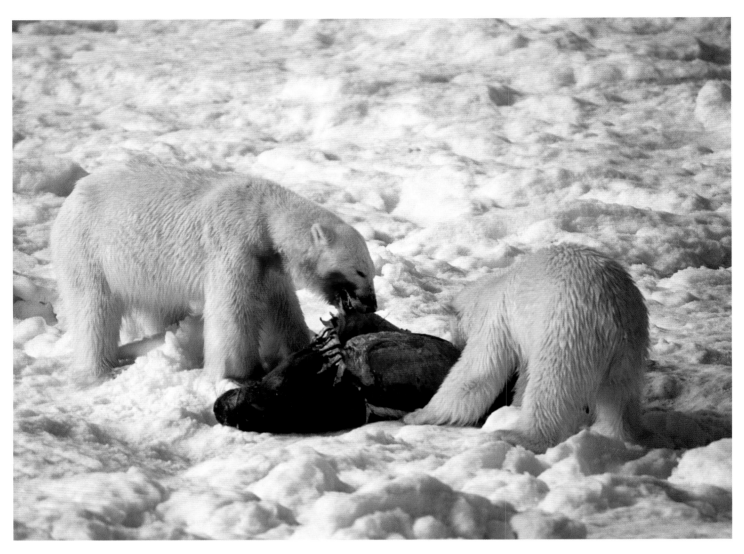

The mother is peeling back the thick skin of a bearded seal. The pair will scrape off the majority of the blubber before they wander off to find a place to snooze and digest their meal.

Survival within the first 4 years of life averages about 75% to 90% each year. Yearlings are less vulnerable than cubs if their mother stops nursing them because they have more fat stored. Causes of mortality after weaning has occurred are hard to determine, but subadults are inefficient hunters and lack of food is still the major factor driving mortality. Many subadults survive by scavenging until their hunting skills develop. Hungry bears may resort to desperate measures. A 2-year-old subadult died on Wrangel Island, Russia, from puncture wounds inflicted by a walrus. More subadults are killed by humans than any other group. Injuries from other bears are also a source of mortality. One subadult I caught was missing a soda-can-size portion of muscle from its rear hind leg. The wound was well healed, but the bear moved with a distinct limp. It is difficult to gauge the importance of such injuries, but such juveniles are rarely seen as adults, suggesting they are usually fatal.

Cub survival is not an important factor determining population growth, but at high population densities it can drop dramatically. Under high-density conditions, infanticide may increase, but we do not know for sure because few, if any, populations are at such high numbers. A stable population only requires a female to produce two surviving off-

spring over her lifespan. Because females can successfully produce a litter every 3 years, over a 22-year reproductive life, a single female can produce 6 or 7 litters of 2 cubs each, for a total of 12 to 14 cubs. This is far above what is needed to keep a population stable. If all cubs survived we would soon be up to our necks in polar bears. Therefore, by default, most cubs die before maturing.

Adult Survival

Biologists place species along a gradient based on their life history patterns. For example, most insects, fish, and small mammals are "r-selected." Such species focus on reproducing as quickly as possible because their lives are short. They tend to have numerous young with low survival rates and their numbers fluctuate widely. Similar to other large mammals, polar bears are a "K-selected" species at the other end of the spectrum. Such species are normally at population levels close to what the environment can sustain (carrying capacity or K). In K-selected species, females typically give birth to a few large young with fairly high survival rates (high relative to r-selected species). Maternal investment is high, and mortality declines from birth to adulthood creating a long lifespan; at least for those that make it past the first few years.

In the wild, the oldest female on record lived to be 32 years and the oldest male to 28 years. Bears in captivity can live another 8 years or more. Few bears make it past 25, and those that do are often in poor condition; the Arctic is a tough place for all but the fittest.

Understanding adult survival rates is crucial to understanding how polar bear populations are regulated. Adult female survival drives polar bear population dynamics. If adult female survival drops, the population size will soon decline. Accurately assessing survival rates is difficult and requires mark and recapture analyses or satellite telemetry monitoring. Adult female survival rates can exceed 96%; adult male survival is about 3% lower. At the end of life, there is a period of senescence mortality when survival rates drop to 60% to 80% and slowly erase the oldest bears from the population.

Polar bears die from various causes. In North America and Greenland, harvest is the most common cause of adult death. Some bears are killed by other bears. In poor ice years when hunting is difficult, some bears succumb to starvation. Adult bears dying of natural causes are rarely found, and when they are, the cause of death is often indeterminable. I once found a dead skinny adult male in his mid-twenties curled up and sheltered by willow trees. The position of the bear suggested it had died in its sleep possibly from starvation. Still the cause of death is difficult to determine; being skinny may be just a symptom of a different problem that ultimately results in starvation. As in all species, the perils of life can result in an accumulation of small injuries that reduce an animal's ability to garner resources. Diseases or parasites may adversely affect individuals and cause a decline in condition, ultimately resulting in death. Adult males themselves can suffer injury during fights in the mating season. Broken canines reduce hunting efficiency. Older bears can suffer from arthritis, making them ineffective hunters. The scarcity of carcasses on

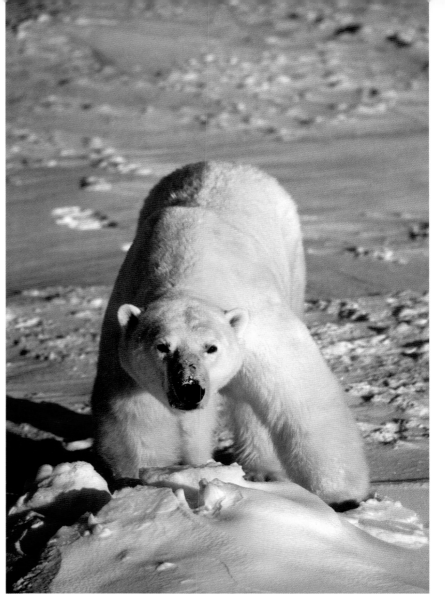

The massive limbs, broad head, and scars on the nose all attest that this is a mature male in its prime and a bear to be reckoned with. Males use such cues to assess potential competitors for food and mates.

land suggests that most bears die on the sea ice where they are quickly covered by snow and are extremely difficult to find. Wear and tear may weaken a bear over time.

Normal mammalian degenerative processes, the same ones that operate on humans, also act on polar bears. Neural degeneration in the spine and deposits in the brain similar to Alzheimer's disease in humans have been observed in captive bears. Indicators of decline in old bears include sunken muscles on top of the head, protruding hipbones, broken teeth, matted fur, and a stiff, slow gait. In aged captive bears, arteriosclerosis has been noted but similar investigations on old wild bears have not been done. For a species that eats so much fat, it is surprising that we do not find bears keeling over from heart attacks, but we do not. The healthy hearts of polar bears may result from the omega–3 fatty acids in seal fat. Polar bear diet research may yet yield new insights for human health. Fries cooked in seal fat?

What pushes a bear over the edge from living to dying is hard to know. All populations experience fluctuations in food availability, and it is during periods of food scarcity that most bears die. Sometimes, death is the result of plain bad luck. A female with two small cubs was killed in

Parasites

Unlike most other mammals, polar bears are remarkably free of parasites. Not all bears are so lucky; more than 80 different parasites have been reported in other bear species. Grizzlies host a variety of single-celled protozoans, gastrointestinal worms, nematodes, and flukes in their blood, liver, heart, and lungs. Terrestrial bears are also hosts to lice, fleas, and ticks. The polar bear left those parasites behind when it moved onto the sea ice. Many parasites need an alternate host to complete their life cycle and those hosts were terrestrial so the parasites did not follow the new ice bears. This is not to say that marine mammals do not have parasites. Ringed and bearded seals can be packed with intestinal, heart, and lung worms, but polar bears are such a new species in evolutionary time that few parasites have evolved to move between them and an alternate marine host.

In the wild, only one parasite is common among polar bears: *Trichinella,* probably *Trichinella nativa. Trichinella* is a small roundworm nematode common in the circumpolar Arctic in walrus, ringed seals, bearded seals, Arctic fox, wolves, sled dogs, belugas, and humans. Humans are most familiar with this parasite through trichinosis, which they can get from eating undercooked pork. How polar bears get *Trichinella* is unclear. Less than 1% of ringed seals harbor the parasite; we do not know about bearded seals. Walrus are often infected but bears in many places do not have access to walrus, and only a full-grown male polar bear is likely to consider walrus as a possible food item.

Trichinella is one tough parasite. It can undergo freezing for years and still return to life. There is some suspicion that polar bears become infected when they cannibalize other bears; however, as in all things ecological the story is complicated. Amphipods and fish can transfer *Trichinella* and the parasite can make its way up the food chain. Bears could acquire the parasite by eating the stomach contents of infected seals.

Trichinella is more common in polar bears than in other marine mammals, with 20% to 60% having it. The parasites are ingested as cysts that dissolve in the digestive system before hatching to produce worms that then lay eggs. Immature worms move about the body and eventually encyst in muscles. The highest densities are normally found in the tongue and diaphragm. We do not know much about what *Trichinella* does to a polar bear. In humans the symptoms include fever, nausea, aching joints, swollen eyes, and muscle pain. In polar bears a serious *Trichinella* infection can cause death. Because infections increase with age, *Trichinella* is likely to be a cause of decline in older bears.

Recently, *Toxoplasma gondii,* a single-celled protozoan parasite, has been identified in polar bears. This parasite, which occurs in nearly all warm-blooded animals, can have serious consequences for pregnant women and people with immune-deficiency diseases. Humans can contract the parasite from cat feces. In humans, toxoplasmosis can cause flulike symptoms, eye damage, skin and nasal lesions, serious birth defects, and psychiatric disorders. The parasite's effect on polar bears is unknown. *Toxoplasma* is common in ringed and bearded seals, which is the likely source for polar bear infection. Over the last decade the parasite's occurrence has almost doubled in polar bears in parts of the Arctic. We do not know why.

Polar bears are remarkably free of parasites and disease though their prey, like this adult bearded seal, are a source of both. The brown-colored head of bearded seals is caused by iron oxides from feeding on the ocean floor. Traces of 40 other elements, some extremely rare, have also been identified in the stained fur of these seals.

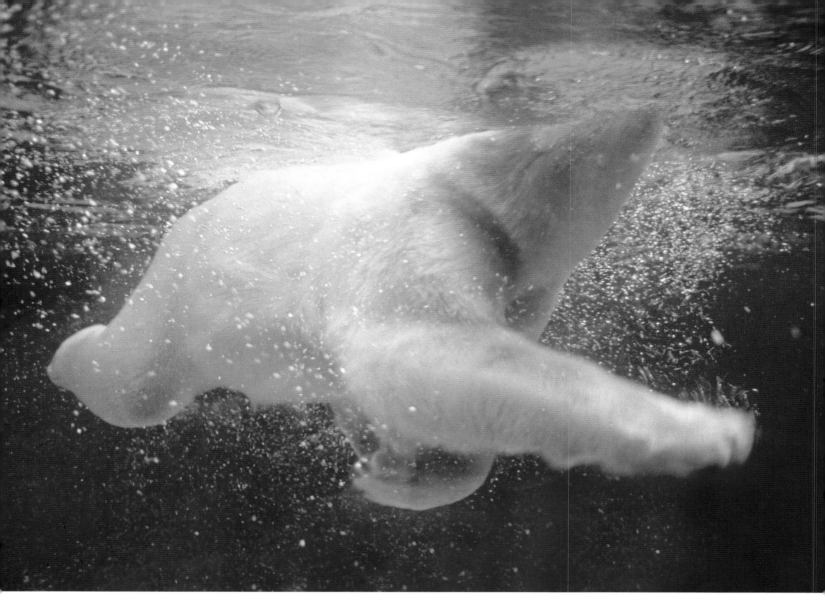

Highly capable swimmers, polar bears paddle with their front paws. Long distance swims are common for adult bears without young. All bears are vulnerable to storms. As the sea ice continues to melt, more open water means larger waves can form during storms and more drowned polar bears may result.

her den when a freak winter rainstorm saturated the snow causing it to collapse, suffocating them all. This sort of occurrence is of growing concern as global warming puts denning females at higher risk of mortality because spring rains are occurring more often. It does not take much of an increase in mortality to move a population from stable to declining.

Polar bears are strong swimmers capable of traveling long distances, but they cannot remain in water indefinitely. In areas such as the Greenland, Barents, Beaufort, and Chukchi seas, some bears drown when they drift too far from land or pack ice. Nobody knows the maximum distance a bear can swim. A lot depends on age, condition, reproductive status, and weather. An adult male with lots of fat to aid buoyancy can swim great distances; a female with small spring cubs can probably swim only half a mile (1 km) before the cubs start to cool and have trouble. The record for a long-distance swim is an adult female tracked by satellite telemetry off Alaska. She swam from land to the ice with a continuous swim of 427 miles (687 km) over nine days. Such swims are expensive in more than one way. Sometime during her trip, which included 1118 miles (1800 km) of walking on sea ice, she lost her yearling. She also lost 22% of her body weight over the 64 days of her trip. Swimming in

Diseases

Polar bears are exposed to diseases like brucellosis, morbillivirus, canine distemper, calicivirus, and rabies. Brucellosis causes abortion in many mammals and morbillivirus is a serious pathogen, similar to measles, in whales and seals. The consequences of such diseases for polar bears are unknown. Prey are the most likely means of disease transmission to polar bears. Rabies, common in Arctic fox, has only been confirmed in one wild polar bear. This may be because a symptom of end-stage rabies is a loss of hind end control. Few biologists would try to capture such an animal: I saw one once and decided against catching it. It is also possible that rabid bears die before researchers see them. Recently, a polar bear in captivity died from West Nile virus, raising concerns about mosquitoes carrying the disease northward. Global warming will certainly spread new parasites and diseases to northern climes. Given that the immune system of polar bears is already compromised by pollution, their ability to fight off parasites and disease is a complicating issue.

calm water is one thing but if a storm blows up, all bets are off because swimming in rough seas is much more challenging. In the Beaufort Sea, 27 polar bears were thought to have drowned as a result of a large September storm in 2004. As the climate has warmed in the Beaufort Sea, the summer sea ice has retreated farther north. The ice used to be much closer to shore and easily accessible. More open water also allows storms to create larger waves. Nowadays, swimming north is a risky endeavor in some areas.

Unusual mortality events have been observed by Inuit hunters. One told of a bear forcing its head into a seal lair that was too narrow, getting caught by its neck, and dying. Luckily for polar bears, their prey are rarely a source of injury. Walrus are the only exception, accounting for the death of the occasional bear. There is one report of a hooded seal that killed a polar bear by biting it in the throat through to the spine. Even more unusual is the spring 1944 account of a wolverine scavenging offshore that encountered a polar bear. The account has it that the bear attacked the wolverine, which responded by seizing the bear by the throat and choking it to death. The hunter who observed this event then shot the wolverine so we do not know if it would have eaten the bear; I do not see why not. As the northern poet Robert Service wrote, "There are strange things done 'neath the midnight sun." Service was not referring to polar bears but the quotation is nonetheless applicable.

The importance of incidental mortality in population regulation is unknown but likely limited. Humans and polar bears often interact in ways that are detrimental to the survival of the bears. Unfortunately, the irrepressible curiosity of polar bears can lead them into lethal situations. They have died from eating all sorts of items, including a lead acid car battery and sardine cans, eaten at the Churchill garbage dump, which was closed in 1996. It is not clear why some items are eaten, but bears

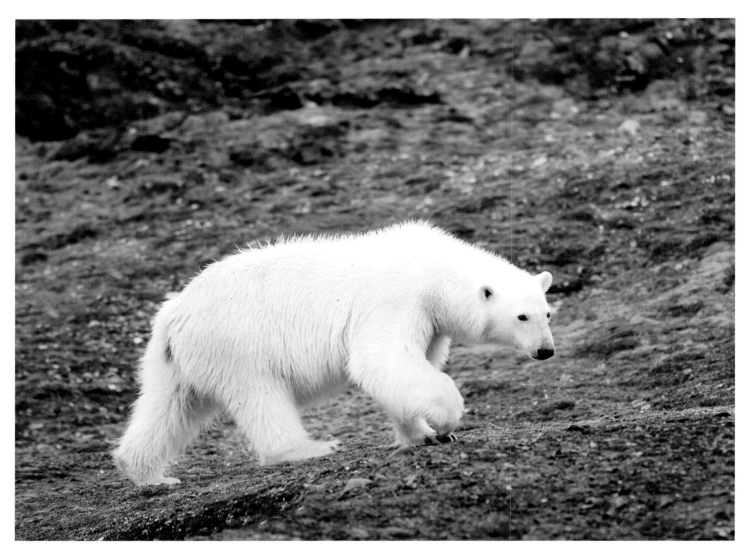

Having lost contact with the sea ice, this bear will be forced to spend the summer on land scavenging. It will lose weight until the ice returns. In many areas bears head northward to summer on thick multiyear ice. They then follow the re-forming ice as it moves southward in autumn.

are not discriminating epicures. One bear drank about a gallon (3.7 L) of hydraulic oil being drained from a loader: the bear's fate is unknown but if it did not die, it was given a major laxative. In Alaska a bear died after eating a mix of antifreeze and dye that had been used to mark a runway on snow. Near Prudhoe Bay, Alaska, a large adult male was found dead on the sea ice from a twisted distended stomach (gastric dilatation-volvulus). Polar bears consume huge meals and stomach twisting can occur if combined with vigorous activity. The frequency of such events is unknown.

In captivity, polar bears die of various causes and degenerative diseases are common. One bear was fed about 6000 marshmallows a day during 19 of its 22 years in captivity and cancer was speculated to be caused by excessive carbohydrates: death by sugar.

Population Dynamics

Typical of K-selected species, populations of bears grow very slowly and are normally near what the environment can support. Population abundance generally changes slowly over decades. By definition, populations do not grow once they reach carrying capacity. Most populations, how-

ever, are hunted and are thus below carrying capacity. A normal growth rate for a population below carrying capacity might be only 2% to 3% per year but can reach 5% or more for short periods in the most productive areas. There is a sustainable yield for some populations if a jurisdiction wishes to hunt their bears. Without hunting, the bears are regulated by natural factors.

The consequence of low population growth rates is a slow recovery from major perturbations, the most common being excess harvest. Many populations were once over-harvested and it took several decades to return to historic levels. If managers set harvest levels too high, it can take years to discover the error because most populations are not closely monitored. Such a situation happened in Canada's M'Clintock Channel where the population was harvested from about 900 bears down to a little over 300. It could take decades to recover the M'Clintock population even with a harvest moratorium. The risk of inbreeding rises if a population gets too small.

It is feared that some populations are showing the effects of climate change. Many bears live with a fine balance between energy intake and energy demands. Changes in a population, such as increasing the fasting period, being forced to swim too far, or having too many males harvested might be enough to cause a population crash. Because we see little immigration or emigration from one area to the next, recovery, if it happens, will be largely through the slow accumulation of new bears from within the population. We have never seen a population crash in polar bears but scientists now believe we are nearing this cusp in some areas. Should such a crash happen, some populations may never recover and those that can, will have very slow recoveries.

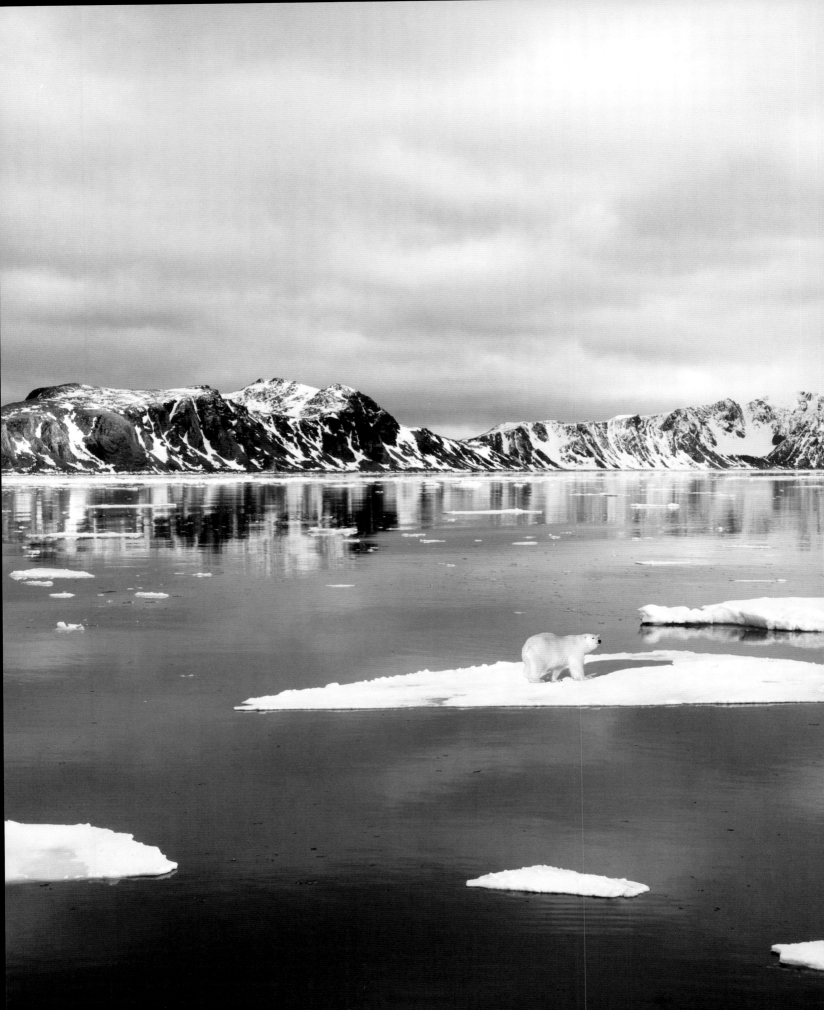

13

THREATS

Polar bears still roam over most of their historic range. Low human density, no agriculture, no habitat conversion, and low industrial activity in the Arctic have spared polar bears the fate of other large carnivores. Unfortunately, the "luck of the polar bear" may be running out. In recent years, the protection of polar bears under threatened species legislation has increased as the threat posed by global warming has become clear. The Red List of the International Union for the Conservation of Nature considers polar bears a vulnerable species. A vulnerable species is the equivalent of "threatened" which is how polar bears are listed in the United States under the Endangered Species Act.

Despite the remoteness of polar bear habitat, the bears are under increasing pressure from human activities but the nature of the threat has changed. The major threat in the 1950s and 1960s, harvesting, was easily managed. Pollution severely challenged some polar bear populations through the 1970s and 1990s. Treaties to control the worst pollutants have helped to stabilize or decrease toxic chemical levels in polar bears. New pollutants keep emerging but once identified these chemicals can be phased out. Unfortunately, the most serious threat to polar bears is one that we have yet to control: global warming. Polar bears are a highly specialized predator that evolved to exploit a habitat that is disappearing: the pace of change in the Arctic is unprecedented in the evolutionary history of the species.

Harvest

Polar bear harvest has a long and varied past. Native peoples throughout the north have harvested polar bears for more than 10,000 years. In the De Long Archipelago in northeastern Siberia 7900 years ago, a hunting culture was centered on polar bear and reindeer harvest. Most of the

(Opposite) **Polar bears are sea ice specialists, and global warming is causing the ice to melt earlier in summer and form later in autumn. Melting sea ice is a form of habitat loss and no species can survive without its habitat.**

International Agreement

In response to the perception that polar bear populations were declining worldwide, the five countries with polar bears under their jurisdiction (Canada, Denmark [for Greenland], Norway, the United States, and the USSR) met in Fairbanks, Alaska, in 1965 at the First International Scientific Meeting on the Polar Bear. Harvest levels were clearly excessive, and the level of environmental awareness in the 1960s and 1970s made implementing conservation measures possible.

Negotiations to ensure international cooperation on polar bear conservation resulted in the 1973 Agreement on Conservation of Polar Bears. The agreement, still in effect today, was one of the first international covenants to apply ecological principles to the protection of an ecosystem. It includes measures to protect denning, feeding, and migration areas through the application of management practices based on sound conservation objectives and the best available scientific data.

The 1973 agreement, which provided a framework for international polar bear conservation, benefited from some existing measures. In Norway, females with cubs had already been protected, and the Kong Karls Land Polar Bear Reserve in Svalbard, a high-density denning area, had been established in 1939. In 1949 the Government of the Northwest Territories, Canada, had restricted polar bear hunting to the predominantly native holders of general hunting licenses. The Soviet Union, in response to declining polar bear populations, had closed hunting in 1956; the US Marine Mammal Protection Act of 1972 resulted in protection of polar bears except for native harvest.

In some areas, the agreement has been successful. A number of denning areas have been protected and polar bear research was given an international mandate. The agreement has been neglected in other areas, such as protection of feeding sites and migration areas. Protection of marine habitat is still minimal because most people do not realize that sea ice is a habitat—and a crucial habitat for polar bears at that.

Hunting, killing, and capturing polar bears are prohibited except for scientific purposes, conserva-tion reasons, protection of other living resources, harvest by local people using traditional methods exercising traditional rights, or where people had a tradition of hunting polar bears. All signatories of the 1973 agreement recognized that under certain circumstances harvesting polar bears might be advisable, but all agreed that conservation was the priority. The meaning of "local people using traditional methods" has been interpreted differently by different jurisdictions. For example, Norway decided that Svalbard had no local people and polar bear hunting ended there in 1973.

The agreement mandates that each nation manage polar bears based on the "best available scientific data," which has created some confusion. The confusion revolves around the interpretation of "best available." data. Many polar bear populations lack scientific data yet harvesting continues. Even in populations where population estimates exist, the interval between estimates far exceeds optimal. The agreement calls for each nation to conduct national research programs, but the support for such research is sadly lacking in some countries.

The agreement was effective at encouraging principles of conservation, involving resource users in research and management, promoting respect among treaty members for cultural differences, and fostering communication. Polar bear conservation has had more successes than failures since the agreement was signed. The spirit of the agreement will be severely tested by global warming.

As polar bears have taken center stage as the poster species for climate change, the agreement is again at the forefront of conservation. As the spotlight on the bears intensifies, so too have political sensitivities. The signatories reconvened in 2009 to open new discussions about the bears. Global warming is a game changer for polar bears and public concern for the ice bear is forcing politicians to address the fate of this most extraordinary animal.

These polar bear skulls and walrus tusks on Little Diomede Island, Alaska, in the Bering Sea testify to the association between northern people and marine resources.

Inuit Qaujimajatuqangit

Inuit Qaujimajatuqangit (pronounced *Khao-yee-muh-yah-tut-khang-geet*) or IQ can be interpreted as "that which has long been known by Inuit"—that is, traditional knowledge that includes cultural insights into nature, humans, and animals. IQ might seem an unlikely tool in polar bear research, but it is formally recognized in the management of some populations.

Wildlife management is 90% human management, and many, if not most, of those humans are local people. Researchers who embrace such seemingly unorthodox tools as IQ can add substantially to their store of knowledge. Nonetheless, there are limitations to IQ. Oral traditions extend back far in time but documentation of observa-

tions is limited and context is difficult to assess. Furthermore, IQ is restricted to the areas where people hunt and travel, and many management issues are relevant on larger scales. In addition, IQ is about past events not future ones, so issues such as global warming are challenging. Nonetheless, local observations are invaluable to researchers and managers because the hunters are often on the land when scientists are not. Hunters know where den areas are, where bears summer, where they hunt, and what they eat. This information can set a baseline for scientific studies. Integrating IQ into polar bear management is progressing, but as with all such endeavors, it takes time to do it right.

Self-Killing Guns

Polar bear harvesting was an industry in the 1900s. Between 1924 and 1968, more than 13,500 polar bears were killed in Greenland and Svalbard alone. Norwegians were masters at harvesting polar bears and they had an ingenious, but nasty, device that was partly responsible for the polar bear population crisis in the twentieth century.

Now prohibited everywhere, the device was a self-killing gun (*selvskudd* in Norwegian, meaning "self-shot"). Simply put, a loaded rifle was placed in a wooden box atop stout footings, like a sawhorse, at head height for a polar bear. The gun pointed into a small open-ended box where bait was placed. The bait was tied to a string that pulled the trigger when the bear tugged on the bait. Few bears could pass up such an enticement and thousands shot themselves in the head. Because most of these contraptions were on land, mothers with young cubs were often the victims. The cubs subsequently died or were caught for the zoo market. The injury rate is unknown but considerable. Two trappers managed over 145 kills in one season on Svalbard. The reason polar bears were so at risk is clear in hindsight.

bears killed were adult females. They are easier to harvest and might have been taken at dens.

Even today, polar bears play an important social, cultural, nutritional, and economic role in the north. Some communities eat polar bear meat; in others it is fed to dogs. In Greenland, polar bear trousers are still worn in winter by men and children. In Alaska, hides are used in handicrafts. Hunters that specialize in polar bears often have high social status. Culturally, hunting of polar bears is taken seriously: to joke about polar bears would bring misfortune to future hunts. The economic benefits of polar bear harvesting are not large. But in communities where unemployment is extremely high, the financial return for an individual can be substantial. The price of polar bear hides has fluctuated significantly. Most polar bears harvested in Canada, the country with the largest harvest, are turned into rugs. Larger hides are more valuable, but hair thickness and length, color, scarring, and hide preparation all affect the value. International trade in polar bears is controlled by the Convention on International Trade in Endangered Species (CITES). At the CITES meeting in 2010, a ban on international trade was narrowly defeated. In response, hide prices have surged due to fears that they may become less available.

About two-thirds of polar bears taken in harvest are male and most are subadults. Females with young are protected. Most bears are taken under a managed quota intended to be sustainable. Sustainable harvest, 3% to 5% of the population, varies depending on population, reproductive and survival rates, and the proportion of females taken. If only females are harvested, only 1.5% of the population size can be taken in a year. If a population is declining, there is no sustainable harvest and every bear shot pushes the population lower. One consequence of the male-biased harvest is a preponderance of females in the population; in some areas

Bears removed annually (average for 2004–2009, including harvest and problem bears) from 19 populations reported by the IUCN/SSC Polar Bear Specialist Group	
Population*	Average no. removed per year
Chukchi Sea	37–200+
Southern Beaufort Sea	44
Northern Beaufort Sea	29
Viscount Melville Sound	5
M'Clintock Channel	2
Lancaster Sound	83
Norwegian Bay	4
Gulf of Boothia	60
Foxe Basin	101
Western Hudson Bay	44
Southern Hudson Bay	35
Davis Strait	60
Baffin Bay	212
Kane Basin	11
East Greenland	58
Barents Sea	1
Kara Sea	0
Laptev Sea	0
Arctic Basin	0

*These are the 19 populations of polar bears recognized by the IUCN/SSC Polar Bear Specialist Group.

almost 70% of the population is female. If the population has too few males, reproductive rates will drop if females are not bred.

Harvest is variable, with some populations receiving none and others exceeding sustainable rates. In any given year, almost 1000 polar bears are killed in legal harvest, by poaching, and as problem animals in the circumpolar Arctic. This would mean 4% to 5% of the world's polar bears are harvested each year, which may or may not be sustainable. But that number is likely an underestimate because animals shot and lost are not recorded, and in Russia, kills are not reported at all. Outside Russia, poaching is not a concern.

To monitor the harvest in most populations, the location and the sex of the bear are recorded, and a tooth is collected to determine age. Despite the best efforts of scientific management, 6 of 19 populations have been reduced by over-harvest in the last decades. It is easy to over-harvest polar bears, and any excess harvest results in a population decline. Most harvested populations are monitored at intervals of 10 to 20 years. Even a small annual over-harvest can be compounded into a major population decline over such an interval. Communities usually cooperate to reduce harvest quotas when necessary to allow the populations to recover.

Polar bear hides are left to dry and bleach in the sun. A hide like this may be sold to visitors or fur traders, turned into handicrafts for sale, or made into clothing for someone local. The meat will often be shared community-wide.

But quotas are always a sensitive issue given the significance of polar bear hunting. As climate change alters polar bear populations, we can expect the sustainable harvest to decline and eventually disappear altogether. Overall, harvest is not a major threat to the long-term persistence of polar bears. Harvest can be controlled and the means to do so are in place.

Human-Bear Interactions

By their very nature, humans and bears are perfectly designed to compete for two reasons. First, northern settlements are often located near prime polar bear habitat and second, polar bears and northern people feed on many of the same resources. Human-bear conflicts are documented back to 1321 in Iceland when a polar bear killed seven or eight people before the bear itself was killed. One can only guess at the toll polar bears have taken on northern people in the past.

Nonetheless, because few humans are in polar bear habitat, the bears rarely kill or maul people. Furthermore, humans in the Arctic are often armed. In Alaska, injuries by polar bears are about 1% of those caused by American black and grizzly bears. In Canada, 4 deaths and 15 in-

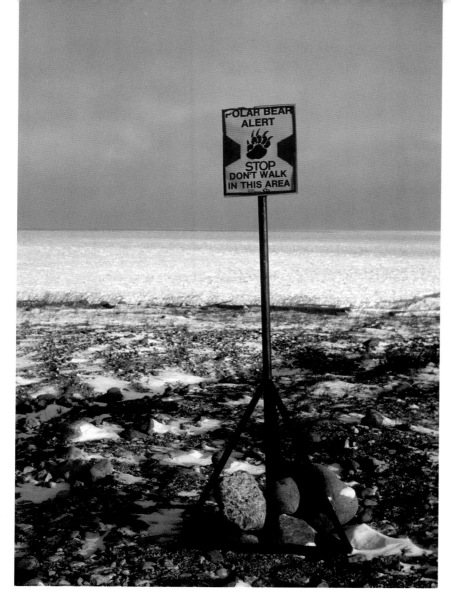

The town of Churchill in Canada justifiably bills itself as the Polar Bear Capital of the World. Nestled between Hudson Bay and a summering area for about 900 bears, the community sometimes looks like a polar bear highway. The Polar Bear Alert program has been very effective at reducing human-bear conflicts.

juries occurred over 15 years; 80% of the cases involved predatory behavior by polar bears. Firearms are effective against polar bears because their habitat is fairly open and provides good visibility. In forested areas, American black and grizzly bears often attack at close range allowing little time for defense. Polar bears occasionally attack people, but such occurrences sometimes involve a degree of stupidity or negligence on the part of the humans. In one case, a polar bear approaching a camp was shot repeatedly with birdshot. The bear retreated to some willows. After a short time, a person approached the bear, thinking it was dead. It was very much alive and managed to remove part of the person's scalp before being driven off again. In another case, following a hotel fire, a local resident was killed by a polar bear while they were both scavenging in the remains for food. In another fatality, a young person clambering over rocks along the shore of Hudson Bay surprised a sleeping bear. Sometimes, a person is just in the wrong place at the wrong time.

Most troublemaking polar bears are juvenile males, but skinny bears of both sexes also cause their share of problems. The incidence of problem bears can be high in some areas. More than twenty bears were recently killed one autumn in a single community. The response

Sport Hunting

Sport hunting is a sensitive issue with a broad spectrum of opinion. To some, the idea of hunting a polar bear for sport is reprehensible. To others, it is a wonderful adventure that fulfills a lifelong dream.

Polar bear sport hunting has a long history. In 1773 Lord Horatio Nelson, then only a midshipman, spied a polar bear on the ice near Svalbard and set off, musket in hand, to stalk the bear. When the musket misfired, the bear attacked. Nelson ended up clobbering the bear with the butt of his gun. The ship's captain, seeing Nelson's predicament, fired a cannon, which scared off the bear. The action was immortalized in a painting by Richard Westall (1809). Sport hunting was pretty sporting back then.

By the mid-1900s, polar bear sport hunting in Alaska was conducted largely with the aid of fixed-wing aircraft on skis. Once a bear was spotted, the hunter was placed on the ice and the bear was herded past him to be shot. In Norway, sport hunting was conducted from sealing vessels that would travel into the pack ice and approach a bear until close enough for a shot. Dead bears were hoisted onboard and skinned. These methods, while effective from the hunter's point of view, were not particularly sporting.

Early calls to increase the sporting nature of the hunt called for the use of bow and arrows. The theory was that once hit by an arrow the bear would attack and then be shot at close quarters. Polar bears are still sometimes sport hunted with bow and arrow. Another suggestion was to replace trophy hunters with catch-them-alive hunters using immobilization. Catch-and-release hunting was proposed as a means to aid scientific studies: this never came to pass.

Polar bear sport hunting changed with the 1973 Agreement on Conservation of Polar Bears and ended everywhere except in Canada, which added a modification to the agreement. Local people could sell a polar bear permit from their quota to a non-Inuit or non-Indian hunter but a native hunter using a dog team must guide the hunt. This was the beginning of modern polar bear hunting. Between 1970 and 1979, sport hunters took less than 1% of the bears killed in Canada. By 2005 this had increased to 25% with 110 sport hunts. How many sport hunts are available depends on the community. Some communities do not support sport hunting; others see it as a viable economic activity.

From a management perspective, sport hunting does not differ from other forms of hunting. As long as the hunts come from a sustainable quota, who pulls the trigger is not biologically relevant. Upward of 80% of the bears taken in sport hunts are males; shooting fewer females helps maintain the reproductive engine of a population. Sport hunters target trophy bears with large skulls. Many sports hunters will not shoot a female or small bear even if it is legal to do. Sport hunts have high success rates, with around 90% of the hunts killing a bear.

The benefits of sport hunting in the Arctic are clear. Each hunt brings substantial income to the guides and creates employment in northern communities. The revenue may not be significant for the broader economy, but at the individual level, the returns can represent a large part of a guide's

to problem bears depends on the attitude of the community, attractant control, sophistication of deterrence programs, management regimes, and tolerance. Churchill, Manitoba, has a Polar Bear Alert Program that is extremely effective and has resulted in few bears being shot and few humans harassed or injured.

Despite improvements in problem bear programs, trouble is on the way because global warming can cause food-stressed bears, which means more problem bears can be expected. When communities are unpre-

annual income. Like it or not, sport hunting can be a sustainable use of a resource. A polar bear sport hunt can cost upward of $30,000 and provides much more income to local guides than selling a hide they may have taken themselves in a subsistence hunt.

Most sport hunters used to come from the United States. However, an exemption from the US Marine Mammal Protection Act that allowed hunters to bring their trophies home ended when polar bears were listed as a threatened species in 2008. That change has resulted in fewer sports hunts.

Recently, confusion has crept into polar bear management with terms like "conservation hunting" or considering sport hunting as a form of ecotourism. Window dressing the name of sport hunting does not change anything: a hunt is either sustainable or it is unsustainable.

This bear taken in the Canadian Arctic was part of a legal harvest with an annual quota. Biological samples will be submitted to the government along with the ear tag so that biologists can assess the effects of harvest and ensure that it remains sustainable. Polar bear hunting is still an important component of many northern cultures.

pared, the first response to a problem bear is often a bullet. And as the carrying capacity declines due to climate change, there may be few other options. Relocation of bears to a safer area is one possibility. But the resources to undertake such action are limited in most small northern communities. That people who live in polar bear habitat have to single-handedly deal with a problem they did not create is grossly unfair. Nonetheless, many northern communities are working to find solutions that will allow them to reduce human-bear conflicts.

Virtually all of the hundreds of chemical pollutants found in polar bears come from factories and agriculture far to the south. The waste products belched into the air and poured into rivers move northward where they can reach dangerously high levels in polar bears.

Pollution

Despite the vast distances between industrial areas and polar bears, pollution is a serious threat to Arctic ecosystems, and polar bears are highly polluted. Toxic chemicals in the Arctic come from various sources, including long-range transport from southern industries and agriculture via air and ocean currents, input from large rivers emptying into the Arctic basin, and migratory species. The major pollutants fall into three groups: persistent organic contaminants, heavy metals, and radioactive materials. It is disturbing to realize that even polar bears have been sullied by human carelessness and indifference.

The chemicals of most concern are persistent organic pollutants. Persistent refers to the resistance to degradation; organic means it has carbon; pollutant implies a deleterious effect on an organism. Many of the worst pollutants contain chlorine, fluorine, or bromine. A host of pesticides show up in polar bears, including DDT residues that were the focus of Rachel Carson's 1962 book *Silent Spring,* which brought the perils of pollution to the public's attention. Industrial compounds such as polychlorinated biphenyls (PCBs) and brominated flame retardants are

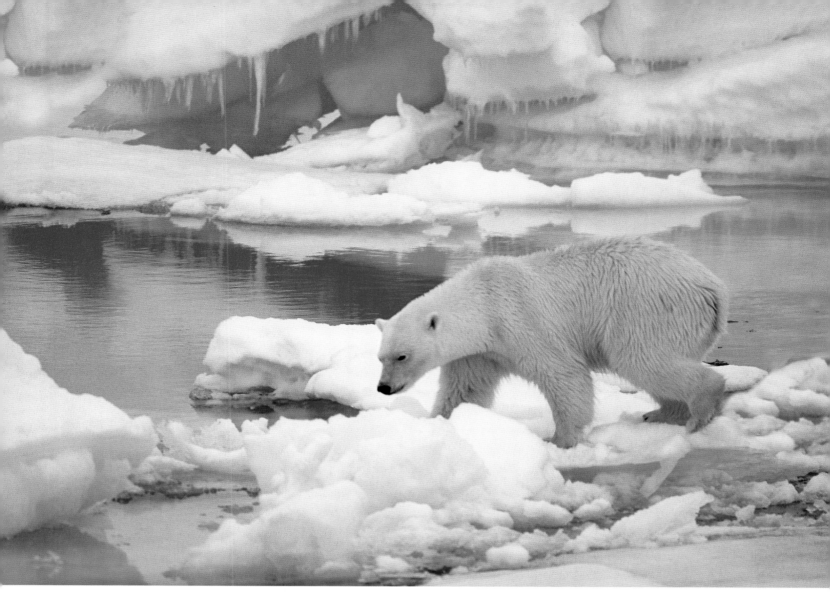

of great concern because they are metabolically active. PCBs were used in electrical insulators, hydraulic fluids, lubricants, liquid sealants, and cutting oils. Due to rising concerns about the widespread distribution of PCBs, many countries have banned production. Excluding unknown production in the former Soviet Union, approximately 3.1 billion pounds (1.4 billion kg) of PCBs were manufactured but only a fraction has been properly destroyed. Brominated flame retardants, a newcomer to the Arctic, are of ongoing concern due to the huge quantities produced, their widespread use, and the rapid increase in Arctic species.

The diet of polar bears and their position in the food web make them extremely vulnerable to pollution. Many pollutants have chemical properties that cause them to adhere to fat molecules (lipophilic) and thus are of concern to polar bears because of their high fat diet. Pollutants are taken up by organisms low in the food web and increase in concentration higher in the food web (biomagnify). For example, an amphipod that eats algae takes in one PCB molecule. A polar cod eats a thousand amphipods, each with one PCB molecule. Then a ringed seal eats a thousand polar cod each with 1000 PCB molecules. Because none of these species breakdown the PCB molecules, the pollution levels keep increas-

There is no such thing as an unpolluted polar bear. This bear's next meal will alleviate the bear's hunger but create a burden for years to come as its body tries to detoxify the pollutants humans have carelessly cast away.

Pseudohermaphrodite Polar Bears

In my first season on the sea ice in Svalbard, I caught an adult female with two yearlings. As always, I rolled the yearlings over to check their gender and to my surprise, things were a bit "different." Both of the yearlings had a greatly enlarged clitoris: essentially a partially developed penis about 0.8 inch (20 mm) long complete with a penis bone. Over the next few years, the abnormality showed up in about 1.5% of the females I caught. Svalbard's polar bears are highly polluted, which may be a cause of the abnormality.

Hermaphroditus of Greek mythology was the two-sexed offspring of Aphrodite and Hermes. Biologically, a hermaphrodite is a plant or animal that has both male and female functional sex organs. Earthworms, slugs, and many plants are hermaphroditic. The term "pseudohermaphrodite" (false hermaphrodite) or "intersex" is used when ambiguity exists in the genitalia but not in the gonads. The twin yearlings I caught were genetically female but pseudohermaphrodites. Some of the pseudohermaphrodites I caught had cubs with them so it appears at least some can reproduce.

The cause of the abnormality is unclear, but hormone disruption during development is one possibility because many of the pollutants in polar bears are hormone disruptors. There are, however, other possible causes. The condition can result, for example, in dogs if a female pup is positioned in the uterus next to male pups and enough hormone washes across to the female to cause abnormal development called freemartinism.

Shortly after we published a scientific paper on the odd bears, I was at the Tromsø Airport in northern Norway after a long field season. I was paged to the counter. A reporter from the *Times* (London) wanted an interview. Sex sells; weird sex sells even better; weird sex linked with polar bears merits the front page.

ing. Polar bears, which are at the top of the food web, are exposed to high levels of pollution in their seal blubber diet.

The good news is that polar bears can breakdown some pollutants and excrete them so that most pollutant levels do not keep increasing over a lifetime. The bad news is that the breakdown products can be extremely active in the physiology of a polar bear before they are excreted. In parts of the Arctic (the worst being from western Russia to East Greenland), the pollution level of some polar bears is so high that species like American mink at similar levels would not be able to reproduce or would simply die. No polar bear in the world is unpolluted and each has its own toxic cocktail to deal with. Consider that there are 209 different "types" of PCBs and each one has its own toxic breakdown products. When the whole gamut of pollution is considered, an average polar bear has several hundred foreign chemicals in its body. The effect of a single pollutant is impossible to determine but assuming so many pollutants has no effect is ridiculous.

Studies have documented that pollutants affect polar bears in many ways but the mechanisms are imperfectly understood. Pollutants can alter liver, kidney, and thyroid gland structure. Some chemicals in polar

bears affect sex and thyroid hormone regulation. Altered hormone levels affect growth, development, and reproduction. There are indications that pollutants alter vitamin A levels in polar bears but the effects of this are unknown. Research also suggests that bone density, nervous tissue, and DNA are affected by pollution.

Population, age, sex, reproductive status, movement patterns, and diet affect the pollution load in an individual. Every bear has its own pollution history, and even bears in the same population may vary widely in pollution load. Body condition affects pollution levels because a fat bear's pollution is diluted in its fat. As a bear uses its fat stores, the pollutants concentrate in the remaining fat. As these remaining stores are used, the pollutant levels in the blood spike upward. Part of the concern is that pregnant females and mothers with newborn cubs undergo dramatic depletion of fat stores. Much of a mother's pollution is transferred to her fat-rich milk and then to developing cubs. This off-loading of pollutants results in cubs, yearlings, and subadults often having higher pollution loads than adults. How these high pollutant loads affect developing polar bears is unknown. One consequence of the off-loading to offspring is that adult males can have pollution levels 40% higher than adult females, raising concerns about males with very high levels.

Several studies show that PCBs negatively affect the immune system of polar bears. PCBs interfere with a bears' ability to produce antibodies, which are the first line of defense in fighting disease, infections, and parasites. Circulating levels of antibodies are lower in polar bears with higher PCB levels. A highly polluted polar bear with a damaged immune system might even succumb to a relatively harmless infection. Pollutants can cause abnormal growth, altered learning capacity, reduced ability to fight disease, and decreased survival. There are indications that mortality increases in highly polluted cubs. Death from pollution may be manifest by succumbing to disease, inappropriate behavior that leads to death, developmental abnormalities, or simply failing to thrive.

What pollution does to the individual is one thing; the effect on a population is even more difficult to assess. The Svalbard population may have recovered so slowly from over-harvest because pollution levels in the 1970s were increasing rapidly at the same time that harvest ended. Because the effects of pollution may be manifest in brief windows when some aspect of the animal's development, behavior, immune system, or hormone system is sensitive to disturbance, definitive documentation of population impacts may be almost impossible.

In recent years, there has been increasing concern over the possibility of radioactive pollution, particularly close to the Arctic. The Chernobyl accident, discarded or damaged nuclear weapons and vessels, discharge and dumping from the nuclear industry, and nuclear weapon tests all contribute to radioactive pollution. Testing of nuclear weapons on Novaya Zemlya in Russia, a polar denning area, had unknown impacts on polar bears. Reports of polar bear cubs with abnormal brown fur patches and "buffalo bears" with unusually short back legs from Novaya Zemlya raise concerns. It is impossible to know if these observations are related to radioactive pollution. But ponder the possible effects of radiation on

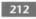
Pollution levels stabilize as females age because they unwittingly transfer pollution to their cubs through milk. A cub this size often has higher pollution levels than its mother.

a pregnant polar bear and her developing cubs if she denned over an earlier underground atomic blast site.

The heavy metals mercury, lead, cadmium, and selenium are all found in polar bears. Some heavy metals occur naturally; others are released from metal smelters, cement production, and fossil fuel burning. Coal burning releases the most mercury. Human intake of mercury and other heavy metals is a major concern in the north because marine mammals, which form part of traditional diets, can have high levels. Polar bear tissues can greatly exceed mercury and cadmium limits for human food. In humans, high levels of mercury have toxic effects on the central nervous system, hormones, and kidney function. The effects of heavy metals on polar bears are poorly understood. Mercury levels are increasing, and concern has arisen over possible synergistic effects of heavy metals, persistent organic pollutants, and climate change.

Perhaps the sight of two small polar bear cubs coupled with the realization that they are being poisoned by milk from their own mother will help focus public attention on the perils of pollution—in the Arctic and beyond. Pollutants must be proactively regulated in a manner that protects both humans and wildlife.

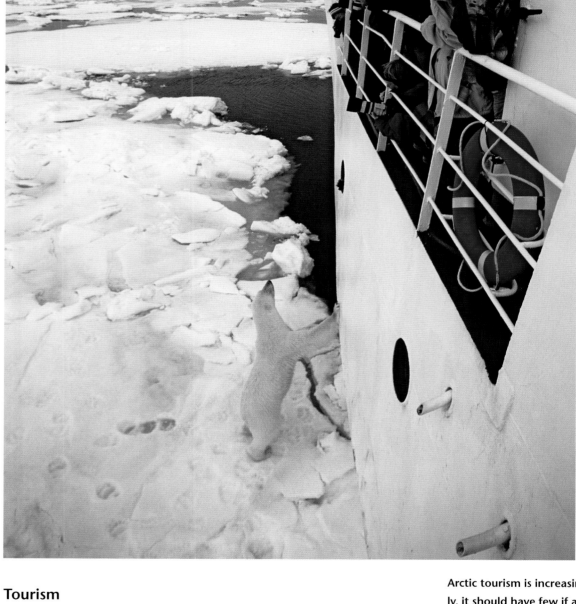

Tourism

Tourism to the north, on Arctic treks, and via large cruise ships are all increasing in polar bear habitat. The effects of polar bear viewing on the bears are usually small, but every year Arctic explorers or tourists shoot a few bears. Polar bears react to snow machines at distances of more than 1 mile (0.6 km) so just having humans in their habitat can cause altered behavior. It does not take much disruption to reduce the efficiency of polar bears trying to catch their dinner. With unsupervised tourism,

Arctic tourism is increasing rapidly. If handled wisely, it should have few if any negative consequences for polar bears. People care about what they know about, and those who see polar bears in the wild are charmed by this Arctic denizen.

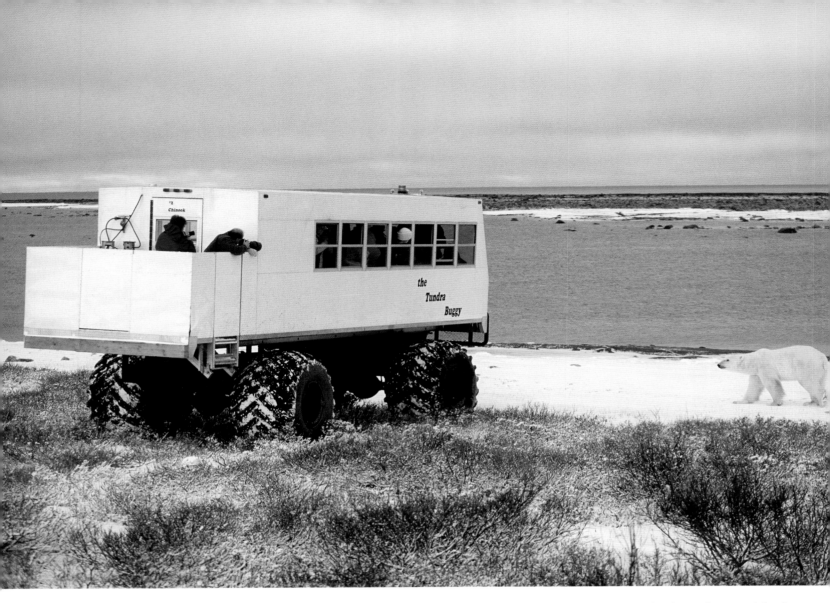

Polar bears pay little attention to the Tundra Buggies that roll about loaded with tourists waiting for a chance to take a once-in-a-lifetime photograph from a warm, safe place. It is impossible not to catch polar bear fever when you are watching a polar bear watching you.

people do stupid things, including finding polar bear dens and bothering the animals. In one instance, people on snow machines chased a mother with a small cub until the mother abandoned her cub. The people caught the cub and sat it on their snow machine to take pictures of it. These people were caught and fined, but many wanted to see a jail sentence for them. Some years back, visits to polar bears with young cubs at dens were inaugurated in Manitoba. The effects on the bears are unknown. Polar bears are resilient and adapt to disturbance, but there are limits to the adaptability. And some life stages are much more sensitive than others. With proper care and awareness on the part of humans, polar bears are accommodating of people in their midst.

Polar bears are one of the most popular wildlife subjects for photography. But tourists striving to obtain close-up photographs can put both themselves and the bear in danger. In the 1980s some photographers used bait to attract polar bears. One photographer regularly used blocks of lard cut into tiny chunks spread out in the snow to keep polar bears nearby. This led to some fine photos but also a lot of unnatural behavior from the bears. Well-known photographs of a polar bear playing with a sled dog were the result of the bear coming to feed on uneaten dog food,

a situation that was touted for tourist viewing. However, teaching a bear to depend on an unnatural food source can alter its behavior. A bear that has learned to approach humans for food comes one step closer to becoming a rug when it moves into areas with hunters. The mantra in bear management is "a fed bear is a dead bear." Fortunately, baiting of polar bears is now against the law in many areas.

The large polar bear viewing trade that has grown up near Churchill, Manitoba, has had no known impacts on the bears. Most bears in the western Hudson Bay population do not come near the restricted area where Tundra Buggies trundle about the barrens. If a bear does feel disturbed there are vast areas it can head to without humans. Overall, the benefits of tourism outweigh any detriments: people who have visited the Arctic and have seen polar bears care about their conservation.

Oil, Gas, Mining, and Development

Arctic offshore and nearshore exploration for hydrocarbons has increased in recent years. The biggest threat to polar bears is an uncontrolled release of oil (a blowout). Part of the problem is that polar bears prefer the shallower nearshore waters and it is in these areas that hydrocarbon exploitation is most intense. The natural curiosity of polar bears makes it worse because they are attracted to oilrigs by sights, smells, and sounds. An additional concern is habitat alteration by oilrigs and by icebreakers that create leads that attract seals and, consequently, polar bears. Very few polar bears have been shot at oilrigs, so this is a minor concern at present. It is difficult to assess the risk of oil development in polar bear habitat because a spill has not yet happened. However, we know from studies on captive polar bears that they will groom crude oil from their fur and can die of kidney, lung, liver, or brain damage from ingesting oil. A large oil blowout in the Arctic would be catastrophic. Oiled bears eating oiled seals would have serious negative population effects.

Polar bears in denning areas are particularly vulnerable to disturbance because mothers cannot relocate cubs readily until several months after birth. More than 9 billion barrels of oil are estimated to lie beneath the ground in the coastal area of Alaska's Arctic National Wildlife Refuge near the Beaufort Sea. Extracting the oil from the area where polar bears den would likely have a negative impact.

Development means infrastructure, which opens up previously remote areas to a gamut of changes. For example, roads are easier to walk on than deep snow. In one instance a polar bear cub leaving a maternity den with its mother was hit by a truck while walking along a winter access road. Similarly, polar bears will often follow snow machine tracks and end up in peoples' camps. And as people build cabins and travel more in remote areas, human-bear interactions will increase. In one instance, sled dogs used to warn of approaching bears managed to kill a young polar bear. In Russia, Arctic station crews believed that shooting a bear in the leg was an effective means of deterrence because the bear would then fear humans for the rest of its life. Alternatively, the bear might just wander off and die.

The Arctic is full of diamonds, gold, uranium, and other minerals.

As the sea ice melts, interest in nearshore and offshore petroleum is rapidly increasing. A blowout would have serious adverse effects on polar bears and their prey. Polar bears fare poorly when they come in contact with crude oil.

As the sea ice disappears, many of these resources are increasingly accessible. As the search for resources increases, geologists and exploration camps are spreading farther afield. More mining means more shipping, which leads to more icebreakers transporting equipment and petroleum products. Icebreakers disrupt seals and their habitat. If all goes well, there is no problem, but the Arctic is a rough environment for ships and equipment. Right now, the effects of human industrial development on polar bears are essentially unknown.

Fishing is another potential disturbance. Currently, fishing for Arctic species is limited, but less ice and increasing harvests might alter ecosystem linkages. Shrimp trawling is a growing Arctic industry. Disruption of bottom sediments and fauna could affect the prey that seals feed on, which in turn would affect polar bears.

Research in the Arctic is also increasing. When studies on oceans, sea ice, glaciers, rivers, lakes, permafrost, plants, invertebrates, fish, birds, mammals, and a myriad of other thing are added in, the Arctic is getting a lot busier. More researchers mean more field camps, more icebreakers, and more firearms.

While the effects of each activity may be small, when added together, the synergistic impacts could be large.

Global Warming

Global warming is the greatest threat facing polar bears because it does not merely threaten individual bears. It threatens the entire species. The planet is warming and the Arctic is warming far faster than lower latitudes. The sea ice is changing and polar bears are losing their habitat. Polar bears might survive on less sea ice but would not survive without it. While consummate fasters willing to exploit almost any food source, polar bears cannot sustain themselves on anything but the rich marine resources they evolved to exploit—and they need sea ice to get those resources. If current projected sea ice losses are realized, analyses suggest that two-thirds of the world's polar bears could disappear by midcentury.

The response of polar bears to global warming is clear. Change starts with lower body weights, followed by smaller body sizes in a few years, along with lower cub survival, and lower subadult survival. Pregnant females arriving on shore earlier with less fat stored have to fast longer

As commercial exploitation of Arctic resources increases, ship traffic will also increase. The potential disruption to polar bears and their prey could add yet another pressure on populations already stressed by other changes.

Polar bear cubs are the weakest link in a population. When sea ice conditions decline, females cannot store enough fat and consequently they produce punier cubs. Smaller cubs have lower survival rates. Lower recruitment of cubs can result in a population decline.

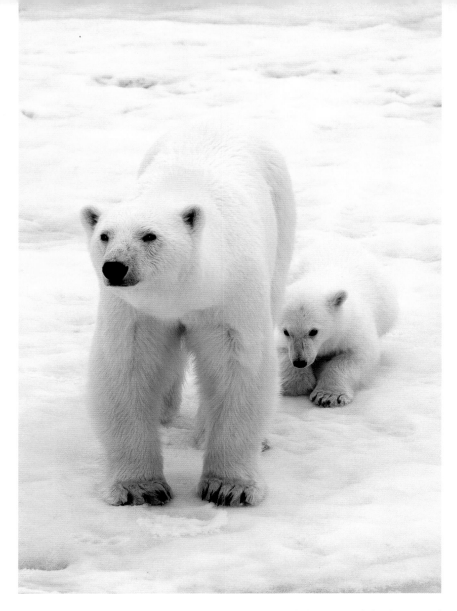

and produce fewer cubs. As things get worse, adult survival declines and then finally, the population declines. A host of other effects have been documented. In Alaska, the proportion of dens on sea ice dramatically declined in response to changes in sea ice stability and females now seek land to den. Hopen Island in Svalbard used to be a major den area but now rarely has any dens because the sea ice does not form early enough for pregnant females to reach there. Reports of infanticide and cannibalism are increasing. Observations of desperate hunting attempts by polar bears are showing up, with bears digging through solid ice to reach seals: extremely inefficient when compared to digging out seals from a snow lair.

The effects of these changes are far reaching. As the ice breaks up earlier, the bears are forced ashore sooner, and when it re-forms later in the autumn or early winter the bears' return to hunting is delayed. The bears lose three ways. They lose spring feeding time and opportunities to store fat; coming ashore earlier lengthens the fasting period, which means they actually need more fat; and they cannot return to the ice as early to hunt. Declines in the body condition of polar bears have already been observed in several populations. Energetics studies suggest that ex-

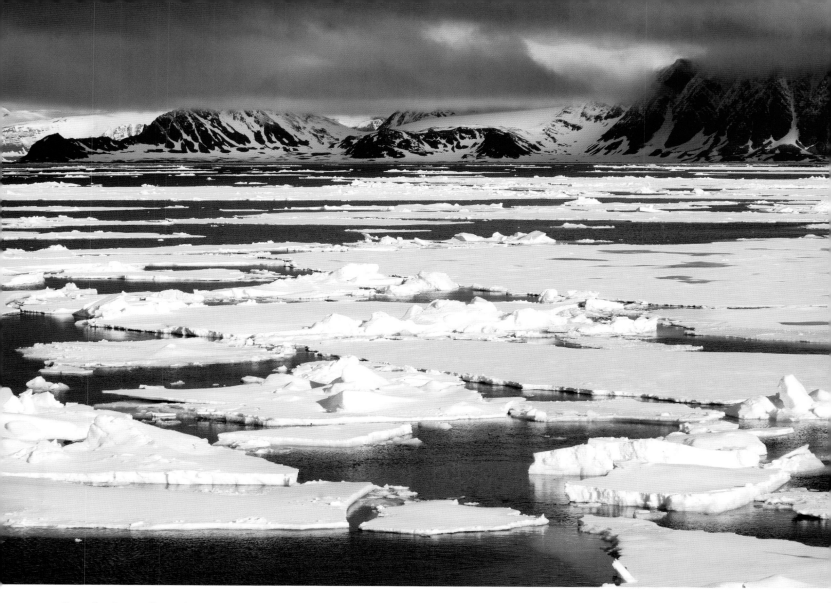

tending the fast will markedly increase mortality. Cubs are a particularly vulnerable link in polar bear populations because nutritionally stressed mothers stop nursing sooner and cub mortality increases. Females in poorer condition also draw down their fat stores and the last milk they produce is the most polluted. Highly polluted cubs have lower survival rates. There are tipping points for any population, and some studies predict that polar bear mortality could spike in a single year and drive a population to desperately low levels. It is abundantly clear that the resources available to polar bears while on land are no substitute for eating seal blubber. People who suggest polar bears will "adapt" are talking nonsense.

Some impacts may be subtle. Because the sea ice forms later, it is thinner and more labile. Sea ice is like a treadmill, and climate change is turning up the treadmill speed. As bears use more energy for locomotion, they have less energy for growth, reproduction, and storage. More dynamic ice also means that bears have a harder time maintaining place fidelity; population boundaries will shift as a result.

Despite climate change, the Arctic will still be cold in winter and there will still be sea ice. But will there be enough ice to support polar

A steady decline in sea ice throughout the Arctic has been documented and that trend is predicted to continue. Current projections suggest that two-thirds of the world's polar bears will disappear by midcentury unless climate warming can be brought under control.

Staying Safe in Polar Bear Country

There are so few polar bear attacks on people that it is difficult to determine why they occur. Polar bears do not usually consider humans prey. But anyone watching a blood-soaked polar bear munching on a seal would be justified in wanting to spend a moment thinking about safety precautions in polar bear country. For the most part, staying safe around polar bears calls for the same precautions taken with American black bears and grizzly bears.

Camping away from points, narrows, the tideline, and small islands is recommended because polar bears frequent such areas. Normal bear safety associated with cooking and food storage is essential. Bears that obtain food often return and lose their wariness. An early warning system such as a tripwire alarm, or even cans suspended on a string, is of benefit around a camp. Experienced dogs can be effective against bears but are not foolproof.

Problems associated with encounters at close range are uncommon in the open habitat of the Arctic. Polar bears, however, make their living sneaking up on seals, and human senses are a poor substitute for those of a seal. You have various options if you see the bear before it sees you—but a swimming bear or a bear on rough ice can be difficult to spot. If you spot a bear, leave the area, change your route, or seek shelter. Every bear is different. A skinny animal may pose a greater threat than a fat, well-fed one. Larger offspring with their mother can be trouble because they are less wary; a mother with small cubs usually avoids humans. A bear assessing the situation may wander back and forth, sniff the air, crane its neck, and swing its head. A curious bear may stand up on its hind legs. An agitated bear may make loud chuffing noises, pop its jaws, stare with eyes fixed, or drop its head below shoulder level with its ears

A fresh set of tracks is a sure sign that you are in polar bear country. A predator-filled ecosystem is richer and more dynamic than the boring and sanitized ecosystems from which they have been removed. By exercising reasonable care, tourists will find a visit to the home of the polar bear safe for themselves and the bears.

bears? Both annual and multiyear sea ice are disappearing throughout the polar bear's range. According to the National Snow and Ice Data Center in Boulder, Colorado, between 1979 and 2011, ice cover in May and June has declined 2.4% and 3.6% per decade, respectively. While this might seem slow, consider that some populations are seeing much more than the average while other areas are showing little change. With 19 populations worldwide, there will be 19 different responses to global warming. The populations in Hudson Bay and the Beaufort Sea may disappear first. In recent years, the sea ice has been melting one week

drawn back. If a bear is approaching at a run or trot, you must prepare for an attack. Polar bears are less likely to bluff charge than other bears, and a charge can be triggered without warning. A polar bear can easily reach 19 miles per hour (30 km/h), which means a bear 150 feet (50 m) away will arrive in seconds!

A bear might be deterred with a warning shot or flare deterrent. Revving a snow machine, yelling, or banging pots might be effective, each bear responds differently: a successful deterrent for one bear may invoke a charge in another. Polar bears quickly habituate to noise; what worked once may have little effect the second time. Several people together are a better deterrent than a single person. Bear sprays are only effective at a distance closer than most people find comfortable. And they are unreliable in cold temperatures or high winds. If you do not have a firearm, grab a knife or a makeshift weapon: a rock, frying pan, paddle, or ski pole will do. Polar bears are unaccustomed to prey that fights back. The nose and eyes are sensitive targets.

In many areas, being armed and competent with a suitable firearm is the best precaution. The distance at which an individual feels he must shoot to kill will vary. Killing the bear beats becoming bear food. If you shoot, aim to kill: wounded bears are a danger to all. Killing a polar bear in self-defense is permitted but must be reported to the local authorities.

If you surprise a bear at close range, it may respond defensively and fighting back may intensify

the attack. Roll into a ball, protect your head and neck, and remain motionless. If the bear continues to attack, your strategy must change: fight for your life.

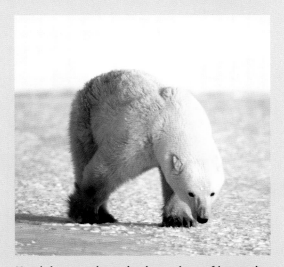

Head down and ears back are signs of impending trouble…or possibly a reassessment and a hasty retreat by the bear. Unpredictability is about the only predictable thing about a polar bear.

earlier every decade in Hudson Bay. Some uninformed people have stated that loss of multiyear ice is not a concern for polar bears. This is absolutely wrong. Multiyear ice is where thousands of bears make their summer homes. An ice-free Arctic in summer is likely within decades. Some have suggested that as the climate warms, the bears will just move farther north as some other species have done. Unfortunately, farther north means the bears would have to live over the unproductive Arctic Ocean where seal abundance is paltry. Polar bears are a species of the continental shelves not the deep Arctic Ocean. Furthermore, if all the

Killer whales are already exploiting reduced Arctic sea ice. Normally excluded from the ice-filled waters of the north, killer whales may become the top predator in the marine ecosystem. If polar bears disappear because sea ice disappears, the Arctic as we know it will no longer exist.

multiyear ice melts in summer, the bears are far from land and this bodes poorly for them.

We can expect the seal populations to decline, resulting in less food for polar bears. Ringed and bearded seals are only found where there is sea ice. In all the years people have watched polar bears, there are only a handful of observations of polar bears killing a seal in open water; this is not their salvation. As the sea ice disappears, Arctic marine ecosystems will be invaded by Pacific and Atlantic ocean species. New species will bring new diseases and parasites. How polluted and nutritionally stressed bears will respond is unclear. Until now, killer whales have been locked out of the Arctic by their long dorsal fin, which does not work well in pack ice. They are now showing up in areas where they have never been seen before. Killer whales will compete with polar bears for seals. Southern seals may move northward but the bears still need a platform from which to hunt. There will still be an Arctic ecosystem but in most places it will not include polar bears.

Each change in and of itself is not enough to push polar bears over the edge but the cumulative effects might be. The pace of change is too fast for polar bears to adapt. No other large carnivore has survived such

massive habitat loss. Natural climate change occurred 10,000 years ago in the Baltic Sea. Parts of the Baltic Sea still freeze in winter and ringed seals manage to hang on. The ice bear did not survive the warming in this area. The polar bears of the Baltic Sea did not adapt to land: they disappeared. If accelerated climate change continues at its current pace, we can expect the same fate for the Arctic polar bear populations.

It is not yet too late for polar bears. Almost all of the most active climate researchers believe that humans are causing the current warming trend. If humans take the threat of global warming seriously and reduce greenhouse gases, there is still a future for polar bears. We will lose populations but the bears should hang on in the highest reaches of the Arctic until the end of the century. If we can get greenhouse gas levels down, the sea ice will re-form and the ice bears will return.

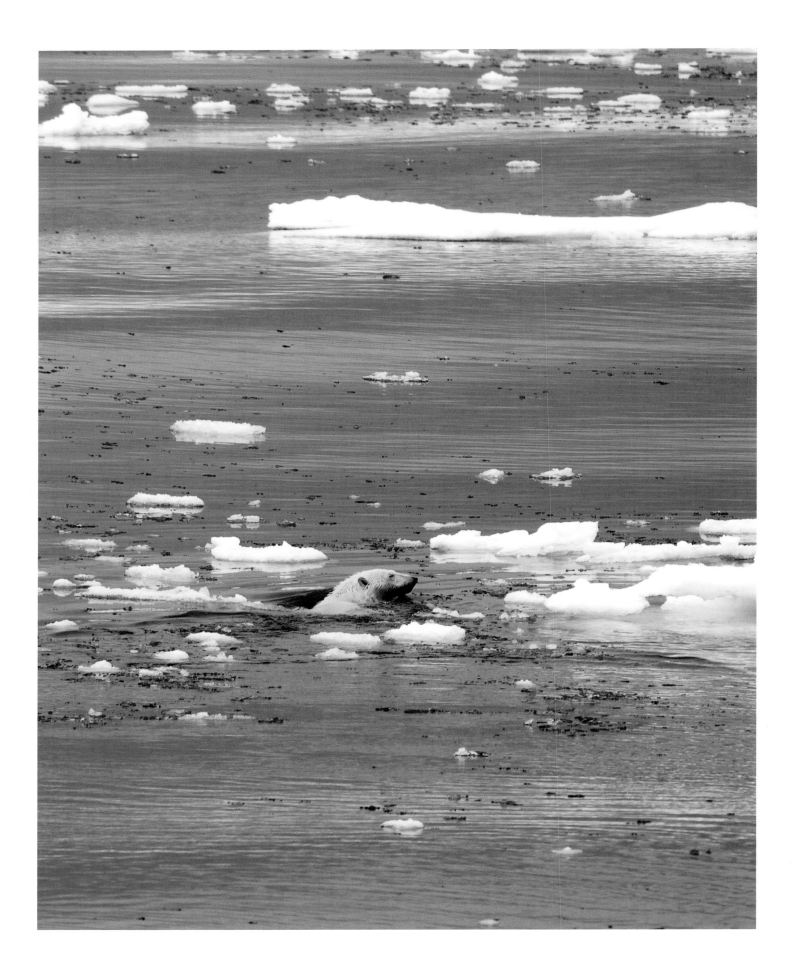

14

LOOKING FORWARD

The polar bear is the quintessential Arctic species and a world without them is difficult to imagine. On an evolutionary time line, polar bears have existed for only a few moments. How much longer they will be with us depends on the actions we take in the immediate future. The greatest risk facing the bears is the burgeoning human population. Too many people on a resource-limited planet create too much waste. Like all species, if our numbers exceed what the ecosystems can sustain, the ecosystems upon which we depend will be damaged. Ultimately, we will be controlled by the same mechanisms that control polar bear populations: food, disease, and conflict. Unlike polar bears, we can control the actions that affect the ecosystems upon which we depend.

Polar bears are still found over nearly all of their historic range. Whether that will continue depends on our actions. The bears are telling us what we already know: we are drastically changing our planet. Scientific studies and monitoring will help us follow the fate of polar bears as the effects of global warming increase, but research suggests a grim future for polar bears.

Shakespeare's most famous stage direction may be from *The Winter's Tale:* "Exit, pursued by a bear." Bears have a central role in the imagination of humans, back to the roots of our expansion into the Northern Hemisphere. Mythology, folklore, literature, culture, nutrition, and economy have all been affected by the existence of this most humanlike carnivore.

The science of global warming is as profoundly solid as any that humans have developed. And the consequence of climate change for polar bears is simple to understand: polar bears evolved to exploit a challenging and unique environment and that environment is disappearing.

We have the means to stop the warming of our planet. We have the technology to develop a sustainable future for humans and polar bears.

(Opposite) **The polar bear's Arctic home is melting. And this highly specialized species cannot survive without the sea ice on which it hunts, travels, eats, sleeps, plays, and rears its young.**

What You Can Do to Help the Ice Bears

The carbon humans put into the atmosphere is the major threat to polar bears. The problems polar bears face stem from our daily lives. We must reduce our carbon footprint. As such, we can help polar bears every day. Using less energy and using energy that produces less carbon is the first step to saving the ice bears. How far we commute to work or school and how we get there plays a role in determining our carbon footprint. As families in much of the world have gotten smaller, our homes and vehicles have gotten larger. Wise decisions on purchases will help improve the outlook for polar bears. The changes have to start at home.

Reducing greenhouse gasses requires leadership from government and compliance from industry. Green initiatives such as public transport and transformation of our energy policies are sorely needed. We need officeholders with a long-term vision that spans generations. The sooner we act the better. Future generations will judge us harshly if we continue to do nothing about global warming.

The effects we are seeing on polar bears are just the beginning. Thousands of species will be affected by climate change. We can slow the rate of change by supporting technology that will help put us in balance with the planet. With time, the earth will cool if we stop using high carbon fuels like coal and the tar sands. Carbon capture might work, but it is not working yet. Carbon emissions keep growing, which signals a slow, sad farewell to sea ice and the ice bear. When the conditions for polar bears become dire, we will be too busy helping humans survive to come to the aid of polar bears. But this is not some distant threat that the next generation can address. We are already losing polar bears. We have to act now. Every little bit each of us does to slow global climate change will help. I am convinced we can save the sea ice and the polar bears if we try.

Learning more and staying informed about the threats to polar bears is important. Below are names (and websites) for nonprofit groups dedicated to wildlife conservation or education; each has its own area of expertise but all are making important contributions.

Polar Bears International
 (polarbearsinternational.org)
WWF Canada (wwf.ca)
WWF US (worldwildlife.org)
IUCN / SSC Polar Bear Specialist Group
 (pbsg.npolar.no)
Center for Biological Diversity
 (biologicaldiversity.org)
Roots and Shoots, a program of the Jane Goodall
 Institute (rootsandshoots.org)
National Wildlife Federation (nwf.org)
RealClimate (realclimate.org)

(Opposite) The future for polar bears is uncertain. People have the technological expertise to curtail the global warming that is destroying the polar bear's habitat. Whether we have the will to do so is the question.

What we need now is the will to do so. Future generations will judge us harshly if we fail to stop the catastrophic results of global warming, as they should.

Polar bears have been good to me. I have learned a lot about their lives and I feel that I owe them something for the privilege of having studied them. If learning more about polar bears inspires people to act in their favor, then, in some small way, the debt is being repaid.

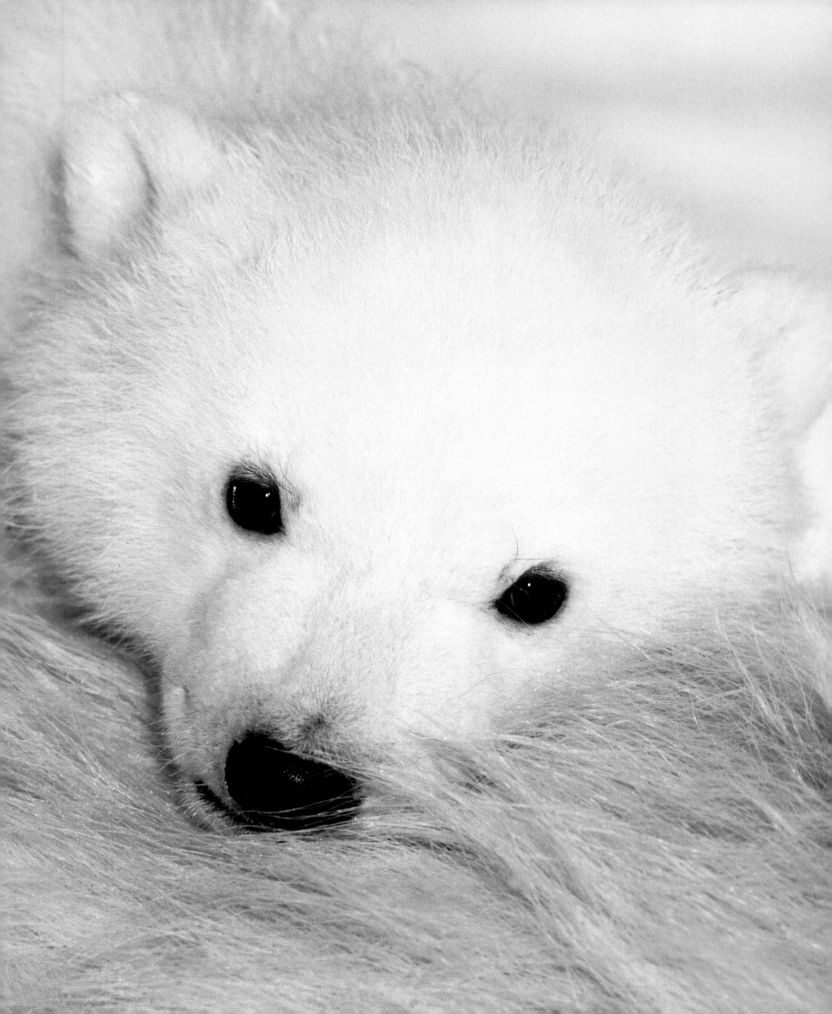

Appendix A

Scientific Names of Plants and Animals

Common name (Scientific name)

African lion (*Panthera leo*)
albatross (family Diomedeidae)
alpine blueberry (*Vaccinium uliginosum*)
American black bear (*Ursus americanus*)
American mink (*Neovison vison*)
amphipod (order Amphipoda)
Andean bear (*Tremarctos ornatus*)
Antarctic fur seal (*Arctocephalus gazella*)
Arctic char (*Salvelinus alpinus*)
Arctic fox (*Vulpes lagopus*)
Arctic ground squirrel (*Spermophilus parryii*)
Arctic hare (*Lepus arcticus*)
Arctic tern (*Sterna paradisaea*)
Asiatic (Asian) black bear (*Ursus thibetanus*)
Atlantic cod (*Gadus morhua*)
Atlantic salmon (*Salmo salar*)
Auvergne bear (*Ursus minimus*)

bamboo (family Poaceae)
bearded seal (*Erignathus barbatus*)
beaver (*Castor canadensis*)
beluga (*Delphinapterus leucas*)
bighorn sheep (*Ovis canadensis*)
black-legged kittiwake (*Rissa tridactyla*)
black spruce (*Picea mariana*)
blue whale (*Balaenoptera musculus*)
bobcat (*Lynx rufus*)

bowhead (*Balaena mysticetus*)
brown bear (*Ursus arctos*)

Canada lynx (*Lynx canadensis*)
capelin (*Mallotus villosus*)
caribou (*Rangifer tarandus*)
cave bear (*Ursus spelaeus*)
cheetah (*Acinonyx jubatus*)
comb jelly (phylum Ctenophora)
common raven (*Corvus corax*)
copepod (subphylum Crustacea)
coyote (*Canis latrans*)
crowberry (*Empetrum nigrum*)

dawn bear (*Ursavus elmensis*)
diatom (class Bacillariophyceae)
dolphin (family Delphinidae)
dugong (*Dugong dugon*)

earthworm (order Haplotaxida)
eider duck (family Anatidae)
elk (*Cervus elaphus*)
Etruscan bear (*Ursus etruscus*)
Etruscan shrew (*Suncus etruscus*)

fourhorn sculpin (*Myoxocephalus quadricornis*)

giant panda (*Ailuropoda melanoleuca*)
giant short-faced bear (*Arctodus simus*)
glaucous gull (*Larus hyperboreus*)
gray whale (*Eschrichtius robustus*)
gray wolf (*Canis lupus*)
great auk (*Pinguinus impennis*)
Greenland halibut (*Reinhardtius hippoglos-soides*)
Greenland shark (*Somniosus microcephalus*)
grizzly bear (*Ursus arctos*)
ground squirrel (family Sciuridae)
guppy (*Poecilia reticulata*)

harbor seal (*Phoca vitulina*)
harp seal (*Pagophilus groenlandicus*)
herring (*Clupea* spp.)
hippopotamus (*Hippopotamus amphibius*)
hooded seal (*Cystophora cristata*)

isopod (subphylum Crustacea)
ivory gull (*Pagophila eburnea*)

jaguar (*Panthera onca*)

Kermode bear (*Ursus americanus*)
killer whale (*Orcinus orca*)
king eider (*Somateria spectabilis*)

larch (*Larix laricina*)
lemming (family Cricetidae)
light-bellied brent goose (*Branta bernicla hrota*)
little auk (*Alle alle*)

manatees (*Trichechus* spp.)
minke whale (*Balaenoptera acutorostrata*)
moose (*Alces alces*)
mountain sorrel (*Oxyria digyna*)
mule deer (*Odocoileus hemionus*)
musk ox (*Ovibos moschatus*)
mussel (*Mytilus edulis*)

narwhal (*Monodon monoceros*)
Neanderthal (*Homo neanderthalensis*)
northern elephant seal (*Mirounga angustiro-stris*)

orchid (family Orchidaceae)

Pacific salmon (*Oncorhynchus* spp.)
penguin (family Spheniscidae)
polar bear (*Ursus maritimus*)
polar cod (*Boreogadus saida*)
porcupine (*Erethizon dorsatum*)
porpoise (family Phocoenidae)

raccoon (*Procyon lotor*)
red fox (*Vulpes vulpes*)
red panda (*Ailurus fulgens*)
reindeer (*Rangifer tarandus*)
ribbon seal (*Phoca fasciata*)
ringed seal (*Pusa hispida*)
rough-legged hawk (*Buteo lagopus*)

sea angel (*Clione limacina*)
sea grass (order Alismatales)
sea lion (family Otariidae)
sea otter (*Enhydra lutris*)
shrews (*Sorex* spp.)
skuas (*Stercorarius* spp.)
skunks (family Mephitidae)
sloth bear (*Ursus ursinus*)
slugs (class Gastropoda)
snow goose (*Anser caerulescens*)
snowy owl (*Bubo scandiacus*)
spectacled bear (*Tremarctos ornatus*)
spotted seal (*Phoca largha*)
squid (order Teuthida)
sun bear (*Ursus malayanus*)
Svalbard reindeer (*Rangifer tarandus platy-rhynchus*)

thick-billed murre (*Uria lomvia*)

vole (family Cricetidae)

walrus (*Odobenus rosmarus*)
weasel (*Mustela vison*)
white spruce (*Picea glauca*)
white-tailed deer (*Odocoileus virginianus*)
willows (*Salix* spp.)
wolverine (*Gulo gulo*)
woolly mammoth (*Mammuthus primigenius*)

Appendix B

Species of Plants and Animals Eaten by Polar Bears

Common name (Scientific name)

alpine blueberry (*Vaccinium uliginosum*)
Arctic bearberry (*Arctostaphylos rubra*)
Arctic char (*Salvelinus alpinus*)
Arctic cottongrass (*Eriophorum scheuchzeri*)
Arctic fox (*Vulpes lagopus*)
Arctic ground squirrel (*Spermophilus parryii*)
Arctic tern (*Sterna paradisaea*)
Atlantic salmon (*Salmo salar*)

barnacle goose (*Branta leucopsis*)
bearded seal (*Erignathus barbatus*)
beaver (*Castor canadensis*)
beluga (*Delphinapterus leucas*)
black-legged kittiwake (*Rissa tridactyla*)
bowhead whale (*Balaena mysticetus*)
brown algae (*Sphacelaria* spp.)

Canada buffaloberry (*Shepherdia canadensis*)
Canada goose (*Branta canadensis*)
caribou (*Rangifer tarandus*)
club mosses (*Lycopodium* spp.)
collared lemmings (*Dicrostonyx* spp.)
common eider (*Somateria mollissima*)
crowberry (*Empetrum nigrum*)

dulse (*Palmeria palmata*)
dwarf birch (*Betula glandulosa*)

eel grass (*Zostera marina*)

fin whale (*Balaenoptera physalus*)
fourhorn sculpin (*Myoxocephalus quadricornis*)

glaucous gull (*Larus hyperboreus*)
gray whale (*Eschrichtius robustus*)
gray wolf (*Canis lupus*)
great auk (*Pinguinus impennis*)
Greenland halibut (*Reinhardtius hippoglos-soides*)
Greenland shark (*Somniosus microcephalus*)

harbor seal (*Phoca vitulina*)
harp seal (*Pagophilus groenlandicus*)
herring gull (*Larus argentatus*)
hooded seal (*Cystophora cristata*)
horseflies (*Tabanus* spp.)
horsetails (*Equisetum* spp.)

kelp (*Laminaria* spp.)
king eider (*Somateria spectabilis*)

lemmings (*Lemmus* spp.)
lichen
light-bellied brent goose (*Branta bernicla hrota*)
little auk (*Alle alle*)

long-tailed duck (*Clangula hyemalis*)

marine algae (*Fucus* spp.)

meadow vole (*Microtus pennsylvanicus*)

minke whale (*Balaenoptera acutorostrata*)

moose (*Alces alces*)

moss

mountain sorrel (*Oxyria digyna*)

mushrooms

musk ox (*Ovibos moschatus*)

muskrat (*Ondatra zibethicus*)

mussel (*Mytilus edulis*)

narwhal (*Monodon monoceros*)

northern gooseberry (*Ribes oxyacanthoides*)

otter (*Lontra canadensis*)

polar bear (*Ursus maritimus*)

polar cod (*Boreogadus saida*)

porcupine (*Erethizon dorsatum*)

puffin (*Fratercula arctica*)

red algae (*Neodilsea integra*)

ribbon seal (*Phoca fasciata*)

ringed seal (*Pusa hispida*)

rushes (family Juncaceae)

sandpipers (family Scolopacidae)

sea lyme grass (*Leymus arenarius*)

sea urchin (*Strongylocentrotus droebachiensis*)

sedges (family Cyperaceae)

snow buntings (*Plectrophenax nivalis*)

snow goose (*Anser caerulescens*)

sperm whale (*Physeter macrocephalus*)

spotted seal (*Phoca largha*)

starfish (class Asteroidea)

Svalbard reindeer (*Rangifer tarandus platy-rhynchus*)

thick-billed murre (*Uria lomvia*)

walrus (*Odobenus rosmarus*)

weasel (*Mustela vison*)

willow ptarmigan (*Lagopus lagopus*)

willows (*Salix* spp.)

witch's hair (*Desmarestia aculeata*)

Appendix B

References

General

Born, E.W. 2008. *The white bears of Greenland*. Ilinniusiorfik Undervisningsmiddelforlag, Ministry of Environment and Natural Resources, Nuuk, Greenland.

Cone, M. 2005. *Silent snow: The slow poisoning of the Arctic*. Grove Press, New York.

Ellis, R. 2009. *On thin ice: The changing world of the polar bear*. Alfred A. Knopf, New York.

Larsen, T. 1978. *The world of the polar bear*. Chartwell Books, Secaucus, New Jersey.

Lynch, W. 1993. *Bears: Monarchs of the northern wilderness*. Greystone Books, Vancouver, Canada.

Pielou, E.C. 1994. *A naturalist's guide to the Arctic*. University of Chicago Press, Chicago.

Stirling, I. 1988. *Polar bears*. University of Michigan Press, Ann Arbor.

Stirling, I., ed. 1993. *Bears: Majestic creatures of the wild*. Rodale Press, Emmaus, Pennsylvania.

Thomas, D.N. 2004. *Frozen oceans: The floating world of pack ice*. Firefly Books, Buffalo, New York.

1 Introduction

Amstrup, S.C. 2003. *Polar bear* Ursus maritimus. Edited by G.A. Feldhamer, B.C. Thompson, and J.A. Chapman. Johns Hopkins University Press, Baltimore, 587–610.

DeMaster, D.P., and Stirling, I. 1981. *Ursus maritimus*. *Mammalian Species* 145:1–7.

Pielou, E.C. 1994. *A naturalist's guide to the Arctic*. University of Chicago Press, Chicago.

2 A Polar Bear Described

Anderson, C.J.R., Roth, J.D., and Waterman, J.M. 2007. Can whisker spot patterns be used to identify individual polar bears? *Journal of Zoology* 273:333–339.

Atkinson, S.N., Nelson, R.A., and Ramsay, M.A. 1996. Changes in the body composition of fasting polar bears (*Ursus maritimus*): The effect of relative fatness on protein conservation. *Physiological Zoology* 69:304–316.

Best, R.C. 1982. Thermoregulation in resting and active polar bears. *Journal of Comparative Physiology* 146:63–73.

Blix, A.S., and Lentfer, J.W. 1979. Modes of thermal protection in polar bear cubs—at birth and on emergence from the den. *American Journal of Physiology* 236:R67–R74.

Calvert, W., and Ramsay, M.A. 1998. Evaluation of age determination of polar bears by counts of cementum growth layer groups. *Ursus* 10:449–453.

Cushing, B.S., Cushing, N.L., and Jonkel, C. 1988. Polar bear responses to the underwater vocalizations of ringed seals. *Polar Biology* 9:123–124.

DeMaster, D.P., and Stirling, I. 1981. *Ursus maritimus*. *Mammalian Species* 145:1–7.

Derocher, A.E. 1990. Supernumerary mammae and nipples in the polar bear. *Journal of Mammalogy* 71:236–237.

Derocher, A.E., Andersen, M., and Wiig, Ø. 2005. Sexual dimorphism of polar bears. *Journal of Mammalogy* 86:895–901.

Derocher, A.E., Nelson, R.A., Stirling, I., and Ramsay, M.A. 1990. Effects of fasting and feeding on serum urea and serum creatinine levels in polar bears. *Marine Mammal Science* 6:196–203.

Derocher, A.E., van Parijs, S.M., and Wiig, Ø. 2010.

Nursing vocalization of a polar bear cub. *Ursus* 21:189–191.

Dyck, M.G., Bourgeois, J.M., and Miller, E.H. 2004. Growth and variation in the bacula of polar bears (*Ursus maritimus*) in the Canadian Arctic. *Journal of Zoology* 264:105–110.

Ewer, R.F. 1973. *The carnivores*. Cornell University Press, Ithaca, New York.

Gittleman, J.L. 1991. Carnivore olfactory bulb size: Allometry, phylogeny, and ecology. *Journal of Zoology* 225:253–272.

Hellgren, E.C. 1998. Physiology of hibernation in bears. *Ursus* 10:467–477.

Hobson, K.A., Stirling, I., and Andriashek, D.S. 2009. Isotopic homogeneity of breath CO_2 from fasting and berry-eating polar bears: Implications for tracing reliance on terrestrial foods in a changing Arctic. *Canadian Journal of Zoology* 87:50–55.

Hurst, R.J., Leonard, M.L., Watts, P.D., Beckerton, P., and Øritsland, N.A. 1982. Polar bear locomotion: Body temperature and energetic cost. *Canadian Journal of Zoology* 60:40–44.

Koon, D.W. 1998. Is polar bear hair fiber optic? *Applied Optics* 37:3198–3200.

Leighton, F.A., Cattet, M., Norstrom, R., and Trudeau, S. 1988. A cellular basis of high levels of vitamin A in livers of polar bears (*Ursus maritimus*): The Ito cell. *Canadian Journal of Zoology* 66:480–482.

Lennox, A.R., and Goodship, A.E. 2008. Polar bears (*Ursus maritimus*), the most evolutionary advanced hibernators, avoid significant bone loss during hibernation. *Comparative Biochemistry and Physiology, Part A: Molecular and Integrative Physiology* 149:203–208.

Levenson, D.H., Ponganis, P.J., Crognale, M.A., Deegan, J.F., Dizon, A., and Jacobs, G.H. 2006. Visual pigments of marine carnivores: Pinnipeds, polar bear, and sea otter. *Journal of Comparative Physiology A* 192:833–843.

Lewin, R.A., and Robinson, P.T. 1979. The greening of polar bears in zoos. *Nature* 278:445–447.

Lønø, O. 1970. The polar bear (*Ursus maritimus* Phipps) in the Svalbard area. *Norsk Polarinstitutt Skrifter* 149:1–115.

Manning, D.P., Cooper, J.E., Stirling, I., Jones, C.M., Bruce, M., and McCausland, P.C. 1985. Studies on the footpads of the polar bear (*Ursus maritimus*) and their possible relevance to accident prevention. *Journal of Hand Surgery* 10:303–307.

Medill, S., Derocher, A.E., Stirling, I., and Lunn, N. 2010. Reconstructing the reproductive history of female polar bears using cementum patterns of premolar teeth. *Polar Biology* 33:115–124.

Nachtigall, P.E., Supin, A.Y., Amundin, M., Roken, B., Moller, T., Mooney, T.A., Taylor, K.A., and Yuen, M. 2007. Polar bear *Ursus maritimus* hearing measured with auditory evoked potentials. *Journal of Experimental Biology* 210:1116–1122.

Nelson, R.A. 1987. Black bears and polar bears —still metabolic marvels. *Mayo Clinic Proceedings* 62:850–853.

Øritsland, N.A. 1969. Deep body temperatures of swimming and walking polar bear cubs. *Journal of Mammalogy* 50:380–383.

Pond, C.M., Mattacks, C.A., Colby, R.H., and Ramsay, M.A. 1992. The anatomy, chemical composition, and metabolism of adipose tissue in wild polar bears (*Ursus maritimus*). *Canadian Journal of Zoology* 70:326–341.

Ramsay, M.A., Nelson, R.A., and Stirling, I. 1991. Seasonal changes in the ratio of serum urea to serum creatinine in feeding and fasting polar bears. *Canadian Journal of Zoology* 69:298–302.

Renous, S., Gasc, J.-P., and Abourachid, A. 1998. Kinematic analysis of the locomotion of the polar bear (*Ursus maritimus* Phipps, 1774) in natural and experimental conditions. *Netherlands Journal of Zoology* 48:145–167.

Rodahl, K. 1949. Toxicity of polar bear liver. *Nature* 164:530–531.

Rosell, F., Jojola, S.M., Ingdal, K., Lassen, B.A., Swenson, J.E., Arnemo, J.M., and Zedrosser, A. 2011. Brown bears possess anal sacs and secretions may code for sex. *Journal of Zoology* 283:143–152.

Scholander, P.F., Walters, V., Hock, R., and Irving, L. 1950. Body insulation of some arctic and tropical mammals and birds. *Biological Bulletin Woods Hole* 90:225–271.

Sivak, J.G., and Piggins, D.J. 1975. Refractive state of the eye of the polar bear (*Thalarctos maritimus* Phipps). *Norwegian Journal of Zoology* 23:89–91.

Slater, G.J., Figueirido, B., Louis, L., Yang, P., and Van Valkenburgh, B. 2010. Biomechanical consequences of rapid evolution in the polar bear lineage. *PLOS One* 11:e13870, 13871–13877.

Weissengruber, G.E., Forstenpointner, G., Kübber-Heiss, A., Riedelberger, K., Schwammer, H., and Ganzberger, K. 2001. Occurrence and structure of epipharyngeal pouches in bears (Ursidae). *Journal of Anatomy* 198:309–314.

Wemmer, C., Von Ebers, M., and Scow, K. 1976. An analysis of the chuffing vocalization in the polar bear (*Ursus maritimus*). *Journal of Zoology* 180:425–439.

3 Evolution

Aaris-Sørensen, K., and Petersen, K.S. 1984. A late Weichselian find of polar bear (*Ursus maritimus* Phipps) from Denmark and reflections on the paleoenvironment. *Boreas* 13:29–33.

Cherry, S.G., Derocher, A.E., Hobson, K.A., Stirling, I., and Thiemann, G.W. 2011. Quantifying

dietary pathways of proteins and lipids to tissues of a marine predator. *Journal of Applied Ecology* 48:373–381.

Doupe, J.P., England, J.H., Furze, M., and Paetkau, D. 2007. Most northerly observation of a grizzly bear (*Ursus arctos*) in Canada: Photographic and DNA evidence from Melville Island, Northwest Territories. *Arctic* 60:271–276.

Edwards, C.J., Suchard, M.A., Lemey, P., Welch, J.J., Barnes, I., Fulton, T.L., Barnett, R., O'Connell, T.C., et al. 2011. Multiple hybridization events between ancient brown and polar bears and an Irish origin for the modern polar bear matriline. *Current Biology* 21:1251–1258.

Figueirido, B., Perez-Claros, J., Torregrosa, V., Martin-Serra, A., and Palmqvist, P. 2010. Demythologizing *Arctodus simus*, the "short-faced" long-legged and predaceous bear that never was. *Journal of Vertebrate Paleontology* 30:262–275.

Kurtén, B. 1964. The evolution of the polar bear, *Ursus maritimus* Phipps. *Acta Zoologica Fennica* 108:1–30.

Lindqvist, C., Schuster, S.C., Sun, Y.Z., Talbot, S.L., Qi, J., Ratan, A., Tomsho, L.P., et al. 2010. Complete mitochondrial genome of a Pleistocene jawbone unveils the origin of polar bear. *Proceedings of the National Academy of Sciences of the United States of America* 107:5053–5057.

McLellan, B., and Reiner, D.C. 1994. A review of bear evolution. *International Conference on Bear Biology and Management* 9:85–96.

Preuss, A., Ganslosser, U., Purschke, G., and Magiera, U. 2009. Bear-hybrids: Behaviour and phenotype. *Zoologische Garten* 78:204–220.

Reimchen, T.E. 1998. Nocturnal foraging behaviour of black bears, *Ursus americanus*, on Moresby Island, British Columbia. *Canadian Field-Naturalist* 112:446–450.

Ritland, K., Newton, C., and Marshall, H.D. 2001. Inheritance and population structure of the white-phased "Kermode" black bear. *Current Biology* 11:1468–1472.

Shields, G.F., Adams, D., Garner, G., Labelle, M., Pietsch, J., Ramsay, M., Schwartz, C., Titus, K., and Williamson, S. 2000. Phylogeography of mitochondrial DNA variation in brown bears and polar bears. *Molecular Phylogenetics and Evolution* 15:319–326.

Stirling, I., and Derocher, A.E. 1990. Factors affecting the evolution and behavioral ecology of the modern bears. *International Conference on Bear Biology and Management* 8:189–204.

4 Early Polar Bear–Human Interactions

Boas, F. 1888. *The Central Eskimo*. Sixth Annual Report of the Bureau of Ethnology, Smithsonian Institution, Washington, D.C.

Conway, M. 1906. *No man's land: A history of Spitsbergen from its discovery in 1596 to the beginning of the scientific exploration of the country*. Cambridge University Press, Cambridge.

Hall, C.F. 1865. *Life with the Esquimaux: A narrative of Arctic experience in search of survivors of Sir John Franklin's expedition from May 29, 1860, to September 13, 1862*. S. Low, Son, and Marston, London.

Oleson, T.J. 1950. Polar bears in the Middle Ages. *Canadian Historical Review* 31:47–55.

Phipps, C.J. 1774. *A voyage towards the North Pole undertaken by His Majesty's command, 1773*. W. Bowyer and J. Nichols, London.

Rasmussen, K., and Worster, W. 1921. *Eskimo folk-tales*. Gyldendal, London.

Sato, Y., Nakamura, H., Ishifune, Y., and Ohtaishi, N. 2011. The white-colored brown bears of the Southern Kurils. *Ursus* 22:84–90.

5 Arctic Marine Ecosystems

Fogg, G.E. 1998. *The biology of polar habitats*. Oxford University Press, Oxford.

Hobson, K.A., and Welch, H.E. 1992. Determination of trophic relationships within a high arctic marine food web using delta ^{13}C and delta ^{15}N analysis. *Marine Ecology Progress Series* 84:9–18.

Thomas, D.N. 2004. *Frozen oceans: The floating world of pack ice*. Firefly Books, Buffalo, New York.

6 Sea Ice and Habitat

Amstrup, S.C., Stirling, I., Smith, T.S., Perham, C., and Thiemann, G.W. 2006. Recent observations of intraspecific predation and cannibalism among polar bears in the southern Beaufort Sea. *Polar Biology* 29:997–1002.

Derocher, A.E., and Stirling, I. 1990. Distribution of polar bears (*Ursus maritimus*) during the ice-free period in western Hudson Bay. *Canadian Journal of Zoology* 68:1395–1403.

Derocher, A.E., and Wiig, Ø. 1999. Infanticide and cannibalism of juvenile polar bears (*Ursus maritimus*) in Svalbard. *Arctic* 52:307–310.

Durner, G.M., Douglas, D.C., Nielson, R.M., Amstrup, S.C., McDonald, T.L., Stirling, I., Mauritzen, M., et al. 2009. Predicting 21st-century polar bear habitat distribution from global climate models. *Ecological Monographs* 79:25–58.

Lindsay, R.W., and Zhang, J. 2005. The thinning of Arctic sea ice, 1988–2003: Have we passed a tipping point? *Journal of Climate* 18:4879–4894.

Lunn, N.J., and Stenhouse, G.B. 1985. An observation of possible cannibalism by polar bears (*Ursus maritimus*). *Canadian Journal of Zoology* 63:1516–1517.

Markus, T., Stroeve, J.C., and Miller, J. 2009. Recent changes in Arctic sea ice melt onset, freezeup,

and melt season length. *Journal of Geophysical Research* 114:C12024.

Parkinson, C.L., and Cavalieri, D.J. 2008. Arctic sea ice variability and trends, 1979–2006. *Journal of Geophysical Research-Oceans* 113:C07003.

Polyak, L., Alley, R.B., Andrews, J.T., Brigham-Grette, J., Cronin, T.M., Darby, D.A., Dyke, A.S., et al. 2010. History of sea ice in the Arctic. *Quaternary Science Reviews* 29:1757–1778.

Stirling, I. 1997. The importance of polynyas, ice edges, and leads to marine mammals and birds. *Journal of Marine Systems* 10:9–21.

Stone, I.R., and Derocher, A.E. 2007. An incident of polar bear infanticide and cannibalism on Phippsoya, Svalbard. *Polar Record* 43:171–173.

Stroeve, J., Holland, M.M., Meier, W., Scambos, T., and Serreze, M. 2007. Arctic sea ice decline: faster than forecast. *Geophysical Research Letters* 34:L09501.

Taylor, M., Larsen, T., and Schweinsburg, R.E. 1985. Observations of intraspecific aggression and cannibalism in polar bears (*Ursus maritimus*). *Arctic* 38:303–309.

Thomas, D.N. 2004. *Frozen oceans: The floating world of pack ice.* Firefly Books, Buffalo, New York.

7 Prey

Andersen, M., Hjelset, A.M., Gjertz, I., Lydersen, C., and Gulliksen, B. 1999. Growth, age at sexual maturity, and condition in bearded seals (*Erignathus barbatus*) from Svalbard, Norway. *Polar Biology* 21:179–185.

Cleator, H.J., Stirling, I., and Smith, T.G. 1989. Underwater vocalizations of the bearded seal (*Erignathus barbatus*). *Canadian Journal of Zoology* 67:1900–1910.

Derocher, A.E., Andriashek, D., and Stirling, I. 1993. Terrestrial foraging by polar bears during the ice-free period in western Hudson Bay. *Arctic* 46:251–254.

Derocher, A.E., Wiig, Ø., and Andersen, M. 2002. Diet composition of polar bears in Svalbard and the western Barents Sea. *Polar Biology* 25:448–452.

Derocher, A.E., Wiig, Ø., and Bangjord, G. 2000. Predation of Svalbard reindeer by polar bears. *Polar Biology* 23:675–678.

Donaldson, G.M., Chapdelaine, G., and Andrews, J.D. 1995. Predation of thick-billed murres, *Uria lomvia*, at two breeding colonies by polar bears, *Ursus maritimus*, and walruses, *Odobenus rosmarus. Canadian Field-Naturalist* 109:112–114.

Dyck, M.G., and Romberg, S. 2007. Observations of a wild polar bear (*Ursus maritimus*) successfully fishing Arctic charr (*Salvelinus alpinus*) and fourhorn sculpin (*Myoxocephalus quadricornis*). *Polar Biology* 30:1625–1628.

Furgal, C.M., Innes, S., and Kovacs, K.M. 1996. Characteristics of ringed seal, *Phoca hispida,* subnivean structures and breeding habitat and their effects on predation. *Canadian Journal of Zoology* 74:858–874.

Hammill, M.O., and Smith, T.G. 1991. The role of predation in the ecology of the ringed seal in Barrow Strait, Northwest Territories, Canada. *Marine Mammal Science* 7:123–135.

Hjelset, A.M., Andersen, M., Gjertz, I., Lydersen, C., and Gulliksen, B. 1999. Feeding habits of bearded seals (*Erignathus barbatus*) from the Svalbard area, Norway. *Polar Biology* 21:186–193.

Hobson, K.A., Stirling, I., and Andriashek, D.S. 2009. Isotopic homogeneity of breath CO_2 from fasting and berry-eating polar bears: Implications for tracing reliance on terrestrial foods in a changing Arctic. *Canadian Journal of Zoology* 87:50–55.

Labansen, A.L., Lydersen, C., Haug, T., and Kovacs, K.M. 2007. Spring diet of ringed seals (*Phoca hispida*) from northwestern Spitsbergen, Norway. *ICES Journal of Marine Science* 64:1246–1256.

Lønø, O. 1970. The polar bear (*Ursus maritimus* Phipps) in the Svalbard area. *Norsk Polarinstitutt Skrifter* 149:1–115.

Lydersen, C., and Hammill, M.O. 1993. Activity, milk intake, and energy consumption in free-living ringed seal (*Phoca hispida*) pups. *Journal of Comparative Physiology B* 163:433–438.

Madsen, J., Bregnballe, T., Frikke, J., and Bolding Kristensen, J. 1998. Correlates of predator abundance with snow and ice conditions and their role in determining timing of nesting and breeding success in Svalbard light-bellied brent geese *Branta bernicla hrota. Norsk Polarinstitutt Skrifter* 200:221–234.

Perrin, W.F., Würsig, B., Thewissen, J.G.M., eds. 2002. *Encyclopedia of marine mammals.* Academic Press, San Diego, California.

Russell, R.H. 1975. The food habits of polar bears of James Bay and southwest Hudson Bay in summer and autumn. *Arctic* 28:117–129.

Ryg, M., Solberg, Y., Lydersen, C., and Smith, T.G. 1992. The scent of rutting male ringed seals (*Phoca hispida*). *Journal of Zoology* 226:681–689.

Smith, P.A., Elliott, K.H., Gaston, A.J., and Gilchrist, H.G. 2010. Has early ice clearance increased predation on breeding birds by polar bears? *Polar Biology* 33:1149–1153.

Smith, T.G. 1985. Polar bears, *Ursus maritimus,* as predators of belugas, *Delphinapterus leucas. Canadian Field-Naturalist* 99:71–75.

Stempniewicz, L. 2006. Polar bear predatory behaviour toward molting barnacle geese and nesting glaucous gulls on Spitsbergen. *Arctic* 59:247–251.

References

Stirling, I., and McEwan, E.H. 1975. The calorific value of whole ringed seals (*Phoca hispida*) in relation to polar bear (*Ursus maritimus*) ecology and hunting behaviour. *Canadian Journal of Zoology* 53:1021–1027.

Stirling, I., and Øritsland, N.A. 1995. Relationships between estimates of ringed seal (*Phoca hispida*) and polar bear (*Ursus maritimus*) populations in the Canadian Arctic. *Canadian Journal of Fisheries and Aquatic Sciences* 52:2594–2612.

Thiemann, G.W., Iverson, S.J., and Stirling, I. 2008. Polar bear diets and Arctic marine food webs: Insights from fatty acid analysis. *Ecological Monographs* 78:591–613.

8 Distribution and Populations

Aars, J., Marques, T.A., Buckland, S.T., Andersen, M., Belikov, S., Boltunov, A., and Wiig, Ø. 2009. Estimating the Barents Sea polar bear subpopulation size. *Marine Mammal Science* 25:35–52.

Amstrup, S.C., Durner, G.M., McDonald, T.L., Mulcahy, D.M., and Garner, G.W. 2001. Comparing movement patterns of satellite-tagged male and female polar bears. *Canadian Journal of Zoology* 79:2147–2158.

Arthur, S.M., Manly, B.F.J., McDonald, L.L., and Garner, G.W. 1996. Assessing habitat selection when availability changes. *Ecology* 77:215–227.

Bethke, R., Taylor, M., Amstrup, S., and Messier, F. 1996. Population delineation of polar bears using satellite collar data. *Ecological Applications* 6:311–317.

Born, E.W., Wiig, Ø., and Thomassen, J. 1997. Seasonal and annual movements of radio-collared polar bears (*Ursus maritimus*) in northeast Greenland. *Journal of Marine Systems* 10:67–77.

Crompton, A.E., Obbard, M.E., Petersen, S.D., and Wilson, P.J. 2008. Population genetic structure in polar bears (*Ursus maritimus*) from Hudson Bay, Canada: Implications of future climate change. *Biological Conservation* 141:2528–2539.

DeMaster, D.P., Kingsley, M.C.S., and Stirling, I. 1980. A multiple mark and recapture estimate applied to polar bears. *Canadian Journal of Zoology* 58:633–638.

Doutt, J.K. 1940. Polar bears in the Gulf of St. Lawrence. *Journal of Mammalogy* 21:90–92.

Durner, G.M., and Amstrup, S.C. 1995. Movements of a polar bear from northern Alaska to northern Greenland. *Arctic* 48:338–341.

Edwards, C.J., Suchard, M.A., Lemey, P., Welch, J.J., Barnes, I., Fulton, T.L., Barnett, R., O'Connell, T.C., et al. 2011. Multiple hybridization events between ancient brown and polar bears and an Irish origin for the modern polar bear matriline. *Current Biology* 21:1251–1258.

Ferguson, S.H., Taylor, M.K., and Messier, F. 2000.

Influence of sea ice dynamics on habitat selection by polar bears. *Ecology* 81:761–772.

Garner, G.W., Knick, S.T., and Douglas, D.C. 1990. Seasonal movements of adult female polar bears in the Bering and Chukchi Seas. *International Conference on Bear Biology and Management* 8:219–226.

Goodyear, M.A. 2003. Extralimital sighting of a polar bear, *Ursus maritimus,* in northeast Saskatchewan. *Canadian Field-Naturalist* 117:648–649.

IUCN/SSC Polar Bear Specialist Group. 2010. *Polar bears: Proceedings of the 15th Working Meeting of the IUCN Polar Bear Specialist Group.* Edited by M.E. Obbard, G.W. Thiemann, E. Peacock, and T.D. DeBruyn. IUCN, Gland, Switzerland, and Cambridge, UK.

Mauritzen, M., Belikov, S.E., Boltunov, A.N., Derocher, A.E., Hansen, E., Ims, R.A., Wiig, Ø., and Yoccoz, N. 2003. Functional responses in polar bear habitat selection. *Oikos* 100:112–124.

Mauritzen, M., Derocher, A.E., Pavlova, O., and Wiig, Ø. 2003. Female polar bears, *Ursus maritimus,* on the Barents Sea drift ice: Walking the treadmill. *Animal Behaviour* 66:107–113.

Mauritzen, M., Derocher, A.E., and Wiig, Ø. 2001. Space-use strategies of female polar bears in a dynamic sea ice habitat. *Canadian Journal of Zoology* 79:1704–1713.

Mauritzen, M., Derocher, A.E., Wiig, Ø., Belikov, S.E., Boltunov, A., Garner, G.W. 2002. Using satellite telemetry to define spatial population structure in polar bears in the Norwegian and western Russian Arctic. *Journal of Applied Ecology* 39:79–90.

Paetkau, D., Amstrup, S.C., Born, E.W., Calvert, W., Derocher, A.E., Garner, G.W., Messier, F., et al. 1999. Genetic structure of the world's polar bear populations. *Molecular Ecology* 8:1571–1585.

Paetkau, D., Calvert, W., Stirling, I., and Strobeck, C. 1995. Microsatellite analysis of population structure in Canadian polar bears. *Molecular Ecology* 4:347–354.

Parks, E.K., Derocher, A.E., and Lunn, N.J. 2006. Seasonal and annual movement patterns of polar bears on the sea ice of Hudson Bay. *Canadian Journal of Zoology* 84:1281–1294.

Ramsay, M.A., and Andriashek, D.S. 1986. Long distance route orientation of female polar bears (*Ursus maritimus*) in spring. *Journal of Zoology* 208:63–72.

Ramsay, M.A., and Stirling, I. 1990. Fidelity of female polar bears to winter-den sites. *Journal of Mammalogy* 71:233–236.

Stirling, I. 1997. The importance of polynyas, ice edges, and leads to marine mammals and birds. *Journal of Marine Systems* 10:9–21.

Stirling, I., Andriashek, D., and Calvert, W. 1993.

Habitat preferences of polar bears in the western Canadian Arctic in late winter and spring. *Polar Record* 29:13–24.

Stirling, I., McDonald, T.L., Richardson, E.S., Regehr, E.V., and Amstrup, S.C. 2011. Polar bear population status in the northern Beaufort Sea, Canada, 1971–2006. *Ecological Applications* 21:859–876.

Stirling, I., Spencer, C., and Andriashek, D. 1989. Immobilization of polar bears (*Ursus maritimus*) with Telazol in the Canadian Arctic. *Journal of Wildlife Diseases* 25:159–168.

Taylor, M.K., Akeeagok, S., Andriashek, D., Barbour, W., Born, E.W., Calvert, W., Cluff, H.D., et al. 2001. Delineating Canadian and Greenland polar bear (*Ursus maritimus*) populations by cluster analysis of movements. *Canadian Journal of Zoology* 79:690–709.

Zeyl, E., Ehrich, D., Aars, J., Bachmann, L., and Wiig, Ø. 2010. Denning-area fidelity and mitochondrial DNA diversity of female polar bears (*Ursus maritimus*) in the Barents Sea. *Canadian Journal of Zoology* 88:1139–1148.

9 Hunting Methods

Calvert, W., and Stirling, I. 1990. Interactions between polar bears and overwintering walruses in the Central Canadian High Arctic. *International Conference on Bear Biology and Management* 8:351–356.

Dyck, M.G., and Romberg, S. 2007. Observations of a wild polar bear (*Ursus maritimus*) successfully fishing Arctic charr (*Salvelinus alpinus*) and fourhorn sculpin (*Myoxocephalus quadricornis*). *Polar Biology* 30:1625–1628.

Furgal, C.M., Innes, S., and Kovacs, K.M. 1996. Characteristics of ringed seal, *Phoca hispida,* subnivean structures, and breeding habitat and their effects on predation. *Canadian Journal of Zoology* 74:858–874.

Furnell, D.J., and Oolooyuk, D. 1980. Polar bear predation on ringed seals in ice-free water. *Canadian Field-Naturalist* 94:88–89.

Hammill, M.O., and Smith, T.G. 1991. The role of predation in the ecology of the ringed seal in Barrow Strait, Northwest Territories, Canada. *Marine Mammal Science* 7:123–135.

Jonkel, C.J. 1968. A polar bear and porcupine encounter. *Canadian Field-Naturalist* 83:222.

Kingsley, M.C.S., and Stirling, I. 1991. Haul-out behaviour of ringed and bearded seals in relation to defence against surface predators. *Canadian Journal of Zoology* 69:1857–1861.

Ramsay, M.A., and Hobson, K.A. 1991. Polar bears make little use of terrestrial food webs: Evidence from stable-carbon isotope analysis. *Oecologia* 86:598–600.

Rockwell, R.F., and Gormezano, L.J. 2009. The early

bear gets the goose: Climate change, polar bears and lesser snow geese in western Hudson Bay. *Polar Biology* 32:539–547.

Smith, P.A., Elliott, K.H., Gaston, A.J., and Gilchrist, H.G. 2010. Has early ice clearance increased predation on breeding birds by polar bears? *Polar Biology* 33:1149–1153.

Smith, T.G. 1985. Polar bears, *Ursus maritimus,* as predators of belugas, *Delphinapterus leucas*. *Canadian Field-Naturalist* 99:71–75.

Smith, T.G., and Sjare, B. 1990. Predation of belugas and narwhals by polar bears in nearshore areas of the Canadian High Arctic. *Arctic* 43:99–102.

Smith, T.G., and Stirling, I. 1975. The breeding habitat of the ringed seal (*Phoca hispida*): The birth lair and associated structures. *Canadian Journal of Zoology* 53:1297–1305.

Stirling, I. 1974. Midsummer observations on the behavior of wild polar bears. *Canadian Journal of Zoology* 52:1191–1198.

Stirling, I. 1984. A group threat display given by walruses to a polar bear. *Journal of Mammalogy* 65:352–353.

Stirling, I., and Archibald, W.R. 1977. Aspects of predation of seals by polar bears. *Journal of the Fisheries Research Board of Canada* 34:1126–1129.

Stirling, I., and Latour, P.B. 1978. Comparative hunting abilities of polar bear cubs of different ages. *Canadian Journal of Zoology* 56:1768–1772.

10 Polar Bear Behavior

Aars, J., and Plumb, A. 2010. Polar bear cubs may reduce chilling from icy water by sitting on mother's back. *Polar Biology* 33:557–559.

Ames, A. 1994. Object manipulation in captive polar bears. *Ursus* 9:443–449.

Derocher, A.E., Andersen, M., and Wiig, Ø. 2005. Sexual dimorphism of polar bears. *Journal of Mammalogy* 86:895–901.

Derocher, A.E., Andersen, M., Wiig, Ø., and Aars, J. 2010. Sexual dimorphism and the mating ecology of polar bears (*Ursus maritimus*) at Svalbard. *Behavioral Ecology and Sociobiology* 64:939–946.

Derocher, A.E., and Stirling, I. 1990. Distribution of polar bears (*Ursus maritimus*) during the ice-free period in western Hudson Bay. *Canadian Journal of Zoology* 68:1395–1403.

Derocher, A.E., and Stirling, I. 1990. Observations of aggregating behavior of adult male polar bears. *Canadian Journal of Zoology* 68:1390–1394.

Hamer, D., and Herrero, S. 1990. Courtship and use of mating areas by grizzly bears in the Front Ranges of Banff National Park, Alberta. *Canadian Journal of Zoology* 68:2695–2697.

Hansson, R., and Thomassen, J. 1983. Behavior of polar bears with cubs in the denning area. *Inter-*

national Conference on Bear Biology and Management 5:246–254.

Larsen, T. 1971. Sexual dimorphism in the molar rows of the polar bear. *Journal of Wildlife Management* 35:374–377.

Latour, P.B. 1981. Interactions between free-ranging, adult male polar bears (*Ursus maritimus* Phipps): A case of adult social play. *Canadian Journal of Zoology* 59:1775–1778.

Lunn, N.J. 1986. Observations of nonaggressive behavior between polar bear family groups. *Canadian Journal of Zoology* 64:2035–2037.

Ramsay, M.A., and Stirling, I. 1986. On the mating system of polar bears. *Canadian Journal of Zoology* 64:2142–2151.

Stirling, I., and Derocher, A.E. 1990. Factors affecting the evolution and behavioral ecology of the modern bears. *Bears: Their Biology and Management* 8:189–204.

Wechsler, B. 1991. Stereotypies in polar bears. *Zoo Biology* 10:177–188.

Wiig, Ø., Gjertz, I., Hansson, R., and Thomassen, J. 1992. Breeding behaviour of polar bears in Hornsund, Svalbard. *Polar Record* 28:157–159.

11 Den Ecology

Amstrup, S.C., and Gardner, C. 1994. Polar bear maternity denning in the Beaufort Sea. *Journal of Wildlife Management* 58:1–10.

Blix, A.S., and Lentfer, J.W. 1979. Modes of thermal protection in polar bear cubs—at birth and on emergence from the den. *American Journal of Physiology* 236:R67–R74.

Clark, D.A., Stirling, I., and Calvert, W. 1997. Distribution, characteristics, and use of earth dens and related excavations by polar bears on the Western Hudson Bay lowlands. *Arctic* 50:158–166.

Durner, G.M., Amstrup, S.C., and Fischbach, A.S. 2003. Habitat characteristics of polar bear terrestrial den sites in northern Alaska. *Arctic* 56:55–62.

Ferguson, S.H., Taylor, M.K., Rosing-Asvid, A., Born, E.W., and Messier, F. 2000. Relationships between denning of polar bears and conditions of sea ice. *Journal of Mammalogy* 81:1118–1127.

Fischbach, A.S., Amstrup, S.C., and Douglas, D.C. 2007. Landward and eastward shift of Alaskan polar bear denning associated with recent sea ice changes. *Polar Biology* 30:1395–1405.

Harington, C.R. 1968. Denning habits of the polar bear *Ursus maritimus. Canadian Wildlife Service Report Series* 5:2–30.

Jonkel, C.J., Kolenosky, G.B., Robertson, R., and Russell, R.H. 1972. Further notes on the polar denning habits. *International Conference on Bear Biology and Management* 2:142–158.

Kolenosky, G.B., and Prevett, J.P. 1983. Productivity and maternity denning of polar bears in Ontario. *International Conference on Bear Biology and Management* 5:238–245.

Larsen, T. 1985. Polar bear denning and cub production in Svalbard, Norway. *Journal of Wildlife Management* 49:320–326.

Messier, F., Taylor, M.K., and Ramsay, M.A. 1994. Denning ecology of polar bears in the Canadian Arctic Archipelago. *Journal of Mammalogy* 75:420–430.

Richardson, E., Stirling, I., and Hik, D.S. 2005. Polar bear (*Ursus maritimus*) maternity denning habitat in western Hudson Bay: A bottom-up approach to resource selection functions. *Canadian Journal of Zoology* 83:860–870.

Richardson, E., Stirling, I., and Kochtubajda, B. 2007. The effects of forest fires on polar bear maternity denning habitat in western Hudson Bay. *Polar Biology* 30:369–378.

Schweinsburg, R.E. 1979. Summer snow dens used by polar bears in the Canadian High Arctic. *Arctic* 32:165–169.

Stirling, I., and Andriashek, D. 1992. Terrestrial maternity denning of polar bears in the Eastern Beaufort Sea area. *Arctic* 45:363–366.

Van de Velde, F., Stirling, I., and Richardson, E. 2003. Polar bear (*Ursus maritimus*) denning in the area of the Simpson Peninsula, Nunavut. *Arctic* 56:191–197.

Veltre, D.W., Yesner, D.R., Crossen, K.J., Graham, R.W., and Coltrain, J.B. 2008. Patterns of faunal extinction and paleoclimatic change from mid-Holocene mammoth and polar bear remains, Pribilof Islands, Alaska. *Quaternary Research* 70:40–50.

Watts, P.D., and Hansen, S.E. 1987. Cyclic starvation as a reproductive strategy in the polar bear. *Symposia of the Zoological Society of London* 57:305–318.

12 From Birth to Death

Amstrup, S.C., and Durner, G.M. 1995. Survival rates of radio-collared female polar bears and their dependent young. *Canadian Journal of Zoology* 73:1312–1322.

Amstrup, S.C., Gardner, C., Myers, K.C., and Oehme, F.W. 1989. Ethylene glycol (antifreeze) poisoning in a free-ranging polar bear. *Veterinary and Human Toxicology* 31:317–319.

Amstrup, S.C., and Nielsen, C.A. 1989. Acute gastric dilatation and volvulus in a free-living polar bear. *Journal of Wildlife Diseases* 25:601–604.

Arnould, J.P.Y., and Ramsay, M.A. 1994. Milk production and milk consumption in polar bears during the ice-free period in western Hudson Bay. *Canadian Journal of Zoology* 72:1365–1370.

Åsbakk, K., Aars, J., Derocher, A.E., Wiig, Ø., Ok-

sanen, A., Born, E.W., Dietz, R., Sonne, C., God-
froid, J., and Kapel, C.M.O. 2010. Serosurvey for
Trichinella in polar bears (*Ursus maritimus*) from
Svalbard and the Barents Sea. *Veterinary Parasitol-
ogy* 172:256–263.

Atkinson, S.N., Cattet, M.R.L., Polischuk, S.C., and
Ramsay, M.A. 1996. A case of offspring adoption
in free-ranging polar bears (*Ursus maritimus*).
Arctic 49:94–96.

Atkinson, S.N., Stirling, I., and Ramsay, M.A. 1996.
Growth in early life and relative body size
among adult polar bears (*Ursus maritimus*). *Jour-
nal of Zoology* 239:225–234.

Cattet, M.R.L., Duignan, P.J., House, C.A., and St.
Aubin, D.J. 2004. Antibodies to canine distemper
and phocine distemper viruses in polar bears
from the Canadian Arctic. *Journal of Wildlife
Diseases* 40:338–342.

Clarkson, P.L., and Irish, D. 1991. Den collapse kills
female polar bear and two newborn cubs. *Arctic*
44:83–84.

Cork, L.C., Powers, R.E., Selkoe, D.J., Davies, P.,
Geyer, J.J., and Price, D.L. 1988. Neurofibrallary
tangles and senile plaques in aged bears. *Journal
of Neuropathology and Experimental Neurology*
47:629–641.

Derocher, A.E., Andersen, M., and Wiig, Ø. 2005.
Sexual dimorphism of polar bears. *Journal of
Mammalogy* 86:895–901.

Derocher, A.E., Andriashek, D., and Arnould, J.P.Y.
1993. Aspects of milk composition and lacta-
tion in polar bears. *Canadian Journal of Zoology*
71:561–567.

Derocher, A.E., and Stirling, I. 1991. Oil contamina-
tion of two polar bears. *Polar Record* 27:56–57.

Derocher, A.E., and Stirling, I. 1994. Age-specific
reproductive performance of female polar bears
(*Ursus maritimus*). *Journal of Zoology* 234:527–
536.

Derocher, A.E., and Stirling, I. 1996. Aspects of
survival in juvenile polar bears. *Canadian Journal
of Zoology* 74:1246–1252.

Derocher, A.E., and Stirling, I. 1998a. Geographic
variation in growth of polar bears (*Ursus mariti-
mus*). *Journal of Zoology* 245:65–72.

Derocher, A.E., Stirling, I. 1998b. Maternal invest-
ment and offspring size in polar bears (*Ursus
maritimus*). *Journal of Zoology* 245:253–260.

Derocher, A.E., Stirling, I., and Andriashek, D. 1992.
Pregnancy rates and serum progesterone levels
of polar bears in western Hudson Bay. *Canadian
Journal of Zoology* 70:561–566.

Derocher, A.E., and Wiig, Ø. 1999. Observation of
adoption in polar bears (*Ursus maritimus*). *Arctic*
52:413–415.

Derocher, A.E., and Wiig, Ø. 2002. Postnatal
growth in body length and mass of polar bears

(*Ursus maritimus*) at Svalbard. *Journal of Zoology*
256:343–349.

Durner, G.M., Whiteman, J.P., Harlow, H.J., Am-
strup, S.C., Regehr, E.V., and Ben-David, M.
2011. Consequences of long-distance swimming
and travel over deep-water pack ice for a female
polar bear during a year of extreme sea ice re-
treat. *Polar Biology* 34:975–984.

Garner, G.W., Evermann, J.F., Saliki, J.T., Follmann,
E.H., and McKeirnan, A.J. 2000. Morbillivirus
ecology in polar bears (*Ursus maritimus*). *Polar
Biology* 23:474–478.

Home, W.S. 1979. Wolverine kills polar bear on
arctic sea ice. *Arctic Circular* 27:29–30.

Kingsley, M.C.S. 1979. Fitting the von Bertalanffy
growth equation to polar bear age-weight data.
Canadian Journal of Zoology 57:1020–1025.

Latinen, K. 1987. Longevity and fertility of the
polar bear, *Ursus maritimus* Phipps, in captivity.
Zoologische Garten NF 57:197–199.

Monnett, C., and Gleason, J.S. 2006. Observations
of mortality associated with extended open-
water swimming by polar bears in the Alaskan
Beaufort Sea. *Polar Biology* 29:681–687.

Oksanen, A., Åsbakk, K., Prestrud, K.W., Aars, J.,
Derocher, A.E., Tryland, M., Wiig, Ø., et al. 2009.
Prevalence of antibodies against *Toxoplasma
gondii* in polar bears (*Ursus maritimus*) from Sval-
bard and east Greenland. *Journal of Parasitology*
95:89–94.

Ramsay, M.A., and Dunbrack, R.L. 1986. Physiologi-
cal constraints on life history phenomena: The
example of small bear cubs at birth. *American
Naturalist* 127:735–743.

Ramsay, M.A., and Stirling, I. 1988. Reproductive
biology and ecology of female polar bears (*Ursus
maritimus*). *Journal of Zoology* 214:601–634.

Regehr, E.V., Hunter, C.M., Caswell, H., Amstrup,
S.C., and Stirling, I. 2010. Survival and breed-
ing of polar bears in the southern Beaufort Sea
in relation to sea ice. *Journal of Animal Ecology*
79:117–127.

Richardson, E.S., and Andriashek, D.S. 2006. Wolf
(*Canis lupus*) predation of a polar bear (*Ursus
maritimus*) cub on the sea ice off northwestern
Banks Island, Northwest Territories, Canada.
Arctic 59:322–324.

Rosing-Asvid, A., Born, E.W., and Kingsley, M.C.S.
2002. Age at sexual maturity of males and tim-
ing of the mating season of polar bears (*Ursus
maritimus*) in Greenland. *Polar Biology* 25:878–
883.

Stirling, I. 1974. Midsummer observations on the
behavior of wild polar bears. *Canadian Journal of
Zoology* 52:1191–1198.

Stirling, I., and Smith, T.G. 2004. Implications of
warm temperatures, and an unusual rain event

for the survival of ringed seals on the coast of southeastern Baffin Island. *Arctic* 57:59–67.

Taylor, M., Elkin, B., Maier, N., and Bradley, M. 1991. Observation of a polar bear with rabies. *Journal of Wildlife Diseases* 27:337–339.

Tryland, M., Neuvonen, E., Huovilainen, A., Tapiovaara, H., Osterhaus, A., Wiig, Ø., and Derocher, A.E. 2005. Serological survey for selected virus infections in polar bears at Svalbard. *Journal of Wildlife Diseases* 41:310–316.

Urashima, T., Yamashita, T., Nakamura, T., Arai, I., Saito, T., Derocher, A.E., and Wiig, Ø. 2000. Chemical characterization of milk oligosaccharides of the polar bear, *Ursus maritimus*. *Biochimica et Biophysica Acta* 1475:395–408.

13 Threats

Amstrup, S.C., DeWeaver, E.T., Douglas, D.C., Marcot, B.G., Durner, G.M., Bitz, C.M., and Bailey, D.A. 2010. Greenhouse gas mitigation can reduce sea-ice loss and increase polar bear persistence. *Nature* 468:955–958.

Andersen, M., and Aars, J. 2008. Short-term behavioural response of polar bears (*Ursus maritimus*) to snowmobile disturbance. *Polar Biology* 31:501–507.

Andersen, M., Lie, E., Derocher, A.E., Belikov, S.E., Bernhoft, A., Boltunov, A., Garner, G.W., Skaare, J.U., Wiig, Ø. 2001. Geographic variation of PCB congeners in polar bears (*Ursus maritimus*) from Svalbard east to the Chukchi Sea. *Polar Biology* 24:231–238.

Bernhoft, A., Skaare, J.U., Wiig, Ø., Derocher, A.E., and Larsen, H.J.S. 2000. Possible immunotoxic effects of organochlorines in polar bears (*Ursus maritimus*) at Svalbard. *Journal of Toxicology and Environmental Health, Part A* 59:561–574.

Braathen, M., Derocher, A.E., Wiig, Ø., Sørmo, E.G., Lie, E., Skaare, J.U., Jenssen, B.M. 2004. Thyroid hormone and retinol status in polar bears (*Ursus maritimus*) at Svalbard in relation to plasma concentrations of PCBs. *Environmental Health Perspectives* 112:826–833.

Cherry, S.G., Derocher, A.E., Stirling, I., and Richardson, E.S. 2009. Fasting physiology of polar bears in relation to environmental change and breeding behavior in the Beaufort Sea. *Polar Biology* 32:383–391.

Derocher, A.E., Lunn, N.J., and Stirling, I. 2004. Polar bears in a warming climate. *Integrative and Comparative Biology* 44:163–176.

Derocher, A.E., Stirling, I., and Calvert, W. 1997. Male-biased harvesting of polar bears in western Hudson Bay. *Journal of Wildlife Management* 61:1075–1082.

Derocher, A.E., Wolkers, H., Colborn, T., Schlabach, M., Larsen, T.S., Wiig, Ø. 2003. Contaminants in Svalbard polar bear samples archived since 1967 and possible population level effects. *Science of the Total Environment* 301:163–174.

Dietz, R., Riget, F., and Johansen, P. 1996. Lead, cadmium, mercury, and selenium in Greenland marine mammals. *Science of the Total Environment* 186:67–93.

Downing, K., and Reed, M. 1996. Object-oriented migration modelling for biological impact assessment. *Ecological Modelling* 93:203–219.

Dowsley, M. 2009. Inuit-organised polar bear sport hunting in Nunavut Territory, Canada. *Journal of Ecotourism* 8:161–175.

Dowsley, M., and Wenzel, G. 2008. "The time of the most polar bears": A co-management conflict in Nunavut. *Arctic* 61:177–189.

Durner, G.M., Douglas, D.C., Nielson, R.M., Amstrup, S.C., McDonald, T.L., Stirling, I., Mauritzen, M., et al. 2009. Predicting 21st-century polar bear habitat distribution from global climate models. *Ecological Monographs* 79:25–58.

Fischbach, A.S., Amstrup, S.C., and Douglas, D.C. 2007. Landward and eastward shift of Alaskan polar bear denning associated with recent sea ice changes. *Polar Biology* 30:1395–1405.

Flyger, V. 1967. The polar bear: A matter for international concern. *Arctic* 20:147–153.

Freeman, M.M.R., and Wenzel, G.W. 2006. The nature and significance of polar bear conservation hunting in the Canadian Arctic. *Arctic* 59:21–30.

Gjertz, I., and Scheie, J.O. 1998. Human casualties and polar bears killed in Svalbard, 1993–1997. *Polar Record* 34:337–340.

Gleason, J.S., and Rode, K.D. 2009. Polar bear distribution and habitat association reflect long-term changes in fall sea ice conditions in the Alaskan Beaufort Sea. *Arctic* 62:405–417.

Herrero, S. 2002. *Bear attacks: Their causes and avoidance*. Lyons Press, Guilford, Connecticut.

Higdon, J.W., and Ferguson, S.H. 2009. Loss of Arctic sea ice causing punctuated change in sightings of killer whales (*Orcinus orca*) over the past century. *Ecological Applications* 19:1365–1375.

Hunter, C.M., Caswell, H., Runge, M.C., Regehr, E.V., Amstrup, S.C., and Stirling, I. 2010. Climate change threatens polar bear populations: A stochastic demographic analysis. *Ecology* 91:2883–2897.

Hurst, R.J., and Øritsland, N.A. 1982. Polar bear thermoregulation: Effect of oil on the insulative properties of fur. *Journal of Thermal Biology* 7:201–208.

Hurst, R.J., Watts, P.D., and Øritsland, N.A. 1991. Metabolic compensation in oil-exposed polar bears. *Journal of Thermal Biology* 16:53–56.

Keith, D. 2005. *Inuit Qaujimaningit Nanurnut: Inuit knowledge of polar bears*. CCI Press, Edmonton.

Laidre, K.L., Stirling, I., Lowry, L.F., Wiig, Ø., Heide-Jorgensen, M.P., and Ferguson, S.H. 2008. Quantifying the sensitivity of Arctic marine mammals to climate-induced habitat change. *Ecological Applications* 18:S97–S125.

Lee, J., and Taylor, M. 1994. Aspects of the polar bear harvest in the Northwest Territories, Canada. *International Conference on Bear Biology and Management* 9:237–243.

Lie, E., Larsen, H.J.S., Larsen, S., Johnsen, G.M., Derocher, A.E., Lunn, N.J., Norstrom, R.J., Wiig, O., and Skaare, J.U. 2004. Does high organochlorine (OC) exposure impair the resistance to infection in polar bears (*Ursus maritimus*)? Part 1: Effect of OCs on the humoral immunity. *Journal of Toxicology and Environmental Health, Part A* 67:555–582.

Loughrey, A.G. 1956. The polar bear and its protection. *Oryx* 3:233–239.

Lunn, N.J., and Stirling, I. 1985. The significance of supplemental food to polar bears during the ice-free period of Hudson Bay. *Canadian Journal of Zoology* 63:2291–2297.

Molnár, P.K., Derocher, A.E., Klanjscek, T., and Lewis, M.A. 2011. Predicting climate change impacts on polar bear litter size. *Nature Communications* 2:186.

Molnár, P.K., Derocher, A.E., Lewis, M.A., and Taylor, M.K. 2008. Modelling the mating system of polar bears: A mechanistic approach to the Allee effect. *Proceedings of the Royal Society B: Biological Sciences* 275:217–226.

Molnár, P.K, Derocher, A.E., Thiemann, G.W., and Lewis, M.A. 2010. Predicting survival, reproduction, and abundance of polar bears under climate change. *Biological Conservation* 143:1612–1622.

Moore, S.E., and Huntington, H.P. 2008. Arctic marine mammals and climate change: Impacts and resilience. *Ecological Applications* 18:S157–S165.

Norstrom, R.J., Simon, M., Muir, D.C.G., and Schweinsburg, R.E. 1988. Organochlorine contaminants in Arctic marine food chains: Identification, geographical distribution, and temporal trends in polar bears. *Environmental Science and Technology* 22:1063–1071.

Peacock, E., Derocher, A.E., Thiemann, G.W., and Stirling, I. 2011. Conservation and management of Canada's polar bears (*Ursus maritimus*) in a changing Arctic. *Canadian Journal of Zoology* 89:371–385.

Polischuk, S.C., Letcher, R.J., Norstrom, R.J., and Ramsay, M.A. 1995. Preliminary results of fasting on the kinetics of organochlorines in polar bears (*Ursus maritimus*). *Science of the Total Environment* 160–161:465–472.

Prestrud, P., and Stirling, I. 1994. The International Polar Bear Agreement and the current status of polar bear conservation. *Aquatic Mammals* 20:113–124.

Regehr, E.V., Hunter, C.M., Caswell, H., Amstrup, S.C., and Stirling, I. 2010. Survival and breeding of polar bears in the southern Beaufort Sea in relation to sea ice. *Journal of Animal Ecology* 79:117–127.

Regehr, E.V., Lunn, N.J., Amstrup, S.C., and Stirling, I. 2007. Effects of earlier sea ice breakup on survival and population size of polar bears in western Hudson Bay. *Journal of Wildlife Management* 71:2673–2683.

Rode, K.D., Amstrup, S.C., and Regehr, E.V. 2010. Reduced body size and cub recruitment in polar bears associated with sea ice decline. *Ecological Applications* 20:768–782.

Schliebe, S., Rode, K.D., Gleason, J.S., Wilder, J., Proffitt, K., Evans, T.J., and Miller, S. 2008. Effects of sea ice extent and food availability on spatial and temporal distribution of polar bears during the fall open-water period in the southern Beaufort Sea. *Polar Biology* 31:999–1010.

Sonne, C. 2010. Health effects from long-range transported contaminants in Arctic top predators: An integrated review based on studies of polar bears and relevant model species. *Environment International* 36:461–491.

Stenhouse, G.B., Lee, L.J., and Poole, K.G. 1988. Some characteristics of polar bears killed during conflicts with humans in the Northwest Territories, 1976–86. *Arctic* 41:275–278.

Stirling, I. 1988. Attraction of polar bears *Ursus maritimus* to offshore drilling sites in the eastern Beaufort Sea. *Polar Record* 24:1–8.

Stirling, I. 1990. "Polar bears and oil: Ecological perspectives." In *Sea mammals and oil: Confronting the risks*. Edited by J.R. Geraci and D.J. St. Aubin. Academic Press, San Diego, California. 223–234.

Stirling, I., and Derocher, A.E. 1993. Possible impacts of climatic warming on polar bears. *Arctic* 46:240–245.

Stirling, I., Lunn, N.J., and Iacozza, J. 1999. Long-term trends in the population ecology of polar bears in western Hudson Bay in relation to climate change. *Arctic* 52:294–306.

Stirling, I., and Parkinson, C.L. 2006. Possible effects of climate warming on selected populations of polar bears (*Ursus maritimus*) in the Canadian Arctic. *Arctic* 59:261–275.

Stirling, I., Richardson, E., Thiemann, G.W., and Derocher, A.E. 2008. Unusual predation attempts of polar bears on ringed seals in the southern Beaufort Sea: Possible significance of changing spring ice conditions. *Arctic* 61:14–22.

Taylor, M.K., McLoughlin, P.D., and Messier, F. 2008. Sex-selective harvesting of polar bears *Ursus maritimus*. *Wildlife Biology* 14:52–60.

Towns, L., Derocher, A.E., Stirling, I., and Lunn, N.J. 2010. Changes in land distribution of polar bears in western Hudson Bay. *Arctic* 63:206–212.

Towns, L., Derocher, A.E., Stirling, I., Lunn, N.J., and Hedman, D. 2009. Spatial and temporal patterns of problem polar bears in Churchill, Manitoba. *Polar Biology* 32:1529–1537.

Wiig, Ø., Derocher, A.E., Cronin, M.M., and Skaare, J.U. 1998. Female pseudohermaphrodite polar bears at Svalbard. *Journal of Wildlife Diseases* 34:792–796.

14 Looking Forward

Derocher, A.E. 2010. Climate change: The prospects for polar bears. *Nature* 468:905–906.

243

References

Index

Page numbers in boldface indicate photographs or illustrations.

87–88, 88–89, **111**, 112, 117–118,
155, 159, 160, 163–164, **164**, 165,
168, 174–175, 185, 203. *See also*
Cape Churchill; Churchill; Polar
Bear Alert; tourism
whaling, 3
whiskers, 15–16

white whale. *See* beluga
wolverine, 195
wolves, 41, 84, 136, 137; predation
on polar bears, 161, 188
woolly mammoth, 160
wounds, 141–142, **142**, 143, 149,
190, 191, 195

Wrangel Island, **3**, 80, 112, 155–156,
156, 190

zooplankton. *See* plankton
zoos, 40, 46–47, 95, 138, 151, 202

F 5/1/15